# THE ISLAMIC ART
# OF PERSIA

THE ISLAMIC ART
OF PERSIA

# THE ISLAMIC ART
# OF PERSIA

Edited by
## A.J. ARBERRY

*Goodword*
B·O·O·K·S

First published in Oxford 1953
First published by Goodword Books 2001

GOODWORD BOOKS
1, Nizamuddin West Market,
New Delhi 110 013
Tel. 462 5454, 462 6666
Fax 469 7333, 464 7980
e-mail: skhan@vsnl.com
website: http://www.alrisala.org

Printed in India

# PREFACE

'THERE is as much sense in Hafiz as in Horace, and as much knowledge of the world.' So Sherlock Holmes took leave of *A Case of Identity* and the sad romance of Mary Sutherland. In a way it would be difficult to summarize more neatly the essential meaning of the Legacy of Persia. It is scarcely surprising, after all, that a land in which civilization has flourished at a continuously high level for nearly three thousand years of recorded history should abound in worldly wisdom. The Persians have long since appreciated the virtue of being *jahān-dīda* ('one who has seen the world'); the contrast between the sage who is *pukhta* ('cooked') and the simpleton who is *khām* ('raw') has been by no other people more subtly and more shrewdly drawn.

What is it that gives form and flavour to a great culture? A long and prized tradition, a poise and an assurance, a satisfaction with work well done—these are some of the evident but superficial symptoms. Beneath the surface other currents flow: poise is itself the delicate balance of forces striving in contrary directions, satisfaction a hardly-won relief from deep-set discontent. It has been often remarked that the Persian character is full of inconsistencies; the observation is true, but the phenomenon is a necessary condition of the perennial consistency of Persian civilization. Conflict within the Persian soul has saved the Persian mind from ever becoming sterile. So much it is necessary to say by way of prelude, before we lift the curtain and glimpse the exquisite pageantry of Persian life.

The causes underlying this variety and, to use the fashionable jargon, polarity of the Persian genius are not far to seek. Persia's broad expanses of mountain and plain have been under uninterrupted cultivation (where they are cultivable) for many thousands of years. During a considerable fraction of that long period the Persians were an imperial people; yet they have also

suffered repeated invasions and subjections to foreign conquerors extending over many centuries. At the time when Greece turned back the hosts of Xerxes, the Persians had already achieved a certain attitude to life which runs through the changing pattern of successive ages like a bright, unfading thread. If the Greeks were seekers and the Romans rulers, the Persians have long since felt at home in the world; they are sure in their experience of it, immune against its shocks and sudden surprises. The world is to be organized and can be controlled or, where it resists control, endured and in the end overcome. The world is to be enjoyed; and if its full enjoyment may only be experienced by a small number of its inhabitants, justice and benevolence dispensed by wise though privileged autocrats can surely make tolerable that tedious and sordid labour which is the destined portion of the great masses; the spectators at the banquet are free to take pleasure in the sight and sounds of the revel, and may pick up a few of the crumbs. Yet this very complacency bears within itself the seeds of violent revolt; like jesters at a royal court, rebels and heretics periodically enliven the otherwise sober and slightly ponderous narrative of Persian history, giving spice and savour to the tale.

These pages illustrate some of the many ways in which Persian culture has influenced Persia's neighbours, and become a legacy to the whole world. As inevitably happens with rich legacies not secured by an attested will, this matter of cultural inheritance is apt to be hotly disputed; interested parties may make claims that take a deal of substantiating. It is the arduous task of the editor of such a volume as this to enlist the support of a team of writers sufficiently enthusiastic to accept the largely gratuitous labour of crystallizing deep study and wide reading into an all too constricting compass, yet discreet enough to see life steadily and see it whole. The editor of this book has every reason to count himself fortunate in having been able to put together a most talented and balanced side; and he would take this opportunity

of recording his gratitude to those who have collaborated with him in the enterprise. Speaking on behalf of them all, he ventures to say that we feel highly privileged to pay this little tribute to a great people, and a great culture which has given us infinite enjoyment. In the immortal words of Mīrzā Abu'l Ḥasan, Persian Envoy to the Court of His Majesty King George III, 'I tell my King, English love Persian very much'.

A. J. A.

# CONTENTS

# CONTENTS

# LIST OF PLATES

## PERSIA AND THE ANCIENT WORLD

## PERSIA AND BYZANTIUM

### With notes on the illustrations

The costume of the Empress is of a distinctly oriental type especially as regards the love of rich ornamentation and bejewelling. Her necklace is of a type that can be paralleled at an earlier date in Persian art. Most striking in its Persian affinities, however, is her crown, for the two small projections on either side, as well as the curved one in the centre, reproduce in a stylized manner the wings and similar ornaments of the typical Sassanian crowns, as shown on the coins, silver plates, and rock reliefs. The small statuette illustrated on Plate 10 (*a*), and the silver plate on Plate 8 may be compared.

PLATE

### THE ISLAMIC ART OF PERSIA

xvi

*List of Plates*

PLATE

Plates 2–6, 8, and 34–47 are reproduced from *A Survey of Persian Art*, edited by Arthur Upham Pope and Phyllis Ackerman (Oxford University Press).

# CHAPTER 1

# PERSIA AND THE ANCIENT WORLD

CONSIDERING the tremendous role which Aryan man has played in world history, how unfamiliar to us (his descendants) are his origins and the lands that were the cradle of our race. Hebrew, Greek, and Roman civilization is absorbed, more or less, by Western man with his mother's milk; the vast Iranian panorama in which our ancestors arose and flourished seems as remote to the majority as the moon. For us its early history is restricted to those occasions when it formed part of that of Israel or Greece. Our interest and sympathies are enlisted on behalf of the Jewish exiles, the drama of Marathon and Thermopylae, the March of the Ten Thousand, or Alexander's meteoric career; incidental in our minds to these events are the extent of the realm of Ahasuerus,[1] the background to the decree of Cyrus, King of Persia,[2] the initiative shown by Darius on his accession, or the rise of Zoroastrianism. In part the reason is no doubt that Persia has lacked a chronicler of its own. No Herodotus or Xenophon has arisen (or survived) from amongst the Persians themselves; the advocates are all on the side of the Greeks. Our information, all too scanty as it is, derives from foreigners, from Jews and Greeks, the national enemies of Persia. This is a powerful handicap. To present the Persian side is to assume the role of 'advocatus diaboli': so completely has it gone by default. An historical attitude of mind, however, compels us to look at the reverse side of the medal; this is what we shall seek here briefly to do. In the virtual absence of literature or written records, a selection from the vast array of facts will have to speak for much of the period, countering as best they may the charms of an Herodotus or the silence of neglect. But before we reach these more historical events we must delve far back

[1] Esther i. 1, 'from India even unto Ethiopia'.     [2] Ezra i. 1.

into the remote past, to an epoch when the significance of these lands for ourselves began.

The term Persia takes definite form late in the history of the Oriental world, with the irruption of Aryan peoples into the Iranian plateau from the vast nomadic reservoir to the east and north of the Caspian Sea, early in the first millennium B.C.[1] At first it denoted an area in the south-west part of modern Iran, bordering upon the Persian Gulf, and including the heart of the later Persian Empire, with the cities of Pasargadae and Persepolis. It was known as Parsa, Persis to the Greeks, to the Arabs later as Fars. In the empire of Darius it was but a single province, but owing to its being the home of the Achaemenid ruling house, it received special honour and its name was commonly applied to the whole empire. In modern times, under the régime of Riza Shah, the more comprehensive name Iran was for a time officially readopted, as part of a policy of exalting the wider Achaemenid or Aryan tradition.

Until some thirty years ago the Persian Empire seemed to have sprung into existence as by a miracle, like Athena fully armed; the story of Persia before the time of Cyrus was a confused patchwork of myth and legend. Archaeological excavations, however, during the past generation or so have revealed a picture of the country, still sketchy in detail, but enabling us to grasp the significant outlines of its cultural history. The evidence has been of two main kinds, pottery and inscribed writings in cuneiform script on clay tablets. The former gives us glimpses of an early civilization, for example, at Persepolis itself, prior to about 4000 B.C., at first neolithic in character, later developing into a full Bronze Age type, homogeneous in essentials, reaching

---

[1] This seems to have been the second Aryan irruption into W. Asia from the steppes of S. Russia: an earlier one had been towards the middle of the second millennium B.C., when the Achaeans first entered Greece, and Aryan peoples spread into Italy and Asia Minor, forming the Hittite Empire in the latter, and appeared amongst the Hyksos chiefs in Syria and Egypt.

from the Syrian coast to the Indus. From the latter we learn much about the political and racial background of this cultural area, with its highland belt in the north stretching from Anatolia across to the Iranian plateau, and its areas of alluvial lowland and steppe to the south, in the Syrian desert and Mesopotamia. It is to this highland belt, of course, that Persia mainly belongs, although she has many and close contacts with the lowland regions. Elam, with Susa its capital, is essentially a bay of the Mesopotamian lowland jutting into the highlands. In those early days the highlands had not yet been occupied by the Aryan or Indo-European peoples. This widespread highland civilization, therefore, known to us fitfully from the archaeological finds for no more than the last thirty years, beginning with the excavation of Susa, was non-Indo-European in origin. It would be fruitless to speculate on the ethnic relations of the peoples who produced it, in the absence as yet of sufficient reliable evidence; they have been tentatively called Caucasian or Caspian.

There should be no surprise at similarities in culture between the highlands and the marshy plains of Sumer; the former had the ores and metals which the latter with their more advanced social development would seek to acquire and use, and therein lay the seeds of a flourishing trade. Elam is little more than 100 miles from Sumer, being virtually a province of the latter. The pottery analogies with Ninevite, Samarra, Tell Halaf, al Ubaid, Uruk, and Jemdet Nasr wares found now on so many sites from the Syrian coast, through the north Syrian steppe and Mesopotamia into and across the Iranian plateau and as far as the banks of the Indus, are no more than one would expect from the existence of the vital connecting links of an area combining the Fertile Crescent with the great Iranian land-bridge of Asia. Whatever the ethnic relationships of the several regions, there was free cultural exchange between them along natural routes of communication. These routes extended even farther, to

India in the south and China in the east: they all met in Iran. Among the products of Iranian civilization over a long period of some three millennia, from around 4000 to 1000 B.C., first and foremost are the admirable painted pots, many of which were first known to us latter-day folk from Susa, by whose name many of them are consequently known. Some of these vessels are equal, if not superior, in technique to the finest wares ever made. They are supported by countless seals and seal impressions, leading eventually to the well-known cylinder seal. In the second millennium B.C. commences the output of animal and grotesque human figurines in bronze, popularly known as 'Luristan' bronzes. On some neolithic figurines, for example, from the neolithic village at Persepolis, the swastika[1] is found, perhaps the earliest occurrence of this symbol, destined to such misuse later. Other features found in prehistoric levels in the highlands of Iran and bequeathed to later times include the *bucranion*[2] or facing ox-head so popular as a decorative element in archaic Greece, and, not least, the Elamite pictographic script.[3]

The inhabitants of the plateau seem from the earliest times to have expressed themselves freely in decorative art. It may be also that somewhere along the western borders of the plateau, and in the lowlands of Elam, the cultivation of wheat was first practised, thus providing Western or Aryan man—ourselves in the main—with one of the fundamental bases of existence.

When Shalmaneser III made the first surviving reference to the Medes, listing them amongst the enemies of Assyria in an inscription of 836 B.C., few would have dreamed that this 'cloud no bigger than a man's hand' would in some two centuries overthrow the Assyrian Empire and destroy its capital, Nineveh, thereby heralding the end of the Semitic Empire of the ancient world and the ascendancy of the Aryan peoples. Nineveh fell in 612 B.C. to the Medes; Babylon in 538 B.C. to Cyrus 'the

[1] E. Herzfeld, *Iran in the Ancient East*, pp. 16, 21, and figs. 16–19.
[2] Ibid., p. 67, fig. 125.  [3] Ibid., pp. 65, 179–80.

PLATE I

AERIAL VIEW OF SUSA

PLATE 2

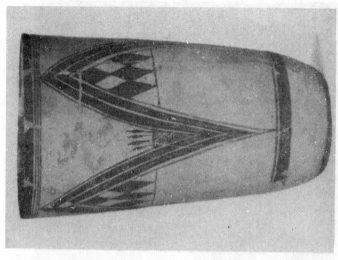

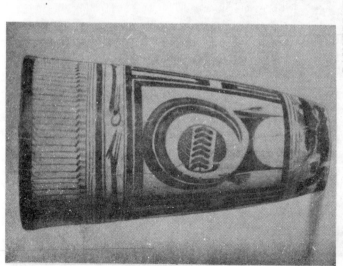

PAINTED TUMBLERS
Susa I style

Persian'. This association of the two peoples was significant: together they were to create a new element in world history, the Persian Empire. Both had swarmed out of the northern steppes during the twilight of prehistory, part of that stream of 'Aryan man' which overflowed the Iranian plateau and the plains of North India. After some centuries as obscure subjects of Assyria and Babylon, during which they had absorbed something of those great Semitic civilizations, they were now to impress on the world the simple and manly qualities which they had brought with them from their ancient home. These sterling qualities, modified in some sort by the enchanting nature of the country—a country whose garden oases have become synonymous with Paradise—were in less than thirty years to create the greatest empire the world had yet seen.

The sack of Nineveh by the Medes under Cyaxares in 612 B.C. set on foot these events. The Medes had settled in that part of the plateau south-west of the Caspian, the modern Azerbaijan, with its capital at Ecbatana (Hamadan). From their largely legendary history the main fact emerges that they were kinsmen of the Persians; by subverting their last king, Astyages, in 550 B.C. and taking over their empire, Cyrus was associating with his obscure Persian principality on the shores of the Persian Gulf a people of the same origins as his own, claiming an uncertain control over Assyria, Mesopotamia, Armenia, and Cappadocia. The Medes continued to occupy an honoured place in Cyrus' empire; which was known as that of the 'Medes and Persians'. Cyrus himself, at first 'King of Anshan', the district around Susa, preferred, as his conquests grew, to emphasize his descent from an ancestor Achaemenes, dwelling at Pasargadae in the original province of Persia; from whom the Achaemenid dynasty drew its name. In the whole range of the ancient East Cyrus is probably the most famous figure to modern eyes. This is due partly to his own real greatness as conqueror and organizer, partly to his association with the Jews, who never

forgot his liberal policy in permitting and assisting the return of the exiles from Babylon. This action won for Cyrus the testimonial contained in the first chapter of the Book of Ezra; whose author failed to appreciate the real causes of the Persian tolerance, i.e. what has been called 'their Gallio-like indifference to the religion of their slaves'.[1] Cyrus, after the conquest of Babylon, reversed Nabonidus' archaeologizing treatment of religion, by which he had centralized all the statues of the deities in Babylon, to the indignation both of priests and people. Cyrus adopted a decentralizing policy, redistributing the holy relics to their original homes all over the empire. It was in the execution of this policy that he allowed the Jewish exiles in Babylon to return to Jerusalem and re-establish there under Zerubbabel in 537 B.C. their own community and religious centre, including a revived Temple;[2] together with the Daniel episode and that of Esther it has through the Old Testament familiarized the Western world with 'the laws of the Medes and Persians' and brought the Persian Empire within our modern ken.

The neglect which has engulfed Persia and Persian history is the more remarkable when the range and splendour of her achievements are considered. The conquest by Cyrus of Media in 549 B.C., followed by that of Croesus of Lydia in 546, Babylon in 538, and Egypt by Cambyses in 525, had within a generation created an empire covering the greater part of the known ancient world, extending from India almost to the Aegean and from the Euxine to the Arabian Sea; like ripe apples these ancient kingdoms had fallen into the lap of the Persian conqueror. Darius, third of his line, completed its extension to the Aegean, and, although baulked in his attempt to include the European Greek States, nevertheless in consolidating this huge empire, the most extensive the world had hitherto seen, gave an example of political organization only paralleled in the ancient world by the Roman Empire.

[1] H. R. H. Hall, *Ancient History of the Near East*, p. 565.  [2] Ezra i–v.

So effectively was this Persian Empire constructed that for two centuries it remained intact in the hands of the clan which had founded it, until then the simple rulers of a remote province.[1] In this respect it compares favourably with the achievements of Alexander, whose empire fell to pieces at his death; moreover, the very speed of Alexander's conquest, and its more ultimate effects in the cultural sphere, were largely due to the preparation of the ground by the Achaemenids, whose empire was taken as a pattern by Alexander. The Oriental colour of the Seleucid court is partly due to that dynasty being half Iranian, Seleucus having married Apama, daughter of Spitamenes, one of Alexander's chief opponents in Bactria. Hence 'the history of Alexander is part of Persian history, its normal continuation being the Hellenistic age'.[2] The Diadochi, heirs to Alexander, became in their turn the prototypes of the Roman Caesars, through whom the European conception of the sovereign or supreme emperor thus ultimately derives from the Persian Great King.

A relatively small army of native Persians, supported by troops from the outer provinces, held this heterogeneous empire

[1] Cf. T. R. Glover, *From Pericles to Philip*, p. 198 (Persia): 'Persia has contributed to the progress of mankind both by what she has done and by what she failed to do. . . . In positive achievement the Persian also set new ideals before mankind—ideals to which indeed he did not himself attain, but which he left to Macedonian and Roman—ideals for the world's good government with the utmost of unity and cohesion combined with the largest possible freedom for the development of race and individual within the larger organism. An Indo-European people with great gifts, which in some degree they still keep, the Persians break upon the West with a series of surprises. In antiquity they first conceived and constructed a world-empire that should last. Then for six centuries they are governed by foreigners, Macedonian and Parthian, but they rise again to a new national life, only too significant for the West.' The whole chapter, like that on the *Anabasis* in the same volume, is an understanding and sympathetic study of Persia.

[2] S. Lévi, *Nouvelles littéraires*, 14 March 1925, quoted by Henri Berr in Foreword to C. Huart, *Ancient Persia and Iranian Civilisation*, p. xv.

together, by means of rapid communications; the Persian 'royal road'[1] anticipated the Roman roads by several centuries. Along these roads, radiating from Susa, the administrative capital, to the remotest corners of the empire, the king's post travelled, bearing his instructions to satrap and general, and bringing back reports on the condition of affairs. Where the king's messengers went, others could go, if at a slower pace; and trade also followed the flag. Although to the Greek popular mind the Persian monarch was βασιλεύς, 'the Great King', supreme example of autocracy, his power was, in fact, very much limited by custom and tradition. The decrees which held together such vast and diverse territories were those of the 'King in Council', not those of an irresponsible tyrant. The government was markedly tolerant, and the religions and customs of the many subject peoples were carefully considered and often fostered in their own countries by the kings; Cyrus, Cambyses, and Darius ruled in Babylon as kings of Babylon and in Egypt as Pharaohs. How different from the stupid attempts of an Antiochus Epiphanes to force Greek cults upon the recalcitrant Jews! Although cruel at times, the Persians on the whole exercised clemency towards their vanquished foes; usually only traitors were treated with severity. They had none of the sheer brutality and delight in cruelty and large-scale massacre for their own sake shown by the Assyrians. The Oriental despot, however, is manifest at times in such deeds as the assassination of Bardiya by Cambyses before his Egyptian campaign. The dramatic form assumed by the history of Herodotus, in which Persia is cast in the role of villain, although admitting mention of these various events and characteristics, draws no general inference from them nor regards them as significant: the villain shall hang, for all that.

The Persian Empire provides us with the first provincial system we know. One of the principal links in its system of government was the satrap, or provincial governor; the word has now

[1] Herod. v. 52–4.

become domiciled in English. These were usually nobles or princes of the blood, and were often appointed for life. In their own provinces they were virtually kings, wielding supreme military and civil authority, and conducting minor diplomatic business with neighbouring states. It was a measure of Darius' genius as an organizer of empire that he was able to keep some twenty such powerful governors (and potential rebels) under control, which he did through the well-developed highways and posts between the provincial capitals and his efficient system of inspectors, some of whom were known as 'The King's Eye' and 'The King's Ear'. Although officially supreme in his province, the satrap was always liable to be informed upon by spies, whether subject to his authority or not; the commander of the troops was also an appointee of the king. Persian notables were often given land and position of power in a province, with the right of direct approach to the king, and native communities, for instance the Jewish priesthood at Jerusalem, were encouraged with a special status. Thus the rule of *divide et impera* was for the first time in history well understood and applied.

One of the responsibilities of the satrap was the collection of taxation, in cash and in kind, to which all satrapies except the home one of the Achaemenids, Persia, were subject. This taxation was based on a careful survey of the whole empire by Darius, an achievement comparable to Domesday Book, and one of his chief titles to fame as an administrator. In return for this taxation the Persian Empire gave its inhabitants very considerable benefits: these included peace, except for the Greek War, and a policy of development by such means as the institution of a coinage system, great public works, for example the completion of the Nile–Red Sea Canal, and the dispatch of exploring expeditions like that of Scylax from the Indus to about Suez, part of a policy of Darius to make Persia a sea power; all these achievements of which a modern state might well be proud. The issue of a stamped, officially guaranteed coinage as a medium of

exchange had probably been originated by bankers and traders in the Ionian cities of Asia about 700 B.C., and developed under Croesus and his Lydian merchants, trafficking with Europe from their strategic position at the terminus of the Asian caravan routes. Darius saw its immense utility, and adopted the invention with such effect that his series of Persian 'Archers', showing on the reverse the Great King kneeling and drawing the bow, is one of the most famous coins of the ancient world.

Aramaic became the official language throughout the western parts of the empire, and seems also to have been used in the eastern, since it influenced some Indian scripts. The old-fashioned cuneiform became less and less understood, until it virtually died out in the fourth century; with Aramaic the far superior tool of the alphabet had come to stay. Encouragement was also given to the development of the sciences, e.g. astronomy (which could be useful in navigation), by Darius, who also founded in Egypt the earliest medical school of which we know. It was perhaps the improvement in trade and communications[1] throughout the known world due to the Persian Empire which about this time introduced the Indian wild hen (and cock) of the jungle to the Mediterranean, to become our own domestic fowl. In the distant province of Palestine the material contact with Persia is illustrated by the remains of a Persian Residency at Tell Duweir (Lachish)[2] and a tomb at Tell Fara (Bethpelet) containing fine examples of Achaemenid silver plate.[3] For the first time the remote Orient was brought into conscious touch

[1] After the peace negotiated by Callias about 448 B.C., trade between Athens and Persia, e.g. Phoenicia and Egypt, seems to have been unhindered, and Herodotus, an Athenian, could travel anywhere at will in the Persian Empire.

[2] *Palestine Exploration Fund Quarterly Statement* (1933), pp. 192–3, pls. iii (i), iv.

[3] Sir Flinders Petrie, *Beth-Pelet I* (London, 1930), pls. xliv–xlvi, p. 14 (where it is erroneously dated 'Philistine'); *Quarterly of the Department of Antiquities in Palestine*, iv (1935), pp. 182 sqq., pls. lxxxix–xci, and reff. ad loc.

with the classical civilization of Greece, as reflected in the account of Herodotus. Nor was this traffic entirely one way. During the latter part of the fifth and the fourth century Greek politicians were in constant touch with Persia, whose alliance was inevitably sought by one of two disputant Greek states. With the aid of their golden 'Archers' the successors of Darius were able to undermine and break that Greek resistance which a century earlier, at Marathon, Plataea, and Salamis, had been too much for his Immortals. It is one of the ironies of history that by this very success they were inviting Nemesis, in the guise of Alexander. At the end of the fifth century the vivid narrative of Xenophon at once illuminates one of the most spectacular and significant feats in history, the 'March of the Ten Thousand', and reveals the inherent weakness of an unwieldy empire whose guiding hand had begun to fail. A well-known Greek vase[1] of this time bears an elaborate painted scene of Darius and his court, and Greek vases of the fourth century show an increasing regard for Oriental effects. Throughout the fourth century Greek architects and sculptors were busy constructing and adorning temples in Asia Minor, of which that of Artemis at Ephesus was but the largest and most famous, while Scopas and his colleagues were applying their skill in decorating the funeral monument of Mausolus, a Carian prince. The Hellenization of some part of the Great King's dominions had commenced long before Alexander.

The comparative mildness of the Persian régime forms part of that moral superiority over previous empires which is, perhaps, its chief title to the consideration of posterity. As conquerors the Persians were restrained from slaughtering the vanquished for slaughter's sake by some tenets of their religion, which impelled them generally to follow the good principle,

---

1 The 'Darius Vase' in Naples, an Apulian Krater of the early fourth century B.C., found at Canusium (A. B. Cook, *Zeus*, pp. 852 sqq., pl. xxxviii; Furtwängler–Reichhold, *Griechische Vasenmalerei*, pl. 88).

that of Light against Darkness, of Ahura Mazda (Ormuzd) against Angra Mainyu (Ahriman). Owing partly to its central situation and partly to this respect and tolerance for foreign peoples and their beliefs, the Persian Empire became a great assimilator of religions, preparing the way for later universal systems. Already under Darius Persian religion had cast off the polytheism of earlier days and proclaimed the 'One God', thus ranking with Israel, Christianity, and Islam as one of the great monotheistic religions, in surprising contrast to that other branch of Aryan-speaking man which filtered down into the Indian peninsula to provide a proliferating pantheon of deities great and small.

In earlier days, before they had become a world power, the Aryans of Iran had been polytheist, worshipping the powers of nature, fire and water, wind and storm, sun and moon, like all the early Aryans, accustomed to a rough life roaming the vast plains and mountains of Asia. The stages by which the Persians abandoned this primitive polytheism are obscure: probably the process was as involved as that of the early Hebrews recounted in the Old Testament, with their many backslidings after the Golden Calf or the Gods of the Canaanites. The very existence of the great prophet, Zarathushtra (Zoroaster), is impugned. Among those who admit his existence the consensus of opinion would place him about the seventh century B.C., which would make it remarkable that he is mentioned neither by Herodotus nor Xenophon. However this may be, as eponymous founder of the Persian religion Zoroaster has been of immense significance in the history of thought. He is supposed to have been born in Azerbaijan in north-west Iran, far from Persia, the home of the Achaemenids; the religion and monarchy thus wed sprang from widely distant parts of Iran. The first monarch to profess the Zoroastrian creed was Darius; Cyrus and Cambyses had apparently been content to accept the received doctrines or to adopt those of subject peoples.

PLATE 3

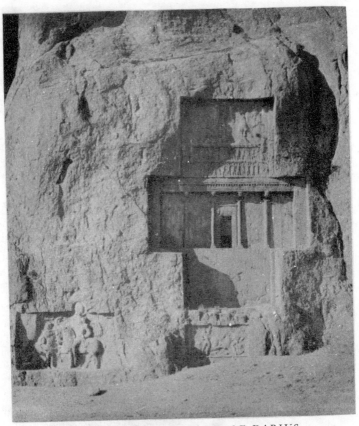

NAKSH-I RUSTAM, TOMB OF DARIUS
5th century B.C.

PLATE 4

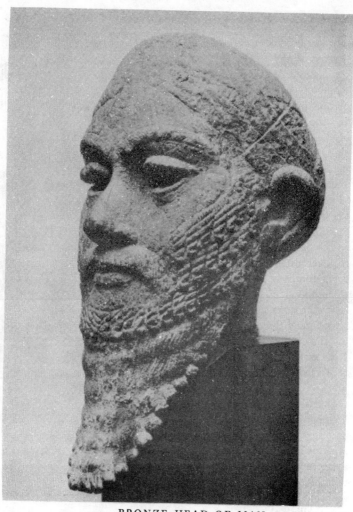

BRONZE HEAD OF MAN
Pre-Achaemenid

Before Zoroaster, as already stated, Persian religion had been more or less the primitive nature-worship of the Aryan people, marked by the powerful influence of the Magi, a priestly caste, analogous to the Levites of the Old Testament, who had a monopoly of religious ceremonial; peculiar to them also were certain practices, e.g. exposure of the dead body to the birds and the killing of most animals except man and dog. The former of these customs has continued in vogue in Persia, and among the Parsees of India, where the 'Towers of Silence' are its modern equivalent. The widespread influence of the Magi and their astrological lore are reflected in the reputed journey of the 'Three Wise Men from the East' to Bethlehem at the birth of Christ, as well as in frequent reference to the Magi or Magians in subsequent literature. Their influence reaches a peak later, in the Sassanian period. The relation of Zoroaster to the Magi is uncertain; the early Zoroastrians buried the dead, and seven royal tombs of the Achaemenid house survive, carved in the mountain side above Persepolis. It has been alleged, however, that Zoroaster himself was a Magian. He appears as a prophet denouncing the whole structure of the existing religion, affirming the existence of Ahura Mazda as the sole deity, Creator and Lord of the Universe. He made a convert of Vishtāsp, formerly identified by some, but doubtfully, with Hystaspes, father of Darius. The new monotheism was adopted by Darius with enthusiasm and found in him a staunch supporter throughout his reign. All his inscriptions abound with expressions of praise and devotion to Ahura Mazda, to whose aid all Darius' exploits are ascribed. The Persian religion was described by Herodotus a century later. He remarks that they do not use statues, temples, or altars in worship, nor consider the gods anthropomorphic like the Greeks. They sacrificed to God on mountain-tops, calling the whole vault of heaven God. In adding 'they also sacrifice to sun and moon, earth and fire, water and winds. . . . to these alone they have sacrificed from of old but have

learned from the Assyrians and Arabians to sacrifice to Ourania as well. . . . The Persians call Aphrodite Mitra', he reveals the admixture of the old Aryan nature-worship; his account is the more significant for being of something not understood by himself, and full of inconsistencies as characteristic as they were of the religion of Israel. In the *Avesta*, the Persian Scriptures, the so-called *Gathas* are deemed to contain the teachings of Zoroaster himself; the Persians also were a 'people of the Book'.

It is probably no mere coincidence that some of the loftiest flights of Israelite religion, such as the conception of Yahweh in Isaiah, were achieved under the Persian Empire and the creed of Zoroaster. It has been pointed out[1] that down to the time of Christ some Jews at least had doubts on the question of the immortality of the soul, a fundamental tenet of Zoroastrianism. The remarkable contacts between the Jews and Cyrus have been discussed above; many other instances could be adduced of the sympathy existing between Jews and the Persians, who were not relegated with the rest of the heathen to eternal damnation. We may wonder how much the development in the later religion of Israel was nurtured by its position within the Persian Empire and its encouragement by the monotheism of Zoroaster.

In the confused pattern presented by Persian religion in the time of the later Achaemenids, from the end of the fifth century B.C. onwards, there appears also the figure of Mithras. At first an attendant upon Ahura Mazda, he was later identified with the omnipotent Sun, and from his first centre in Asia Minor passed through the Achaemenid realm into Europe, pregnant with his immense future significance as a rival to Christianity. Anahita, the great mother-goddess, sometimes identified with Aphrodite, also enters the Achaemenid pantheon at about the same time, deriving from the great focus of fertility cults in Babylonia. These two immigrant deities from distant parts of

[1] Sir P. M. Sykes, *History of Persia*, i. 113.

the empire were the first seriously to challenge the undivided supremacy of Ahura Mazda.

The Persians have always been mystics, sceptical, individualists, interested in the content and objectives of life, qualities they still retain despite the urge of the mechanized world around them towards organization and a greater efficiency. Every conqueror, even the hordes of Jenghiz Khan, has eventually succumbed to their irresistible charm, and been assimilated to the prevailing spirit of the people. They are gay and romantic, possessed of a vitality which appears in their early pottery and in many an Achaemenid bronze figurine, and impressed its pattern on the thousand-year reign of Arab Islam, to burst forth again in native freedom with the Safavids in the sixteenth century. Among their customs noticed by Herodotus are some pretty ones derived probably from days when their Aryan ancestors roamed the Northern plains on horseback: that a child until the age of five is not seen by his father, but brought up among the womenfolk; sons from the age of five to twenty are taught three things only, to ride, to shoot with the bow, and to speak the truth; and fighting in battle is held the highest manly quality, and next to it a large family of children. A good warrior ideal this last! The disapproval of lying and debt suggests the stricter public-school code, an analogy which might find support in their scorn for trade. Many of their qualities are those of a hardy nomad people; by the time of Herodotus, with the advent of empire, they were acquiring a taste for luxury.

To us Western Europeans a number of Persian customs seem familiar, a result probably of our common Aryan origin, e.g. the habit of celebrating birthdays with feasts,[1] or their fondness for dispensing hospitality. It may have been a development of this tendency which led to their cult of luxury in most aspects of life, for which they became proverbial in the ancient world.[2]

[1] Herod. i. 133.
[2] 'Persicos ... apparatus', Hor. *Odes*, i. 28.

Paederasty they learnt from the Greeks according to Herodotus, who quotes it as an example of their tendency to copy their neighbours. A feeling for good taste informed their roystering. Thus, despite their proclivity for food and wine, they avoided being sick or performing other private actions in one another's presence; they were not boors. In this they rather resembled the French in manners than, let us say, the medieval English or Roman gastronomers. A habit of deep potations combined with a clarity of judgement is indicated by their reported custom[1] that decisions made while drunk are reconsidered next day when sober. Their habit of saluting a friend with a kiss on the cheek survives today among the Bedouin Arabs, but not their more servile manner of prostration at the feet of a superior in rank. Polygamy and the seclusion of women, normal in the East, obtained except among the nomads, whose manner of life, as today, made that impossible. It was the large part played in the life of the empire by the harem and its swarm of eunuchs which sapped the fibre of the court, and eventually reduced the later Achaemenid monarchs to a pale shadow of their great predecessors, ready to vanish before the rising sun of Alexander. Yet it was all in all no common foe which evoked the praise of Herodotus and the admiration of Aeschylus, and provided both these masters with a subject for dramas which are among our most prized relics of the ancient world.

In the domain of art the Achaemenids showed less originality than in that of ideas. The principal forms in which it found expression were architecture and the smaller paraphernalia of bronze and silver, such as cups, bowls, jewellery, and harness trappings, the favourite possession of a people but recently emerged from the nomadic state. The chief surviving examples of their architecture, the great platforms and palaces of Persepolis and Susa, owe their inspiration obviously to Assyria and Babylonia, whence was derived the conception of these huge

[1] Herod. i. 133.

piles, approached by stairways adorned with sculptured friezes. The Achaemenids, however, added distinctive qualities of their own to what they took over. The vast palaces and audience-halls of Darius and Xerxes were neither fortifications nor temples, which latter class of building, as Herodotus tells us, is not found in Achaemenid Persia; they were a sort of pavilion, consisting of a light roof over a forest of columns, where the Great King gave audience to foreign ambassadors and other dignitaries. The principle of columnar architecture of this type was obviously adopted from Egypt; in Persia, however, it was given a different character, the columns being much taller and correspondingly slender in proportion. The use of tree-trunks as columns supporting a light roof, especially of a portico, survives still in parts of Persia, especially around the Caspian coast.

Architecturally this huge audience-hall type of building is poor and lacking in imagination. The 'Hall of a Hundred Columns' must have been almost dark inside, and the columns were so close that the eye would only be able to see one aisle at once. The columns supported a novel style of capital, or rather impost, formed of the foreparts of two animals, often bulls, set back to back. This Persian or Persepolitan type of capital is found far afield, e.g. in a mysterious building, perhaps a palace of early Hellenistic date, in a remote valley in Transjordan, known as 'Iraq el Emir', usually identified with the Tyrus of Josephus. A feature of these huge halls were long friezes sculptured in relief with a procession consisting of tribute bearers from the subject states or of noble Persians from the bodyguard of the Great King. On the palaces at Susa the corresponding decorative themes were carried out in glazed brick, under the influence of neighbouring Babylon. These sculptured reliefs, which were essentially subordinated to the architecture, though they cannot equal their Assyrian prototypes for sheer realism, show an advance on them in delicacy and refinement. They also appear to have influenced contemporary or slightly later works

of Greek sculpture, especially the temple friezes, like that of the Parthenon, with their fondness for processional scenes.

During the fifth century, after the Persian Wars, many Greeks visited the Persian court, i.e. at Susa (Persepolis was barely known to them by hearsay); there they must have been impressed by these enormous architectural sculptures, although to some extent the influence is likely to have been mutual, in view of the superior originality of the Greeks in artistic conception and execution. The influence of these Persian friezes may also, perhaps through the Sassanians, have affected Byzantine hieratic art, which is fond of similar processions, especially in mosaics. The portals and doorways in these palaces were usually ornamented with figures of human-headed and winged bulls or other fanciful monsters of obvious Assyrian derivation. The group of buildings seems to have been planned as a whole, and much of it constructed under Xerxes as 'Director of Public Works'. It was never completed, and may have been only for occasional ceremonial use at the home of the royal house, like Rheims or Westminster.[1] During the sixty years from about 520 to 460 B.C. in which Persepolis was a-building, little or no development is noticeable in either architecture or sculpture. Compared, moreover, with the rapid development of contemporary Greek art that of Persia was stereotyped and lifeless. It is the closing chapter in the art of the ancient East, its 'Empire Style'.[2] This art was not home-grown but the work of craftsmen specially brought in from Egypt and Assyria to add splendour to the plans of the royal despot.

Achaemenid art was a patchwork like Aramaic, the official dialect of the empire.[3] The houses of the ordinary citizens, doubtless built of sun-dried bricks and wood, have long since

[1] G. B. Gray in *Cambridge Ancient History*, iv. 189.
[2] E. Herzfeld, *Iran in the Ancient East*, p. 274.
[3] Ibid., p. 233; A. ten E. Olmstead, *History of the Persian Empire*, p. 168.

vanished entirely. In the absence of temples or any kind of religious architecture or representation except the single instance of Ahura Mazda set in a winged disk, Achaemenid art has virtually an entirely lay character. This is true also of its other chief product, metal-work and jewellery. In this class of object the influence of Greece is very pronounced, as well as styles and subjects dictated by the taste of the Scythians, that nomadic branch of the Aryan peoples inhabiting the steppes of south Russia, who were in close touch with the Greek colonies of the Black Sea, but have left no records of their own behind. The best known example of Achaemenid jewellery is the famous 'Treasure of the Oxus'[1] in the British Museum, which includes a number of fine Greek pieces; but there is a number of others, e.g. the silver bowl and dipper from a grave at Tell Fara in south Palestine, excavated by Sir Flinders Petrie.

Few chapters in the rediscovery of the ancient world can rival for interest and significance the copying and decipherment of the great trilingual inscription of Darius on the rock of Bisitun (Behistun) near Kirmanshah by Sir Henry Rawlinson, in 1837 and 1843. Apart from the adventure and difficulty involved in gaining a near enough approach to the all but inaccessible reliefs and inscriptions to copy them, the results deriving from the interpretation of the inscriptions have been momentous, transcending probably in ultimate importance even the discovery of the Rosetta Stone. By providing the key to the cuneiform script of Babylonia it has enabled us to wrest their secret from a torrent of written documents, historical, economic, or imaginative, in half a dozen languages, mostly inscribed on clay tablets, which are still pouring in in thousands from sites all over the ancient East, and whose study will occupy scholars for generations. This flood of documents has already caused a revolution in our views of some aspects of the ancient world: for example, it has made us familiar with that vast Canaanite

[1] O. M. Dalton, *The Treasure of the Oxus* (British Museum, 1926).

literature, in poetry and prose, largely from sites in Syria like Ugarit, which illuminates so strikingly the background of the Old Testament. None of this literature on clay tablets would have been intelligible to us but for the act of Darius of recording his autobiography in a position so inaccessible, and the enterprise of Rawlinson and his successors in copying and interpreting the inscription. Of the three languages in which it is written, Babylonian, Elamite, and Old Persian—all using a cuneiform script—Old Persian, with its mainly alphabetic script limited to forty-three signs, had been partly intelligible since the beginning of the nineteenth century.[1] This Old Persian version of the text, therefore, provided a key to the older cuneiform scripts, and upon the basis so established, their interpretation was eventually worked out. For this unique and immeasurable service our debt to the Achaemenids and Darius in particular is not the less for its being incidental; the inscription is also by far the most considerable piece of literature surviving in the language of the Achaemenids, and an original historical document of the first importance.

It is often held that in sweeping away the failing Achaemenid dynasty Alexander introduced a period of over five centuries of Westernization into Persia; that his rapid foray to the Indus, marked at each stage by the foundation of a Hellenic state fortified with Macedonian colonists, consolidated through a century of Seleucid rule, determined that the main orientation of civilization, throughout that whole area, was to be towards the West. Such a view of the period, however plausible at first sight, requires considerable modification in the light of all the facts. The exploits of Alexander and his successors admittedly carried Greek rule and a measure of Greek culture to the Indus; a Greek kingdom was erected and long flourished in Bactria, the

---

[1] Grotefend in 1802 had identified three names on inscribed tablets from Persepolis: Darius, Xerxes, and Hystaspes; thus determining the values of thirteen signs.

PLATE 5

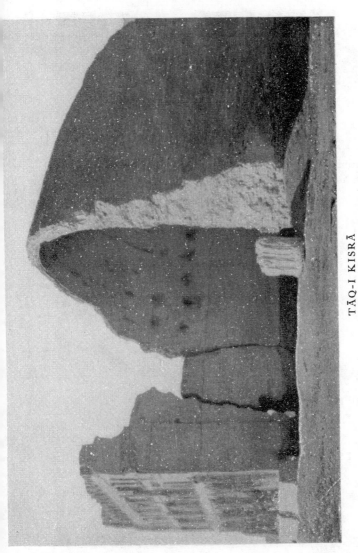

TĀQ-I KISRĀ

Side view of *īwān* and remaining section of façade

PLATE 6

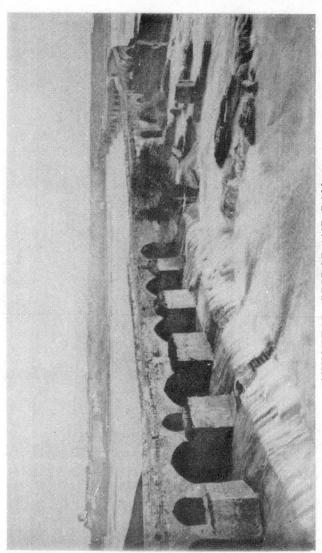

SHUSHTAR. BRIDGE AND DAM
Lower part Sassanian, upper part early Islamic and Seljuk

Greek language and a Greek style of coinage was adopted by the
Parthians, and Greek culture affected many phases of art (e.g.
Gandhara) and life over a vast area. Yet in the nature of things
this Hellenization was bound to be superficial. From the very
beginning it was a hybrid civilization which Alexander set up,
illustrated, for example, by his taking an Iranian wife and com-
pelling Seleucus and thousands of his Macedonians to do like-
wise. Alexander's own conception of the nature of the empire
he was carving out was that it should combine Hellenic and
Oriental civilizations in a single world state. What he did was
to open the flood-gates which had hitherto kept the two apart,
allowing them to flow in upon one another. If a Greek state
arose for a time in Turkistan or beside the Indus, to leave an
enduring effect on Parthian Iran or the India of Chandragupta,
or Hellenistic-Roman works of art found their way to Afghani-
stan,[1] no less surely from his time onwards did the commerce of
the Far East seek the Mediterranean and the Iranian cult of
Mithras travel westwards to Anatolia and Italy, to become the
chief rival to Christianity in a life-and-death struggle under the
Roman Empire. This two-way traffic first became possible
owing to Alexander's breaking down of the frontiers which
hitherto had always separated East and West, and his introduc-
tion of the idea of a unified world, οἰκουμένη. This was the
essential originality in Alexander's achievement, whose effect
was never to be entirely obliterated. The mutual give-and-take
which resulted, especially in the domain of art, has raised an
immense pother between protagonists of East or West; their
dispute, however, when seen in this perspective, is rightly esti-
mated to be a matter of detail. Economically, the dispersion of
the vast sums of gold in the Achaemenid treasuries as pay to
Alexander's armies had an enduring effect on Hellas, by giving

---

[1] Cf. the striking finds at Begram of Syrian glass of the first to fourth
centuries A.D. and Roman bronze figurines (J. Hackin in *Mémoires de la déléga-
tion archéologique française en Afghanistan*, ix (1939)).

rise to a powerful degree of inflation. The consequent rise in prices reduced large numbers of independent farmers and crafts-men to the ranks of the proletariat, compelled henceforth to make a living by hiring themselves out as mercenaries in the pay of any war-lord.[1]

To Alexander's influence as an agent must ultimately be ascribed not only much that is obviously Greek in the great sub-continent of India and right across Asia to China, but also much that is Persian. For a century and a half after Alexander's retreat from India the Maurya empire of north India founded by Chandragupta included within its boundaries Arachosia and Gedrosia (modern Afghanistan and Baluchistan), which belong physically to the Iranian plateau, thus making the frontier of India contiguous with Iran in the narrow sense, then part of the Seleucid Empire. The traffic which normally uses the routes descending into the Indus Valley from the north-west would thereby be encouraged, and it is accordingly not surprising to find signs of Persian influence in Chandragupta's dominions. At Pataliputra,[2] the Mauryan capital, have been found from the early third century B.C. a pillared hall of Achaemenid type with some eighty monolithic columns having the high polish charac-teristic of Persepolitan masonry, as well as a capital of Achaeme-nid derivation and other Persian features. There are also in the museum at Sarnath, from the same vicinity, another similar capital with the figure of a horseman, the well-known capital with four lions back to back seated on a bell-shaped abacus (a type which lingered in India until Islamic times), and several throne supports in the form of a griffin, also highly polished, which may have an Achaemenid ancestry. The practice of Chandragupta's successor Aśoka of erecting columns inscribed

---

[1] Cf. A. J. Toynbee, *A Study of History* (Abridgement of vols. i–vi by D. C. Somervell 1948), p. 377; Finlay, *Greece under the Romans*, ch. i, p. 10.

[2] Cf. R. E. M. Wheeler and S. Piggott in *Ancient India*, iv. 85 sqq., 'Iran and India in pre-Islamic Times'.

with his pious exhortations is also reminiscent of Darius' great inscription and the rock-cut tombs of the Achaemenids. From all this evidence it is inferred that when Alexander's conquest and destruction of Persepolis scattered its artists and craftsmen far and wide, many of them sought refuge at the Mauryan capital, where they established a new school of art with strong Persian affiliations. Various other details of Chandragupta's régime, for instance the system of communications, reflect an Iranian original. From the fifth century onwards India had been in debt to the superior Achaemenid civilization on its north-west border: thus Indian punch-marked silver coinage was on a Persian standard, the Kharoshthi script derived from Aramaic, and traces of Zoroastrianism occur at Taxila. Amongst the fine small objects from Taxila also are two superb gems[1] originally thought to be Ionian, but alternatively regarded as Achaemenid.

Most of Alexander's empire in Iran proper fell from the grasp of his Seleucid successors in less than a century after his death. For the next four or five hundred years the destinies of Iran were to be in the hands of a people of Scythian nomad origin, a branch of that reservoir of nomads who roamed the steppes of Russia and the borderlands of China, of whom the Massagetae formed a part. To the Greeks they were known as Sacae. Though of kindred origin to the Achaemenid Persians, they were at a different level of civilization, and throughout their long rule never outgrew their nomad origins. From their home east of the Caspian they first occupied the area south-east of that sea, the Achaemenid province Parthava, where they amalgamated with the native 'Parni'. To the Romans and ourselves their mixed origin is disguised under the name Parthi, 'Parthians', which includes also groups of later invaders, probably of Turki strain, from as far afield as China. An alternative name for them is Arsacids, from the family of the Arsacidae to which their earliest kings belonged.

It has become a commonplace to say that the history of

[1] G. M. Young in *Ancient India*, i. 33; Wheeler, ibid. iv. 94.

Parthia as recorded by the ancient authorities is a polite fiction. The Parthians have left no written records, although we know that they did write on parchment; their ruling classes, like typical nomads, were probably illiterate. It is possible, however, from various sources to reconstruct in outline their history, which has great significance for the relations of Europe with the Far East. After some eighty years spent in shaking off the Seleucid dominion and holding out against attempts by them to regain control, in the middle of the second century B.C. the Parthian Kingdom was increased by Mithradates I to include Bactria, Babylonia, Susiana, Media, and the original Achaemenid home province of Parsa (Persis). Parthia had thus become an empire, reaching from the Caspian Sea to the Persian Gulf; the ruler by whom this rapid expansion was accomplished, Mithradates I 'the Great', little as we know about him for certain, must rank among the outstanding figures of history. Towards the end of the second century, in a long series of wars against the nomad tribes to the north and east, Mithradates II still further extended the limits of the Parthian Empire to include Armenia in one direction and Seistan (Afghanistan) with much of the north Indian plain in the other. For her share in these wars the whole Western world is indebted to Parthia: the nomad incursions she resisted were but the tail of a wide movement of the nomad tribes of central Asia originating in north-west China, where the Turki Huns had, early in the second century, expelled the Yueh-chi, a mainly Indo-European people. These in their turn settled in the region of modern Russian Turkistan, driving out the former occupants, who swallowed up the Graeco-Bactrian Kingdom and, along with various other tribes encountered on the way, eventually swept on into Parthia, where they overran much of the original province, moving in a westerly direction, and also Seistan, eastwards, and eventually part of north India. This was one of the great nomad raids of history, like the original irruption of the Iranians into the

plateau soon after 1000 B.C., or that of the Muslim Arabs in the seventh century A.D. It ran right across the steppes of Asia. The position was eventually restored by Mithradates II, who recovered Seistan and the original province of Parthia as far as Merv. It is not the least of her services to Western civilization that the new Parthian state bore the brunt of and turned aside these nomad hordes, which otherwise might have swept on into and overwhelmed the Near East and even Europe, over a thousand years before their successors under Hūlāgū actually did.

The long reign of Mithradates II (123–87 B.C.) is significant also in that during it Parthia first came into contact with both China and Rome. One of the missions sent out by the emperors of the Han dynasty in many directions to report on distant lands, under one Chang-K'ien, reached Parthia, and his account is extant. The agricultural produce of the country is noted, and the fact that 'they make signs on leather from side to side', as opposed to the Chinese method of writing from top to bottom. Largely as a consequence of this mission there arose the caravan trade between China and Parthia via Chinese Turkistan, later to develop into the famous Silk Route. In the year 92 B.C., when Sulla was on the Euphrates in connexion with the affairs of Pontus and Armenia, Mithradates, who was also deeply concerned in the same questions, sent an envoy to him with proposals of an alliance. This first contact between Rome and Persia was an historic occasion, and, in the light of their future relations, the more remarkable for being a friendly one. The entrepôt trade via Parthia rapidly assumed wide dimensions; at first it was apparently allowed to pass freely, but later we hear of complaints of Parthian obstruction, evidently with a view to keeping its secrets in her own hands. The route passed from China through Chinese Turkistan (Sinkiang), Bactria (Balkh) to Merv, i.e. through the Tarim basin,[1] thence via Hecatompylos

[1] We owe our knowledge of the Chinese section to recent explorations by Sir Aurel Stein. Cf. his *Innermost Asia* (Oxford, 1932).

(Damghan), Ecbatana (Hamadan), to Seleucia-Ctesiphon, the capital of the Parthian Empire. From Seleucia two routes ran westwards to Syria, one via Ashur–Hatra–Nisibis, the other via Doura, where again there was the alternative of following the right bank of the Euphrates to Nicephorium or taking the short cut across the desert via Palmyra. Besides the famous silk from which the route later received its name, many types of goods were exchanged.[1] Both parties appear to have been interested in the other's fruits: e.g. Parthia received from China the peach and the apricot, in exchange for the pomegranate, 'the Parthian fruit'. To Bactria Parthia sent the Arabian camel, and to China also the Nesaean horses and Babylonian ostriches, known as 'Parthian birds'. The fame of the Nesaean horses had drawn Alexander aside from his route to see them in their home in the Zagros mountains. In addition to silk Parthia received from China Seric iron. The value of the goods handled by the caravan trade is sufficiently witnessed by the wealth of such cities as lived by it, e.g. Hatra, Doura, and Palmyra.

The Parthian Arsacids never outgrew their nomad origin. Although they amalgamated with the peasants they found in possession, their sole interests remained hunting and fighting: no king could be esteemed among them who did not practise these pursuits. Their winter capital was Ctesiphon, their summer capitals Ecbatana and Hecatompylos. When deposed or unpopular with their subjects the Parthian kings[2] followed the nomad tradition of returning into the deserts, whence they would return to power at the next veering of popular opinion in their favour. To these tastes was joined a certain native indifference, which we have already remarked in their Achaemenid predecessors. Organization was never their *métier*; they remained essentially a loosely knit body of vassals over whom the Great

---

[1] Cf. *Cambridge Ancient History*, ix. 598 and reff. for a selection.

[2] e.g. Artabanus III, A.D. 31–37. Herod the Great (who was half a Nabataean-Arab) did the same.

King exercised only a mild authority; comparatively weak, considering their resources, and never following up an advantage against their Roman adversary. The nomads provided the great land-owning families and King's councillors, e.g. the Surena. In war they developed greatly the use of light-armed horsemen, whose chief weapon was the bow. These troops gained the Parthians most of their successes against the Roman armies; they never came to close quarters, but discharged their deadly arrows from a distance. The skill with which they could discharge an arrow backwards from the saddle while galloping away from the enemy has given us the phrase 'a Parthian shot'.[1] The ruling classes fought as armoured knights with sword and spear on the famous Nesaean chargers, also armoured: they were known as *cataphractarii*. These two classes anticipated the medieval knights and the bowmen who beat them at Crécy. Later on the *cataphractarii* were almost superseded by the light horsemen. From the Iranian natives, with whom the Parthians mixed, they derived something, e.g. Zoroastrianism and the old Middle Persian language of the Achaemenids, as well as the fashion of representing the kings on the coins from Mithradates I onwards with hair and beard long.

Of Parthian art very little survives, and that the product not of the nomad ruling classes but of the various subject peoples, or frankly Greek inspired. The chief artistic products are the coins. These were taken over in their entirety as one of the Greek institutions essential to an empire. They reflect most clearly the gradual Orientalization of the Parthian Empire referred to above: at first the king's portraits are clean-shaven, later they take on the Iranian beard, the Greek legends become barbarized and misspelt, and finally the inscriptions are no longer in Greek but in Pahlavi. Of the half-dozen Parthian buildings extant or sites excavated, nearly all are in the western

[1] Cf. Horace, *Odes* i. 19. 11: 'versis animosum equis Parthum'; Virgil, *Georg.* iii. 31: 'fidentemque fuga Parthum versisque sagittis.'

parts of the empire, and it is debatable what in them is native Parthian and what Hellenistic. They include a surprising 'palace', all that remains of a whole city in the desert, at Hatra,[1] fifty miles west of Mosul, with heads or masks applied on the walls, some of an Orientalizing 'moon-faced' character, although Hellenistic influence is still preponderant, for example in the ashlar construction and the triple-gateway plan; the partly excavated caravan city of Doura Europos[2] on the Euphrates above Abu Kemal, with interesting frescoes both religious and secular and temples of Oriental cults, but no very marked Parthian style of building; and other houses, shrines, and tombs at Seleucia, Ashur,[3] Warka, and Nippur. The medium is stone or baked brick. The chief new architectural feature that emerges from these buildings, to enjoy later a long history in the Sassanian and Muslim Arab periods, is the long tunnel-vaulted hall or *īwān* open to the front and closed at the back, of which the most familiar example is the remains of the Sassanian 'Ṭāq-i Kisrā' Arch at Ctesiphon. This arrangement survives in a typical Syrian Arab house today, where the entrance serves as a reception hall or *dīwān*. Carved stucco decoration also appears, for instance at Warka and Kūh-i Khwāja, destined to a great expansion under the Sassanian and early Arab dynasties.[4] The use of baked brick in architecture instead of stone together with

[1] W. Andrae, *Hatra* (2 vols: Leipzig, 1908 and 1912); A. U. Pope, *Survey of Persian Art* (London–New York, 1938), i. 419 sqq.

[2] Cf. *The Excavations at Dura-Europos*, Preliminary and Final Reports. Edited by M. I. Rostovtzeff and others (New Haven: Yale Univ. Press, 1929–46).

[3] Cf. W. Andrae and H. Lenzin, *Die Partherstadt Assur* (Leipzig, 1933), *passim*; Pope, *Survey*, i. 414 sqq.

[4] Cf. e.g. Herzfeld, *Archaeological History of Iran*, pl. x, 2 and p. 74 with *Quarterly of the Department of Antiquities in Palestine*, vols. vi, p. 157, pls. lviii sqq.; xiii, pp. 1 sqq., pls. i sqq. (Khirbet Mafjar: carved stucco panels from near Jericho). Loftus first recognized in this carved stucco the ancestor of a favourite Muslim style and technique; Pope, *Survey*, i. 414 with fig. 93; W. K. Loftus, *Travels and Researches in Chaldaea and Susiana* (1839–52), pp. 224–5 and pl. ad loc.

fast-drying gypsum mortar encouraged the construction of vaults of huge span without centring. A Parthian contribution also appears to have been the placing of a dome over a square building, the transition being effected by the device of supporting it on squinches across the corners, a different method from the pendentive or spherical triangle evolved in the West. In town-planning it has been suggested that the round cities of Hatra and Ctesiphon, themselves perhaps imitating Assyrian military camps as seen on Assyrian reliefs, may be the ancestors of al-Manṣūr's Round City of Baghdad. Of Parthian sculpture all that remained were, until recently, two much-defaced reliefs at the base of the cliff at Bisitun. One, which can be completed with the aid of a sketch made in 1673, represented four nobles doing homage to Mithradates II; each is simply indicated by his name inscribed above, and the style, with the figures in a line, is Achaemenid. The second relief shows Gotarzes II (*c.* A.D. 40–51) in victorious combat with a rival. Both are on horseback: Gotarzes spears his adversary and is crowned by a Victory. That the practice of sculpture in the round did exist during the Parthian epoch, even if the inspiration were Greek, is proved by the discovery by Sir Aurel Stein at Shami in Persis of a small shrine in which were found fragments of bronze and marble statuary showing Hellenistic affiliations: in particular one bronze statue, nearly complete, of a man in Parthian costume,[1] wearing a coat and wide Indian trousers (*shalwār*). The statue, which is most impressive, and gives a picture of a Parthian prince of the blood, would be spectacular whatever its period and origin. From another Parthian site in the same area Sir Aurel Stein obtained a marble head of Aphrodite of about the third century B.C.[2]

[1] Sir A. Stein, *Old Routes of Western Iran*, pp. 130, 141, 150 sqq., figs. 46–9, pls. iv, v; Godard, *Athar-è-Iran*, ii (1937), 385.

[2] Stein, 'An Archaeological Tour in the Ancient Persis', *Iraq*, iii (1936), pp. 140 sqq., pl. xxix.

With the Sassanian period the Iranian national spirit reasserts itself. In place of the easy-going Parthian nomad chiefs, a firmer hand grasps the reins; a centralized government is established, whose aim is to glorify and imitate the old Achaemenid Empire. The destinies of Iran are once more safe in Indo-European hands, after an interval of four and a half centuries under semi-Turanian guidance which were best forgotten. The change of dynasty occurred when Ardashīr, King of Persis and vassal of the Parthian Great King, Artabanus V, rebelled and defeated the latter, who was killed in battle, probably in A.D. 224. In rapid succession Ardashīr conquered first the western and then the eastern provinces of the Parthian Empire from the Persian Gulf to Bactria; the rulers of Makran and of Kushan became his vassals. For some time the significance of the new régime did not dawn upon the outside world; it only began to be understood in Rome that a new national spirit was abroad in Persia when Ardashīr attacked Armenia and Mesopotamia, the former an ally of Rome and the latter part of the empire itself. After a childish attempt on the part of Rome to overawe Ardashīr by reminding him of previous exploits of Roman arms —a measure of the misconception regarding the new state of things which prevailed at Rome—the Emperor, Severus Alexander, in 231–2 took the field himself. Thus it was that the legacy of the spasmodic quarrel with Parthia was taken up again by Rome and developed into a ding-dong struggle between the two powers which, with occasional intermissions, was to last for another four centuries through many vicissitudes, during which the mantle of Rome as champion of the West fell on Constantinople, and in the end Persian political independence was suppressed for a thousand years by the despised 'lizard-eating' Bedouin[1] of Arab Islam.

---

[1] A description of the Arabs used in scorn by Yazdajird III, and acknowledged by them with pride in an embassy sent by 'Umar to call on Yazdajird to accept Islam. Cf. Sykes, *History of Persia*, i. 488, 494–5.

The new Sassanian state, while adopting in the main the outlines of the Parthian Empire, informed these with a new meaning. For a loose agglomeration of subject peoples it substituted a tight centralized bureaucratic administration, similar to that being evolved contemporaneously in Byzantium. The Shāhanshāh (King of kings) is the title of the Great King, who remains always aloof from his subjects: in his presence they are bound by the strictest rules of behaviour and precedence. The feudal order of society is maintained as under the Parthians. In the army, however, the heavy mail-clad cavalry have become the most important troops. These heavy-armed squadrons consisted mostly of the lesser nobility, and depended directly on the king; thus they could not be used by a rebellious provincial governor against his suzerain. A second notable achievement of the Sassanian Empire was the creation of a powerful State Church. This was Mazdaeism, a revival of the old Zoroastrian religion of the Achaemenids, which had always remained the traditional religion of Iran, although thrust into the background during the agnostic Parthian period. In its new form it was no longer a monotheism, with Ahura Mazda as sole God: several other deities, of whom traces appeared at an earlier date, including Mithras and Anahita, now take a far more prominent place in the Mazdaean pantheon. As a State Church Mazdaeism possessed a supreme head and a powerful hierarchy of clergy, the Magi, whose word was law. The central feature of the religion was the Sacred Fire, which was maintained in every community and household, and also in three particularly venerated shrines in widely scattered parts of the empire. The *Avesta*, or Holy Writ, was edited and revised under Ardashīr and Shāpūr I and finally issued under Shāpūr II. At first, under Shāpūr I and Hurmuzd I, other religions were tolerated or even encouraged, e.g. Judaism, Buddhism, Mazdakism, Manichaeism, and Christianity. Persecution of both Manichaeans and Christians, however, followed later, Mani being executed in A.D. 273

under Bahrām I, who handed him over to the Magi, his mortal enemies. The persecution of the Christians which set in under Shāpūr II was largely provoked by Constantine's proclamation of Christianity as an official religion of the Roman Empire; the Christians in Persia henceforward appeared as subjects of a foreign power. The persecution of Mani also was inspired by political motives: the Magi were jealous for their own power. In the sixth century, when the Nestorian Church in Persia was cut off doctrinally from Byzantium, and had its own head in Iran, there was no persecution, and even a Sassanian monarch (Khusrū II) could have a Christian wife (Shīrīn).

The rapid spread of Mithraism throughout the Roman Empire from the Flavian period onwards, and its near-victory over Christianity in the third and fourth centuries, under Galerius and Diocletian, are symptomatic of the narrow margin by which in a wider field the Sassanian Empire just failed to subdue the Roman. The legions stationed in Asia Minor and Armenia adopted the cult and took it with them all round the frontiers, and to Rome itself. Everywhere it spread like a forest fire. When Diocletian, Galerius, and Licinius in 307 dedicated a shrine on the Danube to Mithras, 'protector of their empire' (*fautori imperii sui*), it seemed on the eve of certain triumph. Its attraction would seem to have lain mainly in its moral elevation, the dualistic opposition between good and evil, in which the pure soul was for ever struggling to assist the good to gain the mastery, whereby the maximum effort was called for on the part of each individual, and a positive reaction to every situation encouraged. Here we are not so much concerned with the details of the history of Mithraism as to appreciate its significance as evidence of the continuing vigour and vitality of the Persian religion and ethics, the old Zoroastrian creed of the Achaemenids discussed above, which, after surviving the impact of Hellenistic thought and coming near to vanquishing Christianity in a life-and-death struggle, has not even yet succumbed

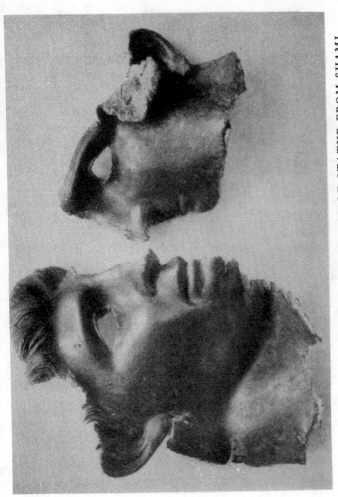

PLATE 7

FRAGMENTS OF HEAD OF BRONZE MALE STATUE FROM SHAMI

PLATE 8

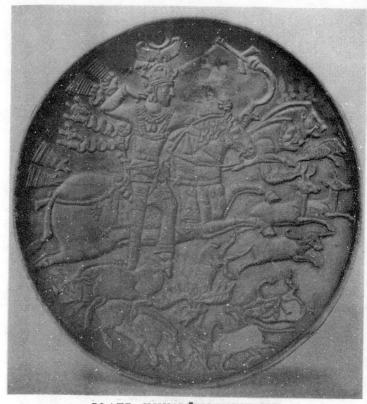

PLATE. KHUSRŪ II HUNTING
Sassanian. Silver, partially gilt

to Islam.[1] On the contrary, we find Islam apparently taking over Manichaean tenets, e.g. the double nature of Christ, according to which the Real Christ was entirely non-corporeal, and the 'Son of Mary' who was crucified was a different person.[2] 'So far as history is yet unfolded, no other Eastern people, apart from the Jews, has meant so much to the West or has taken so large a part in shaping the civilisation and the thought of mankind.'[3]

The widespread influence of Iran in every age as a link between East and West, whether donor or recipient or just intermediary, due to her position astride the great routes of Asia, is illustrated once more for the Sassanian period by the finds of Buddhist wall-paintings at Bamiyan[4] in Afghanistan and of fragments of Manichaean books and manuscripts of silk and paper bearing exquisite miniature paintings of Manichaean monks and musicians as well as wall-paintings at Khocho in Chinese Turkistan.[5] Although these latter are of Islamic date they are evidence of the existence of an art of painting in Iran during the Sassanian era among the followers of Mani, who would appear to have carried their skill into central Asia, where it long survived the religion. Even as these words are written a report[6] comes to hand of further discoveries of frescoes in a style akin to Sassanian in an eleventh-century palace at Lashkari Bazar on the River Helmand in Afghanistan, belonging to the

---

[1] Cf. F. Cumont, *The Oriental Religions in Roman Paganism*, pp. 159 sq.

[2] *Qur'ān*, Sura iv. 156: 'For that they have not believed (on Jesus) . . . and have said 'Verily, we have slain Christ Jesus the Son of Mary' . . . yet they slew him not, neither crucified him, but he was represented (by one) in his likeness.' (Sale's trans.) Cf. Sykes, *History of Persia*, i. 406.

[3] T. R. Glover, *From Pericles to Philip*, p. 199.

[4] Godard and Hackin, *Les Antiquités bouddhiques de Bamiyan* (Brussels, 1928), pp. 65 sqq., pl. 42.

[5] A. von Le Coq, *Chotscho* (Berlin, 1913); Christensen, *L'Iran sous les Sassanides* (Annales du Musée Guimet, 1936), pp. 197–200.

[6] *The Times*, 28 Feb. 1950, p. 5, describing the work of the Délégation française archéologique en Afghanistan, under Monsieur D. Schlumberger.

conqueror of India, Maḥmūd of Ghazna. Iranian influence persisted long in central Asia; it is witnessed to not only by the existence there of Manichaean art, but also by the spread of a vigorous Persian or Nestorian Church which was active there in the sixth century, and bishoprics at Herat and Samarkand. In the seventh century it even made an attempt to convert China. Nestorian churches were known as 'Persian temples'. Persian monks brought the silkworm from Khotan to Justinian. Chess had been adopted from India and naturalized, as had the animal fables of *Kalīla wa-Dimna*, later still to become an Arabic classic. Polo was at home already in the Sassanian period and much indulged in both by men and women.

Intercourse with the West is vouched for in art by the fact that Roman prisoners were employed by Shāpūr I after Valerian's capture on the construction of the great dam at Shushtar, known still as Band-i Qaiṣar, 'the Emperor's bridge', while in a relief on the Arch of Galerius at Salonica the emperor is flanked by bodyguards wearing the scale armour and conical helmets of Sassanian *cataphractarii*, standing beside their horses.[1] It may be a coincidence, but it is more probably due to mutual contacts, that the beginnings of frontal representation of the human figure in sculpture occur at about the same time, i.e. during the third century, in Iran and in the West.[2] Sassanian sculpture consists mainly of some thirty colossal rock-cut reliefs showing the triumph of the Sassanian kings; these vary considerably among themselves, but exhibit no general development as a series. For an idea of their origin in earlier painting in the Parthian period and the type of motifs behind them we are indebted to several *graffiti* scratched on Achaemenid buildings at Persepolis, two of them representing the brother of Ardashīr I

[1] Cf. *Cambridge Ancient History*, Plates, vol. v, 150*b*.
[2] e.g. on coins of Postumus and on a relief at Nishapur representing the triumph of Shāpūr I over Indians. Cf. ibid. xii. 558; Herzfeld, *Iran in the Ancient East*, pp. 319 sq., pl. cxx.

and their father, and some similar ones from Parthian buildings at Doura Europos.[1] The much later reliefs of Khusrū II at Tāq-i Bustān are also clearly derived from an origin in painting. Shallow modelling or engraving has replaced the high relief of the third-century sculptures, which are seen in perspective to have been a temporary phenomenon. The full-face representation of the body, which prevails again after the third century, particularly the awkward attitude of the legs open and bent at the knee, marks a return to the old Oriental style which had always continued below a superficial veneer of Hellenism. In art as in other spheres the new national spirit of the Sassanian Empire was a conscious imitation of the Achaemenids. This was not, however, a very positive movement, but rather a reaction from the Hellenistic episode, a policy imposed by the reigning house on a population which probably recked little of such things. Its real significance was underlined only later, when the removal of the capital of the Islamic world from Syrian Damascus to Baghdad with the advent of the Abbasid dynasty in A.D. 750 heralded the real return of the Oriental spirit and culture in which Iran was to play the leading role; towards that culmination the Sassanians did but pave the way.

In the domain of Iranian architecture the Sassanians occupied a pivotal position; reacting from Hellenistic forms they reverted to the pattern of Achaemenid buildings, with the differences entailed in the transition from the upright-and-cross-piece, 'tree-trunk' architecture of Persepolis to the deep vaults dictated by baked brick construction. The entrance portico of Persepolis, paralleled (today also) in the primitive Iranian house by a 'lean-to' wooden colonnade or veranda, becomes the open vaulted *īwān* of the Sassanian palace, of Tāq-i Kisrā and Firuzabad, while the hypostyle hall becomes the square throne-room behind, roofed with a dome on squinches. Familiarity with the great *īwān* at Ctesiphon has made that form of open vaulted

[1] Cf. Herzfeld, ibid., p. 308 and figs. 401, 402.

hall to us the characteristic of Sassanian architecture. It is that, and more. Flanked by a closed room on either side it gives us the simplest type of peasant house. Doubled, or quadrupled, around an open court this produces the more pretentious residence and the royal palace, and is carried over into Islam as the regular plan of mosque, madrasa, and caravanserai.[1] The dying character of the Hellenistic tradition is exemplified in the façade of the Tāq-i Kisrā, a feeble attempt to imitate the decoration of a great Hellenistic public building, whose whole essence has been mangled and misunderstood. At Tāq-i Bustān, near Kirmanshah, the 'Arch of the Garden', with the hunting scenes in relief of Khusrū II above mentioned, Roman and Byzantine influence is seen in certain capitals, and in figures of Victory in the spandrels of the arch. In front of the site stretches a huge artificial pond, part of a 'paradise' or hunting pleasaunce, which the Sassanian monarchs were so fond of constructing near their residences. Another example of such a 'paradise' is the palace of Qaṣr-i Shīrīn, at the western foot of the Zagros mountains, where the road from Ctesiphon leaves the Iraq plain to climb towards Ecbatana. There the huge palace of Khusrū II lies in a park of some 300 acres. Vast as the structure was, it consisted only of rubble masonry faced with plaster, as surviving fragments show. This and brick-built columns faced with plaster herald a wide use of plaster covering inferior materials shortly to become characteristic of much architecture throughout Islam, a parallel development to the use of carved stucco in sculpture. A 'paradise' has in recent years been traced in association with two desert residences of the Omayyad caliphs, at Qaṣr-el-Ḥair el-Gharbi, in the Syrian desert west of Palmyra, and at Khirbet Mafjar near Jericho in Palestine. In both cases great efforts have been made by the construction of canals and underground *qanāts* in the Persian fashion to provide the park with lavish supplies of water from distant sources. The *qanāt* or

[1] Cf. Herzfeld, *Archaeological History of Iran*, pp. 97 sqq.

*kariz*, an underground tunnel tapping the deep water-bearing strata, with vertical shafts at intervals for access, and emerging eventually at ground level, is a recognized Persian method of irrigation known to Polybius and responsible for the fertility of many of the high mountain-girt plains; it was widely copied in the Middle East, and is still employed, for instance, on the estates of H.M. King Abdullah of Jordan in the Jordan Valley. In recent years many fire temples have been found in Iran. They consist essentially of a dome on squinches supported by four arches, one at each side. The roofed area is often surrounded by a passage or walk on which it opens directly through the arches. The altar for the sacred fire stands usually somewhere under the dome.

Of the minor works of art which the Sassanians have left the principal are their textiles and the splendid series of silver bowls with repoussé ornament in the centre. The latter usually depicted the monarch in some honorific situation, a battle scene, or a pair of animals; many are now in the Hermitage Museum in Leningrad. A unique and most valuable group[1] for dating purposes recently found together in a metal chest in Mazanderan, Caspian coast province of Persia, was placed on show at the Asia Institute, New York, in early 1950, in honour of the Shah's visit to the United States. It included some six pieces out of a hoard which had originally contained at least nine, and two pieces of silk decorated, like the silver vessels, with scenes of the chase and of animal and bird life. Two Sassanian kings are represented, thus giving a range from A.D. 388 to 532 (Bahrām IV to Kavādh I) for the date of the group. All the decoration of the silver vessels is in repoussé, but several techniques for attaching the figures to the background are represented. The pieces are all of magnificent quality, and form the only group of these splendid silver vessels found together. As with the textiles and a series of bronze vessels, the limits of the series, except

[1] *Illustrated London News*, 11 Feb. 1950, pp. 206–7.

for the above group, are not very definite either chronologically or geographically, and many pieces made after the Sassanian Empire had fallen are attributed to the epoch. This, however, serves to emphasize the strength and continuity of the impulse produced by the Sassanian artists and craftsmen.

J. H. Iliffe

# CHAPTER 2
# PERSIA AND BYZANTIUM
## § i. *The Sassanian Period*

A FIRST glance at the history of Byzanto-Persian relations during the first six or seven centuries of the Christian era suggests that these were characterized by little cultural exchange, but rather by a more or less constant series of wars or frontier skirmishes, interrupted by short periods of insecure peace when one or other of the two powers was too disturbed by internal dissension or too supine to prosecute a war, or when one of them, usually Byzantium, was so anxious to maintain peace that she was willing to go to practically any lengths of appeasement to achieve it. The old state of enmity that had existed between Persia and the classical world continued, the bitter strife between Roman and Sassanian rulers was not forgotten, and it was indeed to some extent so that he might be able to cope with the Persian menace from nearer-by that Constantine moved his capital from Rome to the shores of the Bosphorus in 330; Constantine's wars with Persia, as recorded by Ammianus Marcellinus, were indeed among the more important events of his reign. Like many of the struggles that were to succeed them, they were to some extent provoked by events in Armenia, where a more conservative party wished to retain close contacts with Persia, an old and powerful neighbour, while a second party, thanks to the recent Christianization of the country, sought to establish an alliance with their fellow Christians to the west. The fact that the Byzantine Empire was a Christian and Persia a pagan state served in general to fan the flame of hostility.

The latter part of the fourth century saw a somewhat more tranquil state of relations than had prevailed in the time of Constantine. In 421, however, Christians who had been oppressed in Persia fled to the west, and when Byzantium refused

to give them up, war again broke out, though without either side achieving any marked advantage. It was succeeded by a period of tranquillity, the result of more important external preoccupations on the part of both sides, which lasted for roughly a century. But in 527 the Persians took the offensive and attacked the eastern provinces of the Byzantine Empire. They were defeated by Belisarius at Dara in 532, and a short-lived peace was signed between Justinian and Khusrū I. In 540 the Persians again attacked, penetrated to Antioch, and sacked the city. Peace was signed in 545, but the two powers each schemed to obtain the allegiance of minor states in the Caucasus region, and skirmishes soon recommenced. The Byzantine forces were defeated in 575, the Persian in 576, and a series of further but inconclusive engagements followed until 591, when a new peace was arranged. In 602, profiting by the murder of the Byzantine Emperor Maurice by Phocas, Khusrū II attacked once more; Antioch was captured in 611, Damascus in 612, and in 614 the Persian forces continued their advance into Egypt, so cutting off the main source of the Byzantine grain-supply. A second Persian force at the same time moved into Asia Minor and penetrated as far as Scutari, on the Asiatic shore opposite Constantinople. It was the immensity of this new threat, which at the same time cut a vital supply line and showed itself before the defences of the very capital, that served to turn the scales and to bring home to the populace of Byzantium the need for unity. Often in history had a similar situation arisen before; often it was to arise again; and as with Britain in 1940, so then, in the seventh century, it soon became apparent that enemies had misjudged the condition of the state, and the threat of invasion served at the same time to call up an unsuspected resolution among the people and to produce in the person of Heraclius a leader worthy of the occasion: in 622 he suddenly took the field, defeated the Persian forces in a series of skirmishes, and finally routed them completely near Nineveh in 627.

The results of this battle were to have a more wide-sweeping effect than either the Byzantines or the Sassanians had ever suspected, for within a few years a new power had arisen in the Near East, and the forces of Arabia, urged on by militant Islam, assailed their neighbours to east and west. Byzantium soon lost for ever the major portion of her empire; Sassanian Persia, weakened as a result of the war with Byzantium, and suffering at the same time from a certain over-confidence and inertia in face of an Arab threat, fell an easy prey to the ranting hordes of the caliph 'Umar. In the political field the victory was complete; in the cultural it was but short-lived, for the old culture of Persia was not to be destroyed in a day, especially when the Arabs had little of their own to offer in return, and what was an immediate political victory for the Arabs was to become, in the course of little more than a century, a cultural triumph for Persia. Persian art, Persian thought, Persian culture, all survived to flourish anew in the service of Islam, and, impelled by a new and powerful driving force, their effect was felt in a widely extended field from the early eighth century onwards. The first dynasty of Islam, however, the Omayyad, had its capital in Syria and drew from the heritage of Byzantium rather than from that of Persia, and it was only when the capital was moved from Damascus to Baghdad with the establishment of the Abbasid dynasty in 750 that Persian cultural ascendancy was re-established.

The picture that this brief summary of the events along the common frontier of Byzantine and Sassanian territory in Asia Minor suggests is, when viewed from a wider field, far from complete, if not definitely misleading. In the first place events in the south throw a rather different light on the state of relations between the two great powers, and in the second place economic and cultural history tell a different story to this record of battles and treaties. Wars of those days, even if violent over a limited area, were far from exercising anything like a universal

influence; trade continued in spite of them, and racial enmity played little part in Byzanto-Persian relations. Farther to the south, then, with the Arabian desert as a sure boundary between their respective territories, Persia and Byzantium were on much more friendly terms, and warlike engagements were the exception. The Persians accepted, even if they did not approve, the existence of Byzantine satellite states like the Ghassanid on the north Syrian frontier; the Byzantines, though they maintained contacts with the Nestorian Christians east of the desert, made no attempt to interfere with Persian domination of Christian states like that of Hira near the modern city of Kufa in Mesopotamia. And if at times the Yemen constituted a bone of contention, wars were not allowed to interfere with the valuable trade in spices, incense, and similar costly products. The Persians did at one moment go so far as to send an occupying force to the area, and from 570 it was embraced within their territory, yet the Byzantines maintained contacts both by way of the Red Sea route and by land across Christian Abyssinia, and these contacts were sufficient to satisfy all that they desired from the region.

However violent each campaign on the northern frontier might have been, it was, moreover, succeeded by a period of peace, and the negotiations by which these treaties were brought about are not without interest in a survey devoted to stressing the links between the two countries, for ambassadors were exchanged between the powers, charged with arranging the treaties, and they penetrated to the very heart of enemy territory. Even if the respective states were soon at war again, the cultural exchanges set on foot by these embassies were often both prolonged and considerable. The dates of some of these embassies have come down to us. In 356 emissaries were sent to Constantinople by Shāpūr I to negotiate peace; about 415, in the reign of Yazdajird I, Gahballaha, Bishop of Ctesiphon, was sent to Constantinople to announce the succession of

Valash; in 572 a Persian ambassador again went to Constantinople to arrange for the payment of tribute by the Byzantines. There must have been many more similar exchanges which have remained unrecorded. Gahballaha returned with numerous gifts, and there is reason to believe that the majority of the other ambassadors were similarly laden; in any case, at a later date, a whole series of regulations for the reception and entertainment of ambassadors from the Islamic world was set out at the Byzantine court in the Book of Ceremonies. It is also probable that Byzantine ambassadors went to Persia at this time, and men of letters and perhaps also artists in some cases accompanied them. A story recorded by Mīr Khwānd is worth repeating in this connexion, even if it is apocryphal. He recounts that in the reign of Shāpūr II an artist came to the Persian court from Constantinople, to make a portrait of Shāpūr. The portrait was taken back to the Byzantine emperor, who had it copied on to a number of gold plates which were used during banquets at the palace. Soon after Shāpūr himself went to Constantinople in disguise and entered the palace during a feast; one of the guests noticed the stranger's likeness to that of the figure on the plates, suspicions were aroused, and Shāpūr was arrested and taken before the emperor. He confessed his identity, and was thrown into prison, but later, during a campaign against Persia, he contrived to escape.[1] The story is no doubt legendary, but its bearing on the conditions which characterized Perso-Byzantine relationships during Sassanian times is significant; wars in those days did not entail the complete cessation of all more peaceable contacts; artists probably travelled frequently between the different regions.

It was probably to a great extent as a result of exchanges of this sort that a number of Persian ideas penetrated Byzantine thought. Even before Byzantine times the conception that the emperor was a god during his life, and was not deified merely

[1] A. de Longpérier, *Observations sur les coupes sassanides* (Paris, 1868), p. 3.

after death, had been introduced to Rome from Persia, and though Christianity brought an end to this belief, the Byzantine emperor was throughout the head of the Church, and remained, indeed, a semi-religious figure even after the test of Iconoclasm. In secular affairs, too, he was in many ways much more an Oriental than a purely Western monarch: quite early in the days of the Byzantine state, the idea of the Roman *principatus* had changed into that of an Oriental autocrat, who was inevitably accompanied by a rich array of gaily clothed courtiers, and by a panoply of sumptuous furnishings, and who owned a series of splendid palaces. The Byzantine imperial costume, richly ornamented with jewels and precious stones, was actually introduced from Persia by Diocletian before the adoption of Christianity as the state religion, and numerous other ideas in thought and art penetrated at the same time. Most important among them was the affection for rich treasures and brilliantly decorated wall surfaces, which soon came to be a characteristic feature of every Byzantine religious foundation.

In addition to the penetration of Oriental ideas, thanks to embassies and courtly exchanges, trade between Persia and Byzantium was of the greatest importance. Spices, precious stones, ivory, and similar luxuries were not only brought from Arabia by way of Syria, but also along the great Asiatic trade routes which crossed Persia and terminated on Byzantine territory, at Trebizond in the north and at such cities as Antioch in the south. Indeed, the southern route by way of the Red Sea was, in those days of primitive navigation, considered less satisfactory than a land route; and the northerly route by way of South Russia had been closed since early in the Christian era owing to the unsettled state of that area, the home of a number of wild nomadic tribes. Practically all the eastern trade was thus concentrated on the route across the middle of Persia.

The demand for luxuries in the Byzantine world was enormous. Spices were required for use in the homes of the rich for

flavouring the food and scenting the rooms, as well as for incense in the churches; precious stones were essential for the sumptuous treasures of court and church; ivory was probably more used by the Byzantines both for religious and for secular works than at any other time in the world's history. But most important of all the treasures of the East was silk. The secret of the cultivation of this material had in early times been known only to the Chinese, so that all the raw silk that was required in the Byzantine world had to come from there. The requirements were surprising in their extent. Silk was habitually employed for costumes by the ruling classes, and one record speaks of a man who not only dressed exclusively in silk, but also never wore the same garment twice. Ammianus states (xxiii. 6) that silk was also used in the fourth century by even the lowest classes, and the importance of the material in ecclesiastical usage was proverbial. The Persians, as was to be expected, made the best of what was virtually their monopoly, and not only kept the price of silk at a very high level, but used the trade as a lever for other purposes; a series of disputes not unnaturally arose between the two powers as a result. Persia could, in fact, exercise something that was wellnigh a stranglehold by means of a trade which had become much more than one of mere luxury to the Byzantines; and even though in 552 two monks brought the secret of the silk-worm to Justinian, and silk cultivation began in Byzantine territory, it would seem that Persia's role as an intermediary was not at an end, for if the import of raw silk ceased, that of the finished article continued, at all events until the Byzantine weavers had become thoroughly proficient. In any case, Persian motives of decoration dominate in Byzantine textiles for many centuries to come.

It was probably by way of silks, and perhaps other textiles, that a number of Persian decorative motives found their way to the Byzantine world at this time. Thus the peacock's feather motive which appears in the mosaics of the sixth century in the

Panaghia Angeloktista in Cyprus and elsewhere was common on Persian stuffs, and though the first instance that we know is on a Sassanian capital at Tāq-i Bustān, it is essentially a textile rather than a sculpturesque design and was no doubt first developed by weavers. Other Persian sculpture of this date shows a similar influence of textiles, and numerous other instances of the appearance of Sassanian textile motives in the Byzantine world may be cited. Confronted and adorsed figures are thus essentially Sassanian, as is the *hom* or sacred tree, which often stands between them. The popularity of vase motives, with plants springing from them and twisting in identically balancing curves on either side, is similarly to be assigned to Persia. A textile usually known as the Mozac stuff may be cited; it is now generally regarded as of Byzantine workmanship, though following a Persian prototype very closely. It is usually identified as the textile presented to the Abbey of Mozac by Constantine V (741–75). The costumes are in the main Byzantine, but the disposition of the riders and animals and the ribbons that fly behind the horse trappings are both essentially Sassanian. Another important motive, that showing a man in the centre struggling with a beast on either side, though ultimately of Mesopotamian origin, was so developed in the Sassanian world that it can be regarded as a Persian contribution to Byzantine art. The stuff known as the shroud of St. Victor at Sens may be cited as a Byzantine instance of this old Oriental theme.

The importance of the Sassanian role in the inspiration and the production of textiles is again indicated by the difficulty of identifying the source of many of the textiles that have survived. Large numbers of stuffs have indeed been variously assigned to Persia or to one or another centre in the Byzantine world more or less according to the personal prejudices of the various authorities, and their true provenance still remains in many cases uncertain. The well-known rider stuff divided between Berlin and Nuremberg or that from St. Ursula's church

at Cologne and now at Berlin are perhaps the most important
in a long series. Once regarded as undoubtedly Persian, they
have subsequently been assigned to the central part of the
Byzantine world or to northern Syria. A number of textiles
bearing other types of animal designs have similarly been
assigned both to Persia and to the Byzantine world by different
authorities, and it has even been suggested that the essentially
Sassanian motive of a winged gryphon in a circle which was
intensely popular in Sassanian art was also copied in the Byzan-
tine world, though the delightful silk in the Victoria and Albert
Museum which bears this motive is actually Persian; a stuff
which is wellnigh identical with it appears sculptured in stone
as part of the costume of King Khusrū on the rock relief at
Tāq-i Bustān.

Though it is in the art of textiles that Persian influence is
perhaps most obvious, it was of an even more fundamental
character in some respects with regard to architecture; one
school of authorities, indeed, led by Strzygowski,[1] would go so
far as to assert that practically all the essential features of domi-
cal and vaulted construction, as well as the development of the
cruciform plan, all of which constitute the very essence of the
Byzantine style, were first evolved in Iran. Though this opinion
is to be regarded as exaggerated, there is reason to believe that
the role of Persia was nevertheless a vital one, and the elliptical
arch, the use of niches for the external adornment of buildings,
the squinch to effect the transition from the square plan of a
base to the circle of a dome, and probably also the extension of
the square plan by additions at the sides into one of Greek
cross form, were all thought of there before they were elabor-
ated elsewhere. Much of this elaboration took place in Armenia
at an early date, and Armenia in its turn influenced the Byzan-
tine world; some of Justinian's architects were indeed Arme-

[1] See his *Origin of Christian Church Art* (Oxford, 1923), for a convenient
summary of his theories.

nians, and the tremendous spirit of building activity which characterized that emperor's reign owed a good deal to Asiatic ingenuity and invention. At a later date, again, Armenia exercised a considerable influence on the development of Greek architecture, and from the ninth century onwards the links between the two areas in building are as close as those that bind Greece to Persia in the motives of textiles and stone sculpture.

The Byzantines, without doubt, inherited much of the Roman genius for engineering and constructional efficiency; other systems and ideas came to them from Syria and others again from Persia. The exact determination of the balance between the Syrian and Persian factors is, however, a problem which still calls forth the most bitter scholastic argument. It can nevertheless be stated with certainty that it was the blend of the Roman competence with the more imaginative, if less efficient, systems of the East that produced the great glories of Byzantine architecture: St. Sophia, the Church of the Holy Apostles, or SS. Sergius and Bacchus, all erected at Constantinople under the patronage of Justinian, and many another great building in the Christian East and West beside. Without the Persian elements they would never have assumed exactly that complexion which bound them together as examples of the Byzantine style.

In the other arts Persian influence, if less considerable, is nevertheless to be traced. On stone sculpture the favourite Persian animal motives were often copied in the West, and some slabs in the Ottoman museum bear designs of Eastern inspiration; one shows the age-old Persian motive of the lion and bull struggle. In metal-work, again, a plate of the sixth century from Carthage may be cited; it was shown at the Byzantine exhibition in Paris in 1931 (No. 388). It has a repoussé ornament at the centre, which is Sassanian both in style and treatment. Other silver work of early Byzantine times shows equally close Persian connexions, and that from the Bal-

PLATE 9

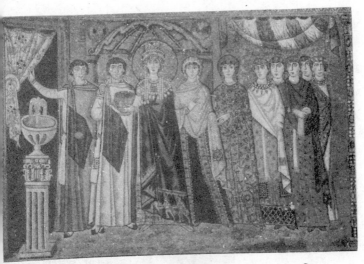

*a.* Byzantine Mosaic, San Vitale, Ravenna. Theodora and her Court

*b.* Byzantine Mosaic, San Vitale, Ravenna. Justinian and his Court

PLATE 10

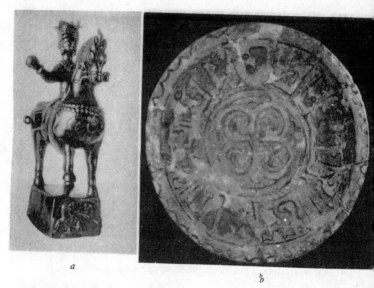

*a*. Mounted figure in bronze. Late Sassanian. Hermitage Museum, Leningrad
*b*. Plate with Kufic ornament. Polychrome ware. Byzantine, 9th-10th century

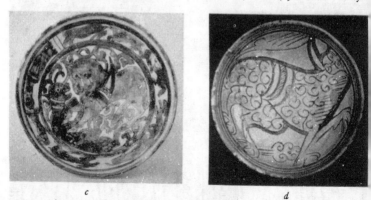

*c*. Bowl from Ray. Persian. 11th century. Formerly in the Vignier Collection, Paris
*d*. Bowl from Salonica. Byzantine. 13th century. Formerly in the Mallon Collection, Paris

kans is often even more Oriental; the famous treasure from Nagy Szent Miklos in eastern Hungary, for example, shows very distinct Sassanian features; the early Bulgar palaces at Aboba Pliska are akin in plan to the Sassanian palaces of Sarvistan and Firuzabad; the Bulgar rock sculpture at Madaba is virtually a Sassanian monument. The contacts between the Bulgars and Sassanians were especially close, and it is possible that certain Sassanian elements in design may have reached Constantinople by way of Bulgaria. This is especially probable with regard to pottery, for plaques of fine, white ware for inlaying on walls have been found both in Bulgaria and at Constantinople, and the designs that adorn them are in many cases of Sassanian origin, though the plaques themselves are of ninth- or tenth-century date; nor have we any very precise ideas as to what Sassanian pottery was like.

A few further instances of the presence of Sassanian elements in the Byzantine world may be cited. The high, soft boots which Justinian wears in the mosaics of San Vitale at Ravenna are of a type proper to Persia, and Theodora's crown as shown on the coins follows a Sassanian original, for two small points appear on either side of the cross at the top of the crown; they are actually a stylized rendering of the double wings which are so usual a motive in Sassanian art and frequently appear as part of the distinctive Sassanian head-dresses, for example, that of Khusrū II. The crowns of other early Byzantine imperial personages, notably that of Theodosius II in the Menologion of Basil II, are also of Sassanian type,[1] as is the ovoid crown worn by many later emperors, for example Theodore of Mistra (1383–1401). This crown was introduced by way of the eastern empire of Trebizond.

Another instance of contact is afforded by the use of the same type of fibulae in Persia and in the Byzantine world. That which holds the chlamys on the shoulders of the figures shown on the

---

[1] J. Ebersolt, *Les Arts somptuaires de Byzance*, fig. 5.

base of the obelisk of Theodosius at Constantinople or again of
the emperor on the Barberini ivory in the Louvre is the same as
that shown on some of the Sassanian rock reliefs, notably those
of Ardashīr at Naksh-i Rustam, of Shāpūr I at Naksh-i Rajab,
and of an unknown king at Darabjird.[1] By the time of Justinian
this type of fibula had fallen out of use. A necklace of Persian
type, however, survived longer, and it is to be seen in the Byzan-
tine world till quite a late date.[2]

It would seem from the foregoing that the traffic in motives
was in the main in one direction, from east to west, and that it
was continued more or less uninterruptedly throughout the
early Byzantine and the Sassanian periods, that is to say, from
the fourth till the seventh century. Neither assumption would,
however, be correct. Though contacts between the two regions
were by no means as spasmodic as the record of wars would
suggest, they can, nevertheless, hardly have been uninterrupted.
And though there have not so far come to light a large number
of concrete instances of Byzantine influence in the Sassanian
world, records speak quite often of the reverence in which
Byzantine craftsmen were held in Persia and of the skill of their
engineers, and Byzantine artificers, no doubt quite often found
their way to the East. Justinian is said to have lent workmen to
Khusrū I, and Shāpūr's great bridge at Shushtar was, according
to Firdausī, built by a Byzantine architect, who was instructed
to call all the wisdom of Rum to bear in its construction. It is,
indeed, in the realm of architecture more than in any other art
that one might expect to see Byzantine influence being exer-
cised in Persia, for the Byzantines were in advance of the Per-
sians in technical methods, even if, as Strzygowski would have
it, they lagged behind them in originality and imaginative
conception.

[1] F. Sarre, *Kunst des alten Persien* (Berlin, 1922), pls. 70 and 73; Flandin et
Coste, *Voyage en Perse* (Paris, 1843–54), pls. 33, 182, 191.
[2] J. Ebersolt, op. cit., p. 34.

## § ii. *The Islamic Period*

The state of hostility that had characterized Byzanto-Persian relations in the Sassanian period was continued after the Islamic conquest, but with the difference that now the military engagements, if less frequent, were nevertheless of wider extent, and the whole frontier from the Caucasus to the Mediterranean constituted a danger from the Byzantine point of view, and not merely that portion of it that directly separated Byzantine from Persian territory. During the first century of Islamic power, indeed, a series of engagements took place, and they were marked by Muslim successes, even to the extent of the penetration of Arab forces right to the walls of Constantinople. But about the middle of the eighth century Byzantine forces took the initiative and advanced to Syria in 745 and to Armenia in 751. Little further progress was made, however, for the new Islamic Empire was more powerful than the old Sassanian, and it was not until internal dissensions had begun to divide Islam that the Byzantines could feel at all secure. By 837 affairs in the East had reached a stage which made it possible for the Emperor Theophilus to attack with real prospects of success, and in a subsequent treaty he obtained a controlling hand in the affairs of the Syrian frontier region. But even so, Islam did not leave Asia Minor in tranquillity, for in 876 the caliphs took the side of a sect known as the Paulicians in their struggle against the authority of Constantinople, and sent forces to occupy certain Byzantine fortresses in southern Asia Minor. By 934 the Byzantines had regained supremacy in negotiations as well as a stronger position along the frontier. But their ascendancy was but shortlived, for the arrival of the Turks about 1040 brought a new energy to the forces of Islam, and the new invaders were soon to constitute a far more serious threat to Byzantine power than ever the Sassanians or Arabs had done before. Within a century the greater part of upland Anatolia was in Seljuk hands.

Though the Seljuks were of Turkish race, coming originally from central Asia, their first contacts with civilization of a static character were made in Persia, and they rapidly assimilated a great many of the elements of the culture and art of that country. The establishment of the Seljuks in Anatolia therefore represented much more the forging of a fresh link with Persia than the establishment of a new one with the unknown area of central Asia. An instance of this is to be seen in the fact that there was at this time a section of the Great Palace at Constantinople which had been built under Seljuk influence, which was known as the περσικὸς δόμος. It was said to be completely Persian in appearance. The Seljuks gave a new complexion to Persian art and culture, but they did not substitute for it anything strange or new. And though the Seljuk conquest of Asia Minor brought a tremendous reduction of Byzantine temporal power, from the cultural point of view the position was not nearly as serious as a glance at a map showing the respective territories of Byzantines and Seljuks in 1040 and 1140 would suggest. Thus, though they were enemies in theory, the relations between the two states were in practice mainly of a very friendly character and contacts and traffic in ideas between the new and the old rulers of eastern Anatolia were frequent and extensive. Embassies and courtly exchanges were thus numerous, and records show that more than one Seljuk of importance went to Constantinople for his education, to return later to Seljuk territory to occupy some high office of state; in some cases even future Sultans were educated at Constantinople. Many elements of Byzantine thought and culture in this way came to form an intrinsic part of Seljuk civilization.

This state of affairs, however, did not arise till the twelfth century; before that time the traffic in motives and ideas was mainly in the other direction, and it was between the eighth and eleventh centuries that some of the most marked effects of Persian influence became apparent in the development of

Byzantine art. So far as art was concerned, the Persian influence at this time was exercised in more than one way; three distinct degrees of influence may in fact be distinguished. In the first place we find objects from Persia being imported by the Byzantines; in many cases the objects themselves or, more often, the designs upon them, were copied in the Byzantine world. These copies, however, show little or no assimilation of Persian ideas; they were simple copies, which left little trace behind them. A Byzantine bronze in the possession of Mr. H. Peirce, dating from the eleventh century, may be cited as an example; it was shown in the Byzantine exhibition at Paris in 1931 (No. 442). It takes the form of two eagles displayed on either side of a central pin, and would seem to reproduce the disposition of a common type of bronze object from Luristan. The Luristan bronzes are of very much earlier date, and the Byzantine copy must have been made more or less by chance; it gave rise to no group or type of object in the West, nor to the development of a new style. Numerous Persian motives of decoration were copied in a similar way from time to time, but such copying was sporadic, and the motives did not become a part of any contemporary or future Byzantine repertory.

In the second place, we see the style or underlying understanding proper to Eastern art being assimilated in the Byzantine world even though no particular object or motive was copied. Eastern influence was exercised more than once in this way, and was responsible for a change of thought, a change in the basic aesthetic approach of Byzantine art. Such a change was of a far more profound character than that brought about by the mere copying of a motive or object, and in many cases produced results of lasting character; such results, however, are harder to trace, being psychological rather than material, and they are, moreover, usually extremely difficult to describe in concrete terms. Yet this subtle penetration of Persian ideas into Byzantine religious art—we have already called attention to it with

regard to the conception of Byzantine as opposed to Roman imperialism—is actually one of the most important factors at the basis of Byzantine culture, and the love of bright colours, rich materials, elaborate costumes, and sumptuous interior decoration is a facet of Byzantine civilization which is in no way to be attributed to Rome, but entirely to Persian influence. It must not be forgotten, however, that certain other elements of Byzantine thought at a rather later date which also emanated from the East are not truly Persian, but belong rather to the Semitic world. Such were the hatred of figural art which dominated a section of Byzantine thought during the eighth and ninth centuries and indeed resulted in the proscription of the images during the Iconoclast period (717–843), and the general tendency towards an expression of the infinite in art, which was particularly to the fore in painting and mosaic work in the Second Golden Age. The curiously awesome figure of Christ the Almighty which, from the dome, dominates the church of Daphni near Athens may be cited as an example of this trend; its significance is esoteric rather than representational, and the whole spirit of the work savours of Semitic mysticism.

The most important way in which the Eastern influences were exercised, however, shows a combination of the two manners so far outlined. Both the object or motive of decoration and the underlying spirit behind it penetrated to the Byzantine world, and were assimilated there, so that a work was produced in the Byzantine world which was Persian both in appearance and feeling. But, thanks to the influence of what may be termed the racial aesthetic, it also became Byzantine. Such an object might appropriately be termed Persianizing, as opposed to Hellenizing, Byzantine. This full assimilation of Persian models and styles was far from infrequent from the eighth century onwards, and a series of instances may be cited in practically all the arts.

At this period the problem of tracing the Persian influence is,

PLATE II

*a*. Silk textile, Byzantine. 8th century. From Mozac, Musée de Tissus, Lyons
*b*. Silk textile, the Shroud of St. Victor. Byzantine. 8th century. Cathedral Treasury, Sens

PLATE 12

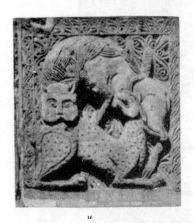

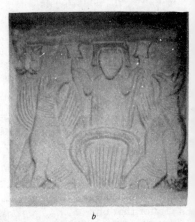

*a*

*b*

*a.* Two animals, struggling. Little Metropolis, Athens. 11th century
*b.* Man between two winged gryphons. Chilandari, Mount Athos. 12th century

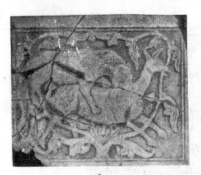

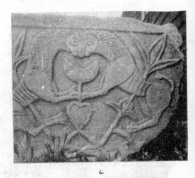

*c*

*d*

*c.* Lion attacking deer. Ottoman Museum, Istanbul. 11th century
*d.* Two stylized lions, confronted. Candia Museum. 11th century

BYZANTINE CLOSURE SLABS OF THE ELEVENTH AND TWELFTH
CENTURIES, BEARING MOTIVES OF PERSIAN ORIGIN

however, more complicated than it was in Sassanian times, for
it is not always easy to distinguish those elements that are purely
Persian from those that are, more broadly speaking, Islamic; by
the ninth century Persian and Arab ideas had blended so subtly
under the influence of Islam that it is often hard to tell whether
a particular work of art or a particular idea is to be attributed
to a particular part of the Islamic world, or whether it is to be
regarded as a part of the general culture complex. The use of
the Kufic script as an artistic motive affords a case in point.
The actual script was first used by Arabs and took its name from
the Arab town of Kufa in Iraq, but it was developed as an
ornamental motive not only for the adornment of books, but
also for that of pots, metal vessels, textiles, or buildings, in the
main by Persian craftsmen. There is, indeed, hardly a work of
art of the ninth century, from whatever part of Persia it may
come, that does not bear a Kufic inscription on it. On the whole
it may, perhaps, more justly be counted as a Persian contribu-
tion to the art repertory than as an Arab one.

The Kufic script, used as an ornamental motive, soon found
its way to the Byzantine world and was used on textiles, pottery
vessels, stone sculpture, and buildings alike. Its vogue was
especially characteristic of Athens in the tenth century, and
though it continued in use there till the fourteenth, it was less
usual after about 1050 than before, and later examples of Kufic
are mainly confined to the adornment of brickwork façades;
that of the eleventh-century church of the monastery of Hosios
Lukas in Phocis, not far from Delphi, may be cited. It is prob-
able that the motive came to the Byzantine world by way of
textiles of Persian manufacture, which were used as models for
the looms of Athens, Thebes, and elsewhere.[1] Similarly the
design and style of the mosaics which decorate the Sala Normana
in the palace at Palermo in Sicily are Persian rather than Arab,

[1] E. Wiegand, 'Die helladische Schule in der mittel-byzantinischen Seiden-
weberei', in *III<sup>e</sup> Congrès Byzantin à Athènes* (1930), p. 222.

though it was in this case thanks to the Arabs and not to Persian influence that the scheme was adopted in the Byzantine world.

Another art in the development of which in the Byzantine area Persian influence played a dominant part was that of pottery, though here again it is not always easy to dissociate the Arab from the Persian contribution. One or two groups of Byzantine pottery do, however, show distinctly Persian, rather than Arab, affinities. Most important is the group usually known as polychrome ware; examples have been found at Preslav and Patleina in Bulgaria, at Kiev and other Byzantine sites in Russia, and at Constantinople itself; they date from the ninth, tenth, and eleventh centuries. Many show Persian inspiration in the motives that decorate the vessels as well as in the style and colouring and to some extent also in the actual technique. At a rather later date a large group of painted wares in the Byzantine world, where brown, green, blue, yellow, and pale red glazes are used over a red body, is again related to a well-known type of Persian pottery, examples of which appear at an earlier date in the Persian world than in the Byzantine. Most important, however, are the sgraffito wares, some groups of which are in the Byzantine world so close to Persian prototypes in appearance that it is tempting to suggest that not only were designs, shapes, and techniques copied, but also that actual potters in a few instances found their way from Persia to the West.[1]

Though less uniformly Persian in style than the pottery, examples of metal-work, enamelling, and ivory carving from Constantinople and elsewhere in the Byzantine world may be cited that show undoubted Persian influence. There is a large group of ivory plaques bearing stylized motives which clearly emanate from the Persian repertory. The dancing girls that adorn plaques from the crown of Constantine Monomachos

[1] The links that bind Byzantine ceramics to Persia have been briefly examined by the author in his *Byzantine Glazed Pottery* (Oxford, 1930); he hopes to discuss them more fully in a forthcoming article.

(1042–55) at Budapest recall figures from illuminations of the Islamic period in Persia. A group of silver vessels of the ninth or tenth century from Bulgaria may also be noted; the vessels are related on the one hand to Byzantine specimens and on the other to Persian.[1] On a larger scale the important group of sculptured marble slabs, examples of which are to be found all over the Byzantine world from Athens to Constantinople and from western Asia Minor to Venice, may be mentioned. These slabs show beast motives that are unquestionably of Persian origin; they were, like the Kufic script, probably inspired by textiles. One such slab bears a less usual but particularly fascinating motive, namely, the ascent of Kai-Kā'ūs to heaven in his chariot; it is built into the walls of St. Mark's at Venice.

Throughout the period from the ninth to the thirteenth century influences were once more not entirely one-sided. Individual works of art in the Eastern world can be cited that show undoubted Byzantine inspiration, and the records speak of the arrival in Iraq of Byzantine embassies and craftsmen; they doubtless also went to Persia. With regard to the former, a copper basin, now at Innsbruck, with decoration in enamel, which bears the name of an Ortokid prince of Amida may be mentioned; at the centre of its interior is a medallion showing a seated figure, obviously copied from a Byzantine coin. Such objects are, however, few and far between in comparison with the number of Byzantine works of art which show Eastern influence.

Outside the sphere of art Byzantine elements are more frequent. The early Abbasid army was thus organized on the Byzantine model, even to the extent of the inclusion of a company of naphtha throwers in a special fireproof uniform; a famous mill at Baghdad was built, according to Ya'qūbī, by a Byzantine craftsman;[2] there were doubtless similar contacts

[1] G. Migeon, 'Orfèvrerie d'argent de style oriental trouvée en Bulgarie', *Syria*, iii (1922), 141.

[2] G. Le Strange, *Baghdad during the Abbasid Caliphate* (Oxford, 1900), p. 142.

with Persia. Trade between East and West was, again, extensive, and there are frequent references to it in the literature. Eastern goods continued to reach the Byzantine world in large quantities, even when Latin traders played a more important role as intermediaries than did the Byzantines themselves, and Byzantium in its turn exported to the East. Byzantine goods are thus referred to in the time of the caliph Manṣūr, and again in 860 Ibn Ṭūlūn is recorded to have rescued from plunderers a convoy of works of art which was on its way from Constantinople to Samarra. There must have been similar convoys to Persia.

## § iii. *Conclusion*

From the point of view of art history the Persian legacy to the Byzantine world is of outstanding importance. It might, indeed, almost be questioned whether Byzantine architecture would ever have developed in the way it did had Persian influence not been exercised in early days. Byzantine textiles and, rather later, Byzantine ceramics, were often for long periods at a time almost as Persian in appearance as they were Byzantine. Byzantine stone sculpture was considerably affected. Byzantine ivories at times show Persian influence, as does Byzantine metalwork. Even in painting and mosaic can Eastern stylistic affinities at times be traced. Cultural history shows similar relationships, and as we become more closely acquainted with the conditions of society in Persia and Byzantium, we no doubt come to realize more and more clearly the great extent of Persia's role in this respect. And, as the story of Near Eastern commerce comes to be more fully examined, there is every reason to believe that it will be found that the contacts between Persia and Byzantium in this sphere were not only of tremendous extent but were also more or less continuous. The old-fashioned type of history, which paid attention only to wars and similar spectacular events, thus presents a very imperfect picture, for the wars exercised no more than a temporary or limited effect on cultural contacts.

Interchanges in trade, art, and thought continued in spite of them, and it is only by means of a careful examination of these more permanent aspects of the life of the past that we can obtain a truly accurate picture of the situation as a whole. The tale of events, the story that a few generations ago was regarded as the be all and end all of history, is thus but a part of the whole, which, considered alone, is often more confusing than it is enlightening. In no instance is this truer than with regard to the relationships between Persia and Byzantium.

D. TALBOT RICE

# CHAPTER 3
# PERSIA AND THE ARABS

An exact assessment of what the Arab world owes to Persia would demand an analysis of the civilizations of both, with digressions that might lead into the fathomless deeps of anthropology. Nevertheless, there are certain elements in the one which may be said, with an approach to historical truth, to have been derived from the other. In general they are superficial features, capable of statement as concrete facts. Of the imponderables which the two have interchanged only a little need or can be said here, for there is already a considerable literature on the subject.

The speed of the Muslim Arab subjugation of Persia has often been the object of comment, yet the matter is not as simple as appears in the bald assertion that the Arabs overran and absorbed the empire of the Sassanian Shahs. Persia did not then, or at any time, lose the identity which she had possessed almost from the beginnings of recorded history. The features making for her endurance were, of course, largely physical and geographical, but they consisted also in certain resilient and indestructible elements in the character of her people and their collective institutions. They remained identifiable even in the systems imposed by the Arabs, the conquerors who in historical times had left the greatest impress on the country.

As in the Moorish conquest of Spain, the flood of invasion did not cover the whole of Persia in one tide, but the rapidity and ease with which it submerged the main provinces may be attributed to the fact that the Arabs were not altogether unfamiliar to the Persians and that both peoples shared ancient religious and spiritual concepts. This becomes more obvious if comparison is made with the difficulties the Arabs encountered in their conflict with the Byzantine Empire. Especially in Iraq,

the ancient Babylonia, which, though a province of the Sassanian Empire, was occupied by 'Nabataeans', a people speaking a Semitic tongue, there had for long been fairly intimate contacts between Arabs and Persians. It was the kind of common ground lacking for Arab and Greek.

At the time of their Islam-inspired migration from their desert peninsula the Arabs were at a primitive level of military development, except for their skill in storming fortifications, owed possibly to the adoption of siege-engines from the Greeks. In the arts of peace too they had scarcely advanced beyond the stage of providing themselves with the prime necessities of life. The great mass of desert-dwellers indeed required no more than they could get from their camels, the only beasts able to thrive in the Arabian wilderness. Agriculture they held to be an occupation beneath the dignity of men and those who engaged in it mere clod-hoppers; from which it was only a step to the disregard of land itself as something outside the range of notice. In general they had little concern with the complexities and refinements of a settled existence.

Yet once the Arabs had burst into the open world beyond their peninsula, their leaders were faced with the necessity of administering their newly acquired possessions and hence of taking an interest in the unfamiliar art of government. The *Fakhrī*, an early-fourteenth-century manual of politics and history, relates how the caliph 'Umar, when at his wits' end to know how to distribute the spoils of war which were pouring in, sought the advice of a Persian who had once been employed in a government office. His suggestion was that a *dīvān*, a register or bureau, should be instituted for controlling income and expenditure, and this became the germ out of which grew the governmental machine that served the caliphate for some hundreds of years. The story contains a grain of truth, for perhaps the most important acquisition made by the Arabs was Madā'in (Seleucia-Ctesiphon) on the Tigris, the capital of the Sassanian

Empire and the centre of its administration and, at the same time, a city rivalling Constantinople for wealth and its civilized amenities. From it Kufa and Basra, Iraqi cities which had developed out of Arab military settlements, recruited the officials able to carry on the administration of the new territories in the early stages of their occupation, and incidentally to teach the tribesmen something of the business of government.

Amongst the leaders in the Arab world the Sassanian kings had long possessed a fabulous reputation for statesmanship. The ninth-century essayist Jāḥiẓ of Basra gives expression to it when, in the course of an essay dealing with the qualities of the Turks, he indulges in a characteristic digression to air his views on sundry other peoples. 'Amongst the races and generations of mankind', he says, 'I have found that some excelled in the practical arts, some in rhetoric, some in the creation of empires and some in military skill.' He goes on to say that his researches convinced him that the Greeks had a genius for philosophy and mechanical devices, that the Chinese were the most skilled artists as craftsmen without being greatly interested in the metaphysical causes of phenomena, and that the Turks were doughty warriors. As for the desert Arabs, they had never been merchants, tradesmen, or physicians nor had they any aptitude for mathematics or agriculture. On the other hand, when they gave their minds to poetry and oratory, to horses, weapons, and implements of war or to the recording of traditions and annals, they were unexcelled. 'Of course', he adds, a regard for fact compelling him to qualify his generalizations, 'not every Turk is a warrior nor every Arab a poet.' Lastly, coming to the Persians, he awards the palm for statesmanship to the Sassanian Shahs.

Jāḥiẓ was merely corroborating the opinion of the caliphs. The Omayyad Hishām ibn 'Abd al-Malik (d. 743) had amongst his books an Arabic translation, made in his lifetime, of a Persian history of the Sassanians, illustrated with their portraits in 'rare'

colours and containing chapters on their political methods, the Persian sciences, and the chief monuments of the national architecture. Presumably the Persian system of government was the subject of his study; it was without a doubt closely followed by the Abbasid caliphs, for to Arabs it presented features that were strange and possibly unacceptable. One was that of an absolute, hereditary monarchy and another that of a government which was, in theory at any rate, strictly centralized. The Arabs, even in such cities as Mecca and Medina, grouped themselves in jealously independent tribes, each of which elected its own chief. Tribes might be divided and subdivided, but in none except the smallest unit was the headship ever hereditary, though it remained by tradition within certain designated families. Early in the history of Islam, in fact, sovereignty was declared to be outside the category of hereditable human possessions.

When the time came for the caliph 'Umar to organize the Muslim state, he provided for a sovereign ruler but retained the principle of election, though only members of the Prophet's tribe of the Quraish were eligible. Within the state the Arab conquerors were to hold a privileged position corresponding to that held in the Sassanian state by the nobly-born Iranian families. 'Umar himself and his three immediate successors in the caliphate were, in fact, elected to office, but Mu'āwiya, who followed them as first of the Omayyad caliphs, was able to create a family dynasty in which power descended from father to son, with an occasional deflexion to brother or cousin.

Apart from the sovereignty, 'Umar's administration bears the impress of the Persian system. Over the various newly acquired territories he placed his own agents, granting them certain restricted powers but keeping the final control in his own hands. The great landlords, who had acknowledged the later Sassanians only to the extent of submitting to taxation, were swept away, but the *dihqāns*, the more substantial peasantry whom the

Sassanians had employed as minor revenue officials, were kept
where they were to be the new government's assessment-
officers and tax-gatherers. Substantially they were regarded
much as the Arab notables in the various districts of Iraq were
by the British forces who invaded that Turkish province in
1914. As being conversant with revenue conditions in their own
district they were assigned certain functions in connexion with
them. It was the *dihqāns* who kept the taxation registers and
could say from experience what the various revenue producers
were liable to pay. For half a century at least after the conquest
of Persia the Arabs had nothing more than the old tax-lists to
go upon; in Khurasan and other less accessible Iranian provinces
the official ledgers were kept in Persian for half a century longer
still, right up to the time, in fact, of Abū Muslim, who was so
largely instrumental in hoisting the Abbasids into the saddle.

As relics of that period a number of Persian fiscal and allied
financial terms remained in Arabic as part of the vocabulary of
the revenue *dīvān*, itself a word reputed to be of Persian extrac-
tion. For centuries Iranians continued to bear a reputation for
skill in money matters and provided even European tongues
with banking terminology, an instance commonly given being
the word 'cheque'.

More than one of the Omayyad caliphs (who prided them-
selves on their Arabism) was called upon to defend the employ-
ment of these 'foreign' instruments, trebly unpopular by reason
of their nationality, their office, and their over-efficiency, for
they were accused of exacting the uttermost farthing—'remem-
bering even the husks of the rice'. One Omayyad governor of
Basra, compelled to leave the city in haste when its inhabitants
broke out in revolt, justified his retention of the *dihqāns* on the
grounds that there was a falling off in the revenue when Arabs
were employed and that the Persians had a keener eye for what
was taxable, were more trustworthy and less extortionate.

The Persian revenue system, as it existed under the first

Chosroes, Anūsharvān the Just, was a simple one. All cultivators of the soil paid a percentage of their crops in kind or cash and all full-grown males paid a poll-tax, from which were exempted members of the recognized noble families, great landlords, knights, 'scribes', and the king's servants. By and large this was the system perpetuated by 'Umar, with the difference that under his régime the privileged class consisted of the Arabs.

Where the revenue contribution was in cash, payment was made in dirhams, silver coins that under the Sassanians had borne on the obverse the image of the king and on the reverse the picture of a Zoroastrian fire-altar with a ministering priest on either side. In spite of Islamic disapproval of such imagery, these coins were adopted by the Arab invaders, who employed native Persian craftsmen to make what they could. As the old coins became scarcer, Omayyad and Abbasid governors in the eastern provinces had fresh ones struck, of identical type but with the addition of either Pahlavi or Arabic inscriptions, or both. The same type, with altar and priests conventionalized as three parallel lines, was perpetuated in the coinage of the Muslim states of North Africa and even in Moorish Spain, while the weight of the purely Muhammadan silver dirham coined by the reforming Omayyad 'Abd al-Malik for use throughout the caliphate was that of its Persian forerunner. This silver dirham continued to be the standard of currency in the eastern provinces until well on in the 4/10th century and for almost as long in Iraq too.

Land-tax (*kharāj*) was from its nature payable when the wheat and barley were gathered in. Anciently, harvest celebrations had coincided with the first day (*Nau-rūz*, 'New Day') of the Iranian solar year, which then began at the midsummer solstice, 21 June. When, during the Achaemenid period, the date of *Nau-rūz* was advanced to the Spring equinox, 21 March, both dates were celebrated in the empire, the newer one being retained in Persia and the original one in Egypt and some of the

western provinces as a holiday, but also as the date for payment of *kharāj*. Historians at various times record not only the Sassanian practice, which persisted into Muslim times, of exchanging gifts at *Nau-rūz*, but also the rough horse-play which then took place in the city streets of Iraq and Egypt. During these summer saturnalia no respectably dressed person could venture into the streets without risking his dignity. By the Copts *Nay-rūz* is still retained as New Year's Day, which, owing to vagaries of the almanac, now falls on 10 or 11 September.

Under the Omayyads, the Arab aristocracy had replaced the Persian in the social scheme of the caliphate, but a change occurred when that dynasty in its turn was replaced by the Abbasids. By their transfer of the capital of the caliphate from Damascus in Syria to Baghdad in Iraq they proclaimed their intention of being princes of all the faithful, and not of the Arab Muslims alone, and of treating non-Arabs with the consideration which had until then been the prerogative of Arabs alone. That this in practice meant a special measure of privilege for Persians is understandable from the fact that the new caliphs themselves had Persian blood in their veins. In defining Persia they drew its boundaries generously, including within them Turkish-speaking tribes from beyond the Oxus as well as men of Arab stock who had settled in Khurasan during and after the Muslim invasion. In this they were adhering to the popular view, defined in the eleventh century by the constitutional lawyer Māwardī, that whereas the bond between Arabs was intimate blood-kinship, amongst non-Arabs it was geographical propinquity or racial interest.

Naturally enough in view of their origins the Abbasids regarded their empire as a continuation of the Sassanian and their own place in it as exactly corresponding to that of their predecessors. The chief difference was to be that Islam was to replace Zoroastrianism as the state religion, of which they were to be the heads precisely as the Iranian kings had been. In con-

trast with the Omayyads, whom the annalists of the Abbasid period depict as irreligious, worldly materialists, the Baghdad caliph was proclaimed a zealous 'Protector of the Faithful' and the guardian of orthodoxy. No Abbasid allowed it to be forgotten that he was a kinsman of the Prophet, whose mantle had been transmitted to him. The laws of Islam were moulded to the requirements of the state, and the association of faith and secular sovereignty was placed upon the pedestal which it had occupied in Sassanian Iran and is so constantly praised by Firdausī in his *Shāh-nāma*.

An abiding instance of this close linking of religious with secular functions lies in the conception of the *qāḍī*, primarily a man learned in the Qur'ān and the Traditions, but one whose function was to preside over the courts of law even where they were concerned with civil causes. The parallel with the priest, who dispensed justice under Zoroastrianism, is a fairly clear one.

There were amongst the Sassanians those who on their coins had designated themselves as *bāghī* ('godlike'). The claim to divine honours was also made by, or acceded to, some of the Abbasids, who attempted to create about themselves 'that reverential awe', in Gibbon's words, 'which distance only, and mystery, can preserve towards an imaginary power'. Like the Sassanians they achieved it by secluding themselves from the common gaze, employing as well as curtains and other paraphernalia numerous guards and chamberlains to impede that access to their chiefs which Arabs claimed as a right. The most terrifying of these adjuncts of sovereignty was the personal bodyguard, which always included one or more individuals whose task was immediately and without question to carry out the monarch's commands, however grim. No one who has read the *Arabian Nights* can forget the sinister figure of Masrūr, the slave without whom 'Haroun al-Raschid' never appeared in public. He was, it may here be remarked, a Turkoman of Farghana and not, as is often said, a negro.

The executioner was the symbol of the absolute power which the Iranian Shāhanshāh wielded over the lives of his subjects and which the Abbasids in their turn arrogated to themselves. It was a pretension which was recognized in public, at any rate, and in the vicinity of the court, but that other views were held privately is a point which emerges from a conversation reported by the annalist Ṭabarī. The caliph Manṣūr had sent one of his freedmen, whom he specially retained for such tasks, to assassinate a man called Fuḍail, groundlessly accused by him of having behaved improperly towards the young prince Ja'far. Hearing of the murder, and unaware of his father's part in it, Ja'far remarked to a companion, 'What will the Commander of the Faithful say to the slaying of an innocent Muslim?' The reply was: 'He is the Commander of the Faithful. He does what he pleases and knows best what he is about.' 'You miserable oaf,' Ja'far retorted (the Arabic is stronger), 'I speak to you in confidence and you give me a public [i.e. a formal and official] answer.' Of Manṣūr certainly it is true that he was very conscious of his rights and dignities. Admonishing his son and successor, Mahdī, he said: 'Shed no blood unlawfully; it is a sin in God's sight. But defend your sovereignty and destroy anyone who disregards it or dares to withdraw himself from it.'

For the administration of the secular affairs of the caliphate Manṣūr is reported to have said that he required four men of integrity: a *qāḍī* at whom no one could point the finger of blame, a police-officer who would enforce the claims of the weak against the strong, a tax-gatherer who would press his claims without extortion, and an 'intelligence' officer who would submit honest reports on the other three. These officials, leaving aside their qualifications, corresponded to some who formed part of the civil service of the Persian kings. Of the first three something has already been said above. With regard to the fourth, the 'intelligence' or 'postal' (*barīd*) service was taken over from the state postal organizations of Byzantium and

Iran, which provided relays of fast messengers bringing to the capital reports of happenings in the provinces and returning with orders or an occasional visitor of importance. The terminology of the *barīd* system, with some linguistic modifications, enriched the Arabic vocabulary with the Persian words for 'courier', 'foot-messenger', 'guide', 'post-horse', 'way-bill', and the like. Early in the Abbasid period, too, a whole series of route-books was written in Arabic to guide officials of the service; they are of interest now as providing information about geographical and economic conditions in the districts bordering the various roads and in the settlements through which they passed.

A state official not mentioned above, although he was the caliph's right-hand man in the direction of the central government, was the vizier. It is a matter of debate whether he was identical in function with the official of the Sassanian government whom the Persian literature of the Muhammadan period calls vizier. That literature makes constant reference to the great Buzurgmihr, vizier to Anūsharvān the Just, and a character so admirable that he may without hazard be regarded as a personification of the virtues rather than a creature of flesh and blood. Whether he is fictitious or not, it is a fact that the aura of godhead with which the Persian kings surrounded themselves created the need for an intermediary between themselves and the outer world. In earlier times he was the *vazurg-framadhār*, the 'great executive' carrying out the king's command, a versatile official able to direct any of the departments of state whether civil or military. Under the later Sassanians he appears to have been replaced by a *dabīrpat* or 'chief scribe'.

It was a 'scribe' also, parallel in function with the Chancellor of medieval European courts, who executed the policy of the Omayyads in their civil administration. The Abbasids replaced him by the vizier (Arabic *wazīr*), whose name, almost certainly Persian in origin, appears with the meaning of 'assistant' in a Qur'ānic passage in which Moses asks for Aaron as his *wazīr*,

in fact Polonius' 'assistant for a state'. Similarly the young Hārūn, not yet caliph and 'al-Rashīd', is given Yaḥyā ibn Khālid al-Barmakī (the Barmecide) as his *kātib* ('secretary') and vizier. In this post Yaḥyā appears to have had only civil functions, although he was one of the warriors to whose efforts the Abbasids owed their throne.

The Barmakī dynasty of viziers founded by Yaḥyā had originated in Balkh (Bactria), where they were hereditary high priests of the Buddhist[1] temple of Nau Bahār. But though they were not Zoroastrians their sympathies and traditions were Iranian, to judge from their attitude towards their fellow countrymen and their care in celebrating the national festivals. To them is credited the invention or development of a number of *dīvāns*, or government departments, which controlled the central administration at Baghdad for a hundred and fifty years after their own fall from power. Their organization only disappeared, indeed, when the power of the caliphs had reached vanishing-point and the Commander of the Faithful was the mouthpiece of the Buyid robber barons, who, coming from the region of the Caspian Sea, traced their ancestry back to Adam in a direct line through the ancient kings of Persia.

The Abbasid caliphate had by that time reached the nadir of its fortunes, but for long before it had been in the grip of the Turkoman guards whom successive Commanders of the Faithful had paid—one can hardly say employed—for protection. These Turkomans were slaves whom the caliph Muʿtaṣim had in the first instance bought in Persia to be his bodyguard. Very soon his successors had to submit to blackmail from their guardians, whose kinsmen were constantly being freshly recruited and had come to form an important constituent of the standing army now being maintained by the state. The rough tribesmen on their way down from their homeland in central Asia had spent

[1] It is not improbable that the Buddhist rosary came to the Arabs by way of Persia and was received by Europe from them.

some time in Iranian territory and had been sufficiently influenced by Persian military tradition to acquire its methods and its terminology. They now wore the short Persian tunic (*qabā*), had the Persian mace amongst their weapons, and carried their arrows in a Persian quiver (of which the name, *tarkash*, may have supplied the French *carquois*). Officers and men drew *jāmakīyāt* ('clothing-allowance': Persian *jāma*, 'clothing'), which came to them from the *Dīwān al-Shākirīya* ('office of the slaves': Persian *chākir*, 'slave') set up at Baghdad to deal with their organization.

The maintenance of standing slave-armies was continued by the Fatimid and other princes who broke away from the Abbasid caliphate, and from amongst them from time to time vigorous individuals arose to become masters of the states they had served. An outstanding personage of this type, one who affected the course of Muslim history, was Aḥmad ibn Ṭūlūn, who, having been sent to be the Abbasid governor of Egypt, made himself independent ruler of that country and Syria and founded the Ṭūlūnid dynasty.

In its most elaborate and complete form the slave state was to be seen in the Mamluk Sultanate of Egypt and Syria, where the rulers, themselves born as slaves, kept a firm control over their subjects by means of large bodies of slaves trained as fighters and a disciplined civil service. It was a system which contained many features originally Persian, notably the *barīd*, and many of the officers of state bore Persian titles. At home in their capital the Mamluks followed the Persian tradition—transmitted through the Fatimids and Abbasids—of maintaining a great display of luxury and ceremonious etiquette. Adoration of royalty was insisted upon so that, when the Sultan appeared, all present bowed down in the attitude usual otherwise only in worship.

The royal household was elaborately organized in departments which, like the officers who had charge of them, bore Persian titles, presumably derived by the Fatimids from those

which had at one time been customary at the Iranian court.
Many of the officials, more especially those in personal atten-
dance on the Sultan, bore symbols of their functions. The
*Dawādār* ('scribe') carried a pen-box, the Squire a bow, the
Master of the Robes a 'hold-all', the Marshal a horse-shoe, the
Taster a round disk representing a table, and the Polo-Master
a polo-stick. Such concrete objects were in course of time
replaced by conventionalized representations or blazons, which,
imported into Europe by returning crusaders, formed the begin-
nings of modern heraldry. Of more immediate interest here is
the fact that the symbols and the Mamluk officials who bore
them were called by Persian names and that the Arabic *rank*
('blazon'), which is derived from the Persian *rang* ('colour'),
may possibly be the ancestor of our own 'rank' and of regimental
and other 'colours'.

There is mention of especially elaborate ceremonial when
those Sultans who were addicted to the Persian game of polo
went to play. Baibars, for example, the Sultan whose troops
stemmed the flood of Mongol invasion and prevented its reach-
ing Egypt, had the custom of playing three games every Satur-
day in the season after the Nile floods. He would set out at
dawn from the royal stables and followed by a cavalcade in
festive dress would pass through cheering crowds to the ground
constructed by one of Saladin's successors in the neighbourhood
of the present-day Bab al-Luq at Cairo. He was not, however,
at such times accompanied by the royal sunshade—the *chatr*,
which was reserved for more solemn occasions.

So far we have been dealing with princes and other important
dignitaries, at whose level international contacts had always
been possible, whether in peace or war. Long before the Muham-
madan conquests Arabs and Persians of all grades of society had
in some measure become acquainted, if only through each other's
merchandise. From time immemorial traders had brought the
products of countries near and far to Arabia, which anciently

had busy international markets, or to contiguous ports such as Basra on the Persian Gulf. In return, caravans went annually from central Arabia to Iran and other countries bearing resins for incense, those 'perfumes of Arabia' which would not sweeten the hand of Lady Macbeth, linen stuffs, and other luxuries. Abū Sufyān, a fellow tribesman of Muhammad's who bitterly opposed his early claims to prophethood and public recognition, made a fortune for himself and the chiefs of the Quraish tribe by supplying capital for trading ventures into Persia.

Two centuries or more before the emergence of the Prophet there had been a well-known market at Hira, the capital of an Arab kingdom established by the Lakhmī dynasty along the Euphrates, not far from the ancient Babylon. There the Arab kings, for long the vassals of the Sassanian Shāhanshāhs, reproduced the life of the Persian courts and gave traders, pilgrims, poets, and other travellers ideas which they carried back with them to the cities of the Arabian peninsula and elsewhere. They also took back with them articles of Persian make which took their fancy and the native names of which are to be found embedded in even the earliest Arabic literature.

With the coming of Islam contacts became more numerous and intimate. By far the greatest number of the peninsula's inhabitants were nomads, loosely organized in tribes whose members had enjoyed a good measure of liberty both as regards their duties to the commonwealth and to the deities they chose to worship. Their physical requirements were little more than those indispensable to existence and their chief excitement lay in the prosecution of inherited feuds. When, possessed and revitalized by Islam, they burst through the weakened barriers surrounding the empires of Persia and Byzantium, they found themselves amongst peoples long accustomed to the forms of settled existence, with refinements, conventions, and amenities which struck them as in many ways desirable.

Like other 'empire-builders' the advancing Arabs were receptive of the ideas of their new subjects, whose material equipment and ways of life many of them were eager to adopt. The members of the shaikhly families in particular, with their opportunities for penetrating into the households of wealthy Persians, were quick to seize upon the luxuries they found. Within a comparatively few years of the invasion young men attached to the court of the Omayyad caliph were discarding their homespun in favour of expensive clothes of brocaded silk cut in the Persian style, eating Persian culinary delicacies, and displaying Persian manners at tables that were themselves an importation from Persia.

Those of the original invading forces who penetrated as far east as Khurasan settled down amongst the local inhabitants and, quickly imitating them, adopted trousers instead of skirted garments, took to drinking wine, and celebrated the Persian holidays. This did not prevent their continuing their associations with the camp-cities of Iraq from which they had sprung, so that it became a common occurrence to hear Persian spoken in the bazaars of Kufa and Basra. By the time of the early battles of the Abbasids the Khurasani Arab troops spoke as much Persian as Arabic.

With the foundation of Baghdad the caliph Manṣūr intended to bring the east and west of his empire closer together. He was determined, moreover, to endow his capital with the amenities of a great city, and although we cannot tell to what extent the humbler citizens enjoyed them, we have evidence that even fairly unimportant government officials regarded the new importations as necessities. Ṭabarī thinks it worthy of comment that a provincial civil servant peremptorily summoned by the caliph and brought by the *barīd*, i.e. post-haste, had in his luggage a Persian prayer-rug, a mattress and cushions, water-pot and basin, and, last refinement of all, a copper lye-holder betraying its Persian origin by its name. Manṣūr would probably not

have approved such luxury in a subordinate had it been brought to his notice. He had a reputation for niggardliness and once had a secretary thrashed in his presence for wearing trousers made of a material which he regarded as too expensive. He extended his economies to his own person and adhered strictly to the sumptuary laws of Islam, of which he was the head. When the famous Christian physician Bukht-Yishū', on a visit to the palace from the college at Jundi-Shapur in south-west Persia, asked for wine with his dinner, he was told that it was not served at the caliph's table. Whereupon he drank Tigris water, tactfully declaring afterwards that he preferred it.

On the temporal side Manṣūr followed the Sassanian tradition. He insisted that members of his household and his court should never appear in public without being dressed in the most costly embroidered silks and scented with the finest perfumes. His new buildings were of Persian design, and it is evident from the architectural terms employed in Arabic that it was by Persian builders that such features were introduced as arches and domes, porticoes and balustrades, windows, ventilators, and water-spouts. To the outside amenities of large houses they added, after the fashion of their own country, gardens, kiosks (garden-pavilions), and fountains. Inside the houses, such furnishings as tables, chairs, mattresses, cushions, and mosquito-curtains, as well as the materials for hangings and floor-coverings, were further importations from Iran. The kitchen, too, was not neglected. Ovens, frying-pans, trays and bowls, mortars and pestles were brought in, to say nothing of the recipes for savoury dishes which had been the secrets of Persian housewives and now found their way into Arabic cookery books.

Wares of this kind, finding their way on to the markets, created a popular demand and stimulated local craftsmen to emulative production. In that way the spinning, weaving, dyeing, and metal-working trades, as well as the decorative arts, with all the chemistry and metallurgy they demanded, received

immediate encouragement. Persian designs became common in the products of Arab looms and workshops. Many of the raw materials required were no doubt produced locally, but soft-iron and steel, with certain kinds of bronze, were brought from Iran. So also were the beautiful lapis lazuli and turquoise which gave their rich colour to the enamels and glazed ware of the Middle East. One such import worth further mention is amber. Its Persian name, *kahrubā* ('straw-attracter'), became embedded in modern Egyptian Arabic, in which both electricity and the electric tram are designated by it.

Local drugs and medicines also received large additions from Persia, for though in the Arabic medical text-books many of the anatomical terms are of Greek or Latin origin, in the pharmacology the names most common are Persian. This is not altogether surprising when taken with the fact that for over four centuries one of the most important schools of medicine in the Middle East existed at Jundi-Shapur in Khuzistan, the province whose capital is Ahwaz. The family of Bukht-Yishū', the Christian physician already mentioned, was settled here and for six generations continued to uphold the school's reputation. The tradition of Persian medicine did not end with them, for amongst the Persians who contributed to the fame of 'Arab' science in medieval Europe were Rhazes (i.e. the 'Man of Ray'), Haly Abbas ('Alī ibn 'Abbās, 'The Magian'), and Avicenna of Hamadan.

Perhaps the most important single commodity received by the Arabs through the medium of Iran was rag paper. It was, of course, a Chinese invention, the introduction of which into Persia came about in A.D. 751, when Muslim forces, after a brush with Chinese troops, captured one or two who were paper-makers by trade. They taught the art to the Persians, who had hitherto used parchment for their documents. In this connexion a story is told of the caliph Manṣūr's having ordered his store-keepers to sell their large stock of Egyptian paper, declaring that

henceforth he would follow the Persian example and use nothing but materials produced at home.

Allied with the making of books was the art of binding, which had been greatly improved by Persian methods of tanning that increased the suppleness of leather and made tooling and ornamentation easier. We hear of specially treasured works that were written in gold ink on Chinese paper and had covers of fine leather lined with brocade and adorned with precious stones and gold.

As imported luxuries and 'foreign' manners became commoner, while simultaneously an orthodox form of Islam took concrete shape, the less well-endowed members of the population, who were in general also those who clung most closely to their Arab nationalism and their religion, were inclined to resent them and demand a return to the early ascetic standards. Their feelings are reflected in the sermons of the religious leaders of the age and the admonitions of its moralists, from which a good deal of social history can be gleaned. The religious text-books of Islam are almost unanimous in their denunciation of music and games, because, it may be inferred, they distracted people from more serious pursuits. The persons chiefly blamed for having introduced them into Arab cities are men of Iranian nationality, and it is a fact that those mentioned in connexion with music were people who had come in pursuit of trade, as craftsmen in other arts, or simply as professional musicians.

When 'Abd Allāh ibn Zubair, a rival of the Omayyads for the caliphate, decided that the Ka'ba at Mecca needed repair, he hired Persian and Greek masons to do the work. Like other craftsmen they sang as they worked, and their tunes appear to have taken the fancy of the local inhabitants. What songs the Grecians sang is lost to memory, but there is frequent reference in Arabic literature to the music of the Persians, some of whom had brought instruments with them which they taught the Meccans to play. Not content with playing, the Meccans and

other Arabs learnt how to construct instruments of their own and establish their own system. Yet as late as the year 300 of the Hijra (A.D. 912) the Baghdad inventor of a new instrument gave it a Persian name.

Under the Omayyads, members of the richer families were eager patrons of music and dancing, going to the extent of bringing to Damascus and other cities in their domains directly from Persia performers in both arts and of both sexes. Their enthusiasm did not fade when, displaced by the Abbasids and driven from Syria, they set up a monarchy in Andalusia. At the court of the second 'Abd al-Raḥmān of Cordova (A.D. 822–52) a Persian singer named Zaryāb ('Gold-finder'), who had at one time been a client of the Abbasid caliph Mahdī, made his mark so effectively that he became a 'star', whose clothes and mannerisms set the fashion and whose taste, even in the art of cookery, was declared to be impeccable.

In the eastern caliphate the demand for Persian music was such that many an impresario made a large fortune out of it. The Arabic anthology *Kitāb al-Aghānī* ('Book of Songs'), the compilation of Abu 'l-Faraj of Isfahan, makes constant reference to the huge fees paid to, or expected by, successful singers and players. It tells also of an entrepreneur—whose father, incidentally, bore the Persian nickname of *Bisyār-diram* ('Many-pence') —who spent a large sum of money in adding an extension to his house for public performances.

Among pastimes other than music regularly claimed by Arabic writers to have been introduced from Persia are the games of polo, chess, and *nard* (*trictrac* or backgammon). Hārūn al-Rashīd is declared to have been the first caliph to play polo, but long before his time the game had formed part of the Persian nobleman's education. The essayist Ibn Qutaiba cites an old Persian manual on royal deportment that includes a section devoted to the rules and etiquette of the game and hints on play. The learner is instructed how to handle the mallet and

control his pony, and careful attention is paid to the manners desirable on the field. Thus the player may not apply his whip to the ball if he has missed with his mallet, which should never be allowed to dig up the ground or injure the pony's legs; care must be taken to avoid disabling other players, of either side, by collision or otherwise; there must be no display of bad temper, nor any cursing or swearing, and balls should not be recklessly driven out of the field 'even if they are six a penny'. Spectators, finally, should not be excluded but should be allowed to sit on the enclosing wall of the *maidān* (ground), the width of which was fixed at sixty cubits especially to include them.

Mention has already been made of Sultan Baibars' devotion to the game. A more famous addict was Saladin, while amongst fictional characters who played was King Yūnān of the *Arabian Nights* who, on the advice of the sage Dūbān, played 'hockey on horseback' (Burton) and so was cured of his maladies by the medicine contained in the handle of the 'goff-stick' (Lane).

As for chess, whatever its origins may have been, its passage through Persia left it in the form which the Arabs inherited together with some of the Persian terminology. *Shaṭranj* remained the name for chess (i.e. *Shāh*, German *Schach*) and *shāh* for the king, with *shāh-māt* as 'check-mate'. The queen was still the 'counsellor' (*firzān* or *farzīn*; cf. Old French *vierge*), the bishop the 'elephant' (*fīl*; cf. French *fou*), and the 'castle' or 'chariot', *rukh*. In the more popular game of *nard*, the French name of which, *trictrac*, appears to represent the click of the dice on the board, the Persian numbers were long retained for scoring, as the *Kitāb al-Aghānī* shows in more than one anecdote.

A common and absorbing pastime in a society where books were rare and literacy unusual was that of listening to stories. By the learned, who form the religious opinion of Islam, romances and works of fiction have always, like music, been condemned as unworthy of the attention of serious men—and gravity is a prime virtue amongst Arabs. Nevertheless, the

story-teller's art has always been a highly valued accomplishment and new material eagerly sought for. The audience of even Muhammad the Prophet dwindled away to join that of his rival, Naḍr ibn al-Ḥārith, who was narrating the Persian legend of Rustam and Isfandiyār. Naḍr's comment when he heard of the Prophet's anger was, 'By Allah, Muhammad cannot tell a better tale than mine'. In their intercourse for trade and on other occasions Persian and Arab travellers exchanged news, ideas, and anecdotes, the Persian contribution towards the latter probably being very considerable. It cannot be claimed that all the romances of the *Arabian Nights* were importations, but the 'framework' story, with its Persian characters Shahryār, Sheherāzād, and the rest, together with some in the body of the collection, bear unmistakable marks of their Iranian provenance. To go farther into that question here would be to trespass on the ground of the Persians' contribution to Arabic literature.

There remains to be said something about the impact of Iranian thought and feeling on Arab collective life. In recent times the theory has been propounded that the conquering Arabs' religion was genuinely embraced only by the nobles and the wealthy amongst the subdued people of Iran, and then only as a security measure. The masses, it is held, clung to their old beliefs, paying lip-service to the new creed, which they cast off as soon as they felt strong enough in combination to do so. For such renegation they would never have lacked leaders, Persia having throughout the centuries been prolific in men claiming to possess divine inspiration that demanded mankind's attention. For illustration there need only be recalled the names of Mani and the Manichaeans, Mazdak (the dualist 'reformer' of Zoroastrianism), Bābak the Khurramite, al-Muqanna' (the 'veiled' prophet) of Khurasan, and 'Abd Allāh ibn Maimūn al-Qaddāḥ (the alleged founder of the Ismā'īlī sect) amongst older claimants, and the 'Bāb' amongst the modern ones.

Whether the theory can be proved awaits further investiga-

tion. In the meantime, evidence of the persistence of Iranian beliefs and their spread even amongst native Arab communities is to be found in the heresy-hunting by religious authorities almost before the time when a conception of orthodoxy had been formulated. *Zindīqs*, as heretics were called—the name is Iranian—were to be found in any of the social strata, one report including even the caliph Ma'mūn himself. The character of the charge levelled against them was not constant. Under the Omayyads it was not so much religious as political, it being held that as they were not completely reconciled to Islam they were hostile to the caliph at its head and hence to the Muslim state. Under the Abbasids, who laid more stress than their predecessors on the religious side of their office, the test was dogma. By strict inquiry into beliefs they checked any possibility of political revolt amongst those Persians whose promotion to eminent positions in the state might have encouraged a revival of national sentiment.

A regular inquisitorial system was inaugurated soon after the accession of the Abbasids to power. The caliph Mahdī appointed special officers to direct it, and in his last testament urged his son and successor to destroy dualists, the advocates of Iranianism. The inclusion of Ma'mūn amongst the *zindīqs* can have had no other foundation than his liberalism and the tolerance he showed towards those whom pious Muslims regarded as lax. A remark made by a Zoroastrian whom the caliph had advised to turn Muhammadan sheds light on this point. 'Your advice is good', said the man, 'but you are not amongst those who would compel men to renounce their [own] faith.'

Under Ma'mūn the cult of Iranianism appears to have been something of a pose. A certain Ibn Ziyād, a member of the Baghdad intelligentsia accused of being a *zindīq*, had the following squib thrown at him by a poet friend:

> O son of Ziyād, O Ja'far's father,
> No heretic are you but rather

A Musulman true in faith and fact,
Tho' like a heretic you act:
Sole aim and goal of your endeavour—
To show the world that you are clever.

That Persians did, however, cling to the faith of their fathers
in predominantly Muslim surroundings was made clear during
the trial for heresy of the distinguished Persian general Afshīn.
He had been employed by the caliph Muʿtaṣim to destroy the
heretic Bābak the Khurramite, and had succeeded. But he had
incurred the jealousy and enmity of rivals, who aimed to bring
him low on a charge of heresy on his own part. In spite of his
services to the caliph, he was arrested and brought to trial. The
first witnesses to confront him were the muezzin and imām of
a mosque who accused him of having had them beaten until
their bones were stripped of flesh. His defence was that these
two men, in spite of an agreement made with the local ruler—
a Soghdian—that his subjects would be allowed to worship as
they pleased, had attacked the local temple, thrown out its
idols, and converted the building into a mosque.

Afshīn was then asked to account for his possession of a
heretical work so elaborately ornamented with gold, jewels,
and brocade that it must have a special value for him. He replied
that it was an heirloom, that it contained material devoted to
Persian ethics, which he practised, and that he disregarded any-
thing else in it. As for the ornamentation, it was on the book
when he had received it and he had never seen any more reason
to remove it than the caliph himself from his copy of the *Kalīla
wa-Dimna*, the famous book of Indian fables.

A Zoroastrian priest lately converted to Islam was next
called. His evidence was that Afshīn had induced him to eat
the flesh of animals not slaughtered according to the Muslim
rites, but, graver still, that Afshīn had admitted he had put
himself among 'these people' and done all that he detested, yet
had never been circumcised. Afshīn turned on the man for

having betrayed his confidences and asked, 'Did I not of my own accord admit you to my house and acknowledge that I favoured Persianism and those who believed in it?'

He was then confronted by a border chieftain who declared that Afshīn's people, when writing to him, addressed him as 'God of gods'. That, said Afshīn, was a traditional title which he preserved only for the sake of his prestige with his tribe. When the question of his circumcision was put to him again he protested: 'Surely, *taqīya* (concealment of one's beliefs where an avowal of them would be hazardous) is an admitted practice in Islam? I feared that circumcision would endanger my life.' This protest was swept away with the retort that he had never hesitated to fling himself against spear and sword on the battle-field, and in the end he was found guilty and put to death.

The admissions of a man of Afshīn's status would appear to invalidate the theory that it was only the poorer class of Persians who were loyal to their old faith. It is true that some among the new Muslims were too poor to carry out all the duties required of them, that some were lax and some sceptical enough to write epigrams saying that the rich had motives for cultivating Allāh that were not given to the impecunious. It is equally true that many of the poor were strict in their observances, even to the extent of performing the pilgrimage to Mecca, from which the law absolved them.

However that may be, revolts against established authority from time to time broke out in Persia and spread to Arab lands, where they found considerable support. According to the famous vizier, Niẓām al-Mulk, who is associated in story with 'Umar Khaiyām and Ḥasan-i Ṣabbāḥ ('Grand Master of the Assassins'), the Ismā'īlī movement was started by a native of Ahwaz, a certain 'Abd Allāh ibn Maimūn al-Qaddāḥ. Its basic principle is that of official Shī'ism, namely, the divine right of the Prophet's descendants to be Commanders of the Faithful, as opposed to the Sunnī claim, which is that caliphs must be

elected. Both Ismāʿīlism and its parent, Shīʿism, believed that the last Imām ('Leader' of the faith) and the Prophet's last earthly successor would be the Mahdī, the harbinger of the restoration of the kingdom of righteousness on earth. Where they differed was over the number of Imāms to be reckoned between him and the caliph ʿAlī, the first of them.

With amazing speed the movement covered the Muslim world. To quote the Niẓām al-Mulk again: 'These accursed people emerged in Syria, the Yemen and Andalusia, and if a full statement of their activities is required, recourse must be had to the histories, especially that of Isfahan.' The arguments they used to secure converts differed with the persons they had as their objective, and the names by which they designated themselves varied with time and place. In Egypt and Aleppo they were *Ismāʿīlīs*, in Transoxiana and Ghazna *Qarmaṭīs*, in Kufa *Mubārakīs*, in Ray (Rhages) *Bāṭinīs*, and so forth. 'But all', says our author, 'have one object in common—the overthrow of Islam.'

For the Arab world the political and social consequences of Ismāʿīlism were many and far-reaching. It gained adherents by the method, not unknown to modern politics, of sending missionaries to form 'cells' of converts. These were admitted only after a careful preliminary initiation, and since the propagandists had to deal with all sorts and conditions of men they had to be prepared for argument and discussion. Out of this necessity grew considerable intellectual stimulation and an eagerness to acquire the learning and philosophies of the time.

For this matter to be viewed in its proper perspective, something must first be said of the political development of Ismāʿīlism amongst the Arab communities. Towards the end of the third century of the Hijra (about the beginning of the tenth century A.D.), the grandson of that ʿAbd Allāh ibn Maimūn al-Qaddāḥ already mentioned as the founder of Ismāʿīlism appeared under the name of ʿUbaid Allāh amongst the Berbers

of North Africa with the claim that he was a descendant of Fāṭima, the Prophet's daughter. The way had been prepared for him by propagandists using Ismā'īlī methods and doctrines as a screen for the political ambitions of their leader, who now proclaimed himself to be the Mahdī. Within a relatively short time he made himself master of the Maghrib and became the first caliph of the Fatimid dynasty. The fourth of that line put the family in possession of Egypt, which remained in their hands until Saladin deprived them of it.

The sixth Fatimid, who reigned over Egypt and Syria under the title of al-Ḥākim, was a strange character who could be murderously cruel and at the same time a generous patron of the arts. He is usually described as insane by the Muslim historians, but he applied method to his pursuit of power. When he was proclaimed by two Persian Ismā'īlīs to be the incarnation of God on earth he encouraged the idea, which naturally caused offence to the more piously minded Cairenes. One of the two propagandists, a man named Darazī, fled to Syria, where he continued his mission among a section of the inhabitants of the Lebanon and Palestine who are known after him as the 'Druzes' and continue to believe in the divinity of al-Ḥākim.

The Persian genius for intrigue and the secret diffusion of occult doctrine was displayed in its most dramatic form by that sect of the Ismā'īlīs which achieved notoriety in the annals of the crusades under the name of Assassins. Like war to modern statesmen, murder was to them an extension of political argument, but it was not the only or even the chief means of persuasion they used. Indeed, to regard the Ismā'īlī Assassins just as brutal and bloodthirsty 'gangsters' is to misunderstand their motive, which was, in a politically unsettled world, to introduce what they regarded as the stable system of the Imāmate with its principle of established authority.

The founder of the sect was Ḥasan-i Ṣabbāḥ, an emissary of the Fatimids and a native of Persia, to which country his father

had emigrated from the Yemen. His 'New Propaganda' seems to have been designed to divert the loyalty of Ismā'īlīs from the older leaders to himself. In A.D. 1090 he got possession of the rock-fortress of Alamut, near Qazvin, and from there he carried on his secret campaign until he had built up solidly organized bodies of adherents in Persia, Mesopotamia, and Syria. It was at this time that the rivalry of the Seljuk Sultans (who were strict Sunnīs) with the Fatimid caliphs of Egypt made the crusades possible, and the 'Old Man of the Mountains', who created such terror amongst the European warriors, was the chief of the Syrian Ismā'īlīs. Now, as has been indicated, Ismā'ī-lism was a cultural as well as a political movement. One year after the Fatimid conquest of Egypt came the foundation of the mosque al-Azhar, which developed, as the need grew to equip emissaries with learning, into the university *par excellence* of Islam. It has changed its character in the course of its history, but in Fatimid days, when it became established as a place of learning, there was close connexion between the exponents of Fatimid doctrines and the philosophers of the Ismā'īlī move-ment, many of whom were Persians, as, for example, Abū Ya'qūb of Sistan, Abū Ḥātim of Ray, Nāṣir-i Khusrau (the Persian 'Faust'), and Ḥasan-i Ṣabbāḥ himself. The historian Juvainī, who accompanied the Mongol forces which stormed Alamut, found large quantities of books in the fortress, as well as astrological and alchemical apparatus.

The intellectual activity which this implies is now reliably connected with the work of the group of encyclopaedists known as 'the Brethren of Purity' (*Ikhwān al-Ṣafā*). At the time when the Fatimids were consolidating their dominion in Egypt and the Ismā'īlīs actively propagating their teachings in Khurasan, the encyclopaedists from their centre at Basra were elaborating a 'secret religion for the enlightened man'. They expounded it in a series of Arabic treatises dealing with the concrete and abstract constituents of the universe in a mixture of Greek

philosophy, gnosticism, and the dualist conceptions of Iranian religion. These treatises were regarded by the adherents of Ismā'īlism as 'glorious' fountains of illumination, a title which indicates the place they held in what orthodox Islam regarded as a gross heresy.

Curiously related to the political organization of the Fatimids, and the Ismā'īlīs generally, was the practice of men following the same trade or craft of grouping themselves about a shaikh or senior who acted as their spokesman and was in some measure answerable for them to the ruling authority. Such groups were not completely identical with the guilds of medieval Europe because of the religious or even mystical element included in the conditions of membership. But we learn that a semi-religious body like the Carmathians, who came to be merged into the Ismā'īlīs, was largely composed of fellahin and craftsmen. The organization of such bodies was greatly elaborated under the Fatimids, in whose time the custom of reserving whole bazaars for particular wares was extended throughout the Muhammadan world.

From their very nature it was inevitable that the guilds should claim Muhammad the Prophet as their founder. Next to him in the chain of authority came the Imām 'Alī and then the peculiar patron of all guilds, Salmān Pāk the Persian, who was the Prophet's barber. Immediately under him stands the elder (Persian *pīr*) or ancestor of each individual trade-group. Salmān Pāk is also regarded as the patron of an order of knighthood (*futuwwa*), of which the most illustrious member was the Abbasid caliph al-Nāṣir (A.D. 1180–1225). Members of the order wore a distinguishing costume, of which the most notable part was a pair of breeches, in general the dress of the Persian, as opposed to the Arab skirt. The drawing on of these garments seems to have been the culmination of the ceremony of induction into the order.

Something of the extent of the membership may be gathered

from the journals of the Spanish poet and traveller Ibn Jubair, who, while on a pilgrimage to Mecca, seized the opportunity of visiting some of the cities of Egypt and Syria. He found that at Damascus and other Syrian towns the Sunnīs were outnumbered by the 'heretical' Shī'a, who were composed of various sects—Rāfiḍīs, Imāmīs, Zaidīs, Ismā'īlīs, Nuṣairīs ('These are mis-believers who attribute godhead to 'Alī'), and others. Chief amongst the sects was that of the *Nubūwīya* ('Prophetists'), 'Sunnīs who are supporters of the *futuwwa*.' Those who achieved distinction in the order were given the breeches to wear. An early stage in the development of the group is perhaps referred to by the historian, Ibn Qutaiba of Merv (A.D. 885), who, when speaking of chivalrous conduct, quotes a tradition of the caliph 'Umar to the following effect: 'Wear loin-cloth, cloak and sandals [i.e. Arab dress]. Throw away top-boots, girth and stirrups and mount your horse at a bound. Let luxury and Persian costume go and never wear silk.'

Still another section of Arab-Muslim society with which the name of Salmān the Persian is connected is that of the dervishes. Though the word *darvīsh* itself has an Iranian origin, it would be going far beyond the limits of this essay to trace the part played by Persia in the history of the movement. It must suffice to indicate the fact that amongst dervish orders the best-known (e.g. the Qādirīs and Mevlevīs) had founders whose connexions with Iran were especially close.

REUBEN LEVY

# CHAPTER 4

# PERSIA AND INDIA AFTER THE CONQUEST OF MAḤMŪD

In the course of history the influence of Persia on India has proved stronger than that of India on the Iranian countries. The Afghan mountains and the desert belt of the Thar separating the Indus Valley from India proper formed a buffer area, inhabited by warlike tribes whose cultural life was always more or less dependent on the predominant neighbouring high civilizations, Indian, Greek, Persian, or Muslim. But this belt likewise isolated these civilizations from one another so much that direct cultural contacts depended on specially favourable political circumstances. As the political history of this part of Asia was primarily determined by the periodical invasions of central Asian nomads into Iran and India, and as these nomads came under Persian influence before reaching India, their successive conquests of India amounted to so many waves of Persian influence. Because this influence was forced on the Indians, it met considerable resistance and was absorbed or eliminated time and again in the homelands of Hindu civilization east of the desert belt. On the other hand, the resistance to Persian supremacy of the central Asian tribes, the Scythians, Bactrians, and later the Turks and Tajiks, offered some opportunity for an Indian cultural expansion through Afghanistan into the Amu Darya and Tarim basins. There, mixed with the provincial Iranian tradition, Indian ideas and innovations could now be absorbed into the high civilization of Persia.

The prehistoric pottery of north-western India and south-eastern Iran shows closely related types which, however, are older than the times to which our concepts of Indian or Iranian civilization can be applied. The first wave of Iranian influence,

the Aryan immigration, followed in protohistoric times (*c.* 1200–
1000 B.C.), and we know practically nothing certain of its
influence on Indian art. The monuments of that period seem to
have been erected mainly in wood and clay, and thus have
perished; the few archaeological finds (swords, axes, lance-
points, &c.), which may be ascribed to this period, suffer from
the lack of a sufficiently reliable chronological basis with which
only future excavations, such as those planned by Dr. M.
Wheeler at the Bala-Hissar of Chārsada, may provide us.

The second wave coincided with the rise of the Maurya
Empire which in many respects had been inspired by the model
of the Achaemenian and Macedonian kingdoms. Maurya court
art was evidently indebted to Achaemenian art, most probably
through architects and sculptors who had found a refuge from
the ruin of Achaemenian civilization at the court of Pata-
liputra, and who were employed because large-scale building
and sculpture in stone were then a novelty in India. However,
these Achaemenian prototypes were never taken over slavishly;
rather, they modified already existing Indian forms which can
be understood only in the light of Indian tradition. And with
the disintegration of the Maurya Empire these Achaemenian
elements were completely absorbed into the national folk
art evolving under the Śunga and Āndhra dynasties. Dur-
ing the Parthian occupation Hellenistic art began to change
over into the 'Gandhāra' style which is regarded by several
prominent scholars less as a 'Graeco-Buddhist' than as a
parallel east-Iranian development flourishing mainly under
Scythian and Kushāna rule. However, in Kashmir a pure
Parthian art survived up to the early Gupta period (3rd–4th
century A.D.) as is proved by the Buddhist ruins of Harvan.

Then the Scythian invasions, which wiped out the Graeco-
Bactrian and Indo-Greek kingdoms, introduced another set of
foreign elements, related more to the north Iranian than to the
Achaemenian tradition. So far only a few monuments have

PLATE 13

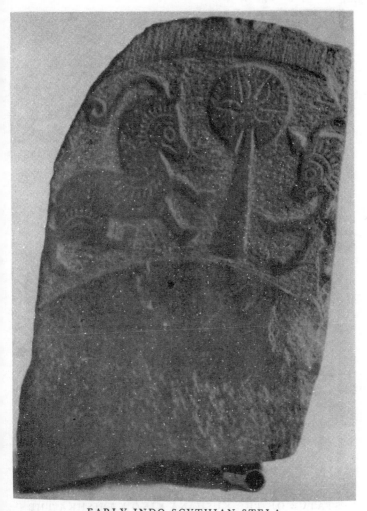

EARLY INDO-SCYTHIAN STELA
with degenerated Achaemenian motifs. *ca*. 80–100 B.C. Found at Salād, Baroda
District, Gujarat. Baroda Museum

PLATE 14

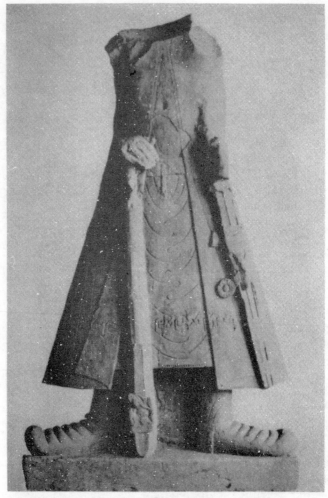

STATUE OF THE KUSHĀNA KING KANISHKA THE
GREAT
2nd century A.D. Mathurā Museum

been traced. A 'Siberian' plaque has been found on the North-west Frontier. A small stela with degenerated Achaemenian motifs (first century B.C.) was discovered at Salad in Baroda district, Gujarat, and a grinding-stone of related type at Kar-wan, some miles farther to the south. Silver bangles ending in dragon, lion, or bull heads similar to those in the 'Oxus Treasure' are common in Gujarat and a great part of Rajputana even today. Statues of Kshatrapa and Kushāna kings and princes in Scythian costume, pointed caps, or armour have been found at Mathura, Bheraghat, and other places, and a similar small bronze with inlaid silver was discovered not long ago. Figures in Scythian costume on the Śaka, Kushāna, and even early Kashmīrī coins are well known. Others appear in the Gandhara reliefs; for example, the gods Pancika, Farro, or Mihira. But the accompanying female figures always wear Hellenistic-Greek or Indian costume.

The zenith of Indo-Iranian cultural contact was reached in the Gupta period. In the third century A.D. the Sassanians had controlled even Malwa in central India, later one of the centres of Gupta power. Thus Sassanian motifs and techniques contri-buted much to the making of classic Indian art. The sun temples of the Magas were common from the sixth to the eighth cen-tury, the Sūrya image from Chamba (eighth century) is half Sassanian, and the Scythian boots remained a characteristic of the sun-god Sūrya, even when his image had become completely Indianized. Parallel with this Iranian cultural penetration into India went a similar Indian influence on the Iranian world. Since Aśoka's reign Buddhism had penetrated into central Asia, and in the Kushāna dependencies of the Sassanian Empire Buddhism and Buddhist art outweighed the official Zoroastrian cult and art. Many of the new motifs now occurring in Sassa-nian art, for instance, the peacock dragons, cocks, and spiral creepers, are of purely Indian origin, and the latest discoveries of Gupta coinage show also that certain iconographic types,

such as the king receiving a ring from Ormuzd, or the 'St. George' motif, are of Indian origin.

With the Hun, Gurjara, Turk, and Arab invasions this fertile contact was interrupted. Echoes of Sassanian and central Asian art can, however, be traced in Rajputana up to the sixteenth century. Sassanian coinage had become common in Afghanistan and the Indus Valley. It lingered on until the eleventh century, becoming more and more degenerate, in Kashmir, Rajputana, and Gujarat, though on the later 'Gadhaiyā' coins little more than a number of dots remains to indicate the royal head and the altar which had still been easily discernible on the Hun coins. The sun cult was absorbed into Vaishnavism with the end of the Pratihāra dynasty (later tenth century). Since the tenth century at least the official art of north-western India had again become purely Hindu. But at the same time the folk art was bringing to the surface other Iranian or central Asian motifs, the horseman stela (*pāliyā*), the plaitwork ornament, the spiral creeper with figure fillings, the heraldic tree, the *hansa* in Sassanian stylization, the hip ornaments on animal figures, &c. In the final stage Rajput art, though Hindu in its conscious subjects, must be classified as Iranian from a stylistic point of view. The simple geometric masses, the plain surfaces, and the organization, by incised lines, of Rajput sculpture—of which the elephant statues of the Mughal palaces of the sixteenth to seventeenth centuries merely represent an offshoot—are identical with the treatment characteristic of both Kushāna and Mongol-Persian sculpture. So, too, in Rajput painting, the geometric composition and sweeping outline, the flatness and simple contrasts of colour, and the chaste romantic atmosphere are all more characteristic of the Iranian than the Hindu tradition. Rajput industrial art until the end of the sixteenth century preserved the types known already from the early Śaka coins.

This strong Iranian strain in Rajput art is to be explained by the fact that many of the Rajput clans were driven from Afgha-

PLATE 15

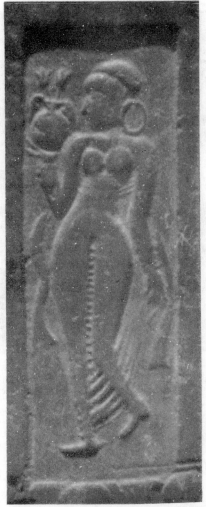

FEMALE FIGURE FROM HARVAN,
KASHMIR

Early 4th century A.D. Mould-impressed relief
on floor tile; local survival of Parthian art

PLATE 16

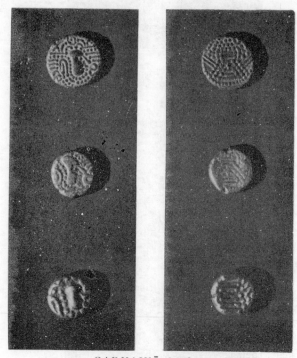

### GADHAIYĀ COINS
Degenerated imitations of Sassanian Coins, Rajputana, 8th–11th
centuries A.D. Baroda Museum. (Obverse and Reverse)

nistan into India, first by the central Asian-Turkish advance to the Hindukush in the sixth, and then by the Muslim conquest of Afghanistan in the seventh to tenth centuries. So far as the excavations made at Mansura-Brahmanabad and Manfuza permit us to infer, the Arab conquest of Sind introduced the Abbasid style into India. The throne of the Rajas of Pugal (Bikaner), said to have been saved by the Bhātī Rajputs from Ghazni, also shows a mixture of Sindi and later Abbasid ornaments.

Of Ghaznavid art in India we know nothing. The residence of the later Ghaznavids at Lahore has not yet been discovered, even if it should ever be possible to trace the ruins of buildings probably executed merely in sun-dried bricks, plaster, and wood. The towers of victory of the great conqueror Maḥmūd (998–1030) and of Mas'ūd III (1089–1114) at Ghazna belong to what is commonly called the 'Seljuk' tradition, which, however, actually began to develop earlier, under the Samanids, and underwent marked changes in the course of Seljuk rule. These towers, with the stellate cross-section of their central shaft, their lambrequins and conic tops, imitate the 'tent' type so characteristic of many other buildings of the same period, from the Gumbaz-i Qābūs at Jurjan (985) to the tomb towers of Rasgat, Maragha, Radkan, Damghan, Ray, Demavend, Veramin, the fine mausoleum of Mu'mīna Khātūn at Nakhtshewan, and finally Bustan (end of the thirteenth century), and their echo in the fluted *minār* of the Ṣāḥib 'Aṭā Masjid at Konia (thirteenth century), &c. But in the ornamentation, especially the arcades and flower arabesques, India's (Solanki-Gujarati) influence is felt first in Maḥmūd's sarcophagus, then in that of Mas'ūd I (1030–40), and again in the monuments of the later Ghaznavids. This influence, however, is completely absent from the famous door-wings from Maḥmūd's tomb, which for some time were claimed as those of the famous temple of Somnāth-Pāttan in Gujarat. Other early Muslim motifs can be traced

only by their echoes in the Rajput art of the Panjab-Himalaya, especially heraldic lions with hip ornaments and spiral creeper-bands very reminiscent of European 'Romanesque' art.

The last monument of this 'Seljuk' style is the famous Quṭb-Minār at Old Delhi, begun in 1199 under Sulṭān Muḥammad Muʿizz al-Dīn Ghōrī, completed under Sulṭān Īltutmish (1210–36), and repaired under Aʿlā al-Dīn Khiljī (1296–1316), Fīrūz Shāh (1351–88), and Sikandar Lōdī (1503). Because in its construction blocks of an earlier temple were used with masons' inscriptions mentioning the famous Chauhān prince Prithvī Rāj III (1170–91), the Quṭb-Minār has been claimed as a Hindu monument. But the other inscriptions, the stellate ground plan, and the conic elevation prove it to be the last, biggest, and finest elaboration from the earlier Ghaznavid towers and Seljuk-Persian mausolea and lofty minarets. Its stalactite balconies and inscription friezes, comparable to those of the Al-Aqmar Mosque (1155) at Cairo, or the Khwāja ʿĀlam Minār (end of the thirteenth century), belong to the best that Indo-Muslim art has ever produced. In the oldest part of the adjoining Quwwat al-Islām Mosque, however (begun 1191, extended 1198, 1229, 1315), Hindu features are in fact strongly in evidence. It was begun earlier than the Minār when Muslim or Muslim-trained masons were still hardly available. Thus for the court the enclosure of a Jain temple was used, and not even sufficient care was taken to destroy all its 'idolatrous' sculptures. Only a screen of 'Muslim' arches (constructed according to the Hindu corbelling system, however) was placed in front of the principal prayer-hall. The calligraphic friezes, somewhat clumsy, were laid out on a background of pure Hindu motifs. These Hindu elements continued to form a part of Indo-Muslim art until the sixteenth century, but were completely integrated thanks to the common central-Asian origin of many Muslim-Persian as well as Hindu ornamental motifs.

The Seljuk and then the Mongol invasions weakened the

PLATE 17

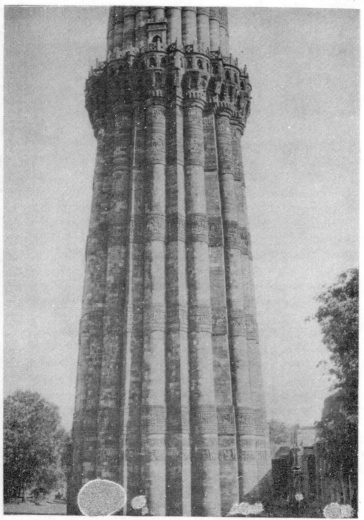

QUṬB-MINĀR
minaret of the Quwwat al-Islām Masjid, Lāl Kōt, Old Delhi, A.D. 1193–99,
repaired A.D. 1368, 1503, and in the last century

PLATE 18

MAUSOLEUM OF SULTĀN FĪRŪZ SHĀH TUGHLUQ

direct contact of the Indian sultanate with the rest of the Muslim world, but also drove numbers of refugees to Delhi. As a result, the art of the early Delhi sultanate followed that of Iran with a certain time-lag. On the other hand, the double pressure of the Mongols from the west, and of the Hindus from the south, enforced a militarism which in due course exploded in the conquest of almost the whole of India. This militarism was to give to military architecture an excessive influence on civil and religious art also. And the conquest in its turn created a 'colonial' mentality which looked with contempt on all things Indian and excluded, for the time being, a further influx of types and concepts from Indian art.

Until the end of the Khiljī dynasty (1320) the Ghaznavid tradition retained its predominant position in India, though more and more shot through with later Seljuk innovations. The 'Arhāī-Dīn-kā Jhomprā' Masjid at Ajmer, built by Quṭb al-Dīn Aibak in 1200, varies the scheme of the Quwwat al-Islām at Delhi in a somewhat richer manner. The colonnades again go back to a Chauhān Jain temple. But the screen has trifoliated or cusped triangular arches such as were used already in the eleventh century in the Masjid-i Jāmi' at Isfahan, and in richer variations in Seljuk Asia Minor or Ayyubid Egypt. Also the stellate ground plan of the corner buttresses (which do not taper) and of the quoin turrets recurs in Seljuk Konia—for example in the minaret of the Ṣāḥib 'Aṭā Masjid. Iltutmish's mosque at Badaun (1223), and even more the screen of his extension of the Quwwat al-Islām at Delhi (1229), stand very near to the later Seljuk mosque type of the Mustanṣirīya at Baghdad (1232); like the early Iranian mosques, the Badāun Masjid still retains two wings with many pilaster-supported naves; other common characteristics are the broad reduplicated keel-arch squinches and the flower cusps along the ogival arch of the *miḥrāb*, the first motif being traceable, for instance, at Gulpaigan in Persia or at Kazan, the latter at Safed Bula in

Turkistan and at Konia (1155). The last, 'baroque' phase is reached with the A'lā'ī-Darwāza (1311), the south-eastern entrance of A'lā al-Dīn's extension of the Quwwat al-Islām, and the Jamā'at-Khāna (then only the central hall), originally intended as the tomb of the saint Niẓām al-Dīn Auliyā, built by A'lā al-Dīn's son Khiẓr Khān (1325). Fundamentally both go back to the still rather simple Samanid mausoleum type, a cube with a low central dome and a high entrance between lower windows. However, their decoration achieved the utmost richness, comprising at once most beautiful Muslim and numerous Hindu motifs, for the first time executed in red sandstone inlaid with marble slabs. The ogival arches are now all of the rounded type, set with small, often reduplicated flower cusps, and supported by engaged columnets with half-Hindu bases and capitals; the miniature arches of the dome drum (an eleventh-century innovation) are also cusped. The Assyrian step-type of the 'kanguras' has now been transformed into a sort of flower frieze, parallel to the Iranian development. On the court side the A'lā'ī-Darwāza opens in a double trefoil arch supported by fine columnets of Hindu (Pratihāra) type, whereas the pent roof was to be carried by complicated Hindu corbels. This new invasion of Hindu ornaments was probably a result of the intensified building activity inspired by the conquest of India which necessitated the renewed employment of Indian masons.

As a matter of fact the tomb type was slow in developing. The mausoleum of 'Sultān Gharī', Sultān Īltutmish's son Nāṣir al-Dīn Maḥmūd (1231), governor of Bengal, is to a considerable extent built of Hindu spoils, its underground funeral chamber is covered by Hindu slab ceilings supported by rather plain Hindu columns, and the *miḥrāb* stands under a Gujarati corbelled dome. Only in the enclosure, especially its arches, do contemporary Persian forms predominate. First the supposed mausoleum of Īltutmish (1210–35) takes up the Samanid type already mentioned. Though no inscription mentions its owner, its site and

PLATE 19

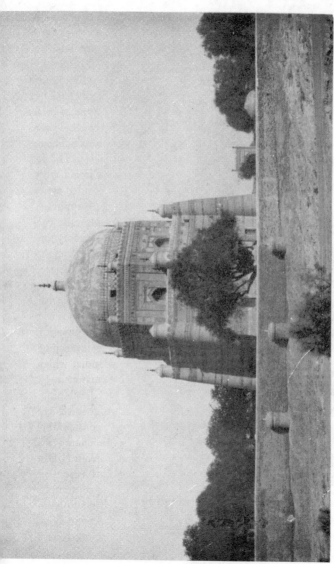

TOMB OF SHĀH RUKN-I ʿĀLAM, MULTAN

A.D. 1320–24

PLATE 20

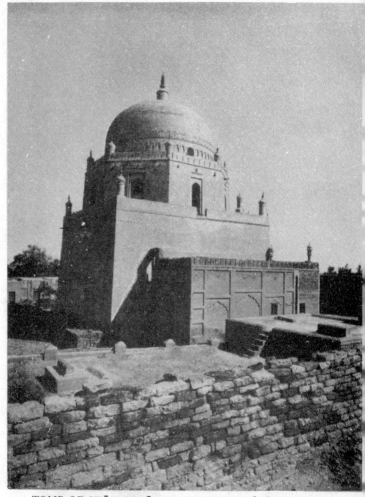

TOMB OF SHĀH BAHĀ' AL-ḤAQQ ZAKARĪYĀ', MULTAN
Erected under Sultān Balbān (A.D. 1264–86)

*décor* stand in so close a connexion with that sulṭān's extension of the Quwwat al-Islām that there is no reason to doubt its traditional attribution. The decoration of this tomb still preserves many Ghaznavid features, such as the flowered Kufic friezes, already in degeneration (in Ghazna first under Sulṭān Ibrāhīm, 1059–99), the Jain *torana* arcades, cusps of a still undeveloped type, and the Assyrian 'kanguras' along the roof. Its dome, which has disappeared, must have been depressed (the inside was of a Jain-Hindu type, as fragments prove), as in Sulṭan Sanjar's tomb at Merv, or in the A'lā'ī Darwāza; not of the sugar-cone type (as reconstructed by J. A. Page), which does not appear until a century later in Uljaitū Khudābanda's mausoleum at Sultaniya. A'lā al-Dīn Khiljī's tomb in his madrasa near-by was never completed, but it would probably have looked very much like his mosque entrance. We must regard the mausoleum of Jām Niẓām al-Dīn of the Samma dynasty, at Thatha in Sind (1508), as a last echo of the same type.

With the Tughluq dynasty (1320) the style of architecture changed completely. Since the dangerous Mongol attack on Delhi in the early years of A'lā al-Dīn's reign, the technique of fortification had developed by leaps and bounds, as the capital grew with the expansion of the empire and the influx of the accumulated treasures of India, and as new sub-towns—Siri, Jahānpanāh, Tughlaqābād, later to be followed by the Killa-yi Firōza, Dinpanah, Shahjahanabad, and others—were added and fortified. Megalomania inspired gigantic building schemes, whereas hurried execution and, in the end, dwindling resources no longer permitted that laborious wealth of decoration which even A'lā al-Dīn had still encouraged. The new type of building showed tapering walls, resembling the fortifications, but permitting also a careless workmanship of rubble work in lime-mortar lined only with dressed stones, whereas their decoration was achieved by means of an intarsia of variously coloured, mainly white or black, stone slabs. Individually the ruins of Tughlaqā-

bād, 'Ādilābād, Bijai Mandal, &c., do not show much of interest. Bijai Mandal palace had a 'Thousand Pillar' hall, of which little remains but the foundations. Ghiyāth al-Dīn's tomb, formerly lying on a fortified island in a tank held by the bund of 'Ādilābād, still conserves the cube type, though with tapering walls. But the centre of each façade is emphasized, the dome rests on an octagonal low drum, as in the Gulpaigān Masjid, or Jabal-i Sang in Kirmān, and follows the lofty, slightly pointed outline of that of Uljaitū Khudābanda at Sultaniya which was constructed only a few years earlier. Inside, too, there are innovations: the intersecting vaulting, in Persia first tried in the late eleventh century, and fully developed in the early fourteenth, is now used, and the arches have grown from the rounded ogival to the keel shape.

Of the other arts of that time we know as yet almost nothing. To judge from later indications, painting seems to have followed what is commonly called the manner of the 'Baghdad School' of the thirteenth century. Professor Norman Brown suspects also some influence in the style of the Jaina paper manuscripts of the Kalpasūtra. And of the industrial arts we can trace some faint echoes in Rajput art, though it is probable that with the progress of research certain works now classified as Persian will turn out to have been Indo-Muslim.

The breakdown of this 'colonial imperialism' in the reign of Sultān Muhammad Tughluq (1324–51) also inaugurated a revulsion from the art of the hated régime. This revulsion, however, did not assume a homogeneous character.

In Bengal and Gujarat it found expression in a completely new style, an adaptation of the local Hindu art tradition to Muslim purposes and ideals. The room conception, the ogival arches, and the domes were Muslim, but all the rest was taken over from Hindu tradition, expurgated, of course, of all idolatrous elements. But as, in Bengal, a heavy brick architecture with slightly curved 'bangaldār' roofs predominated, while in

PLATE 21

TOMB OF SHĀH SHAMS-I TABRĪZ, MULTAN
erected *ca.* A.D. 1300, redecorated in the early 19th century A.D.

PLATE 22

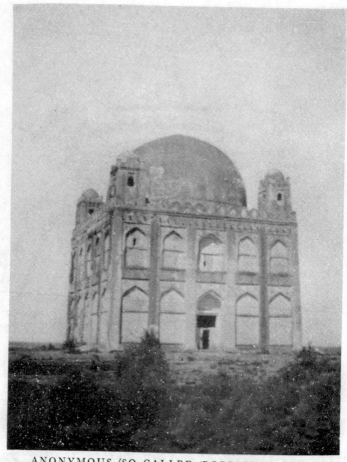

ANONYMOUS (SO-CALLED 'ROBBER'S') TOMB
End of the 14th century A.D. Gulbarga

Gujarat the brisk stone technique of the Solankīs, Vāghelās, and their Jain middle-class successors form the basis, these two styles appear very different from each other, though many decorative details are identical. In Gujarat the Persian element proved stronger. True, even the exterior of most domes only appeared Muslim, for inside, the pure Solankī-Vāghelā corbelled ceiling with its beautifully carved successive stone circles was used. But at least there are a few mausolea of the pure Samanid-Tughluq type, for instance, the tombs of A'ẓam and Mu'aẓẓam Khān (1457?) between Ahmadabad and Sarkhej, and of Daryā Khān (1453) at Ahmadabad, and finally a nameless one to the east of Champaner (on which again the Makāī Kothārs at Pāwāgadh are copied). The Ahmadabad painters also continued the 'Baghdad School' style of Tughluq Delhi, though with some admixture of Gujarati Jain and Hindu elements. Of Bengal we know nothing, except that early in the sixteenth century the manner of the great Bihzād had already been accepted. Printed cotton textiles from Gujarat with Hindu designs have been discovered in Egypt, glazed pottery under Persian and Timurid influence has recently been unearthed in 'Ādilābād and Gujarā; but otherwise we know absolutely nothing of the decorative arts.

In the Deccan a similar development was not possible, as the Bahmanī sultanate formed the Muslim frontier march against the aggressive Hindu imperialism of Vijayanagar. On the other hand, no direct conflicts with Persia could happen, whereas immigrants from Persia and Turkistan were received with open arms. Thus Bahmanī art turned for its inspiration to contemporary Persia, so much so that it must be regarded as an integral colonial offshoot of the latter. Only the small tomb of the founder of the dynasty, Ḥasan Ẓafar Khān, still adheres to the Tughluq tradition. Thereafter all the royal and aristocratic tombs at Gulbarga and Ashtur near Bīdar are of the Persian type of the later fourteenth century—a cube having, as a rule, two stories

of blind niches and a somewhat more than hemispheric, slightly pointed dome on an octagonal drum which, inside, rests on squinches varying from the double keel-arch to a composition of keel and ogival arches, or even trifoliated keel or horse-shoe arches. The finest of the tombs are those of Fīrūz Shāh (1422) at Gulbarga and that of Aḥmad Shāh Walī (1436) at Ashtur, the latter adorned with a beautifully painted ceiling. The Jāmi' Masjid of Gulbarga (1367) has been said to have been modelled on the Great Omayyad Mosque at Cordova, but it actually goes back, probably via a lost Delhi link, to the Masjid-i Jāmi' of Isfahan. The madrasa of the Timurid period is represented by that of the all-powerful Prime Minister Maḥmūd Gāwān (1471) at Bīdar, completely decked with encaustic tiles. The high and slender Persian minaret can be studied in the Chand Minār at Daulatābād (by A'lā al-Dīn Shāh Aḥmad, 1436) and Yūsuf 'Ādilshāh's gateway and *minār* at Shāh Roza, Gulbarga. The Persian palaces, with their broad *īwāns*, survive in the ruins of the Takht Mahal, Gagan Mahal, Tarkash Mahal, Chīnī Mahal, and the Turkish Sulṭāna's Palace in Bīdar Fort (most of them of the reign of Muḥammad III, 1463–82). Only in these latter, some very subordinate Hindu features are found. Of Bahmanī painting so far only a few still unpublished manuscripts are known. They imitate the style of the Ilkhānid and early Timurid period so well that they are generally mistaken for genuine Persian manuscripts, though certain Hindu features and a geometrical composition comparable to that of early Rajput painting betray their Indian origin.

In Mālwa (central India) an intermediate style flourished in the fifteenth and sixteenth centuries. The kingdom of Māndu was more involved in the affairs of northern India than in those of the Deccan, and therefore followed the later trends at Delhi; though the new influences from Persia reached it later and in an attenuated form. Thus Mālwa retained some of the earlier traditions. The *miḥrābs* in the Lāt Masjid at Dhar (1405) and of

PLATE 23

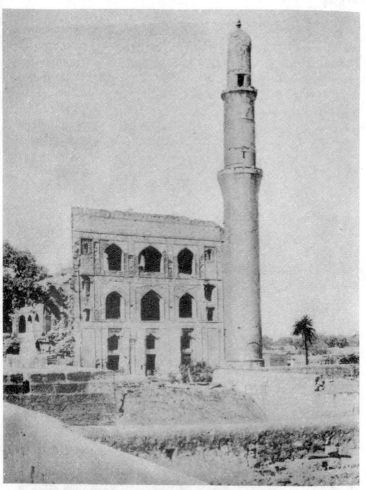

MADRASA OF KHWĀJA MAḤMŪD GĀWĀN
Prime Minister of the Bahmanī Kingdom, Bīdar, A.D. 1471

PLATE 24

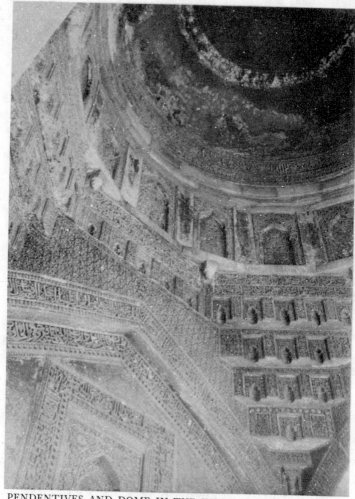

PENDENTIVES AND DOME IN THE KILLA-YI KOHRA MASJID
PURANA KILLA, DELHI

Erected by Shěr Shāh Sūrī, *ca.* A.D. 1540–45

the Jāmiʿ Masjid at Māndu (1454) still conserve the Khiljī flower cusps. The Hindola Mahal (early fifteenth century) at Māndu, like Shitāb Khān's audience-hall at Warangal in the Deccan, continue the Tughluq tradition of heavy tapering walls and buttresses. For the Jāmiʿ Masjid Syrian, Arabian, even north African models have been claimed, but, as Professor Upham Pope has proved, it too can be derived from contemporary Persian models. The tombs of Hōshang, Maḥmūd Khiljī, and Daryā Khān are, on the one hand, the last offshoots of the type established by the mausoleum of the Samanid Ismāʿīl at Bukhara, but have, on the other hand, taken over the high dome of a later age. In Malik Mughīth's mosque a pointed dome rises from a high octagonal drum, as in the Multan tombs which we shall discuss later. Persian also are the intersected vaulting system so general at Māndu, the small niches filled with a conch design, and so forth. The huge Persian *īwān* is found in the great audience-hall of the usurper Medinī Rāi ('Gadā Shāh's Shop', early sixteenth century). In other buildings, however, influences from contemporary Egypt and Palestine seem to have played a part, probably handed on by the embassy of the Amīr al-Muʾminīn al-Mustaʿīd Billāh Yūsuf, son of the caliph Muḥammad ʿAbbāsī, to Sulṭān Maḥmūd Khiljī (1436–69): bundles of columns, light pointed arches, and cusped round windows are featured, almost as in crusader architecture. Hindu elements, though in a subordinate position, are much more in evidence than in the Deccan or in the north, especially in the zenana buildings (where they seem always to have predominated), but best of all in the so-called Jahāz Mahal. The 'House of Gadā Shāh' (later sixteenth century) has preserved some figural murals which are likewise closely related to later Timurid pictorial art.

In Hindustan proper the transition was slower. This had been the heart of the Tughluq Empire, which had had no reason to detest the old imperialism. Thus the new art tendencies manifested themselves not as an expression of revolt but in

a process of slow evolution. Muḥammad Tughluq's benevolent successor Fīrūz Shāh (1351–88) was a great, though parsimonious builder, accepting many new fashions in style, but forced to execute them cheaply in poor masonry embedded in mortar, in plaster, and wall-paintings. Now that the latter are lost, his architecture looks rather monotonous. He abandoned the tapering style except for the minaret buttresses at the quoins. Instead the façades were organized more richly, the roofs covered with many domes, and Rajput trabeate galleries and door-frames taken over. His tomb is an imitation of Jabal-i Sang in Kirman. Of his other buildings we may mention his palace and mosque at Firuzabad, the Kushk-i Shikār, Hauz-i Khāss, Kālī, Khirkī, Tīmūrpura, Bēgampura, and Mehraulī Masjids at Delhi, the repair of the Quṭb-Minār, Khānjahān's mosque at Niẓām al-Dīn, and a number of other buildings at Sarhind, Badāun, and elsewhere in the provinces. Of Nāṣir al-Dīn Maḥmūd II the Lāl Gumbaz survives, after which the progressive disintegration of the dynasty and the invasion of Tīmūr put an end to further building activities.

Thus the same style-tendencies are felt much more in the architecture of the Sharqī kingdom (1394–1500), especially at its capital Jaunpur. The most characteristic feature of the Sharqī mosques is the huge screens of the façades in the axes of the chief *miḥrāb*, especially in the Jāmiʿ and Ātāla Masjids. Though their sloping buttresses represent a Tughluq heritage, their general model must be sought in Timurid Turkistan, especially the Madrasa of Ulugh Bēg and the Tilla Karī Masjid at Samarkand. The vast vaults of the lateral naves also—for example in the Jāmiʿ Masjid—must be of Perso-Turkistani inspiration.

An offshoot of the Jaunpur style is found at Nāgaur, the capital of the small Khānzāda sultanate in Rajputana. There the imitation of the high screen is very free and prejudiced by Hindu features in the Tarkīn-kā Darwāza, which resembles most the Arhāī-Kangura Masjid at Benares.

PLATE 25

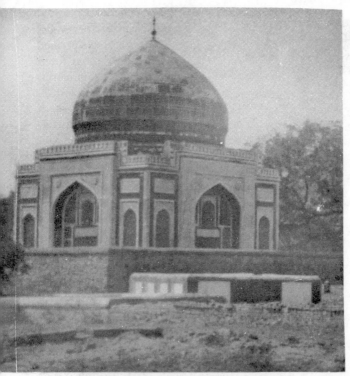

TOMB OF 'ATGAH KHĀN, FOSTER-BROTHER
OF THE MUGHAL EMPEROR AKBAR
A.D. 1567. Niẓām al-Dīn, Delhi

PLATE 26

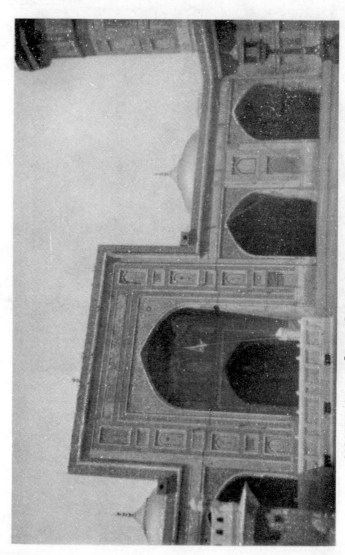

MOSQUE OF HAKĪM 'ALĀ' AL-DĪN OF CHINIOT (WAZĪR KHĀN),
GOVERNOR OF THE PANJAB UNDER THE EMPEROR SHĀHJAHĀN

The Delhi kingdom under the sultans of the Sayyid and Lōdī dynasties (1414–51 and 1451–1526) had by now become rather weak; yet the number of its monuments is not unimpressive, though this may be due to a less wholesale destruction. Most important is the group of the so-called Lōdī tombs at New Delhi (Khairpur), the mausoleum of Bahlōl Lōdī at Raushān Chiragh, the tombs of Subḥān Sulṭāna and of various nobles at Sarhind, the Chaurāsi Gumbaz at Kalpi, &c. The mausolea consist of a cube covered by two stories of blind arcades, a style which we have already seen at Gulbarga and Bīdar, or with a projecting high central entrance as in Fīrūz Shāh's tomb, crowned by a high, pointed dome first used in Uljaitū Khudābanda's mausoleum at Sultaniya (1307) or that of Sulṭān Ḥasan at Cairo; not seldom with a 'lantern' on top, as in the Masjid-i Jāmiʿ at Riẓāʾīya (1277). In Sikandar Lōdī's tomb at Delhi a new type appears, a rather low octagon surrounded by arcades serving as buttresses for the excessively vast dome. Though an octagon surrounded by arcades was used already in Uljaitū Khudābanda's Maqbara, this new form seems to be a rather free Indian interpretation, as the orthodox variety was, beyond the Panjab, introduced first by the Mughals. It went with a predilection for broad, squatting keel-arches, such as appear in Persia—for instance in the Masjid-i Gauhar Shāh at Meshed (1418)—and for Rajput door-frames, brackets, and roof *chhattrīs* derived from the contemporary revival of Hindu architecture in Rajputana. In decoration the Timurid cut-plasterwork came into fashion, especially beautiful in the small Mōth-kī Masjid at Delhi, and likewise the Timurid decoration in encaustic tiles. This latter, however, appears at Delhi only late (1517) and sparsely, though coloured tiles had been used in Afghanistan as early as the reign of the Ghaznavid Masʿūd III (1100), and in the Panjab since the sixteenth century.

There we find four important early Persian mausolea at Multan, over the remains of Shāh Bahāʾ al-Ḥaqq, Shams al-Dīn,

Shadna Shahīd, and Shāh Rukn-i 'Ālam, all covered with en-
caustic tiles and going back to the thirteenth and fourteenth
centuries, though much repaired in later times. Other, though
smaller, Persian mausolea, likewise covered with tiles, are those
of the Nahars of Sitpur in the West Panjab, and that of Shaikh
Mūsā Āhangar (Nīlā Gumbaz) at Lahore, all of Lōdī times.

In Sind we must mention the mausolea of the Tarkhān
dynasty at Thatha. Those of Nawāb Amīr Khalīl Khān (1584)
and of Dīwān Shurfa Khān (1638) might be called smaller
copies of the Gūr-i Mīr at Samarkand; that of Jānī Bēg (1599)
is an octagon with a low dome, whereas the Dabgīr Masjid
(1588) reveals Sūrī influence both in its dome and keel
arches.

The Kashmir style tended towards the West, but preserved in
its mountain isolation most archaic features. The tomb and
mosque of Sultān Zain al-'Ābidīn (1420–70) at Madani, and
that of his mother at Srinagar, though erected on the founda-
tions of Hindu temples, belong in the last instance to the Persian
tradition of Ismā'īl the Samanid's mausoleum at Bukhara. The
wooden mosques (Masjid-i Jāmi', by Sikandar Būtshikan (1390–
1414), Shāh Hamadān (1384), Pāmpur, &c., all rebuilt several
times), with vast cubic halls, pyramidal roof crowned by a spire,
and 'kanadūr' bells, are not yet explained with certainty, but
seem to represent an adaptation of an older Buddhist chaitya
type (e.g. Parihāsapure) surviving also in the Far Eastern
pagodas. Persian tile-work first appears in the Madanī mauso-
leum, but seems to be an early Mughal addition.

Under the Sūrī dynasty (1540–56/8) which temporarily ousted
the Mughals, the Sayyid-Lōdī style reached its most developed
and perfect phase, enriched by new decorative forms apparently
imported from Egypt, which had recently fallen into the hands
of the Ottoman Turks. Its finest monuments are the Killa-yi
Kohna Masjid at Purāna Killa and Shēr Shāh's mausoleum at
Sāsarām (Bihar). The Sūrī Afghans seldom used the two-storied

type of tomb, and then not with blind, but with real arcades, as in the mausoleum of Fāteh Khān at Alwar (1547) or in those of Sarhind and Maner. Generally they preferred the low, arcade-surrounded type first applied in the tomb of Sikandar Lōdī; examples are the tombs of Shēr Shāh and Ḥasan Sūr at Sāsarām and of ʿĪsā Khān at Delhi, and later, in Mughal times, that of Adham Khān at Mehrauli. The smaller Sūrī mosques continue the type of the Mōth-kī Masjid, whereas in the great Killa-yi Kohna the influence of the Deccan also is evident, especially in the corner towers, and of Mamluk-Egyptian decoration (cf. the mausolea of Sulṭān al-Nāṣir, of Aḥmad al-Mihmandār, or of al-Muʾayyad at Cairo) as already mentioned. As the dynasty was shortlived, the number of its monuments is very limited, but the Sūrī style continued late into the reign of Akbar the Great and formed one of the chief constituents of early Mughal art in India and of later sixteenth and early seventeenth century Rajput art (Orchhā, Dātiā, Amber, &c.).

In the Deccan another revolution in style was caused, first by the disintegration of the Bahmanī Empire into the sultanates of Bīdar, Berar, Khandesh, Ahmadnagar, Bijapur, and Golconda (1490–1527), and then by the collapse of the Vijayanagar Empire after the battle of Rakshasa Tagidi (Talikota) in 1565. The two events worked in opposite directions. The emergence of so many new sultanates meant an intensification of Muslim power, and a renewed immigration of military adventurers from Persia, Arabia, Egypt, and the Ottoman Empire. The fall of Vijayanagar started a mass immigration of unemployed Hindu artists, masons, painters, jewellers, weavers, embroiderers, singers, and dancers, the effect of which was felt over the whole of the Deccan and Rajputana. The first introduced the newest fashions of Persia and Turkey; the latter gave a Hindu interpretation to the existing Bahmanī-Persian art.

Thus the Persian element played a less important role in later Deccani art, though it continued to be more conspicuous

than in parallel Mughal art. Moreover, this role was very different, not only in the selection of the favoured Persian forms, but also in their amalgamation with the Hindu element. The Bahmanī tomb type was, on the whole, retained, but the wall arcades were in some cases replaced by trabeate Hindu galleries, and only rarely—for example in the old Jāmiʿ Masjid (under Ibrāhīm I, 1534–57), in ʿAin al-Mulk's mosque and tomb (1556), and later (1636) in the great Jāmiʿ Masjid at Bijapur— is the Persian dome preserved. Elsewhere the dome was always reinterpreted in a Hindu spirit, an immense bubble growing from a wreath of lotus petals, and crowned by an inverted lotus flower. In the Gōl Gumbaz (1656) this Hindu-Persian mausoleum is expanded to giant dimensions (the diameter of the dome is 124 feet, only 15 feet less than that of St. Peter's at Rome), apparently on the model of the huge mosques of Istanbul, though still preserving the original scheme first developed in the tomb of Ismāʿīl the Samanid at Bukhara. Ibrāhīm II's mausoleum (1627/8), on the other hand, stressed the galleries surrounding the central funeral chamber, as in the later Lōdī and Sūrī tombs; and its decoration was a mixture of Hindu and Ottoman-Turkish elements. The arches were first of the broad and squat keel type of Lōdī art, then changed into a double S-curve accompanied by an exterior line of cusps, such as is found, in Turkistan, at Safed Bula. A characteristic of all Deccani arches is the crowning flower which can first be traced, in the sixth century, at Bamiyan as the Pomegranate of Anahita. In the columns, brackets, roof parapets, &c., however, Vijayanagar decoration superseded all Persian traces; but it was the decoration of the Hindu house, of wood-carving, furniture, and metal mountings, not of the idolatrous Hindu temple. For this reason Hindu influence was stronger in civil architecture; but here again it was balanced by Persian ideals. Enamelled tilework was still, though seldom used, e.g. in the Chīnī Mahal at Daulatabad, the screen of which also reminds us of the Jaunpur

PLATE 27

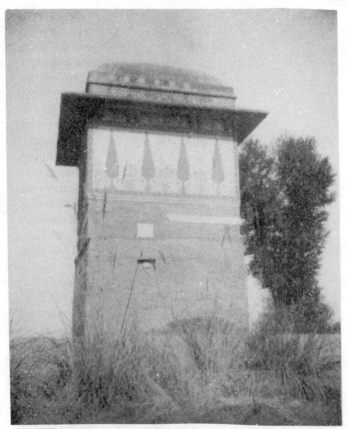

TOMB OF SHARAF AL-NISĀ' BĒGAM, SISTER OF ZAKARĪYĀ' KHĀN,
GOVERNOR OF THE PANJAB (A.D. 1719–1748)
Begampura near Lahore

PLATE 28

TOMB OF GHULĀM SHĀH KALHORĀ

*ca.* A.D. 1772. Hyderabad, Sind

mosques, or in the Bādshāh Āshūr Khāna at Golconda (1597); in the Rangīn Mahal at Bīdar, with its purely Hindu columns and brackets, it was replaced by an ebony and mother-of-pearl intarsia. But the vast Persian *īwān*, such as has become famous in the Tāq-i Khusrū and again in the Mongol and Timurid mosques and madrasas, and the Persian pillar-hall of the Chihil Sutūn type enjoyed an immense favour. The first is represented at Bijapur in the Gagan Mahal (1561), Ānand Mahal (1589), and Sangīt Mahal (1589), and the palaces of Golconda, especially the Gōsha Mahal; the latter in the Āthār Mahal (1646) at Bijapur and the Bādshāh Āshūr Khāna and later palaces at Hyderabad. It must, however, be observed that the first was not formed by genuine vaults, but merely by means of gigantic bridge arches supporting a wooden ceiling (as at Māndu, mentioned above). The earliest example of such a construction in the Deccan is the archway in the Dargāh of Shāh Banda-Nawāz at Gulbarga, erected under Fīrūz Shāh Bahmanī in 1413. Probably we may also regard the Sāt-Manzil, a watch-tower in the Bijapur palace built in 1583 by Ibrāhīm II for Queen Rambhā, as fundamentally a Persian conception.

In Deccani painting a similar conflict of tendencies is to be felt. After the battle of Rakshasa Tagidi a wave of Vijayanagar style swept over Deccani pictorial art for a decade or two, the vestiges of which we can trace in the female scenes in the *Tārīkh-i Ḥusain Shāhī*, the *Nujūm al-'Ulūm*, and several Rāg-mālās, the finest of which is in Bikaner. Later on only the weakness for excessive gilding, Hindu decorative forms, and Hindu lyric motifs remained. Figures of Hindu singers, dancers, and courtesans appear until well into the eighteenth century. But, on the other hand, sixteenth-century Persian and Turkish painting was used already in the male scenes of the same manuscripts, and in the murals of the water pavilion at Kumatgi near Bijapur (where again the female motifs are Hindu). And since the early seventeenth century the sketchy manner in fashion

under Shāh 'Abbās the Great dominated Bijapur painting until it was ousted by the Mughal style of Jahāngīr and Shāhjahān. In the Masulipatam 'pintadoes' we likewise find an odd mixture of Hindu and Persian elements, and a similar combination appears in the arms and other metal-work, and the ivory intarsia in costly wood which can be attributed to this period of the Deccan, whereas painted lacquer boxes seem to have been taken over from Persia.

With the invasion of the Mughals another and much stronger wave of Persian influence reached India. Its first phase, under the Emperor Bābur (1526–30), was of late Timurid-Turkistani character; but this period was so brief and so taken up with warfare that hardly any monuments of it can be traced. Of his capital at Agra only the Rāmbāgh survives, but nothing of its original buildings and layout. Humāyūn's mosque there (1530) is of little interest. We can thus ascertain the general character of this first period only from its echo in the paintings of Akbar's early years.

Much more important is Humāyūn's capital Dīnpanāh (between his tomb, Niẓām al-Dīn and Purāna Killa at Delhi, *c*. 1530–40 and 1555–70). It was razed by his adversary Shēr Shāh, and most of the buildings now remaining belong to the period after Humāyūn's return and of Akbar's minority, and were erected by Humāyūn's widow and the court of his young successor. As Humāyūn, after his return from the court of Shāh Ṭahmāsp, had been accompanied by Persian artists, this second early Mughal style is almost purely Persian, with the modification that Persian tile-work was not seldom replaced by the coloured stone slab intarsia practised in India since Khiljī times. The principal monuments of this later Dīnpanāh are Humāyūn's gigantic mausoleum (in red and white sandstone) with its vast Chārbāgh garden, the smaller Bū-Ḥalīma garden (with a gateway in encaustic tiles), the 'Arab Sarāy, several smaller tombs for members of Humāyūn's family, the Madrasa Khair

PLATE 29

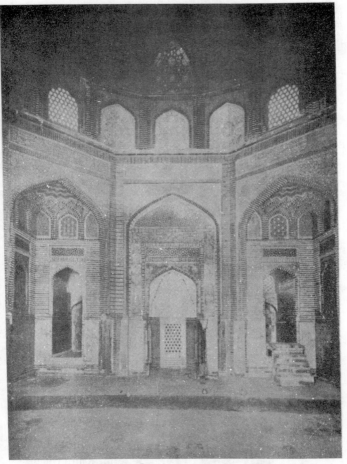

MIḤRAB OF THE JĀMI' MASJID AT THATHAH
Sind, A.D. 1644–47

PLATE 30

PANEL IN GLAZED TILES FROM THE JĀMIʿ MASJID AT
KHUDĀBĀD, SIND
executed under Yār-Muḥammad Kalhora (died A.D. 1718)

al-Manāzil founded by Māhum Ānaga (enamelled tiles and cut-stucco medallions); then the tomb of the regent Bairām Khān-khānān and, at Niẓām al-Dīn, the tomb of 'Atgah Khān (1566/7) —or, farther away, the mosque of Shaikh Abd al-Nabī (1584, near the southern gate of Shahjahanabad). Outside Delhi especial mention must be made of Akbar's mosques (in encaustic tiles) at Ajmer and Nāgaur, the Dargāh-i Ḥaẕrat-i Islām at Lahore, the tomb of Quṭb al-Dīn at Baroda (1583), the memorial tower for Humāyūn at Sarnath (1588), and some tombs at Sarhind.

In a few paintings of Humāyūn's reign and in the first great pictorial creation of Akbar's time, the *Ḥamza-nāma*, the influence of Turkistan is still evident. But under the guidance of two Persian artists, Mīr Sayyid 'Alī of Tabriz and Khwāja 'Abd al-Ṣamad Shīrīn-Qalam, early Mughal painting fell into line with the taste of Shāh Ṭahmāsp's court. The influence of the latter was also strong in textile design and carpet weaving and finally metal-work; from the time of Akbar onwards, Mughal coinage was entirely copied from that of the Safavids. But soon the art of the overthrown Sūrī dynasty was accepted, in whole or in part. Adham Khān's tomb at Mehrauli, for instance, imitates those of Ḥasan Sūr at Sāsarām and 'Īsā Khān at Delhi, with only a slight admixture of new Persian decorative motifs. The Sūrī style, however, continued to play a prominent part for at least two more decades, but it was more and more mixed with the new stylistic elements introduced since 1570 in the wake of Akbar's wide conquests and tolerant policy, and at last amalgamated into the Akbar-Jahāngīr style.

After the alliances with the Rajput princes had been concluded, Akbar came more and more to accept Indian fashions and Indian art such as they had developed at Chitōrgarh, then at Jodhpur and Orchhā, and finally at Amber and Būndī. In the Mughal architecture of Akbar's later years (since *c.* 1570–80) and of Jahāngīr's earlier reign (until *c.* 1620), at Fatehpur-Sikri,

the Red Palace at Agra Fort, Lahore Fort, Sikandra, Allahabad, Ajmer, &c., the Rajput style predominated, by the side of Sūrī, Gujarati, Mālwa, and also Persian features. Persian forms prevailed in the gateways, the arches, and vaults of the substructures, the arcades for administrative and bazaar purposes, the mosque façades, *miḥrābs*, and entrances (as in the Buland Darwāza at Fatehpur-Sikri), the cut-out wall niches and panels, and so on. Persian innovations were the slender, fluted columns with stalactite capitals and the ribbed vault nets (cf. Natanz and Masjid 'Alī, Isfahan), and many ornamental motifs (cf. again Natanz), especially the cypress, whereas enamelled tilework was used but rarely, as at Sikandra and Lahore, and then sparsely. Persian also were the caravanserais, and palace enclosures of the same type, such as those at Ajmer and Allahabad. But domestic architecture, halls, sleeping-rooms, *panchmahals*, roof pavilions (*chhattrīs*), &c., were Rajput, and likewise most of their decoration, whereas in religious art the Sūrī and Gujarati elements predominated, not to speak of other occasional influences, Far Eastern, Tibetan, and Christian. A similar change overtook painting, where the Hindu artists and European models acquired increasing influence on a style aspiring to naturalism, until early in Jahāngīr's reign all the Persian elements had disappeared.

And yet just then Persian art came back, though only as another contributory aspect of the classic Mughal art developing at the imperial court. First Sulṭān Salīm (later Emperor Jahāngīr) had fostered a minor Persian renaissance during the rebellion against his ageing father. As Akbar's pro-Hindu inclinations had become a thorn in the side of the orthodox Muslims, the rebel prince sought support from the orthodox party and affected later Safavid costumes and household fashions, and encouraged Persian artists like Āghā Riẓā. To this attitude we owe some of the finest examples of Persian brocade weaving preserved in India, e.g. the beautiful *fugal* at Bikaner. On the

PLATE 31

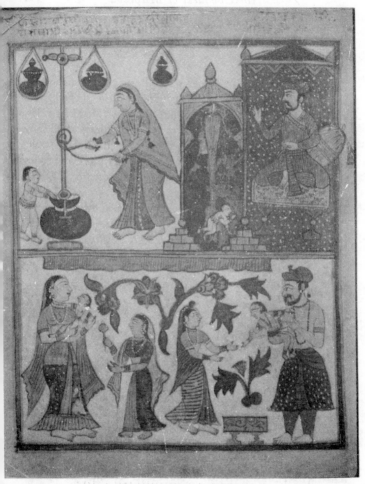

## THE CHILDHOOD OF KRISHNA

Survival of the Ahmadabad School of Painting (offshoot of the 'Baghdad School')
in early Rajput Art (Mārwār), second quarter 17th century A.D. Delhi Art Trade

other hand, the prince was in alliance with an opposition party amongst the powerful Rajput princes (Amber, Bikaner, and Orchhā), and after his accession to the throne he resumed the pro-Hindu attitude of his father.

But his empress Nūr-Jahān was a Persian, and she and her family dominated the Mughal court since the orthodox *coup d'état* of 1623 and under Jahāngīr's successor Shāhjahān. How far the fashions of 'Abbas the Great's period contributed to the introduction of the new architecture in white marble inlaid with precious stones it is not easy to say. The Empress's personal tastes, the model of the white marble architecture of Gujarat and Mālwa, even European influences must also be taken into account. This much is certain, that one of the first, still tentative, experiments in the new style, the Chaunsat Khambah (mausoleum of Mīrzā 'Azīz, son of 'Atgah Khān, 1623/4) at Niẓām al-Dīn, uses Persian columns with stalactite capitals and squat, ribbed-vault nets. Other decorative motifs, occurring as late as the twenties of the seventeenth century, can be traced at the mausoleum of Shaikh Ṣafī at Ardebil, Meshed, and the Masjid-i Shāh at Isfahan.

But in the Panjab and at Delhi and Agra Persian tile architecture flourished anew. The mosques of Wazīr Khān (1634), Dāi Ānga (1635), Muḥammad Ṣāliḥ Kumloh (Chīnīānwālī Masjid, 1659), of Nawāb Sarfarāz Khān (1671), of 'Abdullāh Khān (Takselwālī Masjid, Aurangzeb's reign), the Sadhaurā Masjid (1669) at Lahore, the Shāhī Masjid at Chiniot, the Chīnīwālī Masjid at Thanesar, the Jāmi' Masjid at Muttra (1660–1): the façades of Lahore Fort (1630–40); the mausolea of Fahīm Khān (Nīlā Gumbaz, near Humāyūn's Tomb, 1625) at Delhi, of Āṣaf Khān (1641), Zēb al-Nisā' (Navankōt, 1669), 'Alī Mardān (1657), Dāi Ānga (1671) at Lahore, the Chīnī-kā Rauza (1639, of 'Allāmī Afẓal Khān Shīrāzī) at Agra, the Gulābī Bāgh (1655), the Shāhdāra Gardens, the entrance of the Shālimār Garden (1637), the Gardens of Zēbinda Bēgam (Chauburji, 1646) at

Lahore, the Dakhinī Sarāy in the Jālandhar District (1640) are all excellent examples of this fashion.

Other monuments of the same type, though not decorated with coloured tiles, are the many Mughal *sarāys* and provincial palaces, at Bhimbar, Rajauri, Chingas, Saidabad, Sarhind, Pari Mahal (Kashmir), Ahmadabad (A'ẓam Khān, 1636), &c., and Mughal gardens in Kashmir (Chashma-yi Shāhī, Shālimār Bāgh, Nishāt Bāgh, Achhabal, Vernāg, Rajauri), Lahore (Shālimār, Gulābī, &c.), Pinjaur, Delhi (Fort Gardens, especially the Ḥayāt Bagh, Raushanārā Bāgh), Agra (Angūrī Bāgh), and so many others which have disappeared, but have left a heritage in fine later gardens at Dig, Jaipur, Udaipur, Amber, &c. In the mosques the Persian influence is not so strong; though the Jāmi' Masjid at Agra (1648), the mosque of Shujā'at Khān at Ahmadabad (1689), and others need to be mentioned here.

The most famous monument of this Persian taste, however, is the Tāj Maḥal (Rauẓa-yi Mumtāz-Maḥal) at Agra, the mausoleum of Arjumand Bānū Bēgam, Nūr-Jahān's niece, and of her husband Shāhjahān. It is a work of the finest Safavid taste, executed by two Panjabi architects of Persian origin, Nādir al-Aṣar Ustād Aḥmad Ma'mar Lāhōrī, and his brother Ustād Ḥamīd Lāhōrī. It is flanked by a mosque and a similar hall and gateway in Persian style and accompanied, outside, by two small mausolea of the same type for the Empress's ladies-in-waiting. Except for the use of the most immaculate Makrana marble which translates the gay and gaudy Persian taste into the dreamy, languid spirit of later Mughal art, there are in the Tāj Maḥal only a few other deviations from Safavid orthodoxy —the four Rajput *chhattrīs* around the dome, some differences in the proportion of the dome and dome drum (common, however, in the Deccan), and also the minarets, probably inspired by Maḥmūd Khiljī's tomb at Māndū. It is one of the freaks of history that this 'Wonder of the World', which is least charac-

PLATE 32

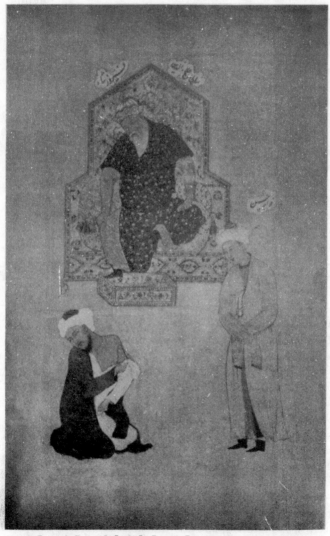

SULṬĀN 'ALĀ' AL-DĪN FĪRŪZ SHĀH OF BENGAL AND HIS
SECRETARY KHWĀJA ḤASAN. SCHOOL OF BIHZĀD
A.D. 1532. British Museum, London

PLATE 33

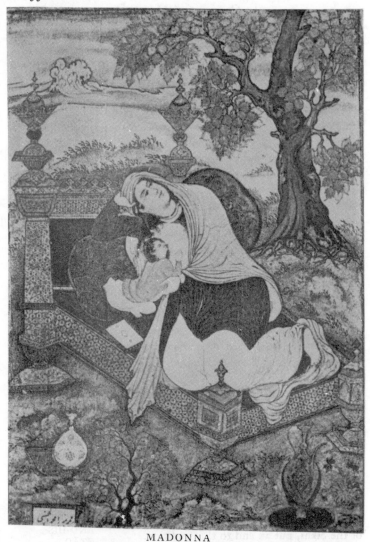

MADONNA

by Mīrzā Muḥammad al-Ḥasanī. Persian Variety of Bijapur Painting, early
17th century A.D. Boston Museum of Fine Arts

teristic of Mughal art, has become the classic representative and emblem of Mughal civilization.

The Tāj Maḥal has found a pale shadow in the mausoleum which Shāhjahān's son, Aurangzeb, in 1678 erected for his wife, Bībī Rābiʻa Daurānī, at Aurangabad in the Deccan. This has nothing of the grandeur and purity of the Tāj; its proportions are cramped, its forms marred by new stylistic elements taken over from the Deccani art of Bijapur and Golconda; but a certain homely sweetness and intimacy cannot be denied to this last representative of the great tradition of the Persian mausoleum. True, there exist two even later buildings, the gigantic tomb of Nawāb Ṣafdar-Jang of Oudh at Delhi (1754) and the Tāj at Husainabad, Lucknow. But the first is a very stiff, academic, and incongruous imitation, beautiful only in those decorative details in which it follows the taste of its own time. The latter does not even pretend to be more than a miniature copy of the Agra masterpiece.

In the Panjab and Sind this Persian style continued to prevail. The buildings and gardens of Aurangzeb's time at Lahore, which have already been mentioned, preserve the Persian type and green tile decoration then the rule, though minor details reveal an intrusion of other Mughal, and even Rajput features. The Bēgampura Masjid, constructed by the last efficient Mughal governor of the Panjab, Zakarīyā Khān (1726–45), has the same tile decoration, though under 'bangaldār' arches and pent roofs and with more baroque design motifs. The tomb of his sister, Sharaf al-Nisā (Zarūrwāla Maqbara), follows a Rajput tower type with squat roof and *chajjas*, but the tile decorations introduce a Persian design so far unknown, a frieze of large-size cypresses (such as those with which we are so well acquainted from the Persian tile decorations of Turkey). The chaos into which the Panjab was thrown by the Afghan invasions, and then the rise of the Sikhs, put an end to this tradition.

In Sind, however, cut off from the rest of the Indo-Muslim

world by the Sikhs and Rajputs, Persian art experienced a last renaissance. The mausolea at Thatha of the last Tarkhāns (tolerated as Mughal governors) were executed in the mixed style of Akbar's later reign (tomb of Mīr Ma'ẓūm 1594, Mīrzā 'Īsā Khān 1644, Mīrzā Tughril Bēg 1686). But under Jahāngīr and Shāhjahān the Persian style of encaustic tile work was again introduced from the Panjab (mosque near Mīr 'Abd al-Bāqī Pūrānī's tomb at Sakhar, 1610; and Jāmi' Masjid at Thatha, 1644–7, enlarged 1658–9), and it flourished at Khudābād, Hyderabad, Larkhana, Sakhar, Matiari, and Drakhan under the Kalhōra and Tālpūr dynasties. The Thatha mosque resembles that of Wazīr Khān at Lahore, the Jāmi' Masjid at Khudābād that of Dāi Ānga at Lahore. Most of the later Sind tombs repeat the cubic Gulbarga–Ashtur–Delhi (Lōdī) type in greater dimensions and very gaudy colours; only a few take up the octagonal ground plan (e.g. Nabī Khān's tomb at Hyderabad, 1787, or Shāh Baharo's tomb at Larkhana, 1735–6) or the top lantern of the Lōdī domes (Larkhana and Sakhar).

As Afghan rule conserved at least some stability in the Western Panjab and Kashmir until the end of the eighteenth century, a last wave of Persian fashions in architecture, painting, textiles, and dress gained some influence in Kashmir and can be traced in the style of house building, the numerous Persian manuscripts, embroideries, and lacquer wares which in the nineteenth century were fabricated there under the successful administration of the Maharajas Gulāb and Rānbīr Singh of Jammu. About 1760 Perso-Afghan fashions in costume were accepted also at the court of Shujā' al-Daula of Oudh and about 1830 at the imperial court of Delhi, now a mere pensioner of the British East India Company. For the Mughal costume of the seventeenth and eighteenth century had by now become a Hindu dress, and in order to distinguish themselves from the Hindus, the last Mughals accepted the Perso-Afghan style. At Lucknow, Bhopal, and Hyderabad (Deccan) this fashion was

soon Indianized and given an extravagant shape, and the fur-lined Persian *kulāh* was transformed into a half-European crown (*tāj*). Persian architecture found some cultivation only at Hyderabad, Deccan, which until recently was felt to be the last protagonist of Islam in India; pillar-halls especially of the Chihil Sutūn type were repeated until early in the nineteenth century.

But elsewhere the Persian tradition was more and more swept away by a current of Hinduized Deccani and pure Hindu aesthetic ideals, a current which grew stronger as the Deccani sultanates and their aristocracy were incorporated into the Mughal Empire—especially under Shāhjahān (1628–59) and Aurangzeb (1659–1707)—and as Hyderabad became important; then the Rājputs became influential; and finally the Marathas overran the Mughal Empire up to the Khyber Pass. Western political and cultural supremacy followed, and only in the last few years has some interest again been aroused in the Iranian countries and their old civilization.

H. Goetz

# THE ISLAMIC ART OF PERSIA

ARCHITECTURE apart, the main achievement of the Persian genius in the Islamic period lies in the field of what used to be called the 'minor' arts—the weaving of carpets and textiles, the making of pottery and metal-work, and the writing, binding, illuminating, and illustrating of books. The religion of Islam requires no icons and monumental sculpture was unacceptable on mosques and uncommon on secular architecture: the Islamic artist preferred to cover his buildings with a skin of glazed tiles or to use carved stucco or brick decoration with largely abstract or floral ornament. The independent statue—that curious invention of the Roman collector in Europe—seems to have made little appeal to the Persian, who, when he wished to indulge his connoisseurship, collected books. This concentration on the objects of every day was continually reinforced by the preference of invading nomads for a few superb and portable possessions. The large, framed picture, so popular in Europe since the Renaissance, found no place in the Persian house or tent. Wall-painting, it is true, was extensively practised, but, if we may judge from the little that has survived, it adopted the style of illumination and miniature-painting, rarely aiming at the monumental quality we find in European or Far Eastern frescoes. No doubt their conversion to Islam and the new conception of authority and kingship caused the Persians to abandon that interest in the 'colossal', to which they had inclined in the Achaemenid and Sassanid periods.

The subject-matter of Persian art was also simpler than that of Europe and the Far East. Islam does not provide a complex iconography. The proscription of the representation of living creatures, though it had theological authority only, was always present to be surmounted. It certainly turned the artist away

from portrait-painting, which would have seemed the expression of an impious self-assertion. At the same time it led to his absorption in the use of line and colour in imaginative ornament. This discipline gave him complete mastery of the elements of expression, and it was on this that he relied, rather than on varied or dramatic content, when he came to illustrate the works of his poets in the pictures of hunting and fighting, music-making, gardens, flowers, and water. These few native themes seem to have been sufficient to feed and release his imagination, and the variations he played on them are infinitely subtle.

Persian art was aristocratic; or so it seems, for the social history of Persia has yet to be written. The demand came almost exclusively from the main courts and great officials, and even where the latter had not their own craftsmen, they imposed their taste on the independent workshops. It is difficult to see in Persian art elements derived either from the 'people' or from the taste of the wealthy burgher, though a rich and powerful merchant class certainly existed. Bucolic imitations of the court style in pottery of the twelfth and thirteenth centuries have been found in north Persia, but they are peasant, not primitive wares; and though a number of fine pieces of inlaid metal-work were made for merchants or untitled people in the twelfth and thirteenth centuries, they differ in no particular from the court pieces. The 'primitive' may be seen perhaps in the barbotine decoration of unglazed earthenware, but the style, which was common throughout the Near East, never found its way into the court ateliers. Persia's social structure remained fundamentally unchanged during the Islamic period: hence the strength and limitations of her art. The tradition was easily preserved and secure, especially as in troubled times craftsmen, considered as among the most valuable possessions of the prince, were spared and adopted by the conqueror. There were, of course, outside influences. Persia was a part of the Islamic world, in which novelties, both intellectual and artistic, were easily and

freely interchanged. Further, there was almost continuous and powerful inspiration from the Far East. But the Persian artist, though particularly susceptible to new ideas, was able to absorb and adapt them to his native mode of expression in a few decades. There was, however, no 'renaissance' with its social and artistic implications in Persia. The value of the individual artist, or rather of the artist as an individual creator, was hardly understood. Great artists there were, but the unique achievement of a Michelangelo or a Rembrandt, redirecting tradition by hammering out a new and personal style, is not to be found. There is variety enough in Persian art, but the savour of the aesthetic experience remains the same. Nevertheless, Persia was fortunate in retaining to the end of her long period of original creation the peculiar excellencies of an aristocratic art. There is rarely any extravagance or outrage of material, and refinement and perfect taste are never lacking.

It is a commonplace that the Arabs, who in less than a century (633–713) conquered an empire extending from Spain to Sind and central Asia, brought with them into these ancient and highly civilized areas little more than their religion, language, and script. It is indicative of their clear understanding of this that the Omayyad caliphs (A.D. 661–749) transferred the seat of government to Damascus in Syria. Omayyad art is an amalgam of elements derived from East Hellenistic—Syrian, Coptic, and Byzantine—and Sassanid art. The former predominate, though it must be remembered that there had already been much give and take between the two cultures. In 749 the Abbasid caliphs, aided by a revolt in east Persia, supplanted the Omayyads. The capital was moved eastwards to the newly founded city of Baghdad. Here were assembled artists from Egypt, Syria, Persia, and Mesopotamia, and in this international and revitalizing atmosphere the Islamic style proper was born and had its first flowering. The achievement of this period is best illustrated by the excavations at Samarra, where, save for

a brief interruption, the caliphs held court from 836 to 883. At Samarra were found examples of wall-painting, stucco and tile decoration, glass and pottery.

The Persian potter's contribution, both to the general style and in isolated motifs, was important, but there were several inventions or rediscoveries which were due not so much to any particular racial component of the Islamic world as to the atmosphere of the period and more especially to the admiration which was felt for the hard white porcelain and stoneware of T'ang China, which, together with celadon and splashed-glaze wares, were found in the Samarra excavations. Chinese shapes and splashed-glaze wares were copied, and to imitate the clean white surface of the porcelain the potters adopted a technique which had been used some centuries earlier by the Parthians at nearby Seleucia—the addition of tin oxide to the glaze to give it a soft, white opacity. Their other achievements were original. Lustre, which had probably been used on glass in Egypt some centuries earlier, was painted in many colours on the fired tin glaze. Painting in blue, purple, yellow, and green on the unfired glaze, a method which required a sure touch and produced a wonderfully complete absorption of the colour, was also practised.

This extraordinary ceramic development has been mentioned in some detail because of its great importance for the future of Persian pottery, but it is still a difficult question how far the best of the Abbasid pottery types were made in west Persia. But if we turn to east Persia to the province of Khurasan, we find an equally brilliant achievement but in a quite different technique.

Already in the ninth century Persia had fallen away from the direct control of the caliphate and various shortlived native dynasties had assumed power. In the tenth century the Buwayhids (A.D. 932–1055) controlled west Persia and Mesopotamia, filling the role of 'mayors of the palace' to the caliphs. Khurasan and Transoxiana belonged to the Samanids (A.D. 819–1004),

who, while remaining true to their new faith, began to restore connexion with their country's past, emphasizing their own descent from Bahrām, the Sassanid hero. Firdausī, the poet of the *Shāh-nāma*, began his career under the Samanids, and at Samarkand, Balkh, Nishapur, and Bukhara there was a genuine renaissance in literature and the arts. The pottery of the period is well known through the excavations at Afrasiyab (Old Samarkand) and Nishapur. Peasant wares and imitations of T'ang splashed-glaze wares are common, but the most important aesthetically are those about to be discussed. The Samanid potters also tackled the problem of painting on their wares, but their solution was quite different from that of their fellow craftsmen in Mesopotamia. Their surface for painting was made by covering the red body of their earthenware with a coat of white—sometimes purple-black or yellow—clay slip. Ordinary painting under a lead glaze tends to run in the firing, so the potters used stable coloured slips. There are several types. The Louvre plate (Plate 34a) is perhaps the finest example of the austere manner, representing in the Samanid technique what the Mesopotamian potters were achieving by blue painting on tin glaze. It would be difficult to imagine anything more perfect ceramically than this beautiful piece, whose sole decoration is the marching Kufic inscription in purple-black slip. Other types are less reticent and are decorated in bright red, purple, and yellow-green slips, the latter perhaps an attempt to reproduce the tone of lustre. The designs include inscriptions, palmettes, entrelacs, and birds, often quotations from Sassanid ornament. It seems that after the fall of the Samanids these magnificent wares ceased to be made with any quality.

This was Persia's great contribution to pottery in the Abbasid period, though *sgraffiato* wares (lead-glazed red earthenware with the design scratched through a white slip) were made in west Persia in the tenth and eleventh centuries, for the most part with designs reminiscent of contemporary metal-work.

The eleventh century saw the supplanting of the Persian dynasties by the Seljuk Turks, a nomad people from the Kirghiz Steppe. The Turks were not wholly barbarian. They had filtered through into the Islamic world in the guise of mercenaries since the ninth century and had quickly absorbed, had even made contributions to, Islamic culture. In A.D. 1055 Tughril Beg was recognized by the caliph as his temporal vicar and was granted the titles of Sultān and Shāhanshāh (King of kings). The three great Sultans, Tughril Beg (1037–63), Alp Arslān (1063–72), and Malik Shāh (1072–92), inaugurated one of the most brilliant periods in Persian history. The two latter were aided by the great Persian minister, Nizām al-Mulk, whose aim, successfully achieved, was to make town-dwelling Persians of the nomad Turks. The non-Persian provinces of the empire, which extended westwards into Asia Minor and Syria, fell away after Malik Shāh's death. The last great representative of the Seljuk line was Sultān Sanjar, who died in A.D. 1157 defending east Persia against other nomads who wished to follow his ancestor's example. Towards the end of the twelfth century the Shahs of Khwarizm (Khiva) on the lower Oxus conquered most of east Persia. They were destroyed by the Mongol invasion of A.D. 1220–1.

In spite of partition in the twelfth century the Seljuk period may be considered as a whole. A definite style, adumbrated in the previous period, was securely established all over Persia. All the arts flourished and enough has survived to allow us to estimate their quality and achievement.

An important technical innovation changed the direction of Persian pottery. We know from references in contemporary literature how much the Persians admired the Chinese porcelain of the period, which under the Sung dynasty had acquired a new thinness and translucency. The Persian potter now devised a body with some of these qualities. We know the method in detail from a technical treatise written in 1301 by Abu 'l-Qāsim

of Kashan, a member of a famous family of potters. Powdered quartz pebbles, potash, and a white plastic clay went to make a hard, fine, white body, to which was tightly fused an alkaline glaze made from the same pebbles and potash. A slip was thus rendered unnecessary and it was easier to paint under the alkaline than under the earlier lead glaze. The glaze could be colourless, stained, or made opaque for overglaze painting. This type of body and glaze survived into the late thirteenth century.

Some of the earlier examples (first half of the twelfth century) reveal in their shapes (Plate 34 b) influences from Chinese bowls of Ting and *ying-ch'ing* type, fragments of which have been found in the Near East. They are left white and simply decorated, if at all, with stiffly curling arabesques or inscriptions. Others are stained cobalt and turquoise blue, brown, green, yellow, and purple. Carved decoration of animals and birds striding through 'arabesque' foliage is common. These wares include plates, jugs, bowls, ewers, and huge jars, in shapes which suit the material and are often perfect in their simplicity. Fine potting makes this one of the few periods when Persian wares invite handling, for it is usually the singing colours which achieve the effect. These monochrome wares continued to be made in the thirteenth century, when the decoration was often moulded and consequently more elaborate, sometimes including figure scenes of Sassanid origin.

Another twelfth-century type employs differently coloured glazes on the same pot. These so-called *lakabi* or painted wares utilize the carved outline of the design to prevent the glazes running. The technique proved remarkably effective on the Berlin dish with the superbly displayed eagle (Plate 35 a). A further type with arabesques, dancers, and musicians cut in black slip under a clear or turquoise glaze is also common. Some of the small jugs and beakers with glossy black ribs are exceptionally lovely (Plate 35 b).

Whether or not Persia had had a share in the wonderful Mesopotamian school of polychrome lustre pottery of the ninth

PLATE 34

*a*. PLATE, slip-painted, black on white. 10th century.
Musée du Louvre

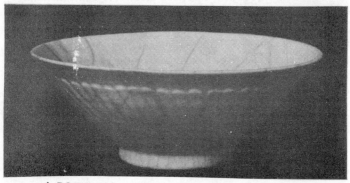

*b*. BOWL, white, with carved decoration. 12th century.
Sir Alan Barlow Collection

PLATE 35

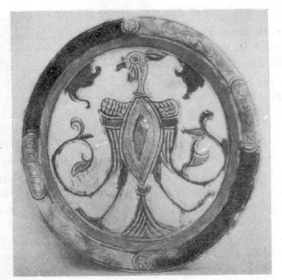

*a.* DISH, polychrome, with carved design. 12th century.
Staatliche Museen, Berlin

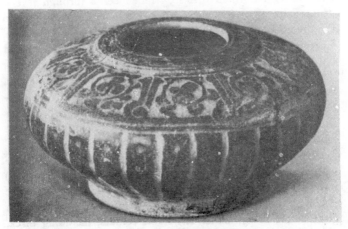

*b.* BOWL, black slip under turquoise glaze. 12th century.
Victoria and Albert Museum

to tenth century, the brownish-yellow monochrome variety had made its appearance in Persia by 1179, when a bottle, now in the British Museum, was made. A hard, whitish body was used and a touch of tin in the glaze rendered it white but not completely opaque. The lustre was sometimes painted on a blue glaze or on alternating panels of blue and white. Both technique and style are fully realized on the earliest dated examples, and it may be that foreign influence was responsible for the sudden appearance of lustre painting, perhaps, as has been suggested, from Egypt, where under the Fatimids (969–1171) there had been a flourishing school. There are two main styles, associated with the important towns of Ray (near Teheran) and Kashan. The earlier Ray pieces are decorated with large figures of horsemen, musicians, birds, and animals framed in stiff scrollwork and reserved on the lustre ground. In later pieces the decoration tends to be fussy and uncontrolled, an indiscriminate scattering of tiny figures and decorative motifs over the surface of the pot. Kashan was a well-known pottery town and the products of its kilns reveal a distinctive style, handed down through several generations of potters, whose names are known. A large plate in the Freer Gallery, Washington (Plate 36 a), is a typical example. It is dated A.D. 1210 and illustrates the story of Khusrū and Shīrīn, how he first set eyes on her beauty as she was bathing. The Kashan potters were fine designers and delighted in a thick ground of reserved and lustred tendrils and dots. 'Moon-faced' beauties, with arched brows and almond eyes, musicians and young men and women conversing by a brook are the most popular themes.

Even more elaborate and detailed narrative scenes were presented in another technique on the so-called *minai* (enamel) wares. Those colours which will take the high temperature —blue, purple, green, and yellow—were painted on the tin glaze before firing. Other less stable colours, including black, red, white, and gilding, were fixed by a second firing in a

low-temperature muffle kiln. Many lovely shades were achieved both in the high temperature and the enamel colours. Sometimes the painting was done on an opaque turquoise ground of extraordinary beauty. *Minai* pottery was made at Ray, Kashan, and perhaps Sava. The figure decoration is similar to that on the lustre pottery but also includes battle-pieces and scenes from the *Shāh-nāma*, which are especially important for what they tell us about contemporary book-illustration, no Persian examples of which survive (Plate 36 b). It is not likely that these wares, technically the most elaborate ever made in Persia, continued to be manufactured after the Mongol invasion and the destruction of Ray (A.D. 1220–1).

More satisfying aesthetically is a type of pottery made at Kashan with black and blue painting under a colourless or turquoise glaze. The finest pieces may be dated to the first twenty years of the thirteenth century. Unusual at this period is the organic flow of the long stems of waterweed (Plate 37 b).

Early Persian metal-work reveals more clearly than the pottery the influence and example of Sassanid art. The reason is that whereas the pottery of the Sassanids, so far as we know it, was undistinguished, their gold, silver-gilt, and bronze vessels rank among the finest plate ever made. The magnificent dishes and ewers, carved with hunting scenes and figures of deities and fantastic animals, were greatly admired by and traded to the nomad peoples on the Persian borders and gave them a taste for such things long before they burst into the Islamic world. In Persia itself silver-gilt and bronze metal-work closely resembling that of the Sassanids was made into the ninth century, especially in the semi-independent areas south of the Caspian Sea. Few examples in precious metal have survived from the period of Persian autonomy in the tenth and eleventh centuries. Two gold jugs with Kufic inscriptions containing the names of members of the Buwayhid dynasty may, if genuine, be dated in the second half of the tenth century. They are deco-

PLATE 36

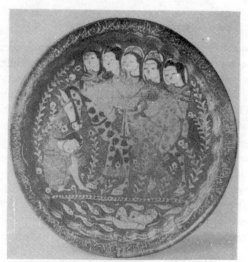

*a.* DISH, lustre painted. Kashan. Dated A.H. 607/
A.D. 1210. Freer Gallery of Art, Washington

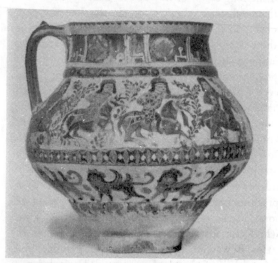

*b.* JUG, painted in polychrome enamels. Early 13th
century. Metropolitan Museum of Art, New York

PLATE 37

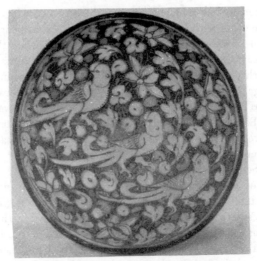

*a*. BOWL, slip-painted, white on grey.
Early 14th century. Fitzwilliam Museum

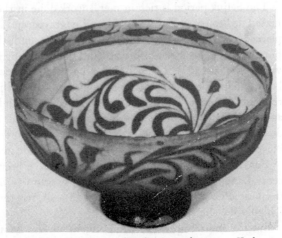

*b*. BOWL, black painted under turquoise glaze. Kasban.
Early 13th century. Victoria and Albert Museum

rated in low relief, the one with rams and winged creatures, the other with 'Sassanid' peacocks in circular medallions. More will be known about Samanid metal-work when the Nishapur excavations are fully published, but some idea of its quality may perhaps be obtained from two famous silver jugs in the Hermitage. One, carved in low relief with full and half-palmettes, has also birds embossed in the round, a feature which was elaborated in Seljuk work. The shapes of these vessels, as of a tenth-century silver treasure in the Gulistān Museum, Teheran, are good, the ewers being reminiscent of Sassanid forms.

Seljuk material in precious metal is also scanty. What there is of it—mostly in Russian collections—is of simple shape, austerely decorated with nielloed inscriptions. Two of the finest late Seljuk pieces—a silver jug and bowl in the Staatliche Museem, Berlin—are, however, more elaborate. The jug has cast and engraved decoration of addorsed birds and friezes of animals in flight against a background of arabesques. The bowl has a fine nielloed inscription and medallions and a charming figure of a musician in repoussé.

The Seljuk period is rich in metal-work done in the humbler material, bronze, which was cast and engraved and sometimes pierced with openwork. Much of it is quite undistinguished, but the shapes are straightforward and the engraving rough but vigorous (Plate 38 a). The Sassanid-type ewer, with pear-shaped body and handle with palmette or pomegranate to help the grip, remained popular. The decoration included panels and friezes of animals, birds, sphinxes, and griffins set in medallions and benedictory inscriptions in Kufic and Naskhi. The most ambitious pieces are the fine openwork incense-burners made in the shape of lions (Plate 38 b). Finds of this material have been made in central and west Persia, but the bulk of it seems to have come from east Persia and the province of Khurasan, where there was a highly developed metal industry.

But the most impressive achievement of the Seljuk metal-

worker was the use of silver and red-copper inlay on bronze, and later brass, vessels. The origin of the technique is obscure, though a small group of post-Sassanid bronze ewers, of which the one in the Hermitage with peacocks flanking a palmette tree is the finest example, are inlaid with small rectangles and disks of copper. But it is a far cry from this group to a bronze penbox in the Hermitage, which is decorated with silver and copper inlaid inscriptions and small engraved figures of birds and foliage. This penbox, the earliest dated inlaid piece known, was made, probably in Khurasan, in A.D. 1148; and it is at present not possible to bridge this gap of four or more centuries.

The most important piece of inlaid metal-work of the Seljuk period is undoubtedly the Bobrinskoy bucket in the Hermitage. It was, according to the inscriptions, made at Herat, in Khurasan, in A.D. 1163 by the caster Muḥammad ibn al-Wāḥid and the inlayer Mas'ūd ibn Aḥmad for a merchant of Zanjan in north-west Persia. This confirms literary evidence of the high organization of the industry and of the fact that silver inlaid vessels were made in Herat and exported. The silver and copper inlaid friezes are five in number, two with festive, court, and hunting scenes, the remainder with Kufic and Naskhi inscriptions. The verticals of the Naskhi letters end in human heads and bodies, a charming fancy which is often most intricately devised (Plate 39).

Several other pieces are signed by craftsmen of Khurasan, the most important being an inlaid ewer in the Tiflis Museum, made at Herat in A.D. 1181. It has a fluted body and on the shoulder are depicted the twelve signs of the zodiac, a common feature, found also on Kashan lustre pottery. Many examples of this type of Persian ewer are known. A very fine piece in the British Museum, of brass, which began to replace bronze at the end of the twelfth century, has birds and lions embossed round the shoulder and neck and a crouching lion over the upturned spout. The fluted body is decorated with inscriptions, in two

PLATE 38

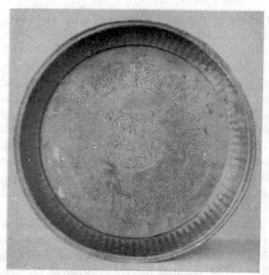

*a.* TRAY, bronze, engraved. 12th century.
Victoria and Albert Museum

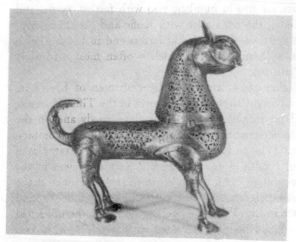

*b.* INCENSE BURNER, bronze, engraved and inlaid with
copper. 12th century. Hermitage Museum

PLATE 39

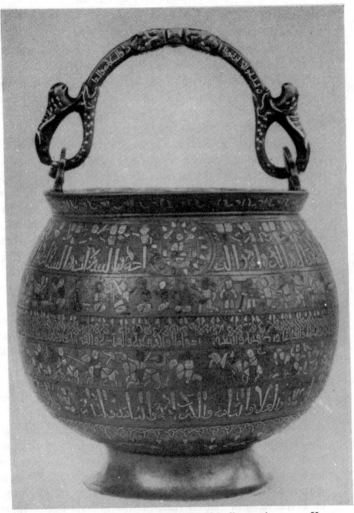

BUCKET, bronze, engraved and inlaid with silver and copper. Herat.
Dated A.H. 559/A.D. 1163. Hermitage Museum

varieties of the human-headed letters, and with the twelve signs of the zodiac, silver inlaid, and surrounded by rich scroll-work. Other products of this school include ink-wells, penboxes, large candlesticks with free-standing birds round the shoulder and embossed lions on the base, and pear-shaped ewers with spouts resembling lamps and handles shaped as drinking lions. The Persian school of inlay retained its fine quality and distinctive character up to the Mongol invasions.

A flourishing textile art had existed in Persia since the Achaemenids, who were famous for their elegant garments and soft wools. Silk was introduced from China in the Parthian period and silk cultivation had probably been established in Persia before the fall of the Sassanids. Only a few Sassanid silks have survived, and fewer woollen tapestries, but representations on rock-cut reliefs and metal-work indicate the general appearance of the stuffs woven at the various centres in Khuzistan, where Shāpūr I is said to have settled captive weavers from Antioch. Lobed and-round medallions, enclosing winged horses, rams, birds, and the strange lion-bird (*senmurv*), decorate one class of these regal silks, which had a profound influence on Syrian and Byzantine weaving. Others are thickly sprinkled with lobed petals and strings of floral and geometrical motifs. The twill-woven designs are impressive and severe, though conceived in a rich polychrome.

It is known from literary evidence that in the early Islamic period weaving was practised throughout Persia, especially in the provinces of Khuzistan, Khurasan, and Fars. A few silks, like the famous sudarium of St. Victor in Sens Cathedral, closely resemble the Sassanid pieces in colour and style and may have been made in west Persia. Another group with angular representations of confronting animals and birds was probably woven in Transoxiana or central Asia. Similar in style but of superb quality is the elephant silk from St. Josse-sur-Mer, in the Louvre, which bears in Kufic the name of an amir of Khurasan,

who died in A.D. 960. This stuff reveals a high technical skill. It is twill-woven, like the Sassanid pieces, but no less than seven wefts are used together, giving a colour-scheme of rich plum for the ground, yellow for the elephants and Kufic inscription, and blue, white, and three shades of tan for the procession of camels.

Seljuk textiles are not numerous but are sufficient to show the wonderful standard of design and technical skill achieved by the weavers in this period. Their beauty derives from qualities quite other than those on pre-Seljuk textiles. The Seljuk weaver was not interested in the sumptuous polychrome of a stuff like the St. Josse elephant silk. He preferred the simple contrast of a few tones, quite often limiting himself to two, putting dark or pale blue, violet, black, or green on beige, white, or red. On the earlier pieces simple designs were broadly treated, but by the late twelfth and thirteenth century the weavers were supremely confident in their graphic skill and could reproduce the most complicated and delicate cartoons. Twill and compound cloths were the favourite weaves, but double cloths and some lovely satins were also made. The designs were heraldic and traditional —two-headed eagles, and peacocks, lions and griffins flanking a 'tree of life'—and were disposed in roundels, stripes, and lozenge or octagonal units. More poetic and pastoral scenes were perhaps borrowed from contemporary painting on pottery. The duck silk (Plate 47a) is a fine example of the early thirteenth century. The Kufic inscription, in blue, surrounds the closely filled ovals of the design which is yellow on a blue ground, the interstices being formed by loosely woven foliage, blue on yellow.

In the Islamic world the Qur'ān is venerated as God's truth revealed through the Prophet, and from the beginning merit was to be derived from the ordering or writing of careful and splendid copies. The Qur'ān, unlike the Christian gospels, was not illustrated nor would decoration based on human or animal forms have been tolerated. Consequently all the artist's invention and religious feeling were concentrated in the fine writing

and the rich but abstract illumination which served as its setting. In Persia, as in China, the art of beautiful writing was held in the highest esteem and princes did not scorn to become the pupils of famous calligraphers. Originally the calligraphers were also the illuminators and sometimes the painters (in secular books), and it was not until the fifteenth century that a division of labour between many artists became common.

The ninth- and tenth-century Qur'āns were written on vellum, sometimes stained the imperial purple and with the Kufic text and illumination in liquid gold. These wonderful manuscripts, however, like most of the eleventh-century paper Qur'-āns, belong rather to the Abbasid style of Baghdad and Egypt. We know very little of the making of fine books in Persia until the twelfth century, when the upright format, as of the modern European book, had already been adopted and paper, the use of which is said to have been learned by the Arabs after the capture of Samarkand, had supplanted vellum. The text was written in Naskhi, Kufic being generally reserved for the chapter headings. Many forms of both scripts were invented by variation of emphasis and articulation in forming the letters. The angular Kufic is a wonderful means of intellectual expression with great power in the urgent thrust of the horizontals of the letters with the strongly emphasized verticals adding a still, monumental quality. The curving Naskhi has a gentler and more even flow, but is none the less dignified and masculine. The calligrapher controlled his letters rather as a great musician compels his emotion into a strict and elaborate musical form. Indeed, very much the same sort of pleasure is to be found in a page of a Seljuk Qur'ān and a page of Bach (Plate 41 a).

Illumination was used to punctuate the calligraphy. The earliest decoration consisted of bands indicating the end of one chapter and the beginning of another. Chapter headings usually had a palmette 'handle' in the margin. A background to the writing might be formed by beautifully drawn arabesques in

brown. Rosettes mark the end of each verse and cartouche-ornaments in the margin indicate various useful divisions of the book—every fifth verse and so on. At the opening of the book might be placed a page or more of pure ornament. The illuminator of a Qur'ān in the British Museum dated A.D. 1036 has exercised his marvellous invention over five such pages. The first text page usually had an elaborate title. The colour-scheme is rich but simple. The illumination is usually in gold, which has a reddish tone when it forms the ground to distinguish it from the design. Details are painted in blue, black, red, and white. Black is usual for the letters but diacritical points are added in blue, red, or green. The Seljuk style persisted well into the Mongol period.

The terrible destruction wrought by the Mongol invasions of A.D. 1220–1 was confined to Khurasan and Transoxiana. Apart from a destructive raid across north Persia which is said to have destroyed Ray, west and central Persia remained unaffected. But in A.D. 1231 a full-scale invasion subdued the whole country and from A.D. 1231 to 1256 Persia was terrorized and impoverished by two Mongol armies. In 1256 Hūlāgū, the younger brother of the Great Khan, arrived to settle and extend the Mongol Empire. In A.D. 1258 Baghdad was captured, the caliphate ended, and Mongol rule extended to the Syrian border. In Persia a permanent settlement was made and the dynasty of the Ilkhāns founded, which, with capitals at Maragha, Tabriz, and Sultaniya in north-west Persia, lasted until A.D. 1335. Some of the early Khans were Muslims, like their brethren in south Russia, others were Buddhist and favourable to Christians—it was during this period that embassies were interchanged between the European and Mongol courts in an unsuccessful effort to present a united front to the Mamluks of Egypt—but when Ghāzān came to the throne in A.D. 1295, largely through the support of the Persian element, the Mongols officially adopted Islam.

The period saw a mingling of Persian and Mesopotamian elements in metal-work, illumination, and painting and the introduction of Chinese motifs in all the arts. Intercourse between west Asia and China was now easier and more intimate than it had ever been and the Ilkhāns remained in close touch with the senior branch of their family, which had founded the Yuan dynasty in conquered China. Chinese paintings, porcelain, and textiles were traded across central Asia and by the sea route, and profoundly influenced the Persian, indeed the Islamic, repertoire of ornament. At the same time the Ilkhāns gathered together at their capitals artists from Mesopotamia and west and central Persia: Khurasan did not fully revive until the fifteenth century.

The potters, as one would expect, suffered least during the period of transition. Simplifications of the elaborately painted *minai* pieces continued to be made. A bowl in the Victoria and Albert Museum, dated A.D. 1242 and decorated with a prince throned between two retainers, is painted in overglaze enamels only. A rather dull variation is provided by the so-called *lājvardina* wares. These were decorated with gold leaf and a small range of colours on a deep blue (*lājvard*) or turquoise glaze. Fourteenth-century pieces are known with the 'new' ornament. Underglaze and lustre painting in the Kashan manner continued, probably in the Sultanabad area. The decoration is niggardly and casual but often very effective. A new type shows sketchy, blotted painting in blue, green, purple, and green-black under the glaze. A fine example is the bowl with a high foot in the Kelekian collection in the Victoria and Albert Museum, dated A.D. 1274.

In the fourteenth century original pottery of fine quality was again made. The decoration consists of phoenixes, deer, flying birds and figures in Mongol costume, framed by naturalistically rendered leaves and flowers, chief among which is the Chinese-lotus (*Nelumbo*). The subjects are predominantly Chinese,

borrowed from porcelain and textiles, but the painting in under-
glaze black and two shades of blue is typically fluent and Persian.
The colour on pieces which have retained their freshness is
brilliant. A beautiful contrast is provided by another ware with
decoration in the same style but applied in white slip on a grey
slip ground. At its best Ilkhānid pottery ranks with the finest in
Persia's long ceramic history (Plate 37 a). These wares continued
to be made in declining quality into the second half of the
fourteenth century.

It is difficult to trace the development of Persian metal-
work in the thirteenth century after the Mongol invasions. The
east Persian school, which flowered so brilliantly in the Seljuk
period, seems to have been overwhelmed, though artists fleeing
before the Mongols brought something of their style to the
west. The other great school of Islamic metal-workers, centred
at Mosul in north Mesopotamia, had escaped the invasions
unharmed and was undoubtedly patronized by the Ilkhāns.
Though pieces have survived which combine elements of both
styles, Mosul influence was paramount in west Persia in the
second half of the century. For example, three bronze balls,
inlaid with silver and gold (which had already supplanted copper
as an inlay) and bearing the name of the Ilkhān Uljaitū (1304–
16), are indistinguishable from signed Mosul works of the period.
Contemporary with them, however, is a magnificent silver-inlaid
brass candlestick in the Stora collection which is dated 1308
(Plate 40a). Here the new style, with its lotus medallions and
borders of twining flowers, is manifest. An important centre for
metal-work, and indeed for all the arts, in the second half of the
fourteenth century was Shiraz, which became the capital of the
Muzaffarids (1353–93), a native dynasty, after the dissolution of
the Ilkhānid Empire. Here in 1360 a Shirazi craftsman made the
famous gold and silver inlaid candlestick in the Harari collec-
tion. It represents an extension of the style found on the Stora
candlestick and is similar to a series of inlaid bowls (Plate 40b)

PLATE 40

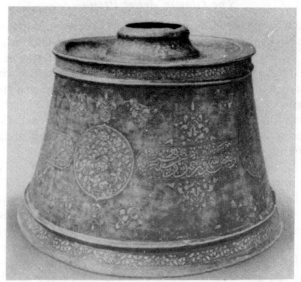

*a*. CANDLESTICK, brass, engraved and inlaid with silver.
Dated A.H. 708/A.D. 1308. Possession Stora

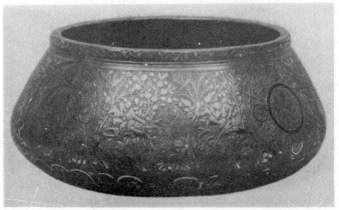

*b*. BOWL, brass, engraved and inlaid with silver. Late 14th century.
Walters Art Gallery, Baltimore

PLATE 41

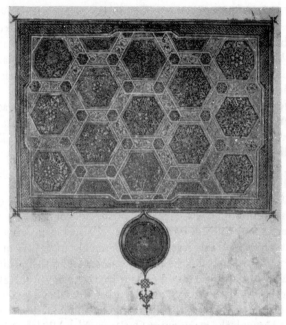

*b.* PAGE OF QUR'ĀN

Written at Mosul in A.D. 1310 for Uljaitu. British Museum

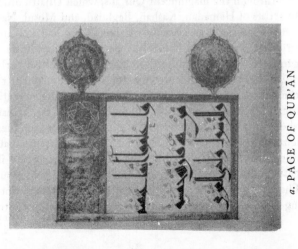

*a.* PAGE OF QUR'ĀN

11th–12th century. National Museum, Teheran

which are as fine as anything done in the Seljuk period. With assured mastery of his difficult medium the artist inlaid court and hunting scenes, gardens, polo matches, and stories from the *Shāh-nāma* with all the elaboration and detail of a miniature painting. Indeed, it is in contemporary books that the closest parallels to these superb bowls are to be found.

Strong though the effect of the Mongol domination was on pottery and metal-work, it completely changed the character of textile technique and design. The Seljuk preference for light and delicate drawing in a few tones was abandoned. Mongol taste, formed of course by Chinese stuffs, demanded the glint of solid metal thread (either flat strips of gilded leather or a gilded or silvered membrane wound on a core) brocaded on a rich satin ground. The brocaded ornament consists of lotus-palmettes and Chinese birds and beasts, disposed in stripes or simple repeats. Arabic inscriptions commonly form part of the design, but so closely did the Islamic weavers follow their Chinese masters that it is by no means certain whether many of these silks should be attributed to Persian, Egyptian, or Chinese looms.

The quality of Mongol calligraphy and illumination is well known through the magnificent Qur'āns, which Uljaitū ordered from artists of Hamadan, Kashan, Baghdad, and Mosul. Naskhi was still beautifully and evenly written. Kufic had exchanged the rugged grandeur of the Seljuk period for shapeliness and elegance. The pages of pure illumination, which owe perhaps more to the Mesopotamian genius for abstract ornament than to the Persian, seem to spring from an inexhaustible invention. Intricate and controlled scrolls and arabesques are set, in distinguished contrast, on blue and gold grounds, with here and there a touch of pale green (Plate 41b). Occasionally the artist, anticipating the next century, employed a richer palette, writing and illuminating in red, white, green, and blue on a plated gold ground.

Though the Islamic prejudice against the representation of living creatures was never absolute even in the Semitic countries,

it did tend to lower the status of the painter as compared with his fellow artists and to prevent the formation of a vital and developing tradition. That the art did persist in Persia through the Abbasid and Seljuk periods is obvious from the many literary references, the decoration on lustre and *minai* pottery, and a few fragments of wall-painting. Abbasid painting, as we see it at Samarra and Nishapur in the ninth century, is a complex of many elements, two of which predominate, the East Hellenistic, itself wellnigh transformed by the 'Oriental' preference for formal ornament and design, and the Sassanid. Few examples of Sassanid painting have, however, survived and its style and quality have to be inferred rather from its influence in central Asia and on the international Abbasid school. Mani (A.D. 216/17–276) has always been revered by the Persians as their first and greatest painter and, certainly, elaborately illuminated and illustrated books were used in the service of his creed. Manichaeism, persecuted in Sassanid Persia, was adopted by the Uighurs of central Asia as their national religion, and it is, strangely enough, at Chotscho, their capital, that there has been discovered illustrated pages of an eighth- or ninth-century book, which, with its elegant little figures seated cross-legged and listening to music, is very similar in presentation and style to Persian work on pottery of the thirteenth century. This 'miniature' style is not, however, apparent at Samarra or Nishapur, where the figure subjects—dancers, musicians, and the like—are based on the East Hellenistic tradition, as it was developed in Syria under the Omayyads and adopted by the Abbasids.

The real heirs to the Abbasid style in painting, as in the other arts, were the Fatimids (A.D. 969–1171) of Egypt, who evolved a new and integrated style, which may be seen on lustre-painted pottery and found monumental expression on the ceiling of the Capella Palatina at Palermo. This tradition, largely destroyed in Egypt by the Ayyubids in 1171, remained an important element in the illustrations to popular moralities and books on

medicine and mechanics of the so-called Mesopotamian or Baghdad school of the first half of the thirteenth century, which constitute the earliest series of illustrated Islamic books that have survived. These illustrations have little formal value as pictures; the figures and background are, rather, diagrams interspersed in the text to supplement the argument. The work is eclectic, and the hands of the neighbouring Byzantines, Syrians, and Armenians, more experienced in illustration, are very apparent. Keen and lively observation occasionally produces a work of great merit: al-Wāsiṭī, who wrote and painted the Harīrī in the Bibliothèque Nationale, was an illustrator of considerable genius.

Contemporary Persian painting, as it may be inferred from lustre and *minai* pottery of Ray and Kashan, especially from the more elaborate *Shāh-nāma* and battle scenes, was more uniform and decorative, and, at the same time, more truly pictorial in character. It is, however, only in the Mongol period that we can begin to speak with confidence of Persian book painting. It is, of course, too large a subject for adequate treatment in an essay of this scope; and it is proposed to treat the painting of the fourteenth century as a prelude to that of the fifteenth and sixteenth centuries and the latter as an element merely of the wider art of the book which found its finest expression in the Timurid and early Safavid periods. This is not an adverse judgement on the aesthetic status of the earlier painting nor is its value merely historical as prefiguring the great period to follow. On the contrary the fourteenth century is notable rather for brilliant and individual creation in several largely unrelated styles, which had not time to coalesce fully into a single national school before the Timurid style appeared in the last decades of the century, fully formed and owing (it would seem from our present knowledge) but few of its qualities to the accomplishment of its forerunners.

At the Ilkhānid courts at the beginning of the fourteenth

century were illustrated books which show the same mingling of Persian and Mesopotamian elements common in all the arts, together with an overwhelming impulse from China—in this case the monochrome ink drawings in the Sung and Yuan manner. Different styles are common in the same book, indeed on the same page, as in the earliest monument, a Bestiary in the Morgan Library, New York, which was copied at Maragha for Ghāzān Khān (1295–1304). A few of its ninety-four illustrations are in the Mesopotamian style, which had obviously still not spent its force: the remainder are strongly influenced by Chinese painting, in many cases direct quotations. The Chinese contribution is even more obvious in the copy of the *History of the World*, shared by the Edinburgh Library and the Royal Asiatic Society and dated 1314. Rashīd al-Dīn, the author of this work, was vizier to the Ilkhāns and a forerunner of the great patrons of the fifteenth and sixteenth centuries. He built near Tabriz a suburb, which was at once university, library, and scriptorium, where he employed scholars and artists from the entire Mongol dominion. His *History of the World* is the first of the great Persian illustrated books. The pictures, which are little more than tinted drawings, are cleverly composed within their long narrow frames and the line is expressive and powerful. It was at Tabriz, about 1330–40, that Persian artists trained in this discipline produced what is probably Persia's greatest book —the series of illustrations to the Persian epic, known as the Demotte *Shāh-nāma*. It is not possible to discuss here this extraordinary masterpiece. But in it, alongside the quieter, more decorative pages which have the richness of colour and dignity of the following century, are to be found deeply moving scenes in monochrome like the funeral of Isfandiyār in the Metropolitan Museum, New York. This great work stands somewhat apart in Persian art. Persia never did this sort of thing so well again nor did the dramatic content of a picture ever interest her artists so much.

Two other Persian schools of the first half of the fourteenth century need passing mention. A number of small *Shāh-nāmas* are known, the illustrations of which are not unlike the Tabriz examples, though without their 'bigness'. They are painted with remarkable delicacy and detail in a rich palette and possess the true 'miniature' style of the Seljuk pottery. From the ancient centre of Shiraz come a series of *Shāh-nāmas*, dating from 1330 to 1353. They show, on red, blue, and yellow grounds, rough but vigorous drawing, which has suggested to some a survival of an earlier tradition. However, Mongol types and landscape are common, and they may represent merely a provincial school. In any case their contribution to the following century and their intrinsic beauty are small.

By the end of the fourteenth century the several dynasties which had succeeded the Ilkhāns had all fallen before another Mongol conqueror, Tīmūr (1335–1405). At one time Tīmūr ruled from his capital at Samarkand an empire which comprised Transoxiana, Persia, Mesopotamia, Syria, and Asia Minor. His conquests, however, were less permanent than those of the Ilkhāns and at his death Syria and Asia Minor reverted to their old masters. Tīmūr's son and successor, Shāh Rukh (1407–47), controlled practically the whole of Persia from his capital at Herat, but, during the dissension in the Timurid house which ensued at his death, the west fell into the hands of the two Turkoman dynasties, known as the Black and White Sheep, the latter of whom ruled at Tabriz and regained nearly all Persia, except Khurasan. Herat, however, remained Timurid for another fifty years and was ruled by two enlightened monarchs, Abū Sa'īd (1457–69) and Ḥusain Baiqara (1469–1506). Finally, in the early sixteenth century the Uzbek Shaybanid dynasty seized Transoxiana and Herat and drove the last representative of the Timurid family, Bābur, to seek his fortune in India, where he founded the long line of Mughal emperors.

Though it is to east Persia—to Transoxiana and Khurasan—

that interest and emphasis now shifts, it was in west Persia and Mesopotamia, especially at Shiraz and Baghdad, that the Timurid style had its beginnings, and it was from these centres that Tīmūr carried off artists to grace his court at Samarkand. Unfortunately the transition from the styles of the first half of the fourteenth century to that of the last decade is but poorly illustrated by two Shirazi *Shāh-nāmas*, dated A.D. 1370/1 and 1393/4, both of which are of indifferent quality and give little indication of what was to follow. The new style was, however, finally realized in a fine Baghdadi work, the *Miscellany* of 1397/8, shared between the British Museum and the Chester Beatty collection, and above all in a second book in the British Museum, the *Khamsa* of Khwājū Kirmānī, copied at Baghdad under the Mongol dynasty of the Jalā'irids in 1396. In these books, especially in the *Khwājū Kirmānī*, Persian painting, which had been directed and partially obscured by Mesopotamian and Chinese influence, burst suddenly into full bloom. We know too little of the social history of the times to explain this extraordinary appearance of a fully integrated style, whose peculiar qualities had been but intermittent and diffuse for upwards of a century. Connexion with China remained close, but the influence of Chinese painting was no longer vital. It merely provided fashionable motifs, especially in decoration, which the Persian artist could manipulate within his established style.

What is the nature and intention of Timurid painting, as we see it in all its freshness in the manuscript of Khwājū Kirmānī? It is, above all, supremely decorative. Indeed, his impeccable colour-sense and mastery of intricate design make of the Persian artist a decorator second to none. To be fully enjoyed the miniatures need to be handled in the parent book, where on fine paper a perfect setting is provided by beautiful illumination and writing—in the case of the *Khwājū Kirmānī*, by the master Mīr 'Ali of Tabriz, who is said to have invented the feminine and dancing

script known as Nasta'līq. The pictorial conventions of the artist were few and simple. He was not interested in the European use of perspective for dramatic effect nor in chiaroscuro as a means of psychological expression. His figures are doll-like and drawn in pure colour, their setting an ever-repeated formula of small sky, high horizon, closely observed flowers, and 'conventional' rocks and trees. The result is, however, not merely an elaborate two-dimensional pattern, nor an expression purely literary, though the miniatures are invariably illustrations—and very successful ones—to the works of the Persian poets. The fact is that the Persian painter's equipment was perfect for the expression not only of the splendour and pageantry fitting for a court art, but also of those more subtle and lyrical moods found in Niẓāmī and Saʿdī. The art is, so to speak, pure, the magic resides in the thing itself, making few demands on emotional overtones or associations to complete its expressiveness.

The Timurids were all great patrons of the art of the book. But perhaps the greatest of all was Shāh Rukh's son, Bāisunqur Mīrzā (died 1443), who was vizier at his father's court at Herat. He has justly been compared to René of Anjou. He assembled artists from the whole Timurid Empire at the academy and library he founded at Herat. Here the paper-maker, scribe, illuminator, margin-cutter, colour-grinder, painter, and binder co-operated in the production of some of the finest books ever made. The full Herati Academy style may be seen in the wonderful Teheran *Shāh-nāma*. Copied in 1429/30 for Bāisunqur's library by one of the greatest calligraphers of the period, Jaʿfar Bāisunqurī, it represents the high-water mark of book-making. The text, exquisitely written, is decorated with designs within gold rulings. It is preceded by three pages of pure ornament. At the end of the book there are two elaborate *khātimas* (the spaces on either side of the key-shaped panel of the colophon). A double-frontispiece and twenty miniatures of the finest quality illustrate the poem. The illumination, an extraordinary

invention of flowery scrolls, arabesques, and Chinese grotesques, is painted in a rich palette of enamelled brilliance—blue and gold, and the purest greens and reds.

But calligraphy, illumination, and painting were but part of the whole book. The binders did not lag behind their fellow craftsmen. In the Timurid period the bindings were of leather over pasteboard. Both covers and the flap, which protected the front edge of the pages, were decorated. The doublures of such a cover and flap are illustrated on Plate 42. It encloses a fine manuscript, copied in 1438 at Herat for Shāh Rukh's library. The text is written on heavy paper of various colours, speckled and painted with landscapes in gold. The decoration of the cover is in hand-cut leather filigrane on a blue painted ground. Monkeys, phoenixes, Chinese lions, and other monsters sport in the arabesque foliage. The most elaborate techniques were used to embellish the exteriors of these covers. Complex landscape and animal designs were produced by stamping with a large metal matrix, and abstract ornament by innumerable impressions with small dies. Gold tooling, gilding, and embossing in relief were also practised. These covers had a great influence on the practice of the craft in Europe, the techniques having been introduced by Islamic binders who settled in Venice.

From the large number of fine books produced throughout the fifteenth century it is difficult to choose one painting to illustrate the Timurid achievement, but perhaps that on Plate 43 will suffice. It was painted at Herat about 1470–80 and illustrates a famous incident in the *Shāh-nāma*: how Rustam's horse, Raqsh, killed the lion which threatened his sleeping master. This picture shows the limits of expression within the apparently simple conventions to which the Timurid painter confined himself. The 'big' design is confidently handled: the colour harmonies, especially the greens and purples, are incredibly subtle. Moreover, there is a curious passion in this

PLATE 42

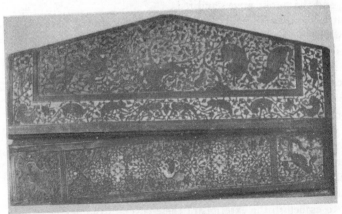

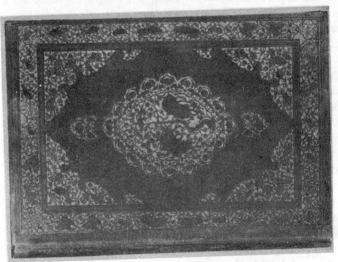

COVER AND FLAP OF A BINDING
decorated with leather filigrane and blind tooling.  A.D. 1438.
Topkapu Sarayi Müzesi, Istanbul

PLATE 43

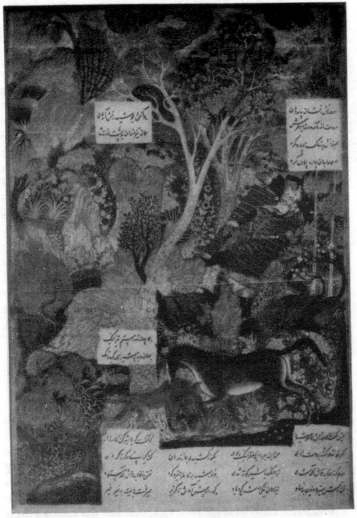

PAGE FROM A *SHĀH-NĀMA*
Late 15th century. British Museum

magical scene: one feels here, as but rarely in Persian painting, the presence of a great individual master.

The Timurid style, by its very completeness and perfection— the result of almost a century's consistent development and practice—seemed doomed to an ever less vital and creative repetition. Yet there were many decades of original painting after the *Rustam*. This was largely due to Bihzād, who in the last two decades of the fifteenth century inspired the tradition with new vigour. Bihzād occupies a curious position in the history of Persian art. Venerated by the Persians as the greatest of their painters, ranking with the almost legendary Mani, he has left no large body of work to support his reputation. The few paintings generally ascribed to him do, however, indicate wherein his contribution lay. In the great *Būstān* of 1488, in the Royal Egyptian Library, Cairo, he is seen as a brilliant designer in the established manner and as a colourist of especial subtlety and invention. The miniatures have in addition a dramatic content which is new. The figures and situations are keenly and individually observed, and the appropriate mood produced by imaginative gesture and dramatic composition. The new style is best seen perhaps in the three miniatures (dated 1493) in the British Museum's *Niẓāmī* of 1442, especially in the scene of Majnūn watching the tribes fighting on their camels (Plate 44). The earlier manner survived for some decades, but the style of Bihzād and his pupils was paramount at the court studios by the end of the century.

In the Timurid period pottery and metal-work seem to have lost direction, so far as one can judge from the very little that has survived. The reason probably was that the end of the fourteenth century saw the beginning of that flood of Ming blue-and-white porcelain to the West, which for many centuries so radically affected Near Eastern and European ceramics. This wonderful material made such an appeal and was comparatively so cheap as to supplant the native wares and inlaid metal-work

on the tables of the rich. Local imitations on a pottery body were made all over the Near East, but little has survived from Persia. The only other ware, attributable to the fifteenth century, comprises a group of bowls and plates, which come from Kubatcha in Daghestan but were probably made in north-west Persia. Pieces in the Kelekian Collection, Victoria and Albert Museum, bear dates in the second half of the century and are decorated in black under a turquoise or green glaze. The plant-forms and arabesques are well drawn and in Persian taste.

The Timurids delighted in parcel-gilt silver plate with applied gold plaques and incrustation of precious stones and glassy enamels. Few of these rather barbaric vessels, which are frequently represented in the miniatures alongside Chinese or Persian blue-and-white, have escaped the melting-pot. Brass-work, incised or sparsely inlaid, continued to be made, but shape and design were undistinguished.

Little is known of the art of weaving under the Timurids, for hardly a piece of silk has survived. As far as one can judge from representations of clothes and hangings in miniatures, the heavy, lustrous effects of the Mongol period seem to have been abandoned in favour of more open and flowing designs. It may also be assumed from the achievement of the Safavid period that the technical skill of both weaver and dyer continued to develop.

In 1502 the White Sheep Turkomans were overthrown by Ismā'īl, the Safavid, and for the first time for many centuries Persia was ruled by a native dynasty. The Safavid period, which lasted until 1722, was one of great prosperity, though much energy was expended in defending both east and west frontiers against the Turks. The early Safavids had their capitals in north-west Persia, at Tabriz and Qazvin, but increasing pressure from the Ottoman Turks caused Shāh 'Abbās the Great (1587–1628) to establish himself at Isfahan, in the centre of his dominions.

The style of Bihzād and his pupils continued without inter-

PLATE 4

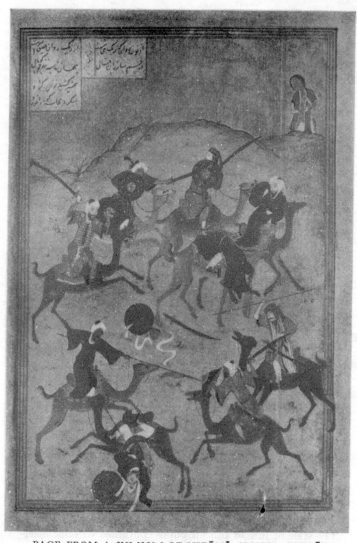

PAGE FROM A *KHAMSA* OF NIZĀMĪ SIGNED : BIHZĀD
Dated A.H. 898/A.D. 1493. British Museum

PLATE 45

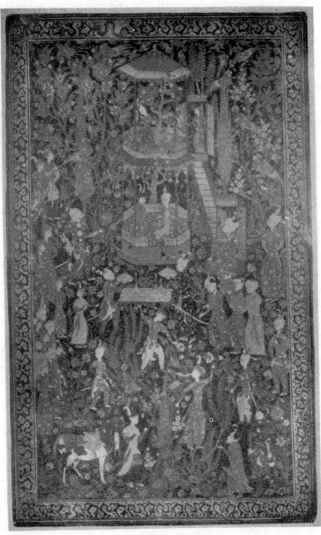

BOOK COVER
Leather, lacquer painted. About A.D. 1540. British Museum

ruption into the sixteenth century. Herat was captured from
the Uzbeks by Ismā'īl in 1510 and Bihzād moved to Tabriz. In
1522 he was appointed director of the Royal Library, to which
was attached a studio and scriptorium. Emphasis again shifted
to west Persia, though Herat remained a provincial centre of
considerable importance. Both at Herat and the capital Bihzād's
style was predominant, though Tabriz had possessed an impor-
tant school of painters under the Turkomans.

The greatest splendour was achieved under Shāh Ṭahmāsp
(1524–76), the son and successor of Ismā'īl, when Sulṭān
Muḥammad, a pupil of Mīrak, himself a pupil of Bihzād, was
chief painter and director of the royal studio. Books produced
at Tabriz at this time are among the most sumptuous ever made
and rank with the best of the Timurid period in quality. A fine
example is the famous *Niẓāmī* in the British Museum, which
was written for Shāh Ṭahmāsp between 1539 and 1543 by Shāh
Maḥmūd al-Nīshāpūrī, an outstanding calligrapher of the
period, and illustrated by a number of great artists, including
Mīrak and Sulṭān Muḥammad. The miniatures are painted
with all the technical brilliance of the period, and with an
assured and sophisticated beauty which amply rewards one for
the loss of the delicate poetry of the earlier painters. The
illumination was as elaborate as in the Timurid period. More-
over, the margins were now frequently painted in silver and
gold—in green and yellow shades—with landscape, hunting,
and other scenes as detailed as the miniatures themselves.

The binders continued to use most of the techniques of the
Timurid craftsmen, though coloured paper tended to replace
leather for the filigrane work on the doublures. An important
innovation was the painted and lacquered binding, which
came into vogue in the reign of Shāh Ṭahmāsp, though it is
found as early as 1483. These covers were of leather or, more
often, of papier mâché, covered with a thin layer of gesso and a
coat of lacquer, the latter providing a good surface for the

water-colours. The painting was protected by several coats of transparent lacquer. Many covers were painted in the manner of a miniature and were undoubtedly designed by the miniaturists themselves. Among the finest are two leather covers in the British Museum. The exteriors are richly decorated with garden scenes on a lustrous black ground, the doublures with hunting scenes on gold (Plate 45). They represent the style of Sulṭān Muḥammad and his followers about the time the British Museum's *Niẓāmī* was painted.

In the second half of the century there was a marked decline in the production of fine books. The energy and co-operation necessary for the making of one of the great Timurid or early Safavid books seems to have been lacking. Instead, separate miniatures, to be collected in albums, became popular. The subjects, too, were more prosaic—portraits of favourites and court ladies and genre and erotic scenes. By the end of the sixteenth century miniature painting had lost most of its vitality, the only original contribution being made by Riẓā-yi ʿAbbāsī, the outstanding painter at Shāh ʿAbbās's capital, Isfahan. His dominating influence, especially in line drawing, which is often most charming and expressive, lasted right through the seventeenth and eighteenth centuries. Seventeenth-century painting is, however, on the whole dull and repetitive. By the eighteenth century all quality was lost.

The pottery of the Safavid period, especially during the reign of Shāh ʿAbbās and the seventeenth century, ranks with that of earlier periods in variety and beauty. It can be seen to best advantage in the very rich collection of the Victoria and Albert Museum. Chinese porcelain was again the inspiration of a large body of these wares. By the end of the sixteenth century the Persian potter had invented a beautiful white translucent body, very similar to the European soft-paste porcelain. The design is often taken direct from late Ming porcelains, but is drawn with a Persian lightness and humanity which is quite different

from the harder, more mechanical Chinese hand, and is superior in verve to the more academic treatment of the court painters. In fact the best examples of the seventeenth-century line drawing are to be seen on these pots, which are painted in two shades of a good blue or in blue with black outlines. Yazd, where an ewer dated 1616 in the British Museum was probably made, was a centre for these wares. Chinese monochromes were also imitated and include celadons of a pea-green colour with discrete and fluent decoration in white slip under the glaze (Plate 46a).

On other wares Chinese influence was but slight. The use of lustre was revived, either on a white, blue, or yellow glaze or on alternating panels of white and blue. The decoration consists almost exclusively of typically Persian landscapes crowded with wild life. Another fine type, with painting under the glaze in yellow-green and red slips and blue, was probably made in Kirman (Plate 46b). The long-necked bottles and narghilis were frequently painted with poetic scenes, such as Khusrū's meeting with Shīrīn. Finally, a word must be said of the type known as Kubatcha, an earlier group of which has already been mentioned. The Safavid variety is painted a rich polychrome under a dark ivory glaze with superbly swirling flowers and trees, and busts of exquisite young men and women, often in European costume. These plates are wonderfully decorative with a charming suggestion of decadence. They were perhaps made in the neighbourhood of Tabriz.

Safavid metal-work is also outstanding. Brass and copper vessels, the latter tinned to give the appearance of silver, continued to be made. They are often of good shape and are well, if modestly, decorated with incised and inlaid ornament. The arms-smiths and instrument makers, however, produced work of the finest quality. Iron and steel were wrought into noble shapes for weapons and armour, then decorated with carved, etched, or gold-inlaid floral arabesques and inscriptions. Thin, steel plaques, which served as decoration on wooden doors or

caskets, were cut into designs which have the delicacy of fine lace. This tradition of fine craftsmanship in metal survived the Safavid dynasty, probably because of the persistent demand for weapons and armour in the disturbed conditions of the eighteenth century.

It is, however, in textiles that the Safavid artist is supreme. The stuffs woven in this period, especially during the reign of Shāh 'Abbās, are unsurpassed in the history of the art. It is difficult to trace the beginnings or to determine the cause of this tremendous outburst, for, as we have seen, few Timurid silks have survived, and when dated pieces first appear in the second half of the sixteenth century, the new fashions and techniques are fully established. It is obvious from the miniatures and from the vast number of pieces in modern collections that splendid stuffs were demanded for all the occasions of court life. The most elaborate and costly materials were used for garments, tents, hangings, and covers, as presents to nobles and foreign rulers, even as envelopes for diplomatic letters.

The designs are of the greatest variety. Flowing and delicate forms of the arabesque were evolved and combined with flowers and animals, lovingly observed and rendered in the most brilliant hues. The Persian passion for gardens is nowhere more beautifully expressed than in the roses, lilies, poppies, and tulips cunningly disposed on the fine weaves. Many of the finest pieces are woven with episodes from the *Shāh-nāma* and from the romantic poets and with hunting and garden scenes. No doubt the cartoons were frequently designed by the fashionable painters at Tabriz and Isfahan, and the styles of Shāh Muḥammad and his successors may often be discerned.

To produce these designs every conceivable technique was employed. The earlier weaves—cloths, twills, and satins—were further developed and elaborated. One of the richest effects was produced by brocading and stamping a small design on a cloth or twill ground of solid silver or gold thread—a type of cloth

PLATE 46

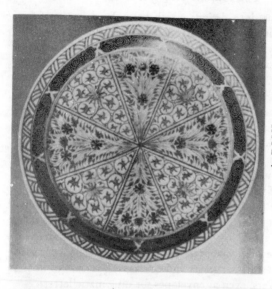

*b.* DISH
painted in slip and underglaze blue. Kirman.
17th century. Victoria and Albert Museum

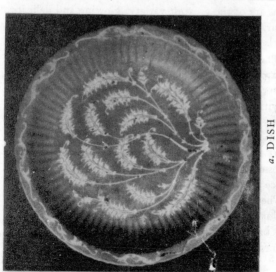

*a.* DISH
slip painted, white on green. 17th century.
Museum für Kunst und Gewerbe, Hamburg

PLATE 47

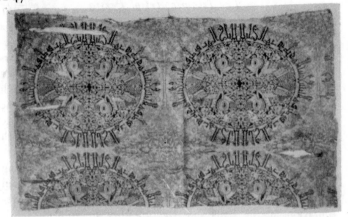

*a.* SILK, dark blue and yellow. 13th century.
Textile Museum of the District of Colombia

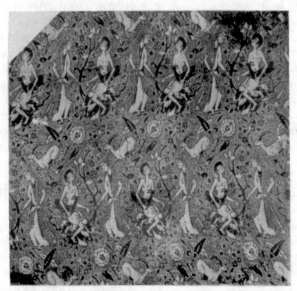

*b.* SILK, red and white, enriched with silver thread.
About A.D. 1600. Victoria and Albert Museum

which was very popular for court costumes. Double-cloths, a technique occasionally used by the Seljuk weavers, and triple-cloths were also employed to produce the most elaborate cartoons. In these stuffs two or three independent cloths are woven together and are brought in front of or passed behind each other to make the pattern and vary the colour. A very fine piece in the Victoria and Albert Museum illustrates the tragic love story of Lailā and Majnūn (Plate 47 b). This silk is woven with two cloths, red and white. Silver thread is used for alternative wefts of the white cloth which forms the background, thus giving a ribbed and glistening effect to the stuff. It was probably woven at Yazd, an important centre, about 1600. Several other representations of the Lailā and Majnūn story are known. One is signed by a famous citizen of Yazd, Ghiyāth al-Dīn ʿAlī, a master weaver and man of many parts, who was a favourite at the court and whose silks were eagerly sought after in Persia, India, and Turkey.

The most extraordinary of the products of the Safavid looms are the velvets. Their beauty and technical elaboration have never been equalled. The Persians did not make *ciselé* velvet, but relied on fine weaving and subtle variations in the length of pile to give lustre and depth to their carpets, hangings, and tent-panels. So great was their skill that they were able to reproduce narrative scenes of the greatest complexity by the introduction of numbers of extra velvet-warps, each used only for a short distance to put in details.

The splendour of Safavid weaving, as of the other arts, hardly survived the fall of the Safavids. In 1722 the Afghans, who had already seized Herat and Meshed, defeated Shāh Husain, the last of the dynasty, and deprived him of his capital, Isfahan. The ensuing anarchy, increased by Russian and Turkish invasions, impoverished the country and enfeebled her spirit, and Persia's long history of original creative endeavour came to an end.                                    DOUGLAS BARRETT

# CHAPTER 6
# RELIGION

## § i. *Introductory*

IN this essay it is not proposed to attempt an estimate of the legacy bequeathed to the Western world by the Islamic faith as a whole: in respect of the past, at any rate—which, for all practical purposes, must inevitably mean in this connexion the medieval past—the reasonable possibilities of even surveying that formidable task have already been authoritatively explored in a companion volume in the Legacy Series, and at too recent a date to warrant our usefully entering the field again here.[1] We are concerned here, in any case, with the ostensibly subordinate and possibly somewhat simpler questions: what contributions to Muslim religious life may justly be regarded as of specifically Persian origin or transmission, and what is the significance of those contributions to the world in general and to the West in particular? If we propose to treat the problem largely in terms of its hopeful relevance to ourselves, it is because the times are peculiarly, indeed urgently, appropriate to its consideration. It may become apparent as we proceed that this particular legacy, apart from casual realizations on it in the

[1] See *Legacy of Islam* (Oxford, 1931): the article on 'Mysticism' by the late R. A. Nicholson and, more particularly, that on 'Theology and Philosophy' by Prof. A. Guillaume. Two later works still, which treat important aspects of the whole problem in far greater detail than was possible in these articles, should also be mentioned: *Islam and Christian Theology*, by J. W. Sweetman (Lutterworth Press, 1945), and *Introduction à la théologie musulmane (essai de théologie comparée)*, by L. Gardet and M.-M. Anawati (Paris, 1948). The last-named study in particular seems likely to become a standard work of reference on the subject: its massive character is grotesquely belied by its modest title. (Owing to limitations of space on the present article, a certain general familiarity with the subject as treated in the articles by Nicholson and Guillaume has had to be assumed in some places.)

past, is still largely unclaimed, could indeed scarcely have been appreciated at its true worth by any age before our own; for we, whose own spiritual portion has come so near to total dissipation by the self-confident improvidence of our more recent forebears and our own preoccupation with other matters, have by now acquired something of the keen eye of the true mendicant (and, let us hope, something of his humility too!), wherever the remotest prospect of largesse offers among our neighbours. Nor need the fact that such neighbours dwell afar off in time or space prove an obstacle to our full participation in their bounty: paradoxically, in the experience of many Orientalists it is the initial unfamiliarity and the very remoteness of things Oriental which first point to the treasure buried in the ruins of our own familiar world. (I use here, almost unconsciously, one of the age-old symbols of the ancient cultures to which we shall later refer (see pp. 164–5) as having passed into Persian mystical poetry, to be set by such master-craftsmen as Ḥāfiẓ.) The bequest which Persian Islam holds in trust for us has the power to help us win back our own lost inheritance; if that should come to pass, the blessing which is the giver's by right will surely be doubled. Debts there cannot be where the gift is of grace.

In the sphere of art and literature the dominant function of the Persian mind has long been recognized as part-solvent, part-catalytic: it is no less so in that other, indeed that fundamental, element of culture—religion. Persia, in its true, ancient connotation (which logically includes, among others, the all-important area of Mesopotamia), may well be described, in a term used by one of our most penetrating anthropologists,[1] as a sort of cultural 'palimpsest'. From the earliest times (right back as far as Sumer at the least) and the farthest bounds (Egypt, Syria, and Greece on the one side, India and China on the other) there can have been scarcely a belief or a dream, a cult or a hope, but was

[1] Christopher Dawson, *Making of Europe* (London, 1932), p. 149.

eventually either integrated into, or held in suspension in, that potent elixir which is Persian culture. In the Sassanian Empire which the Arab armies were subduing throughout the latter half of the seventh century A.D., the solvent process was for the time being complete: it was the catalytic action of this highly subtle compound which was now to take effect, and in the sphere of religion the process was to be accelerated by the sheer bareness of primitive Islam on the one hand, and its fatal lack of true doctrinal authority and discipline on the other.[1] Here, however, we have not the space, nor is it strictly necessary to the development of our main theme, to attempt to describe even briefly the violent effervescent reaction resulting from the meeting of the dark, rich flood of the ancient culture, rising to its spate in Persia, and the limpid torrent of the primitive monotheism of early Arabian Islam.[2] But when, after some two centuries (650–850 approximately), the all-pervading turbulence begins to subside, we can discern the main currents now felt to be so characteristic of Persian Islam—and indeed, for long periods and in varying degrees in the West, of Islam as a whole. The physiognomy of Persian Islam may be conveniently examined under the following very broad and in no way precise or distinct heads: (i) Shī'ism; (ii) Ṣūfī mysticism; (iii) Fatalism. The two last aspects have never failed to find a wide apprecia-

[1] This weakness has, of course, been stressed by many writers: Nicholson, op. cit., p. 224, points out how seriously it was abused by the extremer Ṣūfīs, while Dawson, op. cit., contrasts with it the general resistance offered to the ancient Oriental cults by the early Christian Church, with the important defections of such individuals as Bardesanes or Marcion. It is gravely hampering Islam now in its resistance to modern materialistic corrosions.

[2] Such reactions were naturally occurring all over the ancient world, e.g. in Helleno-Aramaic Syria, but, as nowhere was the ancient culture so rich and concentrated as in Persia, so nowhere was the process so violent, prolonged, or lasting in effect. Persia is still unique in Islam, while a certain homogeneity is visible in the other Muslim lands, even in Egypt, which superficially might have appeared at the outset a clearer-cut entity than Persia herself, and has certainly suffered no more than she under invasion and conquest.

tion outside Persia, since they reach their finest expression not
in explicit doctrinal statements, but in some of the world's
greatest poetry; but Shī'ism, at any rate as a religious idea, has
been largely neglected and often misunderstood. (The neglect,
all the more remarkable in Britain, whose concern with the
Shī'ite community has been considerable, extends in some
measure even to such an early and interesting history as that of
Dīnawarī, edited by Guirgass in 1888 and, after his death,
unindexed for another twenty-four years. The misunderstand-
ings often arise from an injudicious use of anti-Shī'ite sources.)
While viewing Persian Islam in this triple framework, however,
one must constantly bear in mind that the grand contribution
of the Persian genius to Islam was qualitative, so pervasive and
subtle, so quickening and humanizing in every field of thought
as practically to defy our grasp and analysis,[1] save when, as in
the case of Al-Ghazālī, it is embodied in a distinct personality.
We may now proceed to discuss certain prominent features of
each of the three characteristic aspects of Persian Islam sug-
gested above, selecting those only which may shed most light

---

[1] M. Horten, *Philosophie des Islam* (Munich, 1924), states unequivocally on
p. 12: 'Die islamische Philosophie ist von Persern erdacht worden.' In any case,
a fascinating and vitally important field of research may open up as the long
antecedents of Islam, particularly in its Persian manifestations, gradually
emerge to view. The relationships are clearest, of course, in symbols and
imagery, rather than in the realm of abstract ideas; but for many years to
come the task of tracing with any certainty the descent of even the main ele-
ments must remain almost impossibly difficult. Vast tracts, which as yet
remain arid under purely philological exploitation, need first to be brought
to blossom by humaner hands. Despite some stimulating work on bird and
tree symbolism in western Asia by the late A. J. Wensinck, a rare combination
of philological scholarship and true humanism, we are still largely in the plight
indicated by M. Horten, op. cit.—see particularly his 'Einleitung', which,
despite some typical racial obsessions, is most pertinent to our theme in this
essay. See also H. Frankfort and others, *Intellectual Adventure of Ancient Man*
(Chicago, 1946) and W. Thomson, 'Islam and the Early Semitic World',
*Muslim World*, Jan. 1949, pp. 36–63.

on the nature of the legacy Persia offers us in the field of religion; the stupendous figure of Al-Ghazālī will be treated in a separate section.

Before proceeding to such detailed considerations, however, it may be convenient here to indicate some of the reasons why, apart from exigencies of space, it has not been possible in this essay to accord a similar treatment to the pre-Islamic faith of Zoroastrianism. For one thing, despite its official status in the Sassanian Empire, it was but one thread in the rich and tangled skein of Persian religious life, as a number of early heresies such as Manichaeism and Mithraism (of which we gain such tantalizingly brief glimpses in the scanty literature available) only serve to show. Moreover, though, in the commonly accepted, but vague, picture of Zoroastrianism which we are able to form, it does evident credit to the loftiness of Persian vision, it is perhaps even less than these heresies themselves a typical manifestation of the Persian religious impulse as we have come to know it through some thirteen centuries of comparatively well-documented history since the Islamic invasions. Finally—and this is inevitably the most compelling reason of all—it is a disappointing but inescapable fact that close on a century of highly concentrated Iranian scholarship has done little to clear the atmosphere of uncertainty surrounding the whole development, practice, and 'climate' of the Zoroastrian faith; indeed, while many earlier erroneous conceptions have undoubtedly been dispelled, the very character of much of this research would seem to militate heavily against any early promise of positive conclusions calculated to bring this field within the purview of the cultured public; for it has not yet succeeded in assigning a more justly proportionate place to the philological considerations which earlier inevitably governed it, and has tended to remain in consequence subservient to a philosophy long held as outmoded in other branches of Orientalist scholarship and in the humanities generally. Whatever legacy may here lie hidden,

we may not count in the measurable future even on its assessment, far less on its employment to good purpose.

## § ii. *Shī'ism*

That Shī'ism in its religious implications is a Persian phenomenon (having constant regard to the special sense which we attach to the term 'Persia' in this essay) seems so obvious a fact that no one is likely to be misled by the emphasis placed on the Arab origin of many of the earliest adherents of the 'Alid faction by those whose chief concern is political history. Shī'ism, in its most important religious aspect, attempted (to a great extent involuntarily, of course) to supply Islam in the spirit of the ancient light-cults with that infallible actual authority which is sought by all religions in some form or other. The Khārijites, like the Calvinists, found it in themselves; the narrower Sunnite Orthodox, like Luther, believed it to reside in the Book (for a large body in Islam the Qur'ān is literally the Word of God, even the Logos—*kalima* as distinct from *kalām*—though, of course, they would not be willing to concede the full implications of such an attitude); but the Shī'ites, like all the ancient cults, placed it in a man, often a man-god, who was a sort of startling inversion of the Christian God-Man, though there exists here a close parallel as well to some of the Christian heresies on Our Lord's Person. The nearest equivalent of the Shī'ite Imām is not, as has been often asserted, the Pope (the personal as well as doctrinal infallibility attaching to the former is sufficient indication of that), but the Nestorian Christ.[1] With the renascence of the Imāmate idea within Islam, a great part of that community (and in some senses Islam as a whole) enters the family of religions.

Such then is the central feature of the Shī'ite faith. There are innumerable subordinate ideas, some of almost fantastic subtlety, for nearly all of which close ancient pagan and Chris-

[1] Cf. Horten, op. cit., p. 13, on the terms *ḥulūl, tajallī, ẓuhūr,* &c.

tian parallels can readily be found: sacrifice, the atonement made at Karbalā' for the sins of mankind,[1] the holding of the world as a dowry by Fāṭima[2] (cf. Our Lady's Dowry), and the bearing aloft of ʿAlī on the Prophet's 'sinless' shoulders[3] during the iconoclastic raid on the Kaʿba (cf. the Infant in the arms of the immaculately conceived Mary)—to name but a few of the more important. Not all of these myriad ideas were, of course, held by all the Shīʿites at any one time, and to the total of all the ideas held by all the Shīʿites at all times might well be applied the closing words of St. John's Gospel.

By the end of the twelfth century at the latest, Shīʿism was limited geographically to an area not much in excess, if at all, of Persia–Iraq itself; even there it was by no means universal (Saʿdī, for example, was not a Shīʿite), and it had to wait nearly

[1] This tragedy has given rise to one of the ostensibly least typically Islamic phenomena of all Persian Islam: the passion-play (*Taʿziya*). The latter is, however, scarcely a drama in any sense which we could allow: the Islamic mind seems only weakly responsive to the dramatic, and the Persians, though born actors, share in this disability, which would seem to be yet another aspect of their artistic and dialectical inability to integrate opposites and to grasp wholes (see below, p. 155). Even their epic poetry has more of the lyrical in it than of the dramatic: its development is linked radially by innumerable subtle threads to a central idea (it must be emphasized that there can be no question of the genuineness of Persian artistic unity *per se*, though it differs radically from ours), and does not move along straight lines from point to point to a mounting crux or climax. Similarly God is at the infinitely remote centre of their world: the idea of His emergence into our world at a point in time to act effectively runs counter to their deepest instincts: the whole 'drama' of the Incarnation is virtually lost to them (see below, pp. 163–4). Their neglect of the Greek drama may be explicable on these lines, or may, as in the parallel case of the Western Church's apparent neglect of the Greek philosophers, have been dictated by what they found to hand (on the latter point cf. Dawson, op. cit., pp. 60–1).

[2] *Majālis al-Muʾminīn*, by Nūr Allāh Shushtarī (d. 1610), opening sentence of first *Majlis*. (This work is still only available in manuscript and in a rather poor lithograph.)

[3] Ibid., section on the Kaʿba.

another four centuries before being accepted as the official religion, a position which it holds to this day. But the richness and subtlety of its thought were so intense that it long continued to fertilize the whole field of Islamic religion, going far at times towards rescuing even its Sunnite opponents from the dilemmas inherent in their own doctrines. As one of our leading Orientalists has recently so shrewdly emphasized,[1] the master-science of Islam (we would add the essential qualifying word 'Sunnite') is not, as in Christianity, theology-philosophy,[2] but, as in Judaism, the law. The strictly practical turn of mind of the mass of the non-Shī'ite theologians implied from the very outset the ultimate failure of Muslim theology, for God, not unnaturally, proves even less amenable to man's neat, detailed systems than does man. Their writings are not only often dull and pedestrian (dealing frequently with matters which to us scarcely seem to belong to theology or philosophy at all, while neglecting at times what for us is the very heart of the matter), but markedly inconclusive: there is a constant tendency throughout Islamic thought to postulate a problem in terms of black and white and then to reject the black, an inability to see that the fact that 'better' is superior to 'good' does not make 'good' bad (see above, page 154, note 1). The free-will versus pre-destination dilemma is the classic touchstone in these cases: Ash'arī's attempt at a solution, though it seems to have impressed some Western scholars, is a mere desperate expedient compared with the profound answer given by the Ṣūfīs, itself representing the full development of original Shī'ite ideas and finding its sublimest expression in the writings of Al-Ghazālī. Here only do we meet something of that reverence for mystery, that grasp of the possibility that opposites are merely the obverse and reverse of the Divine Mind, which is

[1] H. A. R. Gibb, *Mohammedanism* (Oxford, 1949), pp. 9–10, 88.

[2] The two are even more intricately entangled in Islam than in Christianity. See Horten, op. cit., p. 14.

the dominant note of Christian thought, but which a modern
scholar seems, surprisingly enough, to find characteristic of the
'Oriental thinker' generally.[1] That typical Oriental thinker, the
orthodox Sunnite theologian, was singularly unequal to main-
taining his equilibrium when he had a foot on each of the
apparently parallel paths of Greek philosophy and Revelation:
his confidence in their eventual meeting in God was not suffi-
cient to prevent him ultimately withdrawing a foot either from
the one, to pursue the safe road of minute detail,[2] or from the
other, to hurry off (with Averroes) down the broad highway of
determinism to something very near atheism.

Such thinkers were, as we have suggested, ultimately helped
out of many an impossible position by the relieving Shī'ite
doctrines, especially in Ṣūfī disguise, but while the battle still
raged, they were as hopelessly outranged as was Kingsley by
Newman or Luther by St. Thomas More. The latter compari-
son is perhaps the more apt in another sense, for the Shī'ite
apologists show a marked tendency to be good-humouredly,
even humorously, puzzled by the sheer obtuseness of their
opponents at times and by their failure often even to glimpse
the difficulties of a problem. (The sheer brilliance and ironic
subtlety of even a popular work like Shushtarī's (see above, p.
154, notes 2 and 3) are an indication of the general high level
of Shī'ite apologetics.) In the long run their dogmatic assurance,
coupled with what must seem to many a paradoxical lack of
fanaticism, eventually gave all Islam to some degree a practical,
balanced mechanism of salvation and a convincing background
to the relation between man and God. The almost unbearably
stark emphasis on the twin aspects of monotheism and the
Qur'ān was now spread and poised over such bases as atonement,
intercession, infallibility (now centred in Muḥammad)[3] and the
second coming, to name only a few of the doctrines whose

---

[1] Gibb, op. cit., p. 141.                    [2] Horten, op. cit., p. 24.
[3] See Gibb, op. cit., p. 126.

acceptance throughout Islam was until recently quite wide-spread. To what extent the Mu'tazilite element (much of which after its downfall was absorbed into Shī'ism) contributed to the victory of Shī'ite ideas, it is, of course, almost impossible to estimate: from their record during their brief period of ascendancy under Ma'mūn, however, one may doubt whether on the whole they could have been intimately concerned in any engagement where one of the weapons was tolerance.

As might be expected in view of what we have said hitherto, the question of the extent to which early Christianity may have influenced the formation of the leading Shī'ite ideas is one which has exercised Western scholars to some degree. The resemblance is clearly undeniable, but even more so is the parallel with the pagan cults; and modern psychology is at one with orthodox Christian teaching in suggesting that certain ideas and symbols (the latter particularly) are so inherent in the grain of things and in the human mind as to have an absolute life of their own and a capacity for perpetual independent germination. It now appears more plausible than before that the idea of, say, sacrifice has an objectivity as real as the fact that two and two equal four. (It is only fair to point out, however, that another school of modern thought endorses the assertion, hitherto confined to the dishonest, that the latter proposition has no objective validity either.) In any case, whatever richness or subtlety Shī'ism may have gained from contact with Christianity, it learned—as its disastrous political history shows all too clearly—nothing of the latter's discipline or worldly wisdom.

The question of 'influences', however, is of only secondary importance beside the effective force of Shī'ism in its operation within Islam: in company with the Ṣūfīs and the Fatalists, the Shī'ites held open, into the outwardly forbidding fortress of Islam, a door of hospitality through which all men could pass and repass. Few have done so, and of those few, fewer still have

comported themselves with dignity and gratitude; there is, therefore, an additional obligation on us to give the great body of Muslims no grounds for regarding this door as a breach in their defences.

We have, as we have said, no concern here with the strictly political side of Shī'ism (its failure as a legitimist party or the uses and strange abuses of its central tenets to cover all manner of political, often sinister, ends), though such a study would again reveal much which is typical of Persia, whether in ancient times or at the present day. But one political manifestation is important to us for its quasi-religious implications: Ismā'īlism kept alive in the most striking way the old gnostic, magic cults which have always striven to invest the great religions of the East. Their pretensions to attain to reality by the esoteric means of a secret wisdom, their belief in all religions equally (with its corollary of equal disbelief)—surely there is little need to stress the relevance of such things for us in our day of specialist exclusiveness and agnostic tolerance. The health of Persian Shī'ism (as of Ṣūfism) is well shown by the way in which, as a whole, it consistently rejected the greater part of these practices or rendered them harmless as poetic hyperbole.

## § iii. *Ṣūfī Mysticism*

In Ṣūfism we have what is generally regarded, and not without much justice, as the supreme manifestation of the Persian mind in the religious sphere. Once again we do not propose to discuss its historical significance or development,[1] nor its social implications or the abuses for which it was made to serve as a cloak.[2]

---

[1] These points are admirably treated by Nicholson, op. cit., and in his other writings. See also A. J. Arberry, *Introduction to the History of Ṣūfism* (London, 1942).

[2] See Gibb, op. cit., pp. 127–64, for an excellent short account of some of these aspects.

The two main theories which have hitherto prevailed as to the provenance of its most characteristic doctrines and disciplines have now been qualified to a greater or lesser degree: the Indian 'school' could scarcely be expected to outlive the age of Orientalist dilettantism and Teutonic racial preoccupations, while the Neoplatonist theory, though both ingenious and attractive (and not without considerable force), was given its classic expression before the full complexity of this type of problem had been suggested by the findings of anthropological and psychological research—to say nothing of the constant discovery of new materials in the field of Ṣūfism itself. In a now famous letter, written towards the end of his life, Nicholson avowed his mature belief in the indigenous origin of many of the main features of Ṣūfism, and it seems quite certain that this ripe and courageous judgement will find nothing but support from researches now proceeding. Ultimate proof in the scientific sense can, of course, never be forthcoming in such matters, but, by the tangible test of outward expression, there can be little doubt of Persia's right to claim Ṣūfism as largely her own: names like Ghazālī, 'Aṭṭār, Rūmī, and Ḥāfiẓ come to the mind with a readiness inconceivable in connexion with the early Arabian ascetics or even someone of the stature of Ibn Al-'Arabī.

A modern scholar writes in a recent article of the essential simplicity of Ṣūfism.[1] It is, of course, the fundamental simplicity of all ultimate truths, which are only complicated (though exquisitely at times, and, in any case, quite inescapably) by expression in the thoughts or symbols to which man is bound. So, contemplating the vast body of Ṣūfī literature and literary criticism on the one hand, one must strive on the other never to lose sight of the almost blinding simplicity of its central idea: that of the soul's exile from its Maker and its inborn longing,

[1] A. J. Arberry, 'Tendencies in Islamic Mysticism', *Scientia*, March–April 1949, p. 65.

nourished or suppressed in the face of other attractions, to return and lose itself in Him. At that depth genuine[1] Persian Ṣūfism is not to be distinguished from our own Western mysticism, and Al-Ghazālī, by God's grace, loves his Lord and is loved by Him no less than St. Francis, Rābi'ah no less than St. Teresa of Avila (we shall speak later—see p. 173—of the hope implied in that statement): it is in the expression and the silences of such love that diversity—important in itself, but only in itself—begins to appear.

In speaking of Shī'ism we have had occasion to refer to some of the peculiar difficulties in the position of orthodox Islam, to its many inadequacies and its startling bareness, all of which marked it off and set it at a distance from the great body of world faiths; we have seen too how Shī'ism attempted (and with a great measure of success) to overcome those difficulties, filling in the lacunae and clothing the bareness with material which lay ready to hand, either literally under foot, or on the tongue and in the mind, and which doubtless derived in great part from the ancient cultures of the nearer East. We shall now consider how Ṣūfism, itself in many ways an heir to Shī'ism, reacted to these and other similar difficulties.

The transcendent remoteness of Allāh is a feature of Islam which so impresses even the most casual observer that the many references in Ṣūfī literature apparently emphasizing His loving proximity cannot fail to occasion surprise and bewilderment. There are, of course, innumerable passages where God is the Silent Rose, driving the wretched nightingale to magnificently expressed distraction, the self-sufficient, capricious Beauty, sure of the hapless lover (and of many like him), and therefore dis-

---

[1] A possible charge of question-begging, like the definitions it implies, is virtually meaningless in such a field; we may, however, limit the area of mis-understanding by excluding morbid states and hypnosis, self-induced or otherwise.

playing such indifference towards him as to provoke him to cheap taunts:

> At dawn the bird in the meadow to the newly-risen rose:
> 'Cut out your high-and-mighty airs; plenty like you have blossomed
> in this garden.'[1]

But where else in all Islam shall one find such a tender expression of God's loving concern for the 'lost-soul' as in the following exquisite lines?

> Oh, thou high-gazing royal falcon, whose proper habitat is the
> Lote-tree of Paradise, thy nest is not this corner of Affliction
> City.
> They are whistling thee back from the battlements of God's Throne;
> I know not what has befallen thee to linger thus in this place of
> snares.[2]

(How perfectly, incidentally, the image of the falcon's outward and return trajectory corresponds to the Ṣūfī doctrine of the

---

[1] See A. J. Arberry, *Ḥāfiẓ—Fifty Poems* (Cambridge, 1947), No. 11, for text and a rather different translation. That the poet meant to strike a vulgar note here is difficult to doubt from a consideration of the language of the original, and, within the limits of the imagery in which he is working, it is artistically and psychologically irreproachable. It is difficult, however, for us to justify the use of such media in general: nor is it merely a case of 'working within the accepted imagery of the age', for what should we feel of a mystic who expressed his love of God in the current imagery of our time—that of the advertisement and the film? Human love in itself is not unworthy to provide imagery for the Divine, of course—'t is the only obvious standard man has, and there is no essential dichotomy—but it must be love of great depth and reality, without a hint of the tawdry and the artificial (see below, p. 165).

[2] Arberry, *Ḥāfiẓ*, No. 6. The fact that God speaks here through the mouth of His Messenger is not a distinction to be exaggerated. The frequent Ṣūfī reference to Gabriel as the 'Holy Ghost' is a 'confusion of persons' not difficult to forgive to those who came so near to grasping the 'substance' of the Trinity; the more so in view of the close association of Gabriel and the Third Person in the Christian mystery of the Annunciation.

soul's journey!) Sa'dī is often more remarkable than Ḥāfiẓ in this respect:

> My Friend is nearer to me than I myself; all the stranger this and I
> so far from Him!
> What can I do? To whom can I say: 'My Friend is in my bosom
> while I am separated from Him'?[1]

Here, then, is a prime example of the Ṣūfī equilibrium, established in this case on the twin bases of transcendence and immanence, which is to be found virtually nowhere else in Islam. It is not the same equilibrium as the similar Christian phenomenon, its inclination being towards transcendence as the latter's is towards immanence, but the approach of the two great faiths is here as close as anywhere else one could instance. One may remark here on the constant danger of penetration by the gnostic cults to which Ṣūfism was exposed by this inclination, though, as we have already indicated, it never wholly succumbed, and in general remained remarkably free from their influence.

A similar relative relationship appears on a consideration of the Ṣūfī attitude to the problem of Good and Evil. The great body of Muslims, consciously or unconsciously and in varying degrees, incline to the belief that Creation is wholly good, the extremest view being that what seems to be evil comes from God too, and must therefore be good. Like a similar flourishing Christian heresy, it is an energetic, optimistic, self-respecting faith if nothing else! This attitude alone could not satisfy the Ṣūfīs, however; they saw Good and Evil as inevitably and intimately linked in manifest Creation, the Evil acting as a sort of necessary foil to the Good, appearing as a sort of shadow cast by it, and hence revealing it to us; and they looked to a Higher Good, the Absolute, uncontaminated by association with Evil, and therefore, in a sense, different from the Good we here

---

[1] Sa'dī, *Kullīyāt* (ed. 'Abbās Iqbāl), *Gulistān*, p. 56. The Qur'ānic sanction usually cited for this typically Ṣūfī sentiment (50 : 15) is worlds away in its menacing tone and its bareness. All the tragedy of the Fall is in Sa'dī's lines.

know. To know that Ultimate Good, or rather to be one with it, is to divest oneself of all Evil, of all earthly things and above all of one's Self, for it is in the Self that Evil at its 'purest' resides (cf. modern psychological theories). It is easy to see here, even allowing for legitimate exaggeration and overstatement of a position in order to throw it into sharp relief, how dangerously near to the edge of the Manichaean gulf the Ṣūfīs were drifting, particularly as Manichaeism was a native growth of the very soil they trod. Like many Christians, numbers of them were ultimately drawn into that abyss, holding Creation itself as the Supreme Evil. The majority, however, continued to walk with great skill the *Ṣirāṭ-i Mustaqīm* imposed at every turn on believers in all but the 'creedless' faiths which have come in our time.

The Ṣūfīs, like the great Greek thinkers whose heirs in many senses they were, lacked the twin anchors of the Fall and the Incarnation. It is these which have so often tended to save Christian theologians and philosophers from periodical attempted flights or plunges direct into those infinite regions of the Absolute where dwells God in His Essence, and where, one might safely presume, God alone is capable of dwelling. The 'incompleteness' of orthodox Islam in many matters which seem to us fundamental has already been alluded to: a failure to define positively and explicitly man's place in the world, the reason for his involvement in Evil and his relationship to God, in such terms as do Judaism and Christianity, is one of these. Islam takes the present position for granted, and, though by no means ignorant or totally independent of the great 'background-stories' to the inner mysteries of these two faiths, it has never attempted to integrate them vitally into itself. It is in the light of this pragmatism, associated with the transcendentalism and pseudo-Manichaeism already discussed, that we must view the lack of sympathy shown even by the Ṣūfīs with the Incarnation. The ostensibly more repellent mystery of the Trinity was in

fact much more nearly apprehended by them, as by other non-Christians: the triune pattern is inlaid throughout the external world and the human mind too deeply not to be seen by the 'Lovers of God'—Lover, Beloved, and Love were one, so far they could go without personification, but the Incarnation, of its very nature, postulated a Person. It implied, too, God's utter immanence, His full capacity to suffer and be hurt by man (yet without diminution of His Essence), the redeemability of the Natural Order from its purely temporary investment by Evil, and the fitting of the whole into some infinitely great scheme, which far transcended man's interests alone. It is the Incarnation which has made every minute part of Christian worship of infinite and permanent value to the faithful, whatever their level of spiritual development, thus largely precluding a tension similar to that between the Islamic orthodox and the advanced Ṣūfīs, a tension which, despite the labours of Al-Ghazālī, was to become ever more pronounced. It is the Incarnation which has drawn right through the duality of Christ's Nature the fine line dividing union and assimilation from absorption. In all these respects the Incarnation, the Mystery of Mysteries, runs counter not only to the deepest instincts of Islam as a whole, but to many of the Ṣūfīs' dearest doctrines as well. Yet, that even here the Ṣūfīs had gone unbelievably far, seems to be at least one explanation of a line by Sa'dī:

> Behold the generosity and grace of the Lord; the slave has sinned yet *He* bears the shame.[1]

A word must be said here of the evocative power of the imagery employed in Persian mystical poetry, for, while it is the one feature which brings the Persian religious spirit most immediately before us, it is the value most difficult to assess at its original worth. Imagery and symbolism are dialects of a language which mankind now speaks almost only in dreams, but

[1] Sa'dī, *Kullīyāt* (ed. 'Abbās Iqbāl), *Gulistān*, p. 3.

when the great mystical poets of Persia were writing, it was still in the full vigour of a life as old as man's own. Ḥāfiẓ's frequent image of the healing dust from the Beloved's threshold, for example, not only corresponded to a ritual reality of his own culture, but can be traced back a thousand years or more at one bound.[1] What complex associations it must have had for his hearers, modern man can only dimly apprehend from the stirrings of his own subconscious. Here is a field, the proper cultivation of which requires all the resources of scholarship in dealing with the documents, and something much wider and subtler and more vital in the apprehension of the unwritten tradition, where it behoves us to stir from what Montaigne called the 'soft pillow of doubt'. The uncritical rejection of the traditional has often grotesquely distorted the findings of Islamic studies in the past; a close parallel is the nineteenth-century Higher Criticism—indeed, in both cases the blame can often be placed on identical shoulders.

A final remark must be made in connexion with the human-Divine controversy which has still not ceased to rage around Ḥāfiẓ's verse. In the case of our own very similar Donne[2] the critics have little needed to concern themselves with the real difficulties of such a problem, fortified as they were with publication and ordination dates, but in Ḥāfiẓ the complications cannot be escaped. And yet the dilemma belongs in many ways quite peculiarly to our own age: early Christianity could compare Christ's relationship to His Church with the marriage sacrament and vice versa, conscious that the two ideas were so intimately linked as to safeguard the greater from profanation by these comparisons.[3] Of the many difficulties which a modern

---

[1] *Syriac Documents* in the Anti-Nicene Christian Library, vol. xx, p. 121.

[2] How easily Ḥāfiẓ could have written:

> 'Twere profanation of our joys
> To tell the laity our love.

[3] See above, p. 161, n. 1.

scholar concerned with an earlier culture has to meet, none is greater than the dichotomy which since the sixteenth century he carries within himself, the constant tendency to regard the supernatural and the natural, the political and the religious as essentially different and separable. For the Ṣūfīs (and for a great part of Islam until recently) this danger was virtually non-existent.

## § iv. *Fatalism*

It must be made clear that we have no concern here with that quality of mind which Europeans (learned and otherwise) have tended to associate with Islam in general, and, especially since the vogue for ʿUmar Khaiyām, with Persian Islam in particular. Such a mental picture, however vague, has undoubtedly been in the past a flattering foil to their conception of themselves as men of will and action; now, however, that they have begun to doubt their own unaided ability to interpret the world (far less 'change' it), the foil has ceased to flatter and remains only to mock. Where a deeper knowledge of the East has had little effect in removing this misconception, human vanity alone may prompt us to discard it.

What we have in mind in speaking of 'Persian Fatalism' is that genuine ancient stoical pity which springs not from the exasperation of the intellect caught in its own toils, nor from the shame or violated sense of decency of the fortunate confronted with the wretched and the repulsive, but from a spontaneous sympathy (in the full sense of the word) with all that 'lives but a short time and is filled with many miseries'. Its note is not the bitterness of Al-Maʿarrī or the abstract, altruistic concern of the nineteenth-century Liberal, but an echo, necessarily faint, of the compassion of God Himself. It is expended upon those who have suffered as we have suffered, suffer, or shall suffer, and though a strong current of it runs through all Persian belief and expression, it is nowhere more evident than in Firdausī, the bard by choice of the ancient things.

It is a matter for great regret, though it need occasion no surprise, that of all the Persian poets Firdausī is today the least in favour with Western Orientalists. Even in his own land he is cherished today infinitely less by the cultured and the learned than by the unlettered and the simple—a fate which probably gives him a deal of ironic satisfaction. With the single exception that in the West the latter class have virtually no native heritage left to cherish, his position in this, as in many other matters, is comparable to that of our own Chaucer. He enjoys a similar reputation of paternity in respect of his country's poetry and is patronized even more as something of a bore and a rough-and-ready practitioner of the poetic art. (His authorship of *Yūsuf wa-Zulaikhā*, for example, is authoritatively disputed for reasons which, other things being equal, one could well adduce against Dan Geoffrey's authorship of *Troilus and Criseyde*.) In fact, like Chaucer, he is a consummate and polished master of his craft, with a thousand sly tricks of style and character: contrast the exquisite ballet effect of the dance by Zāl and Rudāba's attendants with the whimsical humour of the Sīmurgh's essays in obstetrics! Many of his lines, indeed whole passages, could have been written by Chaucer as they stand, just as he, on his side, could have written the 'Ballade of Bon Counseill': in fact, it would be no very arduous task to find an actual line in Firdausī for every line of that poem. But the two are never closer together than in their compassion for fallen foes, no less than ill-fated friends. The motive spring of this pity was doubtless different: Chaucer found it hard to hate, where he knew that God, having suffered, must love and forgive; Firdausī to condemn, where we are all—yes, even God Himself to some extent —the impotent victims of Fate. But the quality of their pity is one.

Firdausī's implied reduction of Allāh to the level of the Greek gods could not, of course, fail to arouse the anger of the orthodox, and it is difficult not to concede something to their charges

of crypto-Zoroastrianism and Persian racial pride. But in any case, he stands unmistakably as a type of the impoverished, but dignified old country gentleman (there are strong analogies, particularly in the weaknesses, between Firdausī's way of life and character and those of the vanquished Cavaliers after the Civil War), a living conserver of the ancient culture, tolerant, balanced, unfanatical, lively, humorous—above all, humane. It is a spirit we shall find running all through Persian life, religious and mundane alike. Just as it links Firdausī to our earliest great poet, so it may link us, where so many other links have snapped, to the religious spirit of his country, to the larger faith of which it forms a part, to Faith itself.

## § v. *Al-Ghazālī*

We come now to a consideration of the greatest single personal contribution of the Persian spirit to Islam and of his significance for us. Paradoxically, as it will seem to many, the outstanding personality is of the greatest importance in Islam, almost as important as in Protestant Christianity, and for something of the same reasons.[1]

Probably the greatest single representative Persian, in the sense in which one might suggest St. Thomas More as perhaps the greatest single representative Englishman, is Al-Ghazālī. Neither claim, we fear, would be received with overwhelming enthusiasm among the majority of their respective countrymen at the present day, while both might be hotly contested by a scholarship in the main insensitive to all that Ghazālī and More most cherished. Like More, Ghazālī belonged to a broader culture and community than the purely national and wrote for the most part in its lingua franca; like More too, he dramatically abandoned worldly success when it conflicted with his love of God, though in the retired heart-searchings of these two men

[1] Cf. Horten, op. cit., p. 11.

there was no conscious pursuit of the dramatic; finally, like More, he acquitted himself victoriously (though by a victory not of this world) against many of the evils which have now overwhelmed, or are fast overwhelming, his posterity.[1] None of these considerations is likely to recommend either man to the esteem or love of many of his modern compatriots, though it is permitted to hope that the whirligig of time may bring in—not revenges, indeed, in this case—but a certain humility on the one side and a helping forgiveness on the other.

Despite these obstacles then, we choose Al-Ghazālī, not primarily because he is probably the greatest Islamic theologian (this term, of course, even when joined with 'philosopher' and 'mystic', is quite inadequate to describe him), but because, like More he embodies at its clearest every feature regarded as typical of his countrymen throughout their history.[2] In the remarkable affinity between both sets of features we find the prime condition of all legacies.

Ghazālī's life, particularly the crisis and the renunciation which cut across it, has long been celebrated, at least as concerns the bare facts; but we may suppose that, from his age to ours, there can scarcely have been a generation so universally fitted to grasp its real significance as our own: our fruits like his have turned to ashes, though our ashes, as yet unblown-on by the breath of God, have resurrected no phoenix. His work too, in a remote, impersonal sense, has been well understood to lie in the gathering-up and integration of the tangled threads of the religious life of his time, particularly the dominant strand of Ṣūfī mysticism.[3] We are concerned here, however, with the intimate personal significance for us of his life and work.

[1] Nicholson, however (op. cit., p. 237), claims a topicality of this kind for Rūmī rather than Ghazālī.

[2] Their very representativeness has led to the 'hairiest Esaus' claiming their heritage. See R. W. Chambers, *Thomas More* (London, 1935).

[3] See Guillaume, op. cit., pp. 269–75, for an excellent short study of these aspects. Of books on Ghazālī nothing can compare with *La Pensée de Ghazzali*,

Ghazālī was remarkable, not for any great originality of doc-trine,[1] but for the qualities of piety, charity, humility, common sense, and objectivity which he brought to the study of theo-logy-philosophy and to the practice of mysticism. When to these qualities are added profound learning and a clearly attractive personality, he will readily be seen to be a very rare and precious ornament to Islam, as he would be to any faith. He came as near as anyone ever did to reconciling Islam's inner contradic-tions and to relieving its external stresses; that his success in this respect is not to be compared with the results achieved by St. Thomas Aquinas on the Christian side is probably attri-butable less to any inferiority on his part than to the very real (not merely apparent) nature of these difficulties in Islam. In the words of D. B. Macdonald: 'Islam has never outgrown him, never fully understood him.'[2] In this respect too, no less than in his reverent but clear delimitation of the province of human reason, his position is analogous (though no more than analo-gous) to that of the Scholastic Angel.

In Ghazālī and St. Thomas, separated though they are by some 150 years, the Christian and Islamic faiths draw closer together than at any time in their history. The conditions on both sides favoured such a *rapprochement*: they were times of confusion for the worldly wise, of schism and disorder within the respective communities and devastating attacks from without. Then on both sides arose a figure of stupendous proportions, uniting learning with piety and charity (*O si sic omnes!*), and possessing a greater understanding of the opponent's faith than

by A. J. Wensinck (Paris, 1940). In a short compass it compresses an unbeliev-able degree of shrewd judgement and loving insight.

[1] Few men of Ghazālī's day would, of course, have claimed originality for any doctrine of theirs. It was, incidentally, partly this fundamentally sane desire to be rooted in past authority, which led to the fathering off on to the Greek philosophers of so many strange posthumous offspring in Arabic.

[2] *Development of Muslim Theology*, &c. (London, 1903).

many of its own adherents: one may compare St. Thomas's profounder knowledge of Averroes than that possessed by the Averroist Siger with Ghazālī's scrupulously accurate Biblical quotations. Half-unknowing, their wills surrendered to God, these two great men were building a bridge out towards each other, its bases founded not in sentimentality or a belief in the sameness of all religions, but on a firm rock of dogma and the conviction that all souls are beloved of God, some more than others but none less. (Compare St. Thomas's tolerance towards the Jews and Ghazālī's charity towards the 'infamous Yazīd'.) Standing on this bridge, they could the more easily extend their hands without anxiety for their feet: ultimate contact could, of course, never be made in this life, for the two ends of the bridge touch in Paradise and the final link is God Himself.[1] Here, we would suggest, rather than in his 'influence' on European thought (on which in the past much doubtful detailed speculation has been expended),[2] lies Ghazālī's true significance for us. Since the times of Ghazālī and St. Thomas, however, Islam and Christianity have taken paths which not only render a full grasp of these great figures an ever remoter possibility for their co-religionists, but seem likely to take the two great faiths out of even hailing distance of each other. On the one side we have had the growth of a deadly pantheism within Ṣūfī mysticism and the ossification of orthodoxy, on the other the incalculable tragedy of schism and fragmentation. We are in modern times: it is the moment to draw our conclusions, to point our moral, as both faiths, lamentably weak, take the first shocks of anti-God's latest assault.

[1] Guillaume, op. cit., pp. 274–5, has sensed this communion between the two men. Wensinck, op. cit., pp. 199–201, has some very illuminating remarks on what he calls, with more or less literal intent, the 'Christian morality' of Ghazālī.

[2] Cf. M. Smith, *Ghazālī the Mystic* (London, 1944), ch. xiii; also Asin Palacios's writings.

## § vi. *Conclusion*

We have seen that through Persia there flowed the principal channel irrigating the somewhat arid field of Islam with the rich alluvial flood of the ancient culture (the parent culture to which mankind at large is so heavily indebted), and how Persia irradiated with the spirit of her own genius the abundant harvest resulting. In so doing she raised up within Islam those ideas, practices, and personalities which most closely link that faith with the other great faiths of the world, particularly with Christianity. (We must emphasize here that, even had these aspects of Persian genius never influenced Islam as a whole to the extent they did, their significance in existing within Islam would still be immeasurable.) We have studied Persia's influence in this respect under the three heads of Shīʿism, Ṣūfī mysticism, and Fatalism, and observed the whole process culminating, even to some extent historically, in the figure of Al-Ghazālī. For the last 500 years or so we have witnessed the set of the current in a contrary direction, the vessel of Islam lying becalmed, while the ship of Christendom, beset by tempest and desertion, has scudded ever farther away from her over the surrounding ocean of doubt and despair which now threatens to overwhelm both.

In our world of today the aspiration *ut unum sint* is no longer, as in the Middle Ages, the half-understood, half-rejected, fanciful dream which the will of God so often seems, but a mortal necessity: where love is too imperfect to drive out fear, fear may yet accomplish what imperfect love could not. Even rationalist deism, fantastically mistaking the true nature of Islam, has attempted to draw closer to it, though at the same time rejecting its own half-forgotten origins. For the ultimate creation of this unity among the lovers of God (rather out of love than fear, if that may be) Persia has in the past amassed no small part of the material: it is for Muslims and Christians of

the present day to supply the good intent and the energy.[1] There is no question of 'going back': Islam can no more go back to the great Shī'ites, the Ṣūfīs, and the Fatalists, or to Al-Ghazālī, than we to St. Thomas or St. Francis. Even if return were possible, we should not find their spirit at the end of our journey: they are living with us, however little regarded, and ahead of us, where the great bridge, of which we have spoken, is joined in God. Drawn by His Spirit through them, let us press on to join them there. Whatever mere influence Persia through Islam may have had on Europe in the past in the field of religion, her true glory is that her greatest legacy is a hope.

G. M. WICKENS

[1] Labourers are already at the task: at least two Muslim converts to Christianity, Fr. Jean-Muḥammad Abd el-Jalil, and Mgr. Mulla, have probably contributed more than any individuals for centuries past to a charitable Western understanding of the faith of their birth (see the former's *L'Islam et nous*, Paris, 1947), while the late Archbishop Hughes, whose recent death was so widely mourned among the Muslims of Egypt and the Levant, has created a new vision of the possibilities of Muslim–Christian relationships. It is also a pleasure to record the scholarly contributions to such work long made by the Hartford Theological Seminary.

# CHAPTER 7

# THE PERSIAN LANGUAGE

THE Persian language, the *zabān-i fārsī* (the Fārsī tongue) as the inhabitants of Iran call their beautiful speech, is now the dominant language in the land which has for so many centuries offered the famous name of Persia to the imagination of Europe. This language (and the many related languages which we shall touch upon in the few following pages) can be traced by written documents over a period of some 2,700 years; almost therefore as far back as Greek is known to us. Beyond that period detailed comparison with closely related languages gives us some knowledge for about 1,300 years farther into the past.

The written records, apart from the earliest traces in names found in cuneiform texts of Mesopotamia from the time of the first Cyrus, begin in the early Achaemenian period with the long inscriptions of Darius the Great recorded on the rocks of Behistun near Kirmanshah. If we think of a large literature such as many modern languages, or some languages of ancient centres of civilization such as India, China, or Greece can show, these written remains of the Achaemenian period are slight; our materials apart from religious texts remain scanty till in the tenth Christian century the vivid literature of medieval Persia begins. Great losses of literature befell the intervening centuries. Yet for the linguistic specialist, as for the historian, these early Achaemenian monuments are exceedingly precious; and the frequent visits of scholars to these regions to recover every fragment of surviving evidence for science testifies to the abiding fascination of the problems lying before us. Difficulties of interpretation for the older period persist even now, after so many years of intensive study and research in all branches of 'Iranian' learning: it is already some 180 years, if we count from

the time (1770) when the old Zoroastrian texts were first made readily accessible in Europe by Anquetil du Perron.

Since these Iranian studies are a necessity for any complete study of the Indo-European group of languages, which have been spoken at times from far China (Iranian was spoken by Alans even in Peking in Mongol times) to the remote Irish islands, an English student of his own language must know something also of the Old Persian inscriptions. For Indian studies such Iranian knowledge is yet nearer and in fact indispensable. At a later period (for more than a thousand years, from 300 B.C. to A.D. 1000) Iranian studies are vitally concerned with the history of central Asia, into which some of the Iranian tribes had early penetrated.

One difficulty for the student of Iranian problems may be noted at the outset: the problem of interpreting the linguistic remains of the older Iranian languages which are recorded in some twenty-seven different scripts, either in isolated words or in continuous texts of varying extent. But of these many scripts, those chiefly used by writers within the Iranian world were mostly consonantal, and inadequate to give a clear phonetic form for people living centuries later. Much labour has therefore perforce been given to marshalling the evidence for the pronunciation and form of each word. The intense search for evidence has made this knowledge available in large quantity, though many problems await solution and the initial stage of collecting the evidence is not yet over. The workers have been few, yet the task is important; for no student of Iranian can profess to know any Iranian language, unless he can view the whole process of its development from the earliest period to the present day in all its ramifications. We may notice, too, how the area of Iranian linguistic expansion has contracted in the recent centuries until now two countries alone, Persia and Afghanistan, maintain in full independence their two types of living Iranian, supported less fully by the Iranian surviving in the Caucasus and Tajikistan.

We need to observe first that a language is the spoken speech, not the written speech, which can only be an imperfect symbolization of what is spoken. Political or social reasons may establish a particular form of speech in a dominant position, may atrophy it, and maintain it in written form till it becomes unintelligible without years of study. But the language lives on in the mouth of the speakers, a living and growing form, so long as the children learn it from their mothers. Moreover, a language without contact with adjacent dialectal forms of the same speech can hardly be found. As often elsewhere, so it has been in Persia. In the west of what was called Persia by the Greeks, the Median and Persian languages prevailed in Achaemenian times, to be succeeded by the Parthian language under the kings of the family of Aršaka, the Arsacids; then again by Persian from the third Christian century under the Sassanid dynasty, where we find a mingling of the original Persian basis with Parthian from the north and Soghdian elements from the north-east. To this Persian, already a *mélange* of three Iranian languages, the coming of Islam added massively the Arabic material now so prominent. In spite of the intense interplay of these four ingredients it is now possible, after the patient work of Iranian scholars in the past sixty years, to discern the different elements.

Let us first look at the Persian language of the present day as spoken and written in Persia during the past thousand years. If we take a couple of pieces of this *zabān-i fārsī* and analyse it to discover the origin of its parts, we find that basically it is an Iranian language, much augmented and enriched by adventitious materials, so welded into the structure as to seem rightly fitted into it.

In the year A.D. 999 Abū 'l-Qāsim, surnamed Firdausī 'the man of Paradise', wrote the first dedication to his poem the *Shāh-nāma*. In this 'Book of Kings' the poet has told all the wonderful legends of his country, and among them is the legend of the Saka hero Rustam. After the fatal issue of Rustam's fight

with his unrecognized son Suhrāb, Firdausī represents him in
his grief:

> ču bi-šnīδ Rustam sar-aš xīrah gašt
> jihān pēš i čašm andar-aš tīrah gašt
> ham-ē bē tan u tāb u bē tōš gašt
> biy-uftāδ az pāy u bē hōš gašt
> bi-pursīδ az ān pas ki āmaδ bi-hōš
> baδ ō guft bā nālah u bā xurōš
> bi-gō tā či dārē zi Rustam nišān
> ki gum bāδ nām-aš zi gardan-kašān

When Rustam heard, his head was distracted, the world before his
eye became dark within him. He lost power of body, force and strength.
He fell down and became senseless. When he came again to his senses
he asked, he said to him [Suhrāb] with cry and lament: Tell me, what
is this token you hold from Rustam (may his name perish from among
the heroes)?

Considered from the linguistic side we are here in a purely
Persian world. For every word we can offer the older forms of
the language without leaving Persia. Firdausī is by no means
without the intrusive Arabic words which the new faith had
brought with it. But it is easy to find many such purely Persian
passages in his work. Our manuscripts are naturally much later
than Firdausī and have been modernized, but by a judicious use
of the linguistic evidence the approximate pronunciation of
Firdausī's time can be known. In place of the Old Persian diph-
thongs *ai* and *au*, he has the later simple vowels *ē* and *ō*, from
which the modern Persian *ī* and *ū* have come. Such words as
*tāb* and *tāv* 'force' represent simple derivatives from the base
*tav-* 'to be strong, have power'; from the same base with the
old suffix *-iš* comes also *tōš* 'power'. Apart from certain changes
of sound the forms of the words are those which survive at the
present day.

Next look at a quotation from a contemporary writer. Here
the effect of a thousand years of Islamic culture is very marked.

čūn ba'ẓī az maṭālib ī kih 'arẓ xvāham kard naẓarī 'st va mumkin ast bā maẓāq va 'aqīdah ī ba'ẓī ašxāṣ i sāḥib-naẓar muvāfiq nay-āyad umīd-vār am az šanīdan i īn 'aqāyid malūl na šudah raviš i tasāhul pīš gīrand.

Since some of the opinions which I put forward are speculative and it is possible that they will not accord with the tastes and views of some critical persons I hope they will not be offended at hearing them but treat them with indulgence.

Here we have a text rich in adventitious elements (almost all the significant words are Arabic), lending a variety and sonority which even the foreigner can recognize. The purely Iranian material, however, is necessarily extruded by such a development, an extrusion not in itself inevitable since the ideas expressed can easily be represented without foreign words in the older forms of Persian. By this process Persian has become a language of two vocabularies, which from the abstract linguistic point of view makes possible greater affective expression; just as in English are found the three strands of the language, the native English of Germanic, the Anglo-Norman of the medieval period, and the copious learned vocabulary from Latin (through which also many Greek words first came into English). Two almost synonymous words can at any time be differentiated by affective association. Compared as we shall see with the Old Iranian language, however, the New Persian has lost its old freedom in the use of derivation by prefixing directional words to verbal bases. Such words as *fra* 'forward', *uz* 'out, up', *ham* 'together', *ni* 'down', *apa* 'away', *abi* 'towards', *pati* 'to, against, in place of', *ana*, *anu* 'along', *adi* 'upon', *parā* 'off', *vi* 'apart', and in double use as in *vi-ā-* or *adi-ā-*, ceased to be freely employed to define the verbal idea. In New Persian, as in Middle Persian, only certain inseparable compounds of this type have survived. A rich source of new expressions was thus abandoned. Happily another source of richness of expression was preserved, the great freedom of nominal composition. Many old compounds persisted—as in *suvār* 'horseman', the Old Persian

*assabāra*—of which the components ceased to be recognizable, but the method was continued with both indigenous and foreign members.

We must now go back in time to our earliest knowledge of Iranian texts and look at the ancestor of New Persian in the Achaemenian inscriptions. The material, compared with that of a copious modern language, is regrettably limited, being preserved only on rocks, building bricks, and vases. It is, moreover, not easily interpreted linguistically in its inadequate cuneiform script which fails to distinguish, apart from *ă* to some extent, the quantities of vowels which we know to have existed in a still earlier period and which are clearly traceable in New Persian (even in the modern spoken Persian where the quality of *ū* in *būd* 'was' is distinct from the *ọ* in *šud* 'went' (pronounced *šọd*), older *būta-* and *šuta-*); which fails also to indicate in which syllable the vowel was pronounced, so that theoretically *kᵃrᵃtᵃ* 'made' can be read in various ways and other evidence must be evaluated if we decide to read either *karta*, like New Persian *kard*, or *kṛta* (with syllabic *ṛ*), as other evidence makes more likely.

In the description of the building of his palace at Susa Darius gives detailed information of the work and of the workmen who did it, and of the origin of the materials employed. In lines 37–40 we read:

kāsaka hya kapautaka utạ sinkabruš hya idạ kṛta hauv hačā Suguda abariy kāsaka hya axšaina hauv hačā (H)uvārazmiyā abariy hya idạ kṛta.

The blue crystal stone and the vermilion which was worked here were brought from Sogdiana; the dark blue crystal stone which was worked here, was brought from Chorasmia.

All the words here employed play a great part in the later Iranian languages, though the elaborate inflexion rapidly passed out of use. Thus *kapauta* 'blue, grey' is in New Persian *kabūd*, *sinkabruš* 'vermilion' is *šangarf*, *hačā* 'from' is *az* in New Persian

(less changed in the Balōčī *ač*), *bar-* 'to bring' is still *bar-* in New Persian, as in many other Iranian languages.

Consider also a second text of different type, where Xerxes (Xšayāršā) records his religious activities (in the document usually quoted as the Daiva Inscription):

utạ antar aitā dahyāva āha yadā tya paruvam daivā ayadiy pasāva vašnā A[h]uramazdahā adam avam daivadānam viyakanam utạ patiyaz-bayam daivā mā yadiyaiša yadāyā paruvam daivā ayadiy avadạ adam A[h]uramazdām ayadaiy.

And within these provinces there was [a place] where formerly false gods (*daiva*) were worshipped. Then by the will of Ahura Mazda I dug down that House of False Gods and I proclaimed: Thou shall not worship the false gods. Where the false gods were formerly worshipped, there I worshipped Ahura Mazda.

Here we meet the famous words *daiva-* 'false god, demon'; the later *dēv* (now *dīv*); the *yad-* 'worship', the true Persian form of the word *yaz-* which serves to express worship in Zoroastrian texts, and the Old Indian *yaj-*; and above all, the name of the greatest of the *baga-* 'gods', Ahura Mazda, the later Hormuzd. If we take a phrase such as the Old Persian *avahya rādiy* 'for it (or him)' and compare the New Persian *ū rā*, we can see how greatly the language has changed: five syllables have been reduced to two. In all words there have been serious changes, not only by loss of syllables, but by loss of forms. Thus in *azbayam* 'I called' we have the prefixed *a-* which confines *zbayam* to past time, where otherwise it could express a general present 'I call', or a future 'I shall call', or a volitional 'I will call', as well as 'I called'. But this form *a-* has disappeared from all but the one modern Iranian language spoken near Samarkand in the valley of Yaghnāb.

Other and richer Old Iranian literature has reached us in the sacred books of the Zoroastrians. We who visit the ancient shrine of Mitras on the Roman Wall in northern England are

naturally as interested as the Indians who read of Mitra in their most ancient book or of Mihira in the later accounts of the Saka invaders of India, to see what the ancient Zoroastrian priests said of their *yazata* (*īzad*, 'worshipful being'), Mithra. In the collection of sacred poems, the book of the Yashts in the *Avesta*, the following verses occur in honour of Mithra:

> Miθrəm vouru.gaoyaoitīm yazamaide
> yō paoiryō mainyavō yazatō
> tarō Harąm āsnaoiti paurva.naēmāt̲
> aməšahe hū yat̲ aurvat̲.aspahe
> yō paoiryō zaranyō.pīsō
> srīrā̊ barəšnava gərəwnāiti
> aδāt̲ vīspəm āḏiδāiti airyō.šayanəm səvištō

We worship Mithra, possessor of broad pastures, who, as first, a worshipful being of the spiritual world, comes towards us over the Harā mountain before the swift-horsed sun immortal; who, as first, grasps the splendid gold-decked mountain tops, thence gazes upon all the Aryan home, he the most mighty one.

From a yet older set of verses which are attributed to Zoroaster himself the following lines are taken:

> tat̲ θwā pərəsā ərəš mōi vaočā Ahurā
> kō hvapā̊ raočā̊s-čā dāt̲ təmā̊s-čā
> kō hvapā̊ xᵛafnəm-čā dāt̲ zaēmā-čā
> kō yā ušā̊ arəm.piθwā xšapā-čā
> yā manaoθriš čazdōŋhvantəm arəθahyā

This I ask Thee. Tell me truly, Ahura: Who, being a skilled worker, created lights and darknesses? Who, being a skilled worker, created sleep and wakefulness? Who created the dawn, midday and night, which puts the reasoning man in mind of his task?

Here, apart from the elaborate inflexion, better preserved even than in the Old Persian texts, we see many words which appear in later sources. Thus *pərəs-* 'ask' is the New Persian *purs-*; *raočah-* 'day' is now *rūz* (but in Balōčī *rōč*), *dā-* 'create' survives in *nihādan* 'to place', *xšapā-* 'night' is *šab*. The

pronunciation is, inevitably in an ancient language, in many details disputable.

The grammatical system of Old Persian and Avestan, though not completely known owing to the insufficiency of the texts, can be seen to stand at the same stage of development as the oldest known Indian. Here we have a nominal system of eight cases and a verbal system of great complexity in which not only facts relating to present, past, and future could be stated, but various modalities of will, intention, wish, or possibility could be distinguished by change of ending. These forms disappeared later in the history of Persian largely through the loss of vowels in final syllables, but the concepts continued to be expressed by other means, as by prefixes or periphrastic forms. New Persian has advanced farther than other Iranian dialects towards a linguistic type lacking case endings; for example, the surviving ending -*ān* (where Old Persian had -*ānām* as a genitive plural) has usually no longer its older case value as in *šāhanšāh* 'King of kings', and *mōbadān mōbad* 'chief priest', but serves as a subject plural. The case relationships are now abundantly expressed by free use of prepositions, a use only slightly developed in Old Iranian.

The Old Persian texts and the *Avesta* do not, however, represent our earliest knowledge of Iranian. Let it be noticed that in the Old Indian texts as in the Old Iranian the words *pitar-* 'father', *mātar-* 'mother', *āp-* 'water', *vak-* 'to speak', *kar-* 'to make', *ram-* 'to rest', *tar-* 'to cross' are identical; that Iranian *hvahar-* 'sister', *miθra-* 'friendship', *puθra-* 'son', *raθa-* 'cart', *dayra-* 'wonderful', *hazayra-* 'thousand' differ from the corresponding Old Indian *svasar-*, *mitra-*, *putra-*, *ratha-*, *dasra-*, and *sahasra-* simply by a phonetic difference; and that the inflexion of verbs and nouns is for the most part identical (Indian *bharar* 'he bore', Iranian *barat*; Indian *aśvo*, accusative *aśvam* 'horse', Iranian *aspō*, *aspam*); and it is immediately clear that the problem of their relationship cannot be left there without further investigation. Indeed, after some 150 years of

intensive comparative work the relationship as of two sister
languages is well established; each throws light upon the other's
development from a joint Indo-Iranian period beyond which
one ascends still farther back to that original speech which we
call Indo-European, and of which our own English is one
(greatly developed) member.

When we proceed with our inquiry into the history of New
Persian and seek to define its relationship to other Iranian dia-
lects, the middle period between the Achaemenian and the
Islamic periods presents us with more abundant material in a
wider variety of forms. We can now make use of Persian and
Parthian of the Sassanid period preserved in royal and private
inscriptions and in literature written by the followers of Zoroas-
ter, of Mani, and of the Christian Church. Soghdian, of the
region where the famous Marakanda, later Samarkand, was
capital city, has survived in three dialects and even today is
spoken in the valley of Yaghnāb. Farther east we find in the
ancient city of Khotan the Iranian language of one of the wander-
ing Saka tribes of central Asia, now forgotten in its old home,
where Turkish has taken its place. As a result of archaeological
work during this century our knowledge of this Middle Iranian
period has been much enriched by the discovery of manuscript
materials, chiefly in central Asia, in the region of Samarkand
and also in manuscripts from Khwārizm of the eleventh Chris-
tian century.

Let us first examine the Persian language in the famous book
of Mani, the Šāβuhrayān 'The Book of Shāpūr', dedicated to
King Shāpūr I. Here we may read:

'wd 'č ps pr'whr w'd 'wd 'č ps w'd rwšn 'wd 'č ps rwšn 'b 'wd
'č ps 'b 'dwr 'pwwr 'ws pymwxt hynd 'wš 'dwr pd dst d'št 'wd 'br
'hrmyn 'wd dyw'n prnft 'wš zd
(uδ az pas frawahr wāδ uδ az pas wāδ rōšn uδ az pas rōšn āβ
uδ az pas āβ āδur āfur u-š paimōxt hend u-š āδur paδ dast dāšt uδ
aβar Ahrmen uδ dēwān franaft u-š zaδ)

And after the ether was the creation of wind, and after wind of light, and after light of water, and after water of fire; and he dressed himself in them, and he held fire in his hand, and advanced against Ahriman and the demons, and smote them.

Or listen to one of the favourite parables of Mani:

"wn čʼwn rʼzmyrd ky qʼmyd "ywn qyrdn ʼwd pd xwyš dʼnyšnʼz ʼbčʼr ʽy gwnggwng ʽy "ywn pd qdgqdg ẅ pd drdr hmbxšyd ʼwd dysyd

(āōn čaōn rāz-merd kē kāmēδ āywan kerdan uδ paδ xwēš dānišn az aβzār ī gōnay-gōnay ī āywan paδ kaδay-kaδay uδ paδ dar-dar hambaxšēδ uδ dēsēδ)

Just as a builder who wishes to build a palace and by his own knowledge apportions out the various materials for the palace to the different rooms and gates, and builds.

Here the purely Iranian character of the language will at once be noted. Indeed, apart from a few technical terms from the Syriac language (in which Mani usually wrote), these Manichaean texts are in pure Persian, just as the Manichaean Parthian texts are in pure Parthian. It will be seen too that as early as the time of Mani all the old nominal inflexion has disappeared and the verbal system has been remodelled. The vocabulary retains a rich series of simple, compound, and derivative forms.

The following acrostic verses from a Manichaean Parthian text will suffice to illustrate this language (it is given vocalized but in the original the text is consonantal):

až rōšn uδ yazdān hem uδ izdeh būδ hem
až hawēn amwašt aβar man dušmanēn u-šān ō murdān ēδwāst hem
āfrīδ ku bōxtay bawāh kē man grīw bōžāh až wiδang
bay hem kē zāδ až bayān
bāmēn humyāst uδ nīsāy
brāzāy xumbōy uδ hužihr
bēδ awās gaδ hem ō niyāz

I am from the Light and from the Gods, but I have become an exile, turned aside from them. My enemies are upon me and have led me to the dead. Blessed be Thou (so that Thou be saved), who wilt deliver

my soul from ill. I am a god, born of the gods, brilliant, flashing, and bright, shining, sweet-scented and lovely, but now I have fallen into distress.

Here the old word *baγ*, in Old Persian *baga-* 'god', has the Parthian form to which the Persian presents *bay*; and *gaδ* 'gone', Old Persian *gata-*, contrasts with Persian *šuδ*.

Such Persian and Parthian texts written in the Manichaean adaptation of the Syriac script have a most familiar air. The clarity of the material has provided a secure basis for the study of this middle period of western Iranian linguistic history. Such difficulties as remain lie in the lost and still unrecovered Iranian words. But not all the materials have yet been published, so that some of the unsolved problems will certainly be solved. From this secure basis it is possible to proceed with confidence to interpret another copious mass of Middle Persian materials preserved by the Zoroastrians. This has long been known in the libraries of Europe and among the present-day Zoroastrians in Persia and India, but has hitherto presented forbidding difficulties. Here in the so-called 'Pahlavi' texts of the Zoroastrians much early Persian material has survived of great importance for Iranian studies. The language is copious: the writers are found adapting Aristotelian philosophy, beside the many theological discussions.

The primary difficulty in interpreting these Pahlavi texts arises from the script, in which the original twenty-two distinct consonants of the parent Aramaic alphabet have been reduced to only fourteen different forms. The Sassanid coins and inscriptions show the same script before the reduction had advanced so far and only *w*, *r*, and the *'ain* have been confused. In Pahlavi some consonantal outlines can be read theoretically in a large number of ways, and external evidence is necessary to decide the form in each case. Such necessary evidence is abundantly provided by the newly discovered Persian and Parthian sources. The Pahlavi consonantal system of spelling represents an older

form than that used in the Manichaean texts, and indicates that the usage has been inherited from probably about the fourth century B.C. Thus the word written *t'pyt* \**tāpēt* from an older \**tāpayati* 'it burns' corresponds to a pronunciation in Sassanid times of \**tāβēδ* (which in Arabic script one may write تافيذ).

A second difficulty lay in the use of Aramaic words in a system called *Uzvārišn* 'interpretation', surviving from a time when a purely Aramaic text was read out by the secretaries, not in Aramaic but in a Persian 'interpretation'. The same system has left traces in Soghdian, especially in the Buddhist texts, but is absent from the Persian and Parthian of the Manichaean books, which disclose the spoken Persian of the third Christian century.

A short passage from the epic tale of the conflict of Vishtāsp and Arzhāsp will illustrate this type of Persian in the Zoroastrian books:

AHL 'rč'sp hywn'n hwt'y MN kwp sr nk's 'BDWNyt W YMRWNyt AYK ZK MNN AYT MNN ZK 10 ŠNTk lhyk MNN gwrtw'r SWSYA d'ryt W gwrtw'r zyn YHSNNyt k'ryč'r 'wgwn tg 'BDWNyt čygwn zryr 'yr'n sp'hpt krt

(pas Aržāsp Xyōnān xvatāy hač kōf nikās kunēt ut gōβēt ku ān kē hast kē ān dah-sālak rahīk (rētak) kē gurtvār asp dārēt ut gurtvār zēn dārēt, kārīčār ōgōn tak kunēt čēgōn Zarēr Ērān spāhpat kart)

Then Arzhāsp, lord of the Chionians, looked from the top of the hill and said, Who is yonder ten-year old boy, who has a warrior's horse, who has a warrior's arms, and fights boldly like Zarēr the general of Persia?

Persian and Parthian are closely related dialects and near to New Persian. A very different appearance is presented by both Soghdian and Khotanese. For the pronunciation of Soghdian an important guide is offered us in the modern Soghdian spoken in the Yaghnāb valley, as important for Soghdian as is modern Persian for earlier Persian. But of the language of Khotan, of

which our most recent texts are probably from the tenth Christian century, no modern representative has been found.

The following is a fragment of the tale of the famous hero of the Sakas, Rustam, found in a Soghdian manuscript (recorded like so much Iranian only in a consonantal text):

rxšy ptysynt ywnyδ zyw'rt xw rwstmy č'n'kw 'xw δywt wyn'nt ywnyδ zγ'rt ZKw β'r'yčyk' βr'p'š'nt wβyw xw pδ'k 'sp'δ 'yw δβty m'yδ w'β'nt 'kδry ZKn srδ'nk'xw myn'y 'nxw'st 'sk'tr rm m'xw 'nx''s LA pršt't βwt k'm šw kδ'č LA w'č'yδ k'm šw ms LA ptxwyδ' p'rZY m'yδ zw'ntkw 'ny'sδ' ktšw 'βzyw βr's ẓγw tr'nk' 'nšt'ymn xw δywt 'yw δβty šyr wys'yδ'nt sγtm'nn p'ẓγyr'nt wytr'nt ZKn rwstmy 'škrčy wyδ'γty zyw'rt 'xw rwstmy

Rakhsh agreed. At once Rustam turned back. When the demons saw this, at once they swiftly smote the horseman and the footmen together. To one another they cried: 'The chieftain's courage is now broken, with us he will be unable to fight longer. Let him not flee away, yet kill him not, but take him alive that we may torture him most cruelly.' The demons greatly incited one another; together they called out. They started in pursuit of Rustam. Then Rustam turned.

In any piece of Soghdian there are so many details of pronunciation still to be decided that it is hardly safe to print a vocalized text. But many of the words can with some assurance be given; thus, δēwt, 'demons', vēnant 'they saw', vẹsēδant 'they called', aspāδ 'army', anxās 'fight', ēw δiβ(i)ti 'one another', and žuvantak- 'alive'. The spelling is at times archaistic, so that -'kw from Old Iranian -akam may be written for -'w, and so indicate -au, or -ŏ, or even -u. There is evidence too that the old -nt tended to -nd in pronunciation. The final -u and -i were probably still pronounced; certainly we find that the modern Soghdian still pronounces final -i of the oblique case. We should note too that -ak, -aku, and -'y may have been pronounced alike as -ai, or -ē, or even -ĕ, and that initially an indefinite ə or ŏ sound occurred where a- has been put in such words as akθri,

aspāδ, askātar, and like cases. In place of the close ę̄ possibly ī
was pronounced.

With considerable reservations therefore the above text could
be interpreted as follows:

Raxši patęsint. yōnēθ zęwart xō Rustami. čāno axō δēwt wēnant
yōnēθ žγar tawu βārēčīk frāpašant uβiu xō paδak aspāδ. ēw δiβ(i)ti maiθ
βāwant: akθri awin sarθang xō mēnē anxwāst, askātar ram māxu anxās
nē parštāt βaut-kām, šu kaδā-č nā wāčēθ-kām, šu mas nā patxwayθa,
pār-ti maiθ žuwantaku anyāsθa, kat-šu aβžiu frās žaγu trang anštāyman.
xō δēwt ēw δiβ(i)ti šir węsēδant, saγtmān pāžγērant, wętarant awin
Rustami aškarči. wēδaγtē zęwart xō Rustami.

The vocabulary is purely Iranian, but it has remained separate
from the western Iranian development of Persian and is not
likely to have been intelligible when spoken to a Persian. Cer-
tainly we find the Soghdians had glossaries to explain the
Persian and Parthian words of their sacred texts. The still little-
known Chorasmian of the eleventh Christian century shows
marked relationship with Soghdian. A certain part of the New
Persian vocabulary has been derived from Soghdian. Among
such words we find *sarčīk* 'chief', Soghdian *srč'yk*, *mul* 'wine',
Soghdian *mwδ-*, *pasāk* 'garland of flowers', Soghdian *'ps'k*,
*linǰ-* 'to pull out', Soghdian *δynč-*, and many others.

The remaining Middle Iranian language, of which we have a
copious material, is that spoken formerly in the ancient kingdom
of Khotan to the south-east of Kashgar. A related dialect but
with distinctive character was also spoken in the region of
Tumshuq to the north-east of Kashgar, but of that language
very little has so far been found, and the little known has not
yet been fully interpreted. We know the language of Khotan in
two clearly distinct forms, an older and a later. The older
Khotanese is still a highly inflected language with seven cases
in nominal inflexion and a rich verbal system. The following
verses occurring in unexpected company in an old collection of
doctrinal texts illustrates the older stage:

hämätä pasälä ysama-śśaṃdya grāmu hämätu
späte vicitra banhya vätä hārsta biśśa
karāśśä haṣprīye haphastāre käḍe
padamäna banhyänu padamä būtte śśäru
viysäṃgye hārste khāhe āṣṣiṃgye ggare
murka briyūnu käḍe bagyeṣṣäre pharu
ūtce pastāte ysarūñe tcalce jahe
haḍā pätaunda ysaṃthauna ttauda käḍe

Spring has come. In the earth it is warm. The many-coloured flowers
have blossomed on all the trees. The creeper has burgeoned; they sway
about exceedingly in the wind. The wind from the trees smells sweetly.
The lotus-pools have blossomed, the springs, the ponds and the hills.
The birds sing many a most lovely song. The waters have flowed on the
green bank at the fountain. The days are clouded, the living beings are
hot exceedingly.

The pronunciation of Khotanese can be approximately re-
covered by a study of the sounds expressed by the single and
conjunct letters of its Indian script. We find an elaborate system
of vowels and of consonants, for which the Indian Brāhmī script
could provide only inadequately.

The later stage of Khotanese shows a diminished inflexion
and great phonetic changes. The following passage comes from
the tale of Prince Sudhana and his fairy bride Manoharā when
she has been seized by the hunter:

sūdhaṇa raispūrri byahi ṇetsve vyūhä:nä
kalyāṇa ysīrī bve'yāscye raha baidä
ttu bījāṣa pyūṣṭa strīyi hīyai ysairka
ysīrai pana tta ye se mū cī ṣṭā nväśe

Sudhana the prince went out to hunt with his following, his heart
auspicious, upon his brilliant chariot. He heard that woeful cry of the
woman. In his heart he thought, 'Who is it here lamenting?'

Here we find *ṇetsve* 'he went out' where the older Khotanese
had *naltsute*, *ye* for the older *väte* 'he was', and *ṣṭā* for older
*ṣṭānä*, so that these words are at least one syllable shorter. By

phonetic changes in the final syllable also the inflexion is funda-
mentally simplified. Where in older Khotanese the nominative
singular -*ä* is different from the accusative singular -*u*, in the
later Khotanese there is but the one form -*ä*. The older genitive
-*änu* develops to -*äm* and -*ä*.

When we turn to survey Iranian at the present day we find
a still more diversified field with ever-increasing materials for
the interpretation of the present as of earlier forms. New Per-
sian has itself developed from a highly inflected language into a
clear simplified analytic type, freed from the shackles of the rich
old Iranian inflexion, yet by a new verbal system and by the
abundant use of prepositions able to express the same concepts
which could be expressed by different means in the older stages.
By the end of the Sassanid period in the seventh Christian cen-
tury Persian had evolved more fully than the Pashto of Afghani-
stan at the present day. Apart from the orthography of Zoroas-
trian 'Pahlavi' books, Sassanid coins, and inscriptions, the
difference between the Persian of the Sassanid period (clearly
revealed to us in the third Christian century in Manichaean
books) and the Persian of the early Islamic period is one of
vocabulary. The new religion brought many of its technical
words into Persia and, as the new sacred language, Arabic from
that time became increasingly the source of new expressions.
The mainly consonantal orthography has disguised the phonetic
changes, but till the thirteenth Christian century the Old Per-
sian diphthongs *ai* and *au* survived as *ē* and *ō* and the Old Persian
-*t*- intervocally survived as the fricative *dh* as in *bādh*, later *bād*
'wind', the Old Iranian *vāta*-. In the famous ma�342 script of
A.D. 970, containing Al-Haravī's medical treatise, we have also
still (as in *banafš-βām* 'violet-coloured') the fricative ڤ *β* which
had replaced Old Persian *b* and *p* between vowels. But later
scribes introduced their more recent spelling, and distinction
of vowel sounds could not be indicated by the script.

It is from this New Persian that so many Persian words have

found their way into English, some by slow stages westwards over the Arabs and the continental peoples, others again by way of India. From the most ancient times of contact between Persia and Greece onwards we find traces of the Persian vocabulary in the West. Our 'satrap' through ancient Greek *satrapēs* 'governor of a province' is a Median word corresponding on the Achaemenian inscriptions to Persian *xšaçapāvā*; the word passed both to India (*kṣatrapa*) and to the whole of Europe. Our 'peach' as a Persian fruit, coming to us through a Latin *persica* 'Persian', preserves the name of the ancient land of Pārsa, whence the Persians have their modern Fārs. Our own form 'Persia' passed through the Ionian Greek dialect which pronounced *ē* for a foreign *ā*. The modern Fārs has in its turn been modified through Arabic transmission. The 'evil spirit' of the Persians has become well known to us as Ahriman. The lilac or laylok is named from the colour in a Persian form of the Indian *nīla-* 'dark blue', and the water lily (nenuphar) is the Persian *nīlūfar*, itself from an Indian *nīlotpala*. Caravan, which at first meant a nomad group or a troop, derivative of the Old Persian *kāra-* 'troop', and the word caravanserai, the inn (*sarāy* 'room') to receive travellers, are among our common words. It should, too, not pass unnoticed that in the pre-Islamic period Persia had given a large vocabulary of cultural words to Armenia, where these words are still in vivid use. When recently the Armenians wished to express the concept of a 'convoy' of ships they invented the compound *navakaravan* 'ship caravan' from this Persian element in their language.

When, after the flood of Arabic conquest, at its renaissance in the Samanid period, the Persian language rose again to its old dominant position in literature, it began to extend its influence to its Turkish neighbours. The Turks, who had abandoned their older belief in the qams or shamans, or their Manichaean, Buddhist, and Christian religions with the literatures attached to them, to become Muslims, found in the Persian language an

inexhaustible source of choice expressions to clothe the new
ideas they wished to express in Turkish. In Anatolia the early
Turkish poetry is woven with Persian phrases, and with the
Persian came the richer Arabic vocabulary. Today, after a period
of intense nationalism, the Turkish language is still studded with
Persian words. In it we find the familiar Persian words *mah*
'month', *miyan* 'middle', *mey* 'wine', *can* 'soul', *cihan* 'world',
*dilber* 'charming', *ham* 'raw', *hem* 'same', *afsun* 'sorcery', *mühür*
'seal', *ateş* 'fire', *hane* 'house', and *kemer* 'girdle', and many
another word. At times these foreign words are set in a Persian
phrase. They have become, with the abundant Arabic, a staple
part of the western variety of Turkish.

The Persian language made yet another remarkable conquest
when it was introduced into India with the Turkish and Mughal
invasions. From the local language of the Delhi (Dihli) region,
the older Śauraseni Prakrit, a new language arose, the Urdū.
Persian words and phrases, with the Arabic earlier incorporated
into Persian, were grafted upon the still highly inflected local
speech. In the following short excerpt from the beginning of a
tale the foreign element is decidedly large.

wahān kā ēk bādšāh bahut baṛā aur nāmwar thā, bi-sababi ʿadl u
inṣāf kē raʿīyat usē bahut dōst rakhtī thī, uskā jāh u jalāl aur xazānah wa
laškar bē-šumār thā

Of that place there was a great and famous king. By reason of his
justice the people greatly loved him. His majesty and treasure and
forces were beyond counting.

Here, apart from the words *wahān* 'there', *us* 'he', *baṛā*
'great', *bahut* 'much', *aur* 'and'; and the verbs *thā*, *thī* 'was', and
*rakh-* 'keep', all the words are foreign, either Arabic or Persian.

But Persian is only one of many forms of Iranian still spoken,
though it has attained a prestige in the world of Asia which no
other Iranian language now enjoys. Yet it is a very different
Iranian language, the speech of the Alans, which has in its

modern form retained the most archaic character among all these dialects. The Old Iranian system of eight cases, elsewhere greatly reduced in number, has been carried on in this modern Alan or Ās language, the Ossetic, spoken in the Caucasus, into the present form of the language; though phonetic changes have compelled the speakers to create new means to express them. The verbal system, too, has greatly changed from the Old Iranian type, yet vigorously renovated is able to express all the nuances the Old Iranian verb had known, precise and clear through its elaborate system of preverbs (*a, är, ära, ra, ba, ärba, i, ni, fä, fäl*).

It is in the verbal prefix that one finds one of the most archaic features of Ossetic. Here, as in our oldest Iranian texts, the preverb stands independent of the verb separated by one or more words. Just as in Avestan we find *paitī stavas ayenī* 'I will approach uttering praise', so in Ossetic we have *ba jimä co* 'go to him', *ärba mäbäl xaudtäj* 'it fell upon me', *ni 'j art kodta* 'he set fire to it'. The oldest Indian and Greek has the same freedom, but it is lost in modern Persian. A fully developed definite article *i* marks Ossetic off from its sister dialects. An oral literature of striking originality began to be written down last century and the language is being vigorously adapted to modern use. Among the many tales those of the Nart heroes stand out. From one of these comes the following passage:

ustur i Nārtmä bärägdär ādtäj duuä mugkāgi Bōriātä ämä Äxsärtäg-kātä, Bōriātä ādtäncä bērä mugkāg, Äxsärtägkātä bā ādämäj mink'i, äxsārä bā iting mugkāg

Among the great Narts there were two more distinguished families, the Bōriātä and the Äxsärtägkātä. The Bōriātä were a large family, but the Äxsärtägkātä were few in men, but a mighty family in valour.

In Ossetic we find many words which have no equivalent in the other Iranian languages; some of these belong to the Caucasus, where Ossetic is now spoken. The familiar Arabic

words of modern Persian are rare in Ossetic. In the above passage *ādäm* 'people' is found, but such a word and some few others are common to many Islamic peoples. When Ossetic borrowed in the past it was from its neighbours, and now more fully from Russian. Its archaic character gives Ossetic a place of particular importance when the Iranian linguistic group is studied. There is reason for a more lively interest in these Ossetes and their ancestors the Alans and Sarmatians for us in Britain, when we recall that 5,500 Sarmatians were brought to Britain (where they settled) by the Romans in the third Christian century.

In this brief attempt to illuminate the evolution of Persian by summoning the related dialects to witness, it is not possible to cite many. But three others which have attained to written form richly deserve to stand out. In Afghanistan the Pashto, after a period of eclipse among the educated, has in recent years gained wider national recognition. Among its poetic books are the vigorous verse of Khushḥāl Khān Khaṭak in the time of Aurangzeb:

> rā ša wārwa dā dāstān    nēk wa bad pa kšē bayān
> ham ʿabrat ham naṣīḥat dai    prē di pōh šī dānāyān

Come, hear this tale. Good and bad are shown in it. It is alike warning and counsel. Wise men, take note of it.

The large admixture of Persian and Arabic words will at once be noticed; all Khushḥāl's verses are full of them. But the distinct features of Pashto are well represented in its verbal system and its still extensive nominal inflexion.

Among the Baluchi tribes who speak an Iranian language of the western type, heroic poems and ballads have been recorded by visitors, and here too a more archaic language than Persian has persisted. To find *rōč* 'day' where Persian had *rōz*, but now has *rūz*, little changed from the *rauča-* of the Old Persian texts; or *bandag* 'binding' like Old Persian *bandaka-* 'servant'; or the *kapta* 'fallen' which was known to Middle Persian as a loan-

word *kaft*, but is unknown to New Persian; is to realize how well Baluchi has resisted phonetic change. Here, too, many words have entered from neighbouring languages which infringe its Iranian heritage; yet the following verses are a good testimony to its basic independence:

> kahnē ō kavōt murɣānī
> hāl mahramē dōstānī
> dīrēŋ mizilō rahiyānī
> gwar tau manī minnat āŋ savzēŋ murɣ
> udrē až murɣānī kamundēŋ kōhā
> bi rō gwar mēravā dōstēɣā
> tau nindē manjava rāstiyā

O pigeon and dove among the birds, messenger of my state to my beloved, long mayest thou go. On thee be my blessing, grey bird. Fly from thy cliff of night, from the birds' rugged rock. Go to the abode of my beloved, sit on the right hand of her couch.

Here in Baluchi we find also the foreign element of the Sindhī language beside the familiar Persian and Arabic words. But some of the earlier Iranian inflexion has survived, of which Persian has kept no trace.

Kurdish, too, in the west has its manuscript texts and abundant folklore. It is a good representative of the north-western group of Iranian languages, but like Persian it has undergone extensive phonetic changes, beside which Pashto and Baluchi appear very archaic. The following verses are from the epic tale of Mame Alan (in the orthography which owes much to Turkish models):

> hebūn sē qīzēn padişahē periyane
> rojekā derketin, çūn ser kaniya gulane
> ji xwe danīn postēn kewane
> ketine nava hewza gulane

There were three daughters of the king of the fairies. One day they went to the Fountain of Roses. They put off their garments of the plumage of birds, and descended into the pool of Roses.

It is not easy to recognize at once in *ket-* the *kaft* 'fallen' familiar in the older northern dialectal texts, or in *kewane* 'doves', a word akin to Old Persian *kapauta* 'blue grey'; in *roj-* (that is, *rōž*) 'day' we have the cousin of Baluchi *rōč*.

To these three which have either developed or are developing literatures of their own, I would add the archaic language of Wakhān in the Pamirs, known to us only from travellers. It is here we find *pötr* 'son' where the Avestan has *puθra-* and Persian *pūr*; *mərtk* 'dead', *nayd* 'night', *naydīn-yūpk* 'dew' ('night-water'), *ðəyd* 'daughter' (Persian *duxt*), *pūvəm* 'I drink' (Old Iranian *pā-*), *zem* 'snow' (Avestan *zyam-*: *zim-* 'winter'), *rəwəz-* 'to fly' from *fra-vaz-*, and many other Iranian words of similarly archaic appearance.

It is by comparison with these and many other local forms of Iranian that we can comprehend the position of Persian in the linguistic community of Iran and India, and look thence to the wider horizon of the Indo-European language. Within Iranian studies Persian takes a place of great prominence and importance. In the larger field of general linguistics it can display a development over a long period of time and a type of language, with all its archaic survivals, of extreme analytical character. Its early change from a highly inflected language to a language, already in the third Christian century, without nominal inflexion may have owed something to the political sphere of a large empire which it was called to serve.

The following summary may assist in making the relationship of the Iranian languages somewhat clearer.

1. *Oldest stage* ('*Old Iranian*'):

Old Persian in the Achaemenid inscriptions.

Median in proper names and some words in Assyrian, Greek, and Old Persian texts.

Avestan texts, of uncertain local origin, perhaps from ancient Chorasmia.

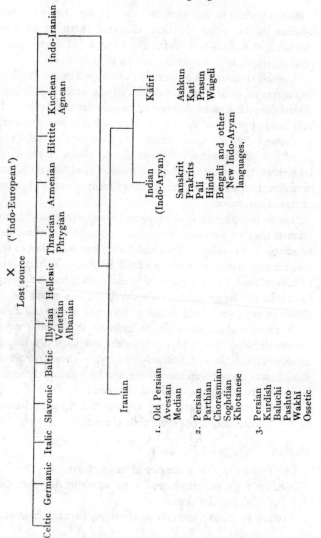

*Persian in its relationship to other Indo-European languages*

| | |
|---|---|
| Celtic | |
| Germanic | |
| Italic | |
| Slavonic | |
| Baltic | |
| Illyrian Venetian Albanian | |
| Hellenic | |
| Thracian Phrygian | |
| Armenian | |
| Hittite | |
| Kuchean Agnean | |

('Indo-European')

X
Lost source

Indo-Iranian

Iranian

Kâfiri — Ashkun / Kati / Prasun / Waigeli

Indian (Indo-Aryan) — Sanskrit / Prakrits / Pali / Hindi / Bengali and other New Indo-Aryan languages.

1. Old Persian / Avestan / Median

2. Persian / Parthian / Chorasmian / Soghdian / Khotanese

3. Persian / Kurdish / Baluchi / Pashto / Wakhi / Ossetic

2. *Later stage* ('*Middle Iranian*'):

Persian and Parthian texts from Sassanian Persia and central Asia.

Soghdian texts from central Asia and in the mountains near Samarkand.

Chorasmian, found quoted in Arabic legal and other manuscripts of the eleventh century A.D.

Khotanese from Khotan in central Asia written between about the fourth and the tenth centuries A.D.

3. *Contemporary stage* ('*New Iranian*'):

Persian, the standard language of Persia, which has incorporated many Parthian and Soghdian elements.

Kurdish in Persia, Iraq, and Turkey.

Baluchi in Baluchistan.

Pashto, the chief language of Afghanistan.

Wakhī and other languages in the Pamirs.

Modern Soghdian, spoken near Samarkand in the valley of Yaghnāb.

Ossetic, the language of the Alans of medieval times, spoken in the Caucasus.

Many local dialects are also spoken in Persia and Soviet Azerbaijan.

H. W. Bailey

# PERSIAN LITERATURE

To keep the discourse within reasonable bounds—for the litera-
ture of Persia and the Persians is vast in extent and reaches back
far into the mists of early time—it has been proposed in this
essay to discuss only the products of the Islamic era (except that
it is interesting to view these against the background of the
preceding ages); to consider the broad general characteristics
of these products, so as to see what is peculiarly Persian about
them; to refer briefly to the contributions made by men of
Persian blood to Arabic literature; and in passing to indicate
something of the way Persian writings influenced the develop-
ment of the literatures of Turkey and Muslim India. To avoid
confusion, the term Persian will in these pages be reserved for
the literature of Muslim Persia; the earlier writings when men-
tioned will be called Iranian.

In the three centuries following the Muslim conquest (seventh
to ninth centuries A.D.) literary activity in Persia was confined
either, with those who clung stubbornly to their Zoroastrian
faith, to the recording and transmission of its sacred scriptures,
or, among the far more numerous converts to the new religion,
and the even greater multitude who were prepared to serve its
interests without passionate aversion or enthusiasm, to the
development and expansion of Arabic literature. The language
of the people was meanwhile undergoing profound changes, in
many respects similar to those which came over Anglo-Saxon
after the Norman conquest; the inflexions of Iranian speech
were gradually shed, and the vocabulary was substantially en-
riched by taking in many thousands of words from the Semitic
speech of their conquerors. When Persian emerged as a literary
medium it proved to be decidedly superior to its parent;
generations of shaping and polishing made it into perhaps the

sweetest, most melodious language of the East, capable of being the instrument of one of the great literatures of mankind.

Before examining the books of Muslim Persia it will be useful to pass in brief review what has survived or is known of Iranian literature; in this order the pattern is more clearly realized. During Achaemenid dominion, and to the last days of the Sassanian Chosroes, Iran had been an imperial power, a classic Oriental despotism; immense wealth in few hands had built an impressive material culture on the prostrate bodies of the indigent masses. That culture was essentially of the palace, and in no branch so markedly as in writing. Apart from the Avestan scriptures of a faith always favourable to the aristocracy, understood and interpreted only by an exclusive clergy, and recorded in a script incomprehensible to the illiterate congregation, the rest of Iranian literature circles round the imperial court and waits upon its interests. The court, even in Achaemenid times, as we learn from Agathias, kept its official annals; the practice was continued by subsequent dynasts. It was out of these materials, as is generally supposed, that an anonymous compiler towards the end of the Sassanian rule fashioned the *Khvadhāy-nāmagh* which, after being translated from Pahlavi into Arabic by the Persian Ibn al-Muqaffaʿ (d. 757) and others, eventually through the genius of Firdausī (d. *c.* 1020) took new shape as one of the world's greatest epic poems, the celebrated *Shāh-nāma.* Though the original has perished and only fragments of the Arabic version have survived, what is in our hands suffices to determine the biased and rhetorical nature of the narrative, which can hardly have failed to impress the Arabs, who had no recorded history of their own and never knew Thucydides, as a model of what historiography should be.

The second great court composition of Sassanian Persia, the *Āyēnnāmagh*, stated by the Arab historian Masʿūdī to have run into several thousand pages, and translated into Arabic likewise by Ibn al-Muqaffaʿ, similarly to vanish but for occasional quota-

tions, supplemented the ornate narrative of the annals with a detailed account of the institutes of the empire; to regulations on government were added excursuses on strategy, archery, divination, and such-like noble arts; a special section, the *Gāhnāmagh*, enumerated the six hundred orders of the aristocracy arranged according to elevation. Though we must regret the disappearance of this massive work, whose influence is abundantly evident in a series of Persian, not to mention Arabic, books, we fortunately possess a substantial indication of its character and style in the *Tansar-nāma*, a letter embedded in Ibn Isfandiyār's *History of Tabaristan* purporting to have been written originally at the beginning of Ardashīr I's reign (A.D. 226–41) but in reality composed, as Christensen has proved, in the time of Khusrū I between 557 and 570.

Mas'ūdī informs us that in 915 he saw at Ctesiphon in the house of a noble Persian 'a great book containing much of their sciences, the histories of their kings, their buildings, and political institutions. In it were portrayed twenty-seven of the Sassanian rulers of Persia, twenty-five being men and two women. Each of them had been portrayed on the day of his death, whether he was young or old, together with his ornament, crown, style of beard and facial expression; if he was at war he was shown standing, if engaged in affairs, sitting.' The book also comprised 'the conduct of each king towards both his officers and the general public, and the great events and important happenings of his reign'. It was dated A.D. 731 and had been compiled from materials found in the Royal Treasury, translated from Persian (*sc.* Pahlavi) into Arabic for the caliph Hishām. It was first proposed by Gutschmid, and his conjecture has been supported by Inostrantzev, Schaeder, and Christensen, that this remarkable book is to be identified with the *Tāghnāmagh*, which is known to us otherwise by quotation only. The title was evidently in the mind of the author (perhaps Jāḥiẓ) of the Arabic *Kitāb al-Tāj*.

Apart from these more or less official manuals of the imperial

court, Iranian Persia also possessed a number of historical romances, such as the surviving post-Sassanian *Kārnāmagh i Ardashīr i Pābhaghān*, passages of which have been compared by E. G. Browne with corresponding sections in the *Shāh-nāma*; notices on the foundation of cities; and a variety of little compilations of popular ethics, the so-called *andarz*-literature, some examples of which are extant. This last-named class of writing, of which the most celebrated specimen is the *Pandnāmagh i Vuzurgmihr* (the Counsels of Buzurgmihr, Khusrū Anūsharvān's wise minister), is a thoroughly characteristic product of the Persian genius and exercised great influence on the subsequent literatures of Islam; to it in large measure we owe the numerous ethical compendia ranging from the *Qābūs-nāma* to the *Gulistān*, not to mention countless poems from the tenth century down to the present day.

Of poetry very little has survived from the old days, though we have some fragments of Iranian epic and even a specimen of *munāzara*, the 'strife-poem' in which two animate or inanimate protagonists engage in argument—a very favourite convention for moralizing still extremely popular. Parts of the *Avesta* itself are metrical, 'a somewhat free octosyllabic measure that resembles the Kalevala verse, so familiar to us through Longfellow's "Hiawatha"'; so Williams Jackson describes it, illustrating the comparison with a stanza from the *Mithra Yasht*:

> Mithra, the celestial angel,
> Foremost climbeth mount Haraiti,
> In advance o' the sun immortal,
> Which is drawn by fleeting coursers.
> He, the first, in gold adornment
> Grasps the beauteous lofty summits;
> Thence beneficent he glanceth
> Over all the Aryan home-land,
> Where the valiant chiefs in battle
> Range their troops in countless numbers.

Of late years Benveniste and Christensen have recovered fragments of poetry from the mass of Pahlavi writings; a specimen in Benveniste's felicitous rendering gives a favourable impression of its quality, and causes regret that so much has perished.

> Le soleil lumineux, la pleine lune rayonnante
> Resplendissent et rayonnent hors du tronc de cet arbre;
> Les oiseaux éclatants s'y pavanent pleins de joie,
> Se pavanent les colombes et les paons bigarrés.

For that much of delight has perished is certain, much even of great antiquity if we are to credit the circumstantial description of the drinking-bout which Astyages arranged for his grandson, the youthful Cyrus, as told by Xenophon in the *Cyropaedia*; the scene there pictured, with Sacas passing the cup and Cyrus later taking his turn as saki, seems to establish an immemorial rite of aristocratic Persia and wakens an echo that resounds through twenty-five centuries of joyous minstrelsy. Chares of Mitylene, as Athenaeus tells us, in the last years of the fourth century B.C. heard Persians singing the Romance of Zariadres and Odatis, a tale retold by Firdausī thirteen hundred years later. The Sassanian monarch Bahrām Gūr (Vahrām V, 420–38) is said by some to have been a poet and to have invented rhyme; while Daulatshāh (d. 1494), admittedly a not too reliable witness, quotes a couplet in antique *mutaqārib* verse—the very metre Firdausī himself used—as inscribed upon the palace built by Khusrū Parvīz (Khusrō Abharvēz, 590–628) for his beloved Shīrīn. It was at the court of the same Khusrū that Barbad (Bārbadh, Fahlabad) sang, reputed inventor of Persian music; he is reported as having had a repertory of thirty modes and 360 airs. What were the conventions, what the images that made up these songs? We know nothing for certain, yet it is surely not too fanciful to suppose that when the conquered Persians began once more to compose poetry in their reformed idiom they took up anew the ancient traditions of their musical land. Again in Xenophon we seem to hear snatches of that

imperishable diction, as when we read that 'the name of Cyrus was on the lip of every man, in song and story everywhere', and how the Mede, his kinsman, said to Cyrus, 'Canst thou not understand that the time it takes to wink is a whole eternity, if it separates me from the beauty of thy face?' It cannot be doubted that in old Iran secular poetry, like secular prose, was primarily courtly in character, composed to celebrate and please the King of kings; so to an overwhelming extent it has continued, *mutatis mutandis*, to this day.

After the catastrophes of Qadisiya (635) and Nahavand (642), and the final overthrow of the Sassanian Empire, no Persian rulers remained to patronize Persian authors; it behoved the scholarly and literary-minded to make what terms they could with their rude new masters. To serve these, while educating them (or, as the austere Arab would say, corrupting them) in the manners and values of Iranian courtesy, was a task congenial to all but the irreconcilable few. Language did not constitute a barrier for long; Persians were soon contesting the honours in Arabic composition with their speech-proud conquerors. 'Take from what is generally called Arabian science—from exegesis, tradition, theology, philosophy, medicine, lexicography, history, biography, even Arabic grammar—the work contributed by Persians, and the best part is gone.' So writes E. G. Browne, scarcely exaggerating; the facts are well known, and the Arabs themselves, except when goaded to fury by legitimate but tiresome Persian pride, often acknowledged their debt to the talented converts. This is not the place for a barren catalogue of names, and as a few illustrative examples we may recall that the following were Persians: Sībawaihi (d. 793), Kisā'ī (d. 805), and Farrā' (d. 822) the grammarians; the philologists Ibn Qutaiba (d. 889), Jauharī (d. 1002), and Ibn Fāris (d. 1005); theologians Abū Ḥanīfa (d. 767), Ghazālī (d. 1111), Nasafī (d. 1142), and Shahrastānī (d. 1153); Zamakhsharī (d. 1143), the exegete-grammarian; Bukhārī (d. 870), the traditionist; the

poets Bashshār b. Burd (d. 783) and Abū Nuwās (d. *c.* 810); the essayists Ibn al-Muqaffaʿ (d. 757) and Badīʿ al-Zamān (d. 1007); the geographers Ibn Khurdādhbih (d. 848) and Ibn Rusta (d. 903); Ṭabarī (d. 923), exegete and historian, and the chroniclers Balādhurī (d. 892) and Dīnawarī (d. 895); Rāzī (d. 923), Bīrūnī (d. 973), and Avicenna (d. 1037), the philosopher-scientists; and the polymaths Fakhr al-Dīn al-Rāzī (d. 1209) and Naṣīr al-Dīn al-Ṭūsī (d. 1273).

These are the outstanding names, men who were leaders each in his own field of specialization, whose works decisively influenced the shape and structure of Arabic culture. To diagnose and isolate the specifically Persian (or Iranian) elements in that culture and its literature is an impossible task, for Arab civilization drew upon many sources, and these sources were considerably contaminated already at the birth of Islam; we cannot certainly analyse the Greek and Aramaic parts of Sassanian culture itself, much less accurately distinguish the three at this later stage. The Persian contribution to the Arab conception of history was undoubtedly massive, as we have seen; it seems feasible that for geography the Arabs relied equally on Persian models, though these no longer exist, since so spacious and heterogeneous an empire as the Sassanian can scarcely have been centrally administered with such efficiency, without reference to accurate maps and statistics. The ancient Greeks in their time were familiar with and satirized the elaborate intelligence system which enabled their powerful neighbours to cohere; maybe geography begins as intelligence harnessed to the exaction of taxes and obedience. Though the Arabs were fairly early acquainted with Greek political thought through the translations from Plato and Aristotle, for the detail of imperial administration they greatly depended on the long experience of the Persians, who for their part were not slow, when they came to be secretaries and ministers of state, to instruct their employers how to rule with decorum and enjoyment. Xenophon

constantly reiterates the importance which the Persians in their first age of grandeur attached to ceremonial and polite accomplishments; the intervening centuries had in no way diminished the tradition. And since even the King of kings must sometimes relax, he needs boon companions in whose society he may take his ease boisterously and yet without loss of authority; Xenophon's description of such a scene might equally well portray the royal dissipations into which the Arab rulers were initiated by their Persian courtiers and courtesans.

It is safe to presume that the extensive *adab*-literature in Arabic—manuals of conduct designed to meet all situations and suit all circumstances—stems directly from old Iranian custom. To the same class of improving entertainment belong—unlikely as it may seem at first glance—the celebrated *Kalīla wa-Dimna* fables which Ibn al-Muqaffaʿ translated into Arabic from the Pahlavi, which in its turn mounted to an Indian original. At one remove come the still more famous *Arabian Nights* with their precursor, now known to us only by name, the Iranian *Hazār afsāna*—this a courtly diversion which through the centuries has found a constantly augmenting audience until it has at last become the stock repertory of the English pantomime. We may reasonably guess that the vast Arabic biographical dictionaries owe something to Persian initiative, for the imperial Sassanian records can scarcely have failed to contain detailed files on the famous and the infamous. Exegesis had exercised the ingenious Persian mind in connexion with the *Avesta* long before the Qur'ān needed to be interpreted and allegorized, and this seemingly typical Arab science may have owed as much to Iranian as to Jewish or Christian example. Persian, too, must surely be some elements in the elaboration of Islamic dogma, and religious and civil law. In mysticism the debt is obvious and immense.

So one might proceed over all the range of Arabic literature. But it is only when we compare the products of Persian genius

in both languages that we come near to appreciating what gulf
divides the two peoples, Arab and Iranian. There is a feeling,
by this criterion, that too close contact with a culture born of
the desert tended (to use Emerson's apt image) to saharize
the Persian spirit, which discovered its full expanse of powers
only through the medium of its native speech. In no branch of
letters is this so patent as in poetry, which we shall now examine.
To Arab taste, poetry was summed up and glorified above all in
the *qaṣīda*, the 'poem with a purpose' in a hundred or more
identical rhymes, cast in a stock mould, with each verse a unit,
an exercise in erudition and ingenuity that left all too little
scope for sustained imaginative intensity and all too much for
imitation and the hyperboles of rhetoric; so that it is an abiding
wonder, and a testimony to the invincible genius of human kind,
that despite this strait-jacket of theory and reason poetic mad-
ness so often burst all bonds and lifted speech to the authentic
heights of the sublime. In pre-Islamic times the *qaṣīda* had
developed fully into a marvellous instrument for expressing the
boasts and prides, the loves and hates, the life and death of the
desert-dweller. Its tribal origin was not obscured when imperial
politics and the war of sects supplanted the narrow conflicts
that absorbed the Bedouin poet; the conventions were rigidly
observed; and with the worship of pure Arab speech, a learned
vocabulary ranked as highly as eloquence and elegance in the
armoury of the perfect bard. So the Persians took over the
form, and began to write *qaṣīda* in their own tongue just as
soon as there were rulers in the country again whose Persian
blood responded to the evocation of Persian speech. All through
the history of their literature they have never lacked for poets
qualified to sing the praises of patrons in elaborate and subtle
tones; a Khāqānī can compete in learned obscurity with all
that Arabia has to offer; add to erudition the manifold artifices
invented to heighten diction, and the awesome spectacle of a
Qivāmī's crowded ornament of words (E. G. Browne counts

some ninety tricks of style in his analysis) is offered to the
amazement or disgust of those who care to look at virtuosity *in
excelsis*. But the Persians found other uses for the *qaṣīda* besides
encomium and abuse, congratulation and elegy; a Nāṣir-i Khus-
rau (d. 1088) applied it to the unwearying exercise of timely
admonition and irreproachable moralizing, a Sanā'ī (d. 1150) to
the praises of Almighty God. In our time the form is still used
on every conceivable occasion; Bahār showed himself its master
with his brilliant homage to Firdausī at the Millenary. Other
ingenious applications of the ancient desert convention may be
characterized in the opening of a *qaṣīda* by Minūchihrī (d. 1041)
enigmatically describing a vat of wine, to toast his patron withal:

'Jamshid's daughter is living yet':
 So I read in a book to-day;
'Above eight hundred years it will be
 In her prison she doth stay.
In the house of the worshippers of fire
 She stands, like a cypress-tree,
Nor sits her down, nor ever at all
 On a pillow her side rests she:
Never of food nor drink she takes,
 Nor her long, lone silence breaks.'

Now as I thought upon this screed,
 It gave me small merriment;
Swiftly as one that maketh trial
 To that ancient house I went,
And I saw a house all of black stone,
 Like a hoop its passage bent.
With magic craft I opened the door,
 And thieflike a fire I lit;
A lamp I took, like a dagger's head
 Golden the shine of it.
And in the house I saw there stood
 A doll, full huge and round

Like a standing camel; by God's grace
  No gold or gems I found,
But earthen girdles seven or eight,
  And a fine veil o'er its head,
Its belly swollen, as great with child,
  Its brow like a palm outspread.
Much dust was gathered upon its brow,
  On its head was a clay crown put,
Thick as an elephant's thigh its neck,
  Round as a shield its foot.

As a sister unto a sister runs,
  So loving I ran to her,
And I gently took from her brow the veil
  Finer than gossamer.
With my sleeve I softly swept her face
  Of the dust and ashes grey;
Like a warrior's helmet from her head
  I lifted the crown of clay.
Beneath the crown was a mouth agape,
  And a throat below the mouth,
And her lips were thick as a negro's lips,
  Or a camel's in the drowth;
Sweet musk was her breath, as frankincense
  Smoked in a brazier.
With the love of a dark-eyed fairy fey
  I was seized by the wine of her,
And I ravished her, my maiden fair,
  And a cup of her wine I drew
Whereof on my palm trickled a drop
  Till my palm as Kausar grew;
And I smelt my wrist, and of that scent
  Jasmined my every hair;
And I set my lips to the goblet's rim,
  And sweetness I tasted there.

The Arabs from early times had shorter poems besides the
*qaṣīda*, though whether these were in fact fragments from

full-length lost originals is uncertain. In late Omayyad, early Abbasid days we begin to meet in abundance the brief lyric written as such, the drinking or the amatory poem; Abū Nuwās, who had Persian blood in his veins, proved himself the most skilful artificer of the new model. The Persians took to it, slowly at first but presently with abandon, until the *ghazal*, as it now stood forth, surpassed all other styles in popularity. We should like to be able to say that the ancestor of this graceful form, remarkable for the simplicity of its diction, made up the words that must have accompanied Barbad's 360 airs; but this is speculation past hope of proof. The first Persian to write abundantly in *ghazal* style was apparently Sanā'ī who used the form mystically, and so set a fashion that many followed; he also sometimes, but by no means always, signed his poems, though he was not the first to do so; the *takhalluṣ* subsequently became an indispensable feature of the lyric. This device is not unknown in our own poetry, though it would be rash to claim it more than a coincidence. Shelley, it is true, knew something of Persian style through reading the works of Sir William Jones, and may conceivably have had a Persian model in mind when he wrote:

> Less oft is peace in Shelley's mind
> Than calm in waters seen.

But it is inconceivable that Herrick should have had any acquaintance with the convention of the *ghazal* as he penned his 'Last Request to Julia':

> My fates are ended; when thy Herrick dies,
> Clasp thou his book, then close thou up his eyes.

His model must have rather been the Latin poets, who also sometimes used this elegant artifice:

> Multa parata manent in longa aetate, Catulle,
> Ex hoc ingrato gaudia amore tibi.

After Sanā'ī the *ghazal* established itself as the prime favourite in Persian poetry. Polished and refined successively by ʿAṭṭār

(d. 1230), Rūmī (d. 1273), and Sa'dī (d. 1291), it was brought to miraculous perfection by the incomparable Ḥāfiẓ (d. 1389), following whom its greatest master among very many was Jāmī (d. 1492). At first the lyric varied considerably in length, but Ḥāfiẓ rarely exceeded ten couplets while Jāmī had a noticeable preference for seven, a curious circumstance inevitably provoking comparison with the sonnet. The *ghazal*, like the *qaṣīda*, is composed on a single rhyme and can choose between a great variety of metres, all derived from Arabic prosody. If one wished to select out of tens of thousands a single specimen that displays the form to finest advantage, one could take Ḥāfiẓ's poem which Jones made into his celebrated 'Persian Song'.

$$\cup - - - | \cup - - - | \cup - - - | \cup - - -$$

> agar ān Turk-i Shīrāzī ba-dast ārad dil-í mā-rā
> bi-khāl-í Hinduyash bakhsham Samarqand ū Bukhārā-rā

> > Sweet maid, if thou wouldst charm my sight,
> > And bid these arms thy neck infold;
> > That rosy cheek, that lily hand
> > Would give thy poet more delight
> > Than all Bocára's vaunted gold,
> > Than all the gems of Samarcand.

The version, which charmed Europe with its first authentic taste of Persian poetry, is quoted in full in the *Oxford Book of Eighteenth Century Verse*.

Two other poetic forms had been perfected even before the *ghazal* fairly entered on its brilliant career; the first of immense length, the second of contrasting brevity; both firmly rooted in Iranian tradition, both purely Persian in character. The Arabs had a little-considered style of versifying which they scarcely consented to dignify with the name of poetry—the *rajaz* couplet which, starting out as an extempore manner of composition, found itself subsequently put to such base uses as mnemonics for schoolboys; the *Alfīya* of Ibn Mālik (d. 1274), an epitome

of Arabic grammar in 1,000 verses, is the most famed example. This, it seems, was the unpretentious parent of the Persian *mathnawī*, the rhyming pair which, now harnessed to any suitable metre, raced to immediate triumph in almost its first trial, the *Shāh-nāma* of Firdausī. The fortuitous marriage of this base couplet, too trivial for fastidious Arab taste, to the stirring annals of ancient Iran, at a time when Persian nationalism was struggling to rebirth, gave the world a vast epic of some 60,000 verses; ill-luck it was that the great monarch of Persia and the neighbouring lands to whom the poet sought to sell his tale of native pride, Maḥmūd of Ghazna, should be a Turk and little apt, until too late, to reward the twenty-five years' labour of glorifying a race he had his reasons to despise. No Arab, only a Persian, could have attempted, and contrived, to paint so intricate a picture on so gigantic a canvas. To Western canons the poem lacks unity of theme and symmetry, and it has therefore been unfavourably compared with our epics; but it is supreme of its own kind, written in a noble and remarkably mature style, with many sequences—most notably the tale of Sohrab and Rustum which inspired Matthew Arnold—to be reckoned great poetry by any standard.

Later poets sought vainly to match this early achievement; so vast an enterprise could only succeed once, seeing that few men of even the greatest parts will risk so many barren years in a single task, and fewer expend paper and ink to copy their productions. The only poem of comparable size to win equal fame was the *Mathnawī-yi maʿnawī* of Jalāl al-Dīn Rūmī, that wonderful encyclopaedia of mystical tales and discourse which R. A. Nicholson gave twenty years to putting into English. After the national legend it was the turn of romance. Gurgānī (*fl.* 1050) succeeded first in this field with his story of Vis and Ramin, based it is said on a Pahlavi original; about the same time, or a little later, the story of Joseph and Potiphar's wife, as told in the Qurʾān, was for the first of many times put into

Persian verse, to be ascribed afterwards to Firdausī. Niẓāmī (d. 1202) specialized in the short epic and wrote five, his themes ranging from the Arab desert romance of Lailā and her mad poet-lover to the Sassanian royal tale of Khusrū's passion for Shīrīn, and the great legend of Alexander. The Pilgrimage to Mecca furnished Khāqānī with a subject for a learned epopee, scarcely to be understood save with the help of extensive commentaries. Niẓāmī's five were matched by five from the Indianborn Amīr Khusrau of Delhi (d. 1325), seven from Jāmī, and five from the latter's nephew Hātifī (d. 1520), besides a host of other good or inferior productions not in Persian only, but also in Turkish and Urdu. These miniature epics, and especially Niẓāmī's, besides being excellent reading in themselves shared with the *Shāh-nāma* the honour of supplying Persia's miniature painters with rich material for the exercise of their craft; the conjunction of glittering verse with brilliant art gave birth to some of the world's most splendid books. *Mathnawī* with mystical subjects were composed before Rūmī by Sanā'ī and 'Aṭṭār; the former also wrote a miniature *Divine Comedy* which seems to mount back to the Pahlavi *Ardā Virāf-nāmagh*, while the latter's *Manṭiq al-ṭair* is an elaborate allegory that engaged FitzGerald's interest. To the same variety of composition also belongs the ethical, moralizing, and philosophical poem, most celebrated example of which is Saʿdī's *Būstān*; a modern instance is the *Asrār-i khudī* ('Secrets of the Self') of the late Sir Muḥammad Iqbāl of Lahore.

From the longest we turn to the shortest Persian verse-form, the *rubāʿī*, famous throughout the world in Edward FitzGerald's superb but imperfect imitation. This is the only kind of poetry that has a purely Persian metre, and the prosodists account for it by telling of a boy playing marbles with walnuts and shouting as he rolled them along

$$- - \smile\smile - \smile \bar{\smile} - - \smile\smile -$$

ghalᵗān ghalᵗān hamī ravad tā bun-i gau.

A poet standing by heard the rhythm and matched it, added another distich, and so created a new fashion of versifying, a fashion moreover which spread with amazing celerity so that soon every old man and maiden, every young man and sage was turning it to a new use. Whatever truth may be behind this romantic legend, it is certain that it was an unknown genius who invented this, the most perfect form of epigram in all literature. If we ask why it succeeded so instantaneously and so brilliantly, the answer must take account of the fact that Persia is the homeland of proverb and apophthegm; and an epigram, to capture the imagination and haunt the memory, needs to state a familiar truth, or draw a remembered image, in a new and arresting manner. These are the qualities we discover in Shelley's

> Rose leaves, when the rose is dead,
> Are heaped for the belovèd's bed;
> And so thy thoughts, when thou art gone,
> Love itself shall slumber on.

These too are the elements that make 'Umar Khaiyām, and therefore FitzGerald, sublime:

> I sometimes think that never blows so red
> The Rose as where some buried Caesar bled;
>     That every Hyacinth the Garden wears
> Dropt in her Lap from some once lovely Head.

And when Khaiyām–FitzGerald wrote

> A Book of Verses underneath the Bough,
> A Jug of Wine, a Loaf of Bread—and Thou
>     Beside me singing in the Wilderness—
> O, Wilderness were Paradise enow!

he was merely giving perfect form to the image Abū Nuwās the half-Persian had crystallized into Arabic before him:

> Four things there be that life impart
> To soul, to body, and to heart——

> A running stream, a flowered glade,
> A jar of wine, a lovely maid.

'Umar Khaiyām (d. 1123), the mathematician and philosopher, composed during his busy life perhaps as many as 750 *rubā'ī*, mostly of a gentle melancholy turn; many hundreds more have been fathered on to him. Most Persians have written or spoken impromptu a *rubā'ī* or two; most of Persia's poets have invented many—Rūmī, for instance, about 2,000; on themes as various as the thoughts of man. The Arabs paid the Persians the compliment of imitating their solitary discovery in prosody, but it was never popular with them, being too brief and perhaps too homely; the Indians and Turks took to it with enthusiasm. There is a popular, rustic style of rhyming in Persian identical in shape with the *rubā'ī* but of a different rhythm; it is therefore called the *dū-baitī* ('couplet'). The wild mystic Bābā Ṭāhir (*fl.* 1050) composed a handful of poems in this form, which has otherwise been neglected in literature, the *rubā'ī* being preferred. A modern Persian scholar, Kūhī Kirmānī, has collected 700 of these folk-couplets as he heard them sung up and down the country; many are of striking beauty, proving the sure instinct for poetry that is in the heart of even the obscurest Persian peasant. Here is an example, a memory of some forgotten tribal fray:

> They brought me news that Spring is in the plains
> And Ahmad's blood the crimson tulip stains;
> Go, tell his aged mother that her son
> Fought with a thousand foes, and he was one.

From this rapid outline of Persian poetry it will have been seen that, receiving from the Arabs a subtle and various metrical system and the rigid discipline of the *qaṣīda*, the bards of Persia broke down the formal ode into a graceful lyric; converted a despised single rhyme into splendid epic and romantic idyll; and added out of the mouth of the people the world's choicest

epigram. Yet, while rejecting the narrow conventions of Arab poetics, the Persians were controlled, perhaps too closely controlled, by artifices of their own. Especially is this apparent in the *ghazal*, a form readily made monotonous if severely regimented. The device of the monorhyme was no serious obstacle in itself, though it sometimes put a premium on verbal dexterity at the expense of discretion, for rhymes are plentiful enough in Persia. More important, and more regrettable, was the artificial limitation of subject and image, to the point that excellence came to be assessed more and more in relation to the exquisite refinement of ideas, and ways of expressing them, a thousandfold familiar already. Abū Nuwās was a revolutionary in his time when he rebelled against the stock pattern:

> O sing me not the old songs—let others if they must
> Make melody of ruins, all desolate and dust.
> Though wine has been forbidden, drink wine while ye have breath,
> For all that lies about us is moving on to death:
> Pour liquid gold, I pray thee, until the cry goes up,
> 'Lo, thou hast caught the sunshine in yonder crystal cup!'

But all too soon the revolutionary became respectable, and respectability turned to mere convention. The rose is a very lovely flower; the song of the nightingale is a moving experience; yet it is possible for them, like the stars, to be mentioned once too often by the poet; nor is it always pleasing to follow the suicidal fluttering of the moth about the candle, or to be told for the thousandth time that the beloved's face is like a moon, her lips rubies, her teeth pearls, her ringlets hyacinths, her brows an archer's bow, her glances the arrows sped from that bow. Preciosity is the vice of too much prized convention, and though it can charm in moderation, its excess is wearisome. The greatest poets of the motherland had too sure a taste, too refined a judgement, often to offend; they were as faultless in their skill as those their fellows who painted pictures and designed illu-

mination, were architects in tiles and weavers of carpets; the trouble came when they were imitated elsewhere, in an environment that prized verbal jugglery above artistic form and common sense. That was the tragedy of the 'Indian' poets. For India, passing under Muslim rule with the coming of the Mughals, now became a second home of the Persian language. Amīr Khusrau of Delhi, himself too fine an artist to betray his sensitivity, is nevertheless called the Parrot of India; many of his successors were but parrokeets, brilliant of plumage with little enduring to say.

Yet it is remarkable how great in quantity and how, after all, respectable in quality has been the poetry written by generations of men to whom Persian was a foreign speech. We need to emphasize once more the courtly character of this writing; India provided a comfortable livelihood for many Persian authors after their own country had fallen into political ruin, and their Indian pupils and followers could scarcely complain that patrons were lacking or unbountiful. The tradition persisted well into the nineteenth century, when, for instance, one Mullā Fīrūz composed and had printed (Bombay, 1837), the *George-nāma*, an epic on the British conquest of India in three volumes and some 2,000 pages; it has continued sporadically even to the present day. But important as this secondary literature has been, it is overshadowed now by the Urdu poetry which was born and nurtured under the wing of the Persian, receiving from its foster-mother form, prosody, content, and image. Amīr Khusrau, for his part, is said to have composed Hindi verses, though this has been disputed and in any case no specimens have survived. Though Indian subjects naturally enjoyed great popularity with the romantics, traditional Persian themes were not neglected. Even today, when new fashions are being discovered by Indian as by Persian poets, and European models are to some extent ousting the old favourites, Urdu, like many other Muslim languages, cannot rid itself of its great

inheritance, and though pattern and theme may change, image and rhetoric strongly survive.

Turkish poetry is no less indebted than Indian to the inventive genius of Persia. Many Turks, indeed, have made notable contributions to Persian literature as well as their own; Navā'ī (d. 1501) and Fuḍūlī (d. 1562) are two honoured names out of a multitude. Turkish writing in every branch was dominated by Persian influences well into modern times, until the dual pressure of nationalism within and Europe without led to an abandonment of the Eastward orientation and the pursuit of new ideals. But not even an Atatürk can expunge six centuries from the pages of a nation's culture, and it will be surprising if the Turks do not presently return—as there are already signs they may—to drink once more at the fountain that has refreshed them so often and abundantly in the past.

If the preponderant part of this essay has dealt with the poetry of Persia, this is not an unjust division of words, for the poetry is admittedly superior in all respects to the prose; yet the prose is very considerable and cannot be lightly regarded. Slower to mature than verse, Persian prose started in a humble, almost apologetic manner, as if conscious of the superior strength and suppleness of the Arabic which Persian scholars preferred. Yet the bare simplicity of these early books is not unattractive; the neglect they have suffered is illustrated by the comparative obscurity of Avicenna's and Ghazālī's Persian writings. Nāṣir-i Khusrau, that great moralist in verse, composed several works in honest, straightforward prose, notably the *Safar-nāma*, a journal of his travels. Near the same time Niẓām al-Mulk (d. 1092), the skilful minister of the Seljuk ruler Alp Arslān and a generous and enlightened patron of learning—he founded the Niẓāmīya college at Baghdad where Saʿdī later studied—composed as a political testament the *Siyāsat-nāma*, playing the Buzurgmihr to his Chosroes, one of the ablest books of its kind. Politics is closely related to ethics, especially in Persia; while a

prime minister was theorizing about the former, a king's grandson dilated on the latter. The *Qābūs-nāma* of Kai-Kā'ūs is the first of a long succession of improving and entertaining manuals of practical wisdom, and in it we see coming to life again the long-buried but never-forgotten convention of the *andarz*-literature. To the same chain of tradition belong such works as the *Akhlāq-i Nāṣirī* of Naṣīr al-Dīn Ṭūsī, Saʿdī's *Gulistān*, the *Bahāristān* of Jāmī, and many less-famous works. The fashion was followed in Turkish and Urdu; and when Europe knew of it, Persian wit and wisdom became proverbial. But by the time Saʿdī put pen to paper Persian prose had been polished almost out of all recognition, and it is as much the elegance of the style as the acceptability of the sentiment that has made the *Gulistān* the most famous book in the language, every schoolboy's model of how to write. There is an art in putting the tritest truism into memorable words, and there is also an art in telling the simplest anecdote; Saʿdī mastered both these skills, and made his little register of cautionary tales which the wealthiest princes have commissioned the most accomplished calligraphers and artists to perpetuate.

No doubt it was the historian as much as anyone who contrived to perfect Persian prose, though some played curious tricks with it in the process. There came a time when the Iranian custom of recording great events for powerful kings ruled again in Persia. Ṭabarī preferred Arabic, but he was after all chiefly concerned with Arab affairs; Juvainī, who served the dread Hūlāgū Khān, wrote the records of the Mongols in a learned Persian that is blood-brother to diplomatese. Ghāzān Khān, Hūlāgū's great-grandson, took for vizier a talented physician, Rashīd al-Dīn (d. 1318), who composed a massive history of the world and encouraged Ḥamd Allāh Mustaufī, an eminent cosmologist, to compile his *Tārīkh-i guzīda*, select annals from the creation down to 1330. To the same period belongs the *Tārīkh-i Vaṣṣāf*, 'an absurdly bombastic composition, in which

sense is concealed in multitudes of words, and history is sub-ordinated to verbal conceit'. So it is characterized by R. Levy, who justly adds: 'The number of writers, particularly in India, who adopted this euphuistic method of composition, was so great that it had its effect in Europe, where to this day the common idea of Persian prose is that its characteristics are ordinarily those of the most florid 'Babu' English.' This impression was by no means accidental or unfair at the time it was made; the fashion of ornamental style has driven sound taste into obscurity again and again in times of decadence, and the Indian historians of the eighteenth century, who wrote in Persian and were in close contact with Europeans, had a great liking for the tortuous and inflated. Yet that it is possible even for a Persian historian to write in simple, unaffected dignity is proved, not only by the early chroniclers of cities, but also by Rashīd al-Dīn himself, and again (despite a wearisome trick or two) by Mīr 'Alī Shīr's protégé Mīr Khwānd (d. 1498), author of the gigantic *Raudat al-safā'*. No doubt it was the primitive bleakness of Persian prose, compared with the sonority and elegance of Arabic *inshā'*—itself to a notable extent the invention of Persian secre-taries of state—that drove the historians, whose task was not so far removed from diplomacy, to multiply ornament and over-load with Arabisms, for they might well despair of complicating Persian grammar and syntax. From Persian the fashion spread back to Arabic and sideways to Turkish and Urdu. But that these Persian conceits can be charming and very far from offen-sive has been shown not only by those Persian stylists, like Sa'dī and Jāmī, who have used them skilfully and with modera-tion, but also by such an occidental imitator as Flecker with his delightful parody *Hassan*.

The biographers of Persia are almost as numerous as her historians, and like their Arab colleagues enter into detail and obscurity to a degree unknown in the literatures of Greece and Rome; they are the true ancestors of that invaluable compila-

tion the *D.N.B.*; and if their accuracy is sometimes called into question, yet the assistance they afford to research is beyond computation. Particularly is this true of the literary historians Muḥammad 'Aufī and Daulatshāh, to whose painstaking records we owe practically all that is known of early Persian poetry. 'Aufī has a double claim to our gratitude, for he also compiled an encyclopaedia of anecdotage, the *Jawāmi' al-ḥikāyāt*, that is an inexhaustible mine of curious and interesting information. To the same general order of composition, though much smaller and more specialist in character, belongs the *Chahār maqāla* of Niẓāmī the prosodist, whose four discourses discuss the perfect secretary, poet, astrologer, and physician. The exordium to this work is a model of courtly compliment.

And honour to the King of this time, that learned, just, divinely-favoured, victorious, and heaven-aided monarch *Husámu 'd-Dawla wa'd-Dín*, Helper of Islam and the Muslims, Exterminator of the infidels and polytheists, Subduer of the heretical and the froward, Supporter of hosts in the worlds, Pride of Kings and Emperors, Suc-courer of mankind, Protector of these days, Fore-arm of the Caliphate, Beauty of the Faith and Glory of the Nation, Order of the Arabs and the Persians, noblest of mankind, *Shamsu 'l-Ma'álí*, *Maliku 'l-Umará*, Abu 'l-Ḥasan 'Alí b. Mas'úd, Help of the Prince of Believers, may his life be filled with success, may the greater part of the world be assigned to his name, and may the ordering of the affairs of Adam's seed be directed by his care. . . .

E. G. Browne's translation, meticulous as it is, gives but a faint impression of the magniloquence of the original with its cumulative coruscation of glittering rhymes, this truly Iranian exaltation of a princeling who happened once to be a poor scribbler's patron.

We have seen that the poets of Persia excelled, when they chose and the opportunity served, in composing epic on the grand scale, but were equally ready, and in general better qualified, to work in miniature, fashioning lyrics and quatrains. The

same duality is observable also in the prose literature. While some have achieved fame by the sheer bulk of their output, others, and they the more numerous, have been content to be known by slender books, chiselled and polished to the utmost perfection attainable. It is the old contrast between the great *Khvadāynāmagh* and the little *Pandnāmagh*, perhaps between quantity for the megalomaniac and quality for the connoisseur. Of the little books in Persian one calls to mind, besides those already mentioned, such works as the *Munājāt* of Anṣārī (d. 1088), a charming litany in mixed prose and verse; the *Lama'āt* of 'Irāqī (d. 1288), a subtle theosophic epitome of the Ṣūfī doctrine of Divine love; or, very different in kind but equally characteristic of the many-sided Persian genius, the *Akhlāq al-ashrāf* of Zākānī (d. 1370), a brilliant and merciless parody of the serious compendia of popular ethics.

To attempt to assess the relative excellences of the grand and the fine in literature is as fruitless as to judge between the architectural magnificence of a Chihil Sutūn and the exquisite beauty of a Bihzād miniature. That one people has produced masterpieces in both kinds, the monumental and the minute, is perhaps to be accounted for by the curiously violent catastrophes of Persia's political fortunes; now a mighty empire of the sword, exercising sway over many subject peoples, now herself a subject nation, tyrannized and massacred by foreign invaders. The uncertainty of human affairs is of all moralizing themes the most beloved.

Upon the arch of Feridun's palace it was written:

> Brother, this world is no man's part for aye:
> Upon the world's Creator be thy stay.
> Reliance sure is not on earth to gain—
> Many like thee hath it raised up, and slain.
> What care, when spirit forth from flesh doth rise,
> Whether on throne or dust the body dies?'

<div align="right">(Sa'dī, <em>Gulistān</em>)</div>

The bitter experiences of many centuries, of much suffering

and much disappointment, have produced in the Persian charac-
ter an admirable serenity and detachment from material things,
so that poet and author, artist and craftsman, are content to
devote extravagant time and infinite patience, chiselling and
polishing, wresting the vital, glittering ruby from the hard,
lifeless rock of ineluctable fate.

So, as we look back upon the rich and varied history of Persian
writing, and try to say what are the most important elements in
the Persian legacy to the literature of mankind, we may sum up
somewhat as follows. Proud in the remembered glory of empire,
stubbornly refusing to accept the verdict of fortune as irrepar-
able, a Firdausī sings to keep alive in his people's soul the instinct
of greatness, like the artists who daubed the walls of public
places with scenes from the triumphs of ancient times; and if
Firdausī had never sung, the very ruins of those days would still
shout their challenge.

I am Darius, the great King, the King of kings, King of lands
peopled by all races, for long King of this great earth, son of Vishtasp
the Achaemenian, a Persian, son of a Persian. . . . If thou thinkest, 'How
many were the lands which King Darius ruled?' then behold this
picture: they bear my Throne, thereby thou mayest know them. Then
shalt thou know that the spears of the men of Persia reach afar; then
shalt thou know that the Persian waged war far from Persia. . . . O
man! This is Ahuramazda's command to thee: Think no evil; abandon
not the right path; sin not!

What her poets recite in stirring rhyme her historians pro-
claim in stately prose, proving by their laborious genealogies
that the blood of emperors still flows in Persian veins. The
courtly manners, the royal bounty and mercy of old are kept
alive in the pages of the moralists and writers on etiquette, so
that every Persian, though he may for a time be subdued to
another people's will, may preserve in his heart the tradition
of kingship. The ancient virtue must still remain his whole
concern; so said Ḥanẓala of Badghis, an obscure poet who

died about 875, when the nation was newly stirring after two
centuries of Arab sway:

> If Honour lies within the Lion's jaws,
> Go, greatly dare, seek Honour in that place;
> Strive after Grandeur, Riches, Ease, Applause,
> Or manly meet Disaster face to face.

But too often the same story was repeated. Princes of Persian
blood strove indeed after grandeur, riches, ease; too often it was
only to meet disaster at the hands, not of superior foes, but, as
it came to seem, a destiny too powerful to vanquish.

> And when his blood outspilled
>     Stained all the vale,
> The heart of Faith was stilled,
>     And Hope grew pale.
>
> He stood with ready blade,
>     Death's self to slay;
> But Death my king waylaid
>     And won the day.

So mourned Abū Manṣūr of Merv (*fl.* 1000) for his defeated
hero. Turks and Mongols and Tartars swept over Persia's broad
plains and mountain-ranges, devastated her lovely cities, en-
slaved her fair women, massacred her noble and learned men.
The spirit yearned to be comforted; the preacher and the poet
had comfort to offer, but of different kinds. To some the Ṣūfī
message brought perfect satisfaction: the human soul, cut off
from the true Beloved while inhabiting this mortal flesh, must
necessarily suffer anguish, yet it may aspire to come once more
to the lost city of its dreams.

> I made a far journey
> Earth's fair cities to view,
> But like to Love's city
> City none I knew.

At the first I knew not
That city's worth
And turned in my folly
A wanderer on earth.

From so sweet a country
I must needs pass,
And like to cattle
Grazed on every grass.

As Moses' people
I would liefer eat
Garlic, than manna
And celestial meat.

What voice in this world
To my ear has come
Save the voice of Love
Was a tapped drum.

Yet for that drumtap
From the world of All
Into this perishing land
I did fall.

That world a lone spirit
Inhabiting
Like a snake I crept
Without foot or wing.

The wine that was laughter
And grace to sip
Like a rose I tasted
Without throat or lip.

'Spirit, go a journey,'
Love's voice said;
'Lo, a home of travail
I have made.'

Much, much I cried
'I will not go';
Yea, and rent my raiment
And made great woe.

Even as now I shrink
To be gone from here,
Even so thence
To part I did fear.

'Spirit, go thy way,'
Love called again,
'And I shall be ever nigh thee
As thy neck's vein.'

Much did Love enchant me
And made much guile;
Love's guile and enchantment
Captured me the while.

In ignorance and folly
When my wing I spread
From palace to prison
I was swiftly sped.

Now I would tell
How thither thou mayest come;
But ah, my pen is broken
And I am dumb.

This is Rūmī's solution of the problem of suffering; it has been proposed by many of Persia's greatest poets and thinkers and constitutes one of the chief characteristics of the Persian outlook, a rich and precious legacy to human thought. Yet with the polarity which is so marked a feature of their psychology the Persians have as often advanced an exactly opposite solution.

Abū Shakūr of Balkh (*fl.* 950) summed up the agnostic side of his people's attitude to life when he wrote:

> To this point doth my learning go—
> I only know I nothing know.

His greater contemporary, Rūdakī (d. 954), pointed the hedonistic moral:

> With dark-eyed maidens happy dwell
>     And satisfied;
> This world is but a tale to tell,
>     And naught beside.
>
> It little boots for man to praise
>     The joys of yore,
> Or to recall those happy days
>     Gone by before.
>
> This world is cloud and tempest yet,
>     A tear, a sigh;
> Then pour me out the wine, and let
>     The world go by.

And another of the same time, Kisā'ī (*fl.* 950), has the same advice to offer:

> Yon little bird his anthem clear
> Chaunteth on the evening air,
> As the amorous swain will do
> That serenades his darling true.
>
> What is his message? This he says:
> 'Lover of the shadowy ways,
> Take the hand of thy own love,
> And walk beside her in the grove.'

Wine to cheer the heart of man, and love to comfort his soul, as he walks the dark corridor between annihilation and annihilation—the philosophy of 'Umar, Ḥāfiẓ's doctrine of unreason,

the *carpe diem* of all who have ever loved the beauty of the world and known it to be swiftly perishing, like the spring's carpet of flowers spread in a Persian desert; this is the other voice of Persia, the voice of the great defeated, taking consolation in the treasures all may look upon and touch for a while, and none may possess for ever.

> Loving in the time of youth—
> That is happiness, in sooth;
> Happiness, at love to play
> With the lovely all the day;
> Happiness, to sit apart
> With companions of one heart,
> And in harmony divine
> To imbibe the purple wine.
> Best it is in youth for thee
> To be loving instantly,
> Since, when thou art aged grown,
> All thy virtue will be gone.
> To be young, and wary of
> The intemperance of love—
> What is that, if it not be
> Weariness, and misery?
> If a man be young and strong,
> And not love the whole day long,
> O the pity and the ruth
> Of the season of his youth!

(Farrukhī, d. 1037)

If in making this final analysis of the value of Persian literature we have turned aside from the discussion of form, where we found so much of account, and dwelt rather upon the spirit which inhabited that form, it is because we believe that the truly enduring things, in words as in actions, are the things of the spirit. In her writings, as in her art, the soul of Persia lives; compared with this abiding triumph, the ruin of her politics matters very little. For the Persians, in victory as in defeat,

but especially in defeat, have taught the world how to live with dignity and pleasure, whether the dignity be emperor's or beggar's, whether the pleasure be of earth or heaven. They have known life, and loved life, for all its pains and sorrows; and when the time has come for them to say farewell to life, it has always been with a backward glance of regret, and a prayer, like Iraj Mīrzā's (d. 1925), to be remembered.

> Know ye, fair folk who dwell on earth
> Or shall hereafter come to birth,
> That here, with dust upon his eyes,
> Iraj, the sweet-tongued singer, lies.
> In this true lover's tomb interred
> A world of love lies sepulchred;
> Each ringlet fair, each lovely face
> In death, as living, I embrace.
> I am the selfsame man ye knew
> That passed his every hour with you;
> What if I quit this world's abode,
> I wait to join you on the road,
> And though this soil my refuge be
> I watch for you unceasingly.
> Then sit a moment here, I pray,
> And let your footsteps on me stray;
> My heart, attentive to your voice,
> Within this earth's heart will rejoice.

That is an invitation which none who has been privileged to know the literature of Persia is likely ever to decline.

A. J. ARBERRY

# CHAPTER 9

# PERSIAN CARPETS

THE pile carpet is a comparatively modern amenity in England. It was almost unknown in the seventeenth century. Except for rare importations from France, the Low Countries, and some still rarer from the East, it was equally unknown in our elegant eighteenth-century drawing-rooms. Not until the power loom became thoroughly established in the early nineteenth century —in Axminster, Kidderminster, Glasgow, and elsewhere—did the pile carpet come to be regarded, by poor and rich alike, as a necessity in the household.

But in Persia the pile carpet has been in common use for many centuries—for how many no one knows and no one will ever know. For 'the termless antiquity of the Persian carpet' is an accepted rather than a proven theory. The phrase is Sir George Birdwood's. That famous Orientalist and classical scholar delved, with characteristic zeal, into the ancient writers for proofs of the existence of pile carpets in the time of Cyrus— who died in 529 B.C. He quoted in support of his thesis from the Bible and from a score of classical writers. It might be expected that from such a galaxy of authors he would produce convincing proofs. But what do we find? There are references in plenty to vestments, hangings, draperies, brocades, and embroidered cloths; but there is no reference which can be construed as indicating that piled carpets were in use in Achaemenian times. We do not know, and it is unlikely that we shall ever know, if the floors of the palace of Darius at Persepolis were covered with pile carpets.

Birdwood, in his anxiety to prove that he had discovered the forerunners of the great Safavid carpets, pleaded that the hangings —so frequently mentioned by the ancient writers—were actually carpets: adding that to this day the Persians hang carpets on

their walls. Unhappily for the argument, the Persians—certainly when Birdwood wrote—rarely did so. Their furnishings were of an extreme austerity: one or more carpets covered the floor; a pair of oil lamps stood, in studied symmetry, in niches in the walls; the windows (in the wealthier mansions) were pranked with coloured glass, and the walls embossed with white plaster. That—with a small table and a few straight-backed chairs—was all. There were no *objets d'art*; no vases of flowers; no pictures —and rarely, very rarely, a hanging rug.

Nevertheless, although the antiquity of the Persian carpet is unproven, it may be fairly deduced. For Persia is a very cold country in winter where some form of covering for the ground under the tents of the nomads must have been in use from earliest times. And the Persian people are by nature skilled and artistic craftsmen. Such a people would not for long remain content to cover their tent floors—like Eskimos or Red Indians —with the skins of beasts. The urge to fashion something closer to the need, more varied and above all more colourful, was there. The materials too were there—for the sheep is an indigenous animal in Persia. Thus, the hand-knotted carpet may well have been evolved by art out of the sheepskin rug—the primal floor covering of the pastoral nomads of the plateau.

Is it not more probable, therefore, that the true ancestors of the great carpets of Persia were not the sumptuary hangings, brocades, and embroideries of Egypt, Babylon, and Nineveh, but the humble tribal rugs of her nomadic shepherds?

Gradually some of the nomads settled in villages; and as the villages grew in size and the houses in importance, larger pieces became a necessity. The accepted method of floor construction was to lay earth over poplar beams, criss-crossed with poplar branches. Without a stout floor-covering to protect it from wall to wall, the earth floor would quickly wear away and the dust would be intolerable. Thus it became the custom in Persia—and still is—to cover all the floors, from wall to wall, with carpets.

To this need and to the need for warmth in the bitter cold of their uplands, the Persian people applied a flair for the production of textile fabrics and an unrivalled sense of colour and design; and thus they became, for the delectation of mankind, the supreme masters of the art of carpet weaving.

It has been suggested that the art did not originate in Persia but was introduced by Turkish or Mongol invaders from central Asia. Some of the discoveries of Le Coq, Kozlor, and Sir Aurel Stein in those regions seemed to lend support to this theory. But on historical grounds it can hardly be sustained.

The earliest Mongols to enter Persia were the White Huns who invaded Khurasan in the fifth century A.D. But they got no farther, and they were destroyed a century later. Furthermore, the Mongol tribes never brought their women with them on their campaigns; and rug weaving was practised by women, not by warriors.

Again, in the geography called *Ḥudūd al-ʻālam*, written in A.D. 892,[1] the author states that rugs were woven at that time in Fars, 1,000 miles from Khurasan. What Turk or Mongol—at that time—could have taught the craft to those far-distant weavers?

Early in the tenth century Maḥmūd of Ghazna, a Turk, established his dominion over Khurasan; but the Arab geographer Muqaddasī, who travelled through Khurasan a few years later, wrote that the highlands of the Qainat were already famous for their carpets and prayer rugs. They could not possibly have acquired the art so quickly from Maḥmūd's Turks.

Furthermore (and this is perhaps the conclusive answer), the Turks and Mongols—wherever they may be—weave (if they weave at all) with the Turkish knot, and with no other; and the Persians—wherever they may be—weave (if they weave at all)

[1] *Ḥudūd al-ʻālam: The Regions of the World*, translated and explained by V. Minorsky. E. J. W. Gibb Memorial (Luzac, London, 1937).

with the Persian knot, and with no other. The two systems of weaving (as explained below) are different, and the line of cleavage between the peoples which use one or the other is extraordinarily distinct. It is inconceivable, therefore, that the Persians should have learnt to weave the Persian knot from the Turks or the Mongols, who used a different system altogether.

With a few unimportant exceptions, the knot used in all hand-knotted carpets from the East is made by tying a piece of coloured yarn to two strings of the warp and then trimming off the surplus ends of the yarn, according to the length of pile

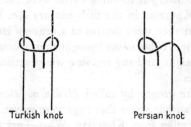

Turkish knot        Persian knot

required. The piece of yarn is tied to the strings of the warp in one of two different ways, depending on whether the weaver is of Turkish or Persian race. This rule is almost invariable, and the few exceptions can always be traced to an extraneous influence.

The two basic types are commonly known as the Ghiordes knot and the Senneh knot.[1] By whom this misleading nomenclature was first devised is not known; but it has been repeated, times without number, by writers and rug-fanciers alike. The little town of Ghiordes in western Anatolia possesses an ancient and honourable record as a weaving centre; but that is hardly a sufficient reason for naming after it a technique which is com-

[1] There are several methods of applying the two knots (left to right or vice versa; on four strings of the warp instead of two, &c.); but basically the two types are distinct and constant.

mon to all the peoples of Turkish race. Among the famous
weaves which are woven with the Turkish knot are the Ushak
and Ghiordes carpets; the many types of Anatolian rugs; the
Shirvans, the Kubas, Kazāks, Genjés, and Karabāghs of the
Caucasus; the carpets of Tabriz and of the Herīz area; the rich
variety of the Hamadan weaves, the multifarious tribal rugs of
Merv, Bukhara, and Kashgar; the Kizil Ayaks, the Beshīrs,
Yamūts, and Kara-Kalpaks; and many others, equally merito-
rious, if less renowned. All these weaves are produced by peoples
of Turkish race and speech. Surely, if things are to be called by
their proper names, the knot which they weave should be called
the Turki or the Turkish knot.

But the choice of the name 'Senneh' for the second basic
type is stranger still. The person who first named it after the
small town of Senneh in Persian Kurdistan (of all places) per-
haps presumed that the thin and supple rug woven there must
have necessarily been woven with the knot of the second basic
type. For this knot does indeed produce a fabric somewhat more
supple and more delicate than the Turkish knot. But the in-
cautious pioneer—whoever he was—was deceived by appearance
and failed to check his sources. For the rugs of Senneh (like all
the Kurdish weaves) are woven with the Turkish knot. The
term 'Senneh' is, therefore, a complete misnomer for the knot
of the second type.

This is the type which is used by weavers of Persian race and
speech—the weavers of Arak, Meshed, Birjand, Kirman, Isfa-
han, Nain, Kashan, and Qum. It must be called, then, by its
proper name—the Farsi or Persian knot.

How came it to pass that both basic types—the Turkish and
Persian—are used in Persia today? Not, as might be expected,
side by side in the same town or village, but only in separate and
distinct sections of the country. The explanation must be sought
in history.

In the tenth century A.D. some important tribes of Turks—

later known as Seljuks after the founder of their famous dynasty
—which, with their wives and families, had been moving west-
wards from central Asia, reached the borders of Khurasan. In
a few years they had wrested the whole of Persia from the em-
pire of the Arab caliph of Baghdad. Although they established
their authority throughout the country, it was only in the
provinces of Azerbaijan, Hamadan (and probably in Seraband
and Bakhtiari) that they settled down and supplanted the Per-
sian inhabitants. Many of these fled southward before the
invaders. The womenfolk, both of the incoming Turks and of
the Persians whom they supplanted or expelled, were carpet
weavers—though they knotted their rugs in a different manner.
Thus, a racial and linguistic frontier line was established across
Persia—on one side of which the population remains mainly
Turkish and weaves the Turkish knot; and on the other side,
Persian and weaves the Persian knot.

In the distant provinces of Kirman and Fars there are impor-
tant areas inhabited by Turkish tribes, Afshars and Qashgais,
who in past centuries were transplanted there from motives of
discipline or policy by the reigning monarch. There they con-
tinue to dwell as Turkish enclaves, and to weave their tribal
rugs; still Turkish in design and colour, and still woven with
the Turkish knot which they brought with them centuries
ago.

In view of the above considerations, it may be safely affirmed
that carpet weaving in the Persian manner existed in the country
long before the Seljuk or Mongol invasions, and that it was an
invention of the Persians themselves.

The passing references of the Arab geographers—many of
whom visited Persia between the ninth and fourteenth centuries
—indicate that the carpet weaving which existed there during
that long period was essentially a tribal or cottage industry. It
supplied the needs of the population for a warm, pleasing, and
durable floor-covering at a reasonable cost. The designs in vogue

were probably small repeating patterns, traditional in each locality. As such, they did not call for the aid of special designers and draughtsmen.

Of these early Persian weaves no vestiges remain. This is not surprising, because (and the fact is sometimes overlooked) Persian carpets are made of two highly perishable materials—wool and cotton. The former wears away under the constant friction of the human foot; and it is, of course, attacked by grubs and insects. Both materials are rapidly destroyed by damp and are slowly oxidized by exposure to the atmosphere. Thus, although —as we have seen—it has been the practice of Persians for centuries to carpet their floors from wall to wall, no pieces have survived which we can definitely date earlier than 1500.

It is probable that the great Seljuk Sultans, who reigned in Herat and Ghazna in the eleventh and twelfth centuries—and who were great builders and patrons of the arts of painting and calligraphy—failed to perceive the possibilities in the weaver's craft. For there are few references to carpets in contemporary writings. That the craft should have been neglected by the Mongol conquerors—Jenghīz Khān, Hūlāgū, and Tīmūr who followed them—is less surprising. There are indications, however, that during the reign of Tīmūr's famous son, Shāh Rukh, the craft of carpet weaving attained a certain notability; for carpets are depicted in a number of early fifteenth-century miniatures. Their designs are mostly rectilinear—which indicates that the craft had not yet reached an advanced stage of mastery. The later Mongol Il Khāns, however, were men of culture.

There was another Mongol prince besides Shāh Rukh—the enlightened Uzūn Ḥasan of the White Sheep dynasty (1466–77)— who certainly did possess fine carpets in his palace. We know this from the descriptions of the Venetian, Josafa Barbaro, who was Ambassador of the Republic to his court in Tabriz.

It was not, however, until the establishment of the Safavid

dynasty that the weaver's craft received the royal patronage and recognition which it merited. In 1499, after seven centuries of alien rule, a new dynasty arose in Persia. Although Ismā'īl, its founder, claimed descent from the Prophet himself (an Arab) and was a kinsman of Uzūn Ḥasan (a Mongol) and of his wife Despina (a Christian princess of the house of the Comneni), he is regarded by the Persians as the first national sovereign to occupy the throne of Cyrus and Shāpūr since A.D. 641. He was a fanatical Shī'a and established the Shī'a faith as the national religion. To the Persians he is the Restorer, the Liberator, the saintly founder of a famous national dynasty.

The first three monarchs[1] of the new dynasty were men of vision and ability. There are, indeed, few instances in history where three rulers in the direct line have equalled in the kingly virtues of their time the three Safavid monarchs—Shāh Ismā'īl, Shāh Ṭahmāsp, and Shāh 'Abbās.

We have seen that with the possible exception of Shāh Rukh and Uzūn Ḥasan, the predecessors of the Safavid kings were alien monarchs who were not greatly interested in a purely Persian village craft. But the first Persian princes to reign after 800 years of alien rule might well have sought to acquire merit in the eyes of their subjects by becoming patrons of an industry so peculiarly Persian and so receptive of the inspirations of art. Whether they were moved by policy or virtuosity, or both, it is to the high credit of these princes—particularly of the last two—that they perceived the possibilities which lay in the craft of carpet weaving. They endowed it with their interest and patronage, so that in a short time it rose from the level of a cottage *métier* to the dignity of a fine art. The most famous of the carpets which today adorn our museums and collections —carpets which have placed the Persians in the premier position

---

[1] There was a confused period of ten years between the death of Shāh Ṭahmāsp and the accession of Shāh 'Abbās, during which three rival princes struggled for power.

as designers and as weavers of floor-coverings and which have been copied and recopied in countless fabrics the world over— were almost certainly produced during the long reigns of Shāh Ṭahmāsp and Shāh ʿAbbās. Under the former the movement reached its highest development; under the latter it gained its greatest renown.

There are no indications that Shāh Ismāʿīl established a court factory in Tabriz, his capital. He was probably too busy consolidating his régime and fighting the Turks and Uzbeks. Shāh Ṭahmāsp, however, may have done so. The question will be referred to later when the heritage of the Safavid carpets is examined.

We do know something about Shāh Ṭahmāsp's interest in carpets. He is said, indeed, to have designed a few himself. We know, too, that he wrote to Sulṭān Sulaimān the Magnificent offering to send him carpets for the mosque—now known as the Suleimanié Jāmiʿ—which the great Sinān was building for him in Istanbul (Ṭahmāsp very properly importuned his royal brother not to forget to send him a list of the sizes). The carpets were in due course woven and dispatched. The Hungarian ambassador (who reported the matter) said that they were made in Hamadan and Dargazin; which may indicate that no court factory existed at the time.

Happily there is no doubt at all that Shāh ʿAbbās, the most famous of the Safavid kings, established a court factory in his new capital, Isfahan. For there are a number of contemporary references to it. We know from two Frenchmen, Tavernier and Chardin, from Sir Robert Sherley, from a Polish Jesuit, and particularly from the Shāh's Secretary—who wrote a long and detailed chronicle of his reign—that it was situated near the palace, between the Chihil Sutūn and the Great Maidān. As both landmarks exist today it can be placed quite accurately. Tavernier says that carpets were being constantly woven there for the royal court. This we can well believe; for Shāh ʿAbbās

was building his capital with great rapidity, and there must have been a constant demand for carpets for the palaces, for the offices of state, for the houses of the courtiers and high officials, and for presentation to foreign potentates and their envoys. We have seen a similar activity recently, during the reign of Shāh Riẓā Pahlavi.

The carpets which were produced during this great period present a number of problems which have puzzled experts for two generations and will puzzle their successors for generations to come. Although they were woven some four centuries ago (which, measured by the time scale of the antiquarian, is not long) we know surprisingly little about them. How is it that this industry came with such startling speed into full fruition? When were these carpets made? Where were they made? And why, after a few generations of splendour, did the art decline?

A reply to the first of these questions has already been suggested: the sudden rise in the craft to the dignity of a fine art coincided with the establishment of a new, national, and dynamic dynasty in Persia. It coincided also with that puissant, fructifying wind which was blowing through the whole world in the sixteenth century.

The second question is: How do we know that most of the great carpets which have come down to us were produced (as we declare with such assurance that they were) during the reigns of Shāh Ṭahmāsp and Shāh ‘Abbās? It must be admitted that incontrovertible proofs do not exist. Indeed, until comparatively recent years the dating of antique carpets was a haphazard business. The authorities of a generation ago, like Martin and Bode, made some sad guesses. They propounded dates and origins with a temerity which is surprising in persons of such eminence. How much more satisfying was the caution of Tattersall and Kendrick of the Victoria and Albert Museum. To them a carpet was 'Persian' or 'North-west Persian', and its

date 'probably sixteenth century'; and their reserve was not the fruit of indolence or dullness, but of devotion and integrity.

During the last two decades, however, the matter has been studied further. Much circumstantial evidence has been collected and a technique has been devised which has enabled authorities to attach approximate dates on many of the great carpets; and these dates generally fall within the period indicated.

The technique consists of establishing the dates of certain carpets about which we possess positive information, and grouping round them other carpets, similar in style, about which we possess no clues. The phrase 'similar in style' is here used to denote a family resemblance, an affinity in design, materials, colour, and weave.

The 'positive information' which enables us to date a carpet —which can then be used as a nucleus of a group—is the following:

(*a*) The date may be woven into the carpet itself.

(*b*) The carpet may be identifiable historically.

(*c*) The design of the carpet may be traceable to an illustrated or illuminated manuscript, to a painting or book cover, the date of which is known.

The first of these methods would be, of course, the most valuable of all—if only the master craftsmen of those days had possessed the foresight to weave the dates into a few more of their productions. Unhappily they omitted to do so. Of the many hundreds of carpets and fragments which have come down to us from Safavid times only a few were dated. Still, the dated pieces include the Ardebil carpet—the pride of the Victoria and Albert Museum—and a fine hunting carpet in the Museo Poldi Pezzoli, Milan. It has been possible to use these two dated pieces—and others of less renown—as starting-points for the formation of groups of carpets similar in style.

The second method—that of basing a group on carpets which

can be identified historically—has also proved of value. The most notable instance of historical identification is that of two pieces in the Residenz Museum of Munich. In 1605 Sigismund Vasa, King of Poland, sent an Armenian merchant by the name of Muratovitz to Persia with instructions to order a number of carpets for the royal palaces. Muratovitz travelled by sea to Trebizond and thence, via Erzerum, Kars, Tabriz, and Qazvin, —to Kashan. There, as he himself declares, he placed his orders and superintended the weaving of the carpets, which bore the royal coat of arms. Four of them—two emblazoned with the Polish eagle—are in the Residenz Museum. They have enabled us, with some assurance, not only to date a group of pieces similar in style, but to affirm that they were woven in Kashan.

The third method—from the design alone—is fruitful in results. But only if we are prepared to agree that a design which appears in a carpet—as well as in a dated manuscript, book cover, or painting—must have been drawn by one and the same hand.

There are good grounds for accepting this premiss. For an intelligent and ardent monarch, anxious that carpets should be produced during his reign which would be superior to the best products of previous ages, would be likely to call upon the finest painters and illuminators of his court to co-operate with his most renowned master weavers in their production.

The task of fixing the place where each of these carpets was made is even more perplexing than that of determining their approximate dates. For there is no positive evidence of their origin. Each piece, indeed, might have been woven in one of half a dozen localities. It is hardly practicable to discuss this matter in detail within the limits of this chapter; but it will be examined below in respect of two of the most famous of the Safavid carpets which we possess.

Our heritage of Persian carpets of the fifteenth, sixteenth, and seventeenth centuries has been estimated at 1,500 pieces

including fragments. By no means all of them are worthy of note. Many are weak in design and faulty in execution. Of these it may be said that, if age be a merit, they have no other. There are, however, many pieces of real excellence among them, and at least 200 of renown.

The quality of the legacy which the designers and the master weavers of the Safavid weavers have bequeathed to mankind may be judged by a brief examination of seven pieces—which one person, at least, considers to be among the best carpets in the world. No attempt has been made to arrange them in order of merit, date, or provenance. For—as has been explained above —the dating of ancient carpets is a precarious adventure, and the task of determining their place of origin is no less vague and unfruitful. This will appear below in the remarks on the first of the seven—the Ardebil carpet of the Victoria and Albert Museum (Plate 48).

This renowned carpet is so called because it came from the mosque in Ardebil where Shāh Ismāʿīl and Shaikh Ṣafī ad-Dīn, his ancestor (after whom the Safavid dynasty was named), are buried. The carpet was acquired in 1893 from Messrs. Vincent Robinson & Co., who had purchased it from Messrs. Ziegler & Co. of Tabriz.[1] It bears the following inscription, which is taken from the beginning of an ode by Ḥāfiz:

> I have no refuge in the world other than thy threshold;
> There is no protection for my head other than this door.

> The work of the slave of the threshold
> Maqṣūd of Kāshān, in the year 946

The Ardebil carpet is—by reason of its design and craftsman-

---

[1] Another carpet was removed from the mosque at about the same time as its more famous counterpart. A portion of it—notably most of the border—was used to repair the carpet now in the Victoria and Albert Museum.

PLATE 48

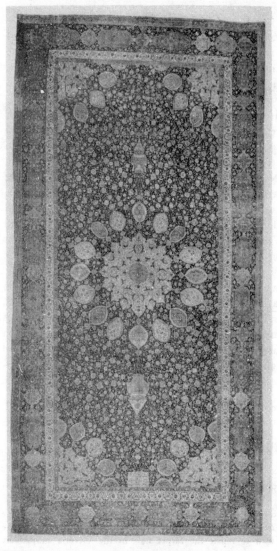

ARDEBIL CARPET
Dated A.H. 946/A.D. 1539. Victoria and Albert Museum

ship—one of the great carpets of the world. It is also an histori-
cal document of the first importance, because it bears a signature
and date. Thus it has become the nucleus of a group of splendid
medallion carpets, similar in style, which can be ascribed with
assurance to the middle of the sixteenth century; for the carpet
was woven in the year A.D. 1539 (A.H. 946), the thirteenth year
of the long reign of fifty-two years of Shāh Tahmāsp.

The warps and wefts of the carpet are of silk. The knot is
Persian. There are approximately 17 by 19 knots to the inch,
which is about equal to the best quality Kashan carpets of
about twenty-five years ago.

Unlike many of the famous carpets of the period, the Ardebil
is tranquil in design and free from disturbing images of animals
and figures. For it was woven to lie in a holy place, where
representations of animals or human forms were banned by the
Qūr'ān.

The drawing and execution are admirable. The sixteen ogival
panels, radiating and equidistant from an almost round sixteen-
pointed medallion, suggest that the design was intended to
indicate a circular dome, from which the two golden lamps were
suspended. As usual, a quarter of the centre design is repeated
in the four corners—a harmonious and satisfying convention.

The cartouche border, with its twin guards in which the
cloud-band motive has been cleverly introduced, is justly
famous. It has become the prototype of this style of border in
every country where carpets are made.

All authorities agree that a carpet of such outstanding design
and craftsmanship could not have been produced except by a
combination of the first designers and craftsmen of the age—
such as might be found, most probably, in a court factory. And
because, during part of the reign of Shāh Tahmāsp, his capital
was in Tabriz, it has been asserted by some that the carpet was
woven there—in a royal factory established by that prince.
Furthermore, these authorities have maintained that the

splendid group of sixteenth-century medallion carpets—which undoubtedly possess a strong family affinity with the Ardebil—must have been woven in Tabriz as well.

But how could this be? The Ardebil is dated A.H. 946 (A.D. 1539); but long before that date Ṭahmāsp—realizing that Tabriz (owing to its exposed position) was in danger of attack from his enemies the Turks—had moved his capital to Qazvin. His caution was well founded. For in 1533—six years before the Ardebil was completed—Tabriz was captured by the Turks. During the succeeding twenty years it was abandoned and re-occupied no less than four times. Are we to believe that when Ṭahmāsp removed his seat of government for safety to Qazvin he left his factory behind; and that the carpets which he ordered for the Mosque at Ardebil were woven in Tabriz during the Turkish occupation?

Tabriz may be dismissed as the birthplace of the Ardebil on technical grounds as well. For the carpet was woven with the Persian knot, whereas the people of Tabriz were Turks and undoubtedly wove the Turkish knot—as they do to this day. It is possible, of course, that Maqṣūd, who wove it, may have been ordered by the Shah to come north to Tabriz with several hundred weavers from Kashan and to set up a court factory there; and that the factory with the weavers was transferred to Qazvin when Ṭahmāsp moved his capital. In that case the Ardebil—and probably most of the other carpets of that group —were woven in Qazvin. If that were so, however, we would expect that some record, some vestige, or some tradition of this important undertaking, would remain in Qazvin; yet nothing remains; and it has never been suggested by the Persians that any of the Safavid carpets were woven there.

If, then, the claims of Tabriz and Qazvin appear too shadowy, where could the Ardebil and its companions have been woven?

The towns of south Persia (Kirman and Shiraz) and of east Persia (Meshed) may be excluded on technical grounds. Sultana-

bad did not exist, for it was founded in the nineteenth century. In Hamadan the Turkish knot was used; and there is no evidence that fine carpets were woven there. Isfahan did not become a centre of fine weaving until Ṭahmāsp's successor, Shāh 'Abbās, made it his capital and established his court factory. There remain, then, Ardebil itself and Kashan, the birthplace of Maqṣūd, who produced the carpet.

Ardebil is certainly a possibility. Maqṣūd may have been instructed to bring his weavers and set up his looms there—perhaps in the precincts of the mosque where the carpets were to be laid. Indeed, the inscription on the carpet itself may have been intended to convey that it was woven on hallowed ground. But again we are met by the total absence in Ardebil of any tradition that this took place. It is hardly conceivable that a tradition would not have existed in the mosque itself if the carpets had actually been woven in its precincts or in the neighbourhood.

Finally, the Ardebil may have been woven in Kashan. This does not follow, however, from the fact that Maqṣūd's cognomen was Kāshānī. For in a country where surnames did not exist, the birthplace following the given name was merely an added means of identification. It did not necessarily indicate that Maqṣūd lived and pursued his craft in Kashan. Yet Kashan undoubtedly possesses a claim as against Tabriz, Qazvin, or Ardebil to be the birthplace of the famous carpet. It is now, and has been for centuries, a centre of fine craftsmanship. M. le Chevalier Chardin, writing in the sixteenth century, observed: 'Cachan . . . il ne se fait en aucun lieu de la Perse plus de satin, de velours, de taffetas, de tabis,[1] de brocard uni et à fleurs de soie et de soie mêlée d'or et d'argent qu'il s'en fait en cette ville et aux environs.'[2] Sir Anthony Sherley says much the same thing about Kashan and specifically mentions 'Persian carpets of a

---

[1] *Tabis* is not a misspelling of *tapis*; it is 'tabby', or watered silk.
[2] *Voyages de Mr le Chevalier Chardin* (Amsterdam, 1711).

wonderful fineness'.[1] And, of course, the Kāshānī's use, and have always used, the Persian knot.

Here, then, we must let the matter rest, with the hope that the reader has not been wearied by the vain pursuit. The object of the short inquiry has been to indicate the danger—if, indeed, a stronger term should not be used—of making positive assertions as to the birthplace of the Safavid carpets. The Ardebil was chosen for the inquiry because it is one of the very few which are dated and signed. Yet, in spite of these precious indications, we are unable to trace its origin. How then dare we postulate about the origins of those pieces which do not possess even those important clues?

We do not know, and it is doubtful if we shall ever know, where these carpets were woven. All that we can do is to indicate some of the more likely localities and to register their claims. The reader, if he is sufficiently interested, may inwardly record his preference.

The next on our list of the great Safavid carpets—among the most valuable of the heritages that Persia has bequeathed to mankind—is the Hunting Carpet in the Austrian Museum for Art and Industry, Vienna. It is in the first rank of the great carpets of the world. Some authorities, indeed, have declared it to be the finest carpet ever woven. It is the only carpet listed here in which warp, weft, and pile are of silk. Parts of the figures are brocaded in silver or silver gilt. It counts $27 \times 29$ knots to the inch, which is far closer in weave than any other of the Safavid carpets.

The hunt which is depicted is a catch-as-catch-can affair. The huntsmen are mounted and armed with spears, swords, and bows. They are attacking—with considerable *élan* but apparently without much method—a concentration of lions, leopards, wolves, bears, antelopes, wild asses, jackals, and hares. This is

---

[1] *Brief and True Report of Sir Anthony Sherley, his Journey into Persia*, &c. (London, 1600).

PLATE 49

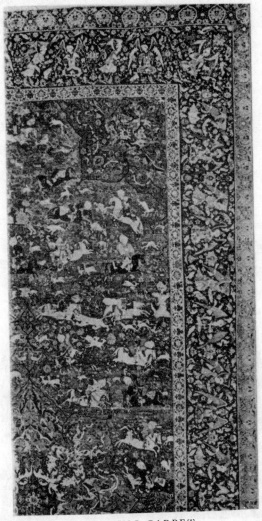

HUNTING CARPET
Mid-16th century.
Museum for Art and Industry, Vienna

PLATE 50

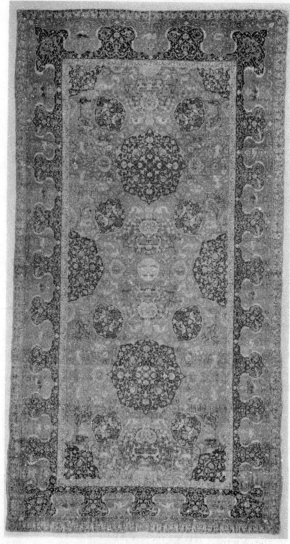

CHELSEA CARPET
16th century. Victoria and Albert Museum

strictly in the Persian tradition. For with the Persians the hunt is often prepared for the huntsman—as, indeed, it is with us—so that he may be spared unnecessary fatigue. The eight-pointed green medallion is embellished with golden dragons and phoenixes, in the Chinese manner. Again, as is common in Persian design, the corners repeat a quarter of the medallion.

The border is an outstanding feature of this magnificent carpet. Its ground colour is a deep crimson. The design consists of a succession of winged figures receiving offerings of bowls of fruit from other winged figures. These are beautifully drawn and evenly spaced upon a background pattern of birds, cloud-bands, and flowers.

The carpet was almost certainly designed by a court painter; perhaps—as Dr. F. R. Martin and others have suggested—by Sulṭān Muḥammad, the celebrated court painter of Shāh Ṭahmāsp. It has all the animation, movement, and superb pictorial skill of that admirable master. If, indeed, it was designed by him it was probably woven about the middle of the sixteenth century, for Sulṭān Muḥammad died about A.D. 1555.

The carpet has been attributed to Kashan on the grounds that the Kāshānīs were accustomed to weave silken fabrics and that some silk carpets were undoubtedly woven there in the sixteenth century. But this proves nothing. A silk carpet can be woven in any factory if the competent craftsmen are there. Still, Kashan probably possesses as good claims as any other town to the distinction of having produced perhaps the finest silk carpet ever woven.

In the opinion of some authorities the weak point of the carpet is the ground colour, which is salmon-pink. The colour was probably very rich and lovely when the carpet was first woven.

The third of our seven carpets is the so-called Chelsea carpet of the Victoria and Albert Museum (Plate 50). The piece

was acquired, over fifty years ago, from a dealer in Chelsea, and it has been known in the museum as the Chelsea carpet ever since.

Some authorities have claimed that it is earlier than the Ardebil. It may be; but there appears to be no special reason for this assertion. The carpet possesses an undoubted kinship with the Ardebil and probably belongs to the same group of famous carpets of the reign of Shāh Ṭahmāsp, as the Ardebil itself.

It is without doubt one of the great carpets of the world. Kendrick and Tattersall (in whose care it was) declared that it almost challenged the Ardebil for the first place in the Victorian and Albert collection. Bode declared that it occupied 'the first place among all carpets'. We cannot but agree with these authorities. The carpet is indeed a triumph of imaginative and elaborate design combined with perfect execution. It possesses all the nobility and tranquillity of the Ardebil, with the added interest of beautifully drawn animal figures. Its colour is a sober combination of deep carmine red with bold medallions and ogees in dark blue. Like the Ardebil its warp and weft are of silk. It counts 21 × 22 to the inch, which means that it has about 50 per cent. more knots per square inch than the Ardebil. It is in an excellent state of preservation.

Where was the Chelsea carpet woven? I can only refer the reader back to the previous discussion of this question; adding that the Chelsea and the Ardebil were probably woven in the same place—wherever that was.

The fourth carpet of our choice is an All-over Animal and Floral Carpet in the Austrian Museum for Art and Industry, Vienna (Plate 51). This is one of the finest examples extant of the all-over animal and floral group of carpets, of which a number have come down to us. As such it has an undoubted claim to a high place among the great carpets of the world. Like the Ardebil, the Austrian Hunting carpet, and the Chelsea, its warp

and weft are of silk. It counts $17 \times 19$ to the inch—about the same as the Ardebil. The whole design (with the exception of the twin large green flowers in the middle of the upper and lower halves) is admirably drawn and executed. The distortion of the two flowers is probably due to faulty execution, because they are woven on the bias—a difficult operation.

The border displays a superb treatment of the cloud-band motive with entwined arabesques. The inner guards are made up of cartouches of equal length—each filled with an inscription —and there is nothing more decorative than an inscription guard or border. The ground of the carpet is rich red; the border dark green; the inner guard yellow.

Where were the carpets of this group woven? They have been attributed—on what appear to be rather doubtful grounds—to east Persia. They may have been made there. But to the writer at least they appear nearer in fabric to the carpets of the west. But again we do not know.

When were they made? Authorities are generally agreed that they were woven at the end of the sixteenth century. They probably were.

The next carpet on our list is the Rose Ground Vase Carpet of the Victoria and Albert Museum. The best among the great carpets must include a representative of the Vase design, and its various modifications. For one thing, many more carpets in this design have come down to us from the Safavid period than of any other. And no wonder. For it is, by and large, one of the best designs for a floor-covering that has ever been devised. It has determined and defined for all time a large number of classical Persian forms and motives which have been copied and recopied for 400 years. It has been woven in almost every textile floor-covering that exists, and it has been used by printers of furnishing materials the world over.

Including fragments, there are probably more than fifty pieces in the Vase design in the museums and private collections

of the world. Most of the important collections possess examples. It was not a simple matter to select the carpet out of the best half-dozen which expresses most completely the designer's plan. For if ever a design was truly planned, this was.

The choice finally lay between a carpet in the National Museum, Berlin, and one in the Victoria and Albert Museum. The London carpet is more refined and more graceful; the Berlin piece bolder and more striking. The motives in the London carpet are smaller than those in the Berlin carpet, so that the plan is shown. In the Berlin carpet much of the surface is taken up by the large motives, so that the plan is almost lost. Both pieces are fine examples of the genre. The final choice was the London carpet.

The borders of both carpets are weak—as indeed are the borders of most of the Vase carpets.

Where were the Vase carpets made, and when?

The reader must not be wearied with another hopeless quest. But I cannot refrain from expressing some disagreement with Professor Upham Pope's view that they were woven in the small mountain village of Jōshaqān.

That village enjoys a just but limited renown in Persia. For it is the only locality which has continued to produce the same style of carpet in weave, dyes, and design for at least 200 years, and (for aught we know) for much longer. Except for the lack of wear, the bloom and the patin of age, some of the Jōshaqān carpets of today might have been woven two centuries ago.

But these carpets, old and new, possess one peculiarity which, if given due consideration, may be thought to modify Professor Pope's somewhat categorical judgement. *They are all woven in straight lines.* No Jōshaqān carpet of the last 200 years possesses a single curvilinear motive or flower; yet he asserts that the Vase carpets—those masterpieces of curvilinear design —were woven in this village.

PLATE 51

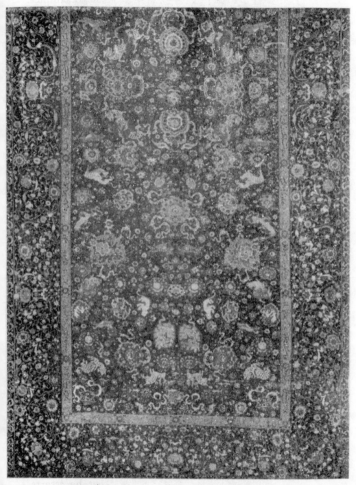

ANIMAL AND FLORAL CARPET
16th century. Museum for Art and Industry, Vienna

PLATE 52

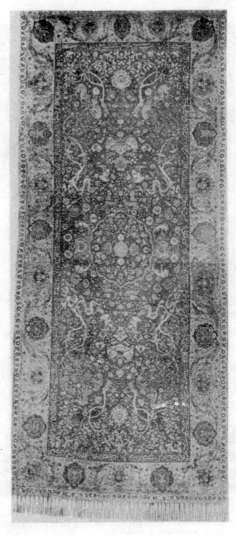

ANIMAL AND FLORAL MEDALLION
CARPET
Mid.-16th century. Museo Poldi Pezzoli, Milan

It is almost unnecessary to add that carpets of such fine quality and intricate design call for the associated efforts of skilled dyers, of creative designers, of planners and draughtsmen, and of master weavers—all of whom must have been trained for long years in their craft. Such persons are not to be found in small mountain villages in Persia. There is no scope for their activities among the poor and ignorant peasantry. They can only work in the more civilized atmosphere of the towns.

The monumental *Survey of Persian Art* contains no less than 152 plates of Persian carpets. Of these Professor Pope has definitely attributed no less than thirty-six to this small village, with four more possibles. But to Isfahan itself, where we know —beyond shadow of doubt—that Shāh 'Abbās had established a court factory close to his palace (so that this curious and indefatigable prince might watch from day to day the progress of his carpets) Professor Pope attributes only *one* piece. Where, then, were all the carpets woven which were produced during the reign of the Great King? The writer suggests with due diffidence that the Vase carpets were woven in the court factory in Isfahan itself.

We know that a considerable number of carpets in the Vase design were made. Would it not be in the nature of things for Shāh 'Abbās to select a fine design from among those submitted, and to order from it a number of carpets to be made in his factory in various sizes and ground colours—rose, red, dark blue, medium blue, cream, and tan—like the Vase carpets which have come down to us? If this suggestion appears reasonable we can plead with some assurance that the carpets of this group were woven in Isfahan during the reign of Shāh 'Abbās; that is, in the late sixteenth or early seventeenth century. Most authorities are at least agreed upon the date.

Our next carpet is a Medallion Animal and Floral Carpet with inscription guard, from the Museo Poldi Pezzoli, Milan

(Plate 52). This splendid carpet appears to bear a family resemblance to the Chelsea carpet. Its weave is similar; it has the same tranquillity, deriving from its low tones of red and dark blue. Like its relative in London its warps and wefts are of silk. It counts 18 × 20 knots to the inch—not as fine as the Chelsea carpet, but somewhat finer than the Ardebil. Unlike those two carpets, however, some of the figures in the Milan carpet are brocaded with silver gilt.

The design possesses some unusual features. Light, realistic trees—very different from the conventionalized tree patterns which usually appear in Persian carpets—have been introduced into the field. Though skilfully drawn and perfectly executed, they may appear (to some eyes at least) out of harmony with the staid formalism of the rest of the design. Again, the head of the medallion is separated from the medallion itself—a breach of an accepted convention which may be disturbing to the devotees of tradition.

The animal and floral figures in the field, the stately medallion, the broad inscription guard, and the graceful flowing border are superbly drawn and carried out.

Authorities are generally agreed that it was woven—like its relatives the Ardebil and Chelsea carpets—in the middle of the sixteenth century, during the long reign of Shāh Ṭahmāsp. As to its birthplace, the reader is referred to the discussion on pages 244–5.

The seventh and last carpet on our list is an inscribed Medallion Carpet with Animals and Flowers and Inscription Border, from the Metropolitan Museum of Art, New York (Plate 53). A number of carpets similar to this in design and style have come down to us from Safavid times, but this is admittedly the best of the group. Its warp and weft are of silk. In quality it is among the finest of the woollen pile Safavid carpets; for it counts 23 × 24 knots to the inch, which is finer than the Chelsea carpet and is only surpassed by the silk Hunting Carpet of the Austrian Museum.

PLATE 53

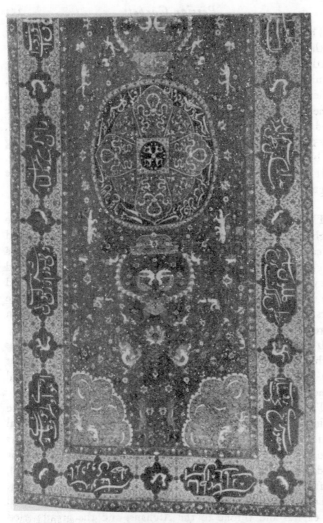

MEDALLION CARPET WITH ANIMALS AND FLOWERS.
INSCRIPTION BORDER
Mid.-16th century. Metropolitan Museum of Art, New York

The design is more austere, less elaborate, than that of most of the great carpets. But it is no less admirable for that. Apparently the artist who conceived it did not aim at compelling admiration or wonder. He sought rather to appeal to a deeper, stiller emotion. The round medallion with its strange cruciform panels in green enclosed by an inscription on black; the large medallion heads (with their suggestion of Islamic headstones), the magnificent inscription border—again with silver lettering on black—gives to this carpet a ritualistic, an ecclesiastical air.

It was probably woven in the sixteenth century during the reign of Shāh Ṭahmāsp; where, we do not know.

The century between the death of Shāh 'Abbās and the Afghan invasions was for Persia a period of decay, turmoil, and defeat. The four last Safavid monarchs possessed few of the kingly virtues of their predecessors of the dynasty. They devoted the greater part of their lives to the pleasures of the harem and the table and to planning political murders. On every front the Persian armies suffered defeat. Baghdad, Tabriz, and Hamadan were captured.

It has been truly said that every movement in art carries within itself the seed of its own degeneration; and that without the perennial stimulus of patronage, praise, and a congenial atmosphere, genius will wilt and fail to flower.

The successors of Shāh Ṭahmāsp and Shāh 'Abbās failed to maintain their interest in the art of carpet weaving. The royal patronage was withdrawn from the designers and master weavers who had worked for Shāh 'Abbās. They were soon scattered, or died, and were not replaced. Although their designs endured, craftsmanship degenerated. It became slovenly, inexpert. Finally, in 1722 Shāh Ḥusain, the last of his line, surrendered his capital and throne to the Afghans, and the great period came to an inglorious end.

Those hundred years of decline witnessed the gradual decay

of the art of carpet weaving; and the short but bloody rule of
the Afghan chiefs almost extinguished what was left of it.
This, one of the darkest periods of Persian history, was followed
by twenty years of uninterrupted conflict. One Nādir Qulī, a
tough but capable military commander—who had previously
been a successful leader of a robber band—drove out the
Afghans, recaptured Tabriz, Hamadan, Derband, Baku, and
the Caspian provinces, and was elected to the vacant throne.
During the turbulent reign of that rough soldier, scant attention
was given to the art of weaving.

There is no evidence of a revival of the craft during the reign
of the kindly but illiterate Karīm Khān Zend (1750–79) who
made Shiraz his capital. Indeed, Sir John Malcolm, who wrote
a detailed history of the period and devoted a whole chapter
to the products, manufactures, commerce, and arts of Persia
at the end of the eighteenth century, had no word to say about
its carpets. That such a meticulous observer should have made
no reference to the craft is an indication of the low level to which
it had sunk.

Carpet weaving, however, had not disappeared; it had shrunk
once more into an insignificant but useful handicraft. The
establishment and consolidation of the Qājār dynasty which
followed soon after the death of Karīm Khān provided Persia
with a long period of order and comparative peace and gave the
industry the opportunity of revival.

The three important Qājār monarchs—Fatḥ ʿAlī Shāh, Nāṣir
al-Dīn Shāh, and Muẓaffar al-Dīn Shāh—pursued with success
the ancient traditions of the Persian monarchs. These traditions
tended to prevent Persia from acquiring the uncertain benefits
of Western reform. They endowed her instead with other bene-
factions of inestimable worth—stability and a large measure of
security. After the Qājār monarchs had provided for themselves
—and had permitted their subordinates to provide for them-
selves—a proper and traditional measure of self-compensation,

these princes allowed their people freedom to pursue their lawful occasions, to plough, to sow, to reap, to traffic—and to weave. Whereas early in the nineteenth century the careful Malcolm had omitted carpet weaving from the industries of Persia, numerous travellers in the succeeding fifty years testified to its interest and importance.

The industry had, however, undergone a fundamental change. The great period had left its imprint upon it—an imprint which had endured for three centuries and which will seemingly endure as long as carpets continue to be woven in Persia.

The technique employed in the preparations of the materials and in the weaving process remained the same. The imprint was in design. For the influence of the designers whom the Safavid princes had gathered about them was profound and permanent. They had copied, invented, adapted, and fixed for good a large and varied series of lovely floral and animal forms—Chinese, Arab, and Persian—which appear, time and again, in a thousand permutations, in the designs of their successors. Every Persian designer of today can draw them with his eyes shut. Any suggestion that one of them could be altered or improved would be received with polite but unmistakable disfavour. These motives are the foundation of Persian classical design.

For many centuries—but in a small way—Persian carpets had been an article of foreign commerce. As far back as the fifteenth century they were known and valued in the West. They appear in ancient inventories and in a few Italian and Flemish Renaissance paintings (although most of the carpets thus depicted were Caucasian or Turkish weaves).

It was not until the middle of the nineteenth century, however, that Persian carpets began to find their way into the West in appreciable quantities. The trade was in the hands of Tabrizi merchants—men of substance and renown. They had branch offices in Istanbul, where their principal business was to buy the manufactures of the West and ship them home, via

Trebizond. These merchants had agents in the important towns of Persia, who collected old carpets from the houses and the bazaars. Most of these pieces had been long in service; for there were no banks in Persia in those days and the custom was (as, indeed, it is today) for people to invest in carpets which could, at need, be reconverted into cash. These pieces invariably realized a higher price after ten to forty years of service than their owners had paid for them in the first instance. Thus there issued from the houses into every bazaar in Persia a constant stream of antique or semi-antique pieces.

These carpets had been produced exclusively for the home market. They had not been woven in factories: they were tribal or village pieces, usually in small repeating patterns. The sizes were long and narrow and, to our way of thinking, awkward.

The agents of the Tabrizi merchants collected as many of these old pieces as they could find and sent them to Tabriz. There they were sorted, baled, and dispatched upon their long overland journey by caravan to Trebizond. At Trebizond they were shipped to Constantinople, which became the world's market for carpets. Buyers from Britain, from the United States, from France (the demand from Germany came later) visited the Turkish capital in increasing numbers. The demand for carpets continued to grow; but the supply of old pieces from the houses steadily diminished.

The enterprising merchants from Tabriz were faced with the danger of the extinction of their profitable trade. They resolved to meet the crisis by producing new carpets—to be specially woven for export—in sizes, colours, and designs which they believed would appeal to Western taste. Thus, about the year 1880 the weaving industry of Persia—which since the Afghan invasion had dwindled into an insignificant village craft— received a stimulus which has placed it today in the forefront of Persia's commercial activities.

The basic character of the craft was of necessity changed.

The Persian carpet, from being an article produced to meet a restricted domestic need, became essentially an article of export, with a demand as wide as the world itself.

The Tabrizi merchants were not content merely to place their orders with the village weavers and leave it at that. They soon established looms in the towns where the weaving process could be easily and more properly controlled. The movement began in Tabriz itself, but they extended it before long to Meshed, Kirman, Sultanabad, and Kashan. In each locality the moving spirit was the Tabrizi merchant.

Those early Tabriz, Meshed, and Kirman carpets of the new era were few in number and aroused curiosity when they first appeared on the market in Constantinople sixty to seventy years ago. Unlike the old-time mellow pieces which had hitherto been received, these carpets had never before seen service. To the unhabituated eyes of the buyers they were extravagantly bright and crude in colour. Their sale presented a formidable problem. But the ingenious merchants of Tabriz attacked it with their usual sagacity. Before long the roofs of the *hāns* where they traded were covered with carpets of price, exposed to the fierce rays of the Turkish summer sun. And in the early morning, men with watering cans roamed among them, like gardeners watering their flowers; for it was found that watering the carpets before the sun was up tended to speed the fading process.

Other methods too were tried. The carpets were placed face upwards on the ground in the bazaar—where the traffic was thickest—and left for many weeks to be trodden on by man and beast. Then the accumulated filth was washed off with wood ash or a native cleaning root. The result was passable. But it was soon discovered that the reduction in colour had been produced—not by trampling the rugs in the dust, or cleaning them with the root—but by the wood ash. And so the covered ways of the bazaar ceased to be garnished with carpets, and washing with wood ash alone became the accepted technique.

Thus, by a long process of trial and error, the technique of carpet washing was born.

The development of the export trade changed the character of the craft. But was it changed for the better? The answer must be in the affirmative. It can hardly be disputed that the carpets produced in Persia between the beginning of the eighteenth century and the middle of the nineteenth cannot compare in variety, in excellence of design, or in craftsmanship with the best products of the Kirman and Kashan weavers of the early twentieth century; nor with the weaves of Nain and Qum in more recent years.

Although the effect of this sudden change of objective was profound it had little effect on the technique of carpet weaving. That, indeed, has varied little down the centuries. The essentials of design—modified as they have been in recent years to meet the public taste of the West—have persisted, with surprising constancy, from generation to generation. The calls of fashion, the demands of the stylist and the interior decorator, have their day and are forgotten; but the motives of the great designers of the sixteenth century still stand. They reappear in a thousand combinations in the carpets of today, to proclaim the continuity of a great tradition.

A. C. EDWARDS

# CHAPTER 10
# PERSIAN GARDENS

*Horti Persanum erant amœnissimi*

WHEN the Englishman utters or thinks the word 'garden', a definite picture rises in his mind. What that picture is will depend on several things—upon his station in life, upon his interest in flowers, and perhaps above all upon his degree of mobility. If he is very humbly situated, his idea of a garden may not extend much beyond an allotment of utilitarian purpose, with a possible row of sweet peas thrown in to furnish his wife with a vase for the kitchen window-sill; if he is a little more prosperous, the vegetables will be relegated to the back, and the front garden will be devoted to some flower-beds and a patch of lawn; if his prosperity runs to the possession of a motor-car, in which he can tour his own county or even a wider area to visit the many gardens now open to the public, the scope of his imagination will be enlarged and that mental picture will become more varied and more ambitious. He will acquire a familiarity with the grander type of garden, expensively laid out, it may be, some centuries ago, with ancient hedges, avenues, and vistas, with architectural features such as stone balustrades and parapets, mossy statues, pools and fountains, garden-houses, orangeries, and classic temples coolly poised to reflect their beauty in the waters of a lake. Quite likely he will admire without coveting. It is not at all the sort of thing he wants for himself. The garden the average Englishman wants for himself, if I correctly interpret his wishes, is something manageable and packed with colour; what we mean when we say a cottage-garden; something intimately associated with its house; with narrow paths, and beds thick with flowers —pansies, and auriculas and Sweet William and Madonna lilies, hollyhocks and roses, daffodils and snowdrops; no elaborate plan,

but a jumble that comes up year after year, apparently giving its owner no trouble (though he knows better); the sort of garden represented on the grocer's Christmas calendar or on picture postcards of Anne Hathaway's cottage. Repellent in such reproductions, in reality they are enchantingly pretty, endearingly sentimental, and essentially English.

No such vision can ever come into the mind of the Persian. His idea of a garden is quite different. All that he demands, this denizen of a high, rocky plateau, is coolness at the end of the day's journey; coolness and greenness; the sound of trickling water after the silent desert, after the miles of shadowless plain.

This is his idea of Paradise, and suitably enough the beautiful word 'Paradise' is one of the few that the English language owes to a Persian derivation. *Pairidaēza*, from *pairi*, 'around', and *diz*, 'to form or mould', meant an enclosure or park, as in modern Persian *firdaus* still means a garden or paradise. The word travelled into the European languages through the pen of Xenophon in the *Oeconomicus* (παράδεισοι), when he relates how Cyrus personally conducted Lysander round his paradise at Sardis. Lysander was full of admiration for the beauty of the trees, the accuracy of their spacing, the straightness of their rows, the regularity of the angles, and the multitude of sweet scents wafted to them as they walked, but when he exclaimed on the skill of the Agent who had measured everything so exactly, Cyrus proudly replied that the whole of the measurement and arrangement was his own work (somewhat nettled, I suspect, at the attribution of credit to the wrong man), and that he had even done some of the planting himself.

'What, Cyrus?' exclaimed Lysander, looking at him and marking the beauty and perfume of his robes, and the splendour of the necklaces and bangles and other jewels he was wearing, 'did you really plant part of this with your own hands?'

Cyrus assured him that it was so. Never, he said, had he sat down to dinner when in sound health, without first working hard at some task of war or agriculture. We may wonder whether a certain plane-tree was of Cyrus' planting, which Xerxes so admired on his way to Sardis that he remained in rapture before it, and before continuing on his road hung golden chains and armlets round its branches.

We may thus regard the younger Cyrus as the first Persian gardener to be mentioned in literature. It is a romantic thought, coupled with the introduction of the word 'paradise' into the Greek language and consequently into ours. Sir Thomas Browne, with his taste for the romantic, thought so too, though he seems to have fallen into some confusion between the elder and the younger Cyrus. No matter: we do not look for accuracy in Sir Thomas Browne; it is for other, more poetical things that we look. Speaking of the hanging gardens of Babylon, he observes that 'the Persian gallants' after the victory of Cyrus the elder over the Babylonians, 'bravely maintained their botanical bravery. Unto whom we owe the very name of Paradise, wherewith we met not in Scripture before the time of Solomon, and conceived originally Persian.' Sir Thomas held a high opinion of Cyrus (the younger) as a gardener, 'Not only as a Lord of gardens, but a manual planter thereof, disposing his trees like his armies in regular ordination. . . . All stories do look upon Cyrus as the splendid and regular planter.'

Now I imagine from the internal evidence given by Xenophon, that the paradise planted at Sardis in Lydia four and a half centuries before the birth of Christ, by the scented young conqueror with jangling bangles and necklaces, in his beautiful robes, was more of an orchard and a farm than what we should call a garden. Nevertheless, it probably set the design that Persian gardens have followed ever since; if, indeed, the design had not been anticipated many years before the death of Cyrus

in 401 B.C. That this seems probable is confirmed by the discovery of a pottery bowl at Samarra by Professor Herzfeld, which is thought to date from about 2000 B.C. and shows 'crossed canals defining four beds each with a tree and a bird'. This is the orthodox plan: a design of extreme formality, as we can deduce from Lysander's insistence on the straightness, the accuracy, and the regularity of the rows and angles. This was the thing to be admired. And so we find, in fact, that all Persian gardens are based on this geometrical principle, until it acquires something of a mystical quality in the conception of the division of the garden into four quarters, the shape of the Cross, 'a cosmological idea that was very ancient in Asia, and was absorbed into various religions, the conception of the universe as divided into four quarters, usually by four great rivers'. It will be remembered that in the second chapter of Genesis 'a river went out of Eden to water the garden; and from thence it was parted, and became into four heads. The name of the first is Pison . . . and the name of the second river is Gihon . . . and the name of the third river is Hiddekel . . . and the fourth river is Euphrates.' This design is seen reproduced in the so-called Garden Carpets of the seventeenth and eighteenth centuries. It must not, however, be regarded as a purely artificial or conventional notion: it arises, on the contrary, from the very practical need for irrigation in a dry land. Anybody who has watched a Persian gardener, with one trouser-leg tucked up, letting the water flow into his little banked-up canals, or *jubes*, will appreciate exactly how this design with its ramifications was inevitably imposed. It recalls, on a grander scale, a child's intuitive system of sandcastles, with their moats and ditches recurrently filled by the tide. Morning and evening the *jubes* have to be flushed with water and the beds flooded; it is a necessity that we in England, living under a relatively heavy rainfall, find hard to realize. It dictates, in fact, the shape of the garden as we find the garden laid out in Persia. It could not be otherwise. Water is the first

need, and irrigation ordains the pattern. It is instructive, I think, to note how the practical and the mystical here combine in these unforeseen and unintentional ways: in the shape of the Cross and in the shape of the life-giving streams. The natural and the supernatural meet together—but this speculation takes us into waters far deeper than the water of any Persian *jube*, and must be left to the philosophers and poets while we return more soberly to the consideration of the Persian garden as we historically know it.

The climate and altitude of the country are first to be considered. They present difficulties on a noble scale. Generally speaking, Persia is a plateau, dry, sunny, windy, shimmering with heat in summer, very cold in winter, very poorly watered, and almost entirely dependent on the snow melting from the mountain ranges. This supply is brought down to the towns and villages by an ingenious and ancient system of underground tunnels called *Qanāts*. Their rounded openings which give access to the artery for purposes of investigation or cleaning are a familiar feature of the landscape, aptly compared by Dr. Fryer in the seventeenth century to molehills cast up, popping up at intervals in a straight line of descent from the foot-hills to the valleys where a patch of brilliantly green wheat, green poplars, willows, and puffs of pink blossom stand out from the surrounding brown of the desert. More than half of Persia's million square miles is desert, lying exposed to the burning sun for the greater part of the year, with dust-devils rising into columns above the desert plains, and mirages of lakes and mountainous scenery far more fantastic and beautiful than any Persian gardener ever designed. The rainfall is negligible (save, of course, in the Caspian provinces of Gilan and Mazanderan, with which, in our account of Persian gardens, we are scarcely concerned). At Isfahan, for example, the rainfall is only 4½ inches a year, at Seistan in eastern Persia 1·88 inches, and at Teheran

$9\frac{1}{2}$ inches. In the British Isles the average annual rainfall varies from 40–60 inches in the Lake District to 25–30 in the eastern and south-eastern areas, so the discrepancy may readily be appreciated. In this island we set up a wail when an Official Drought has lasted a fortnight, and in the churches we start offering up prayers for rain. What should we say to a drought that we knew with certainty would last for at least six months?

On the other hand, when rain does come in Persia, it may come with a will. Sir John Chardin leaves us a description of a downfall in Isfahan, two days before Christmas in 1666, when all the streets ran with water, gardens were flooded, walls collapsed, pavilions were overturned, and the river overflowed its banks. All this, we may say, might happen anywhere. Even the well-behaved Thames has been known to invade the cellars of houses on Millbank. But from the gardening point of view the interesting part of Chardin's observation concerns the absorbent property of the soil: 'Two days later', he says, 'the water had all run away, and two days after that no sign was left of it. The soil of Isfahan drinks water like a sponge; four drops will soak it, and a quarter of an hour's sun or frost will entirely dry it up.'

There is also the wind to be reckoned with. The *shamāl*, or northerly wind, blows over the interior most of the summer months, a drying, gritty wind which may lift the dust of the central highlands right out into the Persian Gulf—a long journey for dust to take. In eastern Persia a north-westerly wind blows from the end of May till the end of September, sometimes at the gale force of seventy miles an hour. Such violence and extremes of Nature come never into the calculations of the English gardener. He is a fortunate man who has a temperate climate to deal with.

Drought, wind, and desert soil do not make for auspicious gardening. Moreover, the major cities of Persia stand at an altitude comparable to or exceeding the topmost peak of

Britain's highest mountains, Teheran at 4,000 feet, Isfahan at nearly 6,000, Shiraz at 5,200, Meshed at 3,000. (Snowdon and Ben Nevis respectively reach 3,560 and 4,400 feet.) The thermometer thus varies violently: in Isfahan in winter it may descend to below zero Fahrenheit, but in summer it rises to about 97° and in Shiraz has been known to touch 113°. Out in the desert plains, in that pure air, under the direct rays of the sun, the heat is, of course, intolerable: it is a thing scarcely to be conceived by us. The crawling travel of a caravan across those plains could end only in a gasping desire, as psychological as it was physical, for that Paradise of trees, shade, and water which constitutes the Persian garden.

How pure is that air! No account of Persia or her gardens would be complete without a reference to that clear, clean, invigorating mountain-height air and to the sun which even on winter days can warm you through and through, if you can get into shelter out of the wind. Chardin conveys this vibrant quality of the atmosphere by a pretty illustration: it is not necessary, he says, to cork a bottle of wine; you need only to stick a flower, such as a rose or a carnation, into the neck of the bottle.

How poetical! how romantic! and how Persian!

The Persian New Year, *Nau-rūz*, is fixed for the 21st day of March, and most punctually the spring arrives to coincide with the national holiday. Then the desert breaks into flower, the judas-trees burst into clusters of magenta on their leafless boughs, the fruit-blossom powders the valleys with great puffs of white and pink. If at this time of year we climb towards Shimran and penetrate into one of the deserted gardens lying in the foot-hills of the Elburz, we shall find more colour and more flowers than later on when everything is dried up and only the trees retain their greenery. It is unlikely that they will be cultivated flowers, such as the petunias, the stocks, the zinnias,

of which the Persians are so fond in their town gardens, for these neglected wildernesses in the hills have long since passed beyond the care of any gardener, but there are sure to be some overgrown rose-bushes, some sweet-scented jasmine, some almond, peach, and apricot, sharing their refuge with the lizards and, more than likely, a trippe of goats. There will be the native wild flowers too; for, as at home we speak of garden-escapes, here we may speak of desert-escapes, the small anemones and ranunculi, the little pointed tulips, yellow (*T. sylvestris*), pink (*T. Aucheriana*), red-and-yellow (*T. Ostrowskiana*), and a white one with a brownish stripe which seems very common round Teheran but whose specie name I do not know. The desert blows lavishly with these, all delicate between the boulders, but even more delicate is the tiny *Iris persica*. A pale glass-green, not more than 3 or 4 inches in height, it seems astonishing that so frail a thing should ever heave its way through so stubborn a soil. I like best to come across it in the desert, where it looks like a butterfly defying a lion; but even within the shelter of garden walls its fragile courage surprises, so nigh to the snows of those enormous mountains.

The walls which afford this shelter are likely to be broken down. One can enter through any gap; and the gaps are many. One does not have to look for an authorized doorway. One just steps over a fallen section of the wall and finds oneself immediately within the precincts of the garden. These walls of sun-baked mud are common to all Persian villages and caravanserais and gardens: they are the natural rough architectural feature of the whole country, cheap and easy to build in the first instance, but equally easy to let fall into disrepair. And Persia is a country where things very readily disintegrate into disrepair. It must have something to do with the climate and with the happy-go-lucky character of an Oriental people. Perhaps the modern Westernized Persian cannot wholly appreciate

the romantic approach of the European to his country. The Westernized Persian would prefer us to insist on the layout of the public garden in the Majliss Square at Teheran: a few scarlet geraniums fenced in by wire. The Westernized Tehrani fails entirely to appreciate the wilderness beauty of the gardens lying within his reach, on the foot-hills of the Elburz.

Now I have allowed myself to lead myself away, for once I start thinking of Persian gardens I am lost. I can see only the fruit-blossom, and the little desert-escapes, and the unpruned rose-bushes, and the grape-hyacinths growing beneath them, all making a picture of such remembered beauty for me that I forget the task in hand, which is, I suppose, an historical account of how the gardens of Persia came into being and what they signify. I must therefore return to this question of walling-in the gardens, getting away from the simple mud-brick enclosure of a particular garden that I once frequented on the slopes of the Elburz range. All Persian gardens are walled in. It is part of their character. The Persian, unlike the American, has a feeling for his personal privacy; and, of course, for the privacy of his women: he would never willingly expose his private life to the gaze of the passer-by. So he builds a wall round his garden. Sometimes in the past these walls were elaborated with battlements and with round pigeon-towers at the angles. These pigeon-towers must have added some architectural nobility to the rough blank wall. They are recorded at the four corners of Shāh 'Abbās's Hazār Jarīb near Isfahan, and sometimes the wall itself might be decorated with panels of paint or lacquer, crowned by a finial in wrought metal. Again, the walls might be used as a support for climbing plants, as in the garden of Karīm Khān at Shiraz, where they were clothed on the inside with grape-vines trained on trellises.

Pigeon-towers were not primarily designed for decorative purposes: they were utilitarian in origin. To this day the circular

tower, pierced with hundreds of square holes and streaked with whitened droppings, like some sea-girt rock, the refuge of gannets and kittiwakes, is a frequent object sticking up in the neighbourhood of a Persian village. It recalls the dove-cote or columbarium so often found associated with Tudor manor-houses in England, and has the same charm. But whereas the lady of the manor-house had some affection for her doves or pigeons, coaxing them to peck grain from her hand and to settle without fear upon her wrists and shoulders, so that she seemed smothered in a gentle cooing mass of wings and feathers, the Persian takes a far more practical point of view. He eats his pigeons; and above all he collects their dung, a very valuable form of organic manure. The famous melon-gardens at Isfahan depend upon it; and have depended upon it right back into centuries. Jean Baptiste Tavernier, writing in 1677, notes more than 3,000 of these pigeon-towers round Isfahan. Three thousand towers with at least a thousand pigeons in each! The whole air must have been vocal with cooing and the brush of homing wings.

It is always rash to romanticize, so we must record that there was a black market even in those days, of a curious kind. Christians were not allowed to keep pigeons, so many Christians became Muhammadans in order to enjoy the privilege. It was a valuable property; and in the argument between cupidity and religion, cupidity won.

Once inside the walls, the garden lay open to the wanderer on the lines that we have already indicated. A certain monotony must have attended Persian gardens; or perhaps we should say similarity rather than monotony. It would be churlish to complain of monotony in so grateful a sanctuary. But we may safely say that the layout was always more or less the same: the long avenues, the straight walks, the summer-house or pavilion at the end of the walk, the narrow canals running like ribbons over blue

tiles, widening out into pools which oddly enough were seldom circular, but were more likely to be rectangular, square, octagonal, cross-shaped, or with trilobed or shamrock-like ends. Sometimes these pools were reproduced inside the pavilion itself: a mirror of water beneath a domed roof, fantastically reflecting all the honeycomb elaboration of the ceiling. I remember in particular one such pool with a kind of central throne on which some nineteenth-century Shah might sit, attired in the minimum of clothing, while the ladies of his harem, similarly attired or unattired, slithered down chutes from an upper gallery straight into the embracing arms of their imperial master.

With such sportive games taking place indoors, the garden lay outside for the delectation of such meditative spirits who chose to pace its paths. It must be admitted that no Shah of Persia ever created for himself a garden comparable to that famous garden of 60,000 acres laid out some eight miles from Peking by K'ang Hsi, the Ch'ing Emperor of China in the seventeenth century, and further adorned in the eighteenth century by the Emperor Ch'ien Lung. That fabulous garden far exceeded in size and fantasy anything which had ever occurred to the elegant though perhaps rather unimaginative Persian mind. A flat piece of ground to start with, the Chinese had conceived the idea of turning it into hills and lakes, with canals, bridges, and distant landscape views—all on a scale to arouse the envy of such English landscape-gardeners as Repton or Capability Brown. Had they been given so free and, above all, so extravagant a hand, what amazing gardens we might now have inherited in England!

The rulers of Persia, and her rich men and great ministers of state, might well have expended their wealth and their imagination on such creations. They did no such thing. They laid out their gardens on a smaller, neater, and more orderly scale, in accordance with the Cyrus tradition. These Persian gardens

have their own charm, but they cannot claim any display of originality or invention. Exception might be made for such hill-side gardens as the steep Bāgh-i Takht (Garden of the Throne) to the north of Shiraz, where the conventional pattern was perforce varied by a succession of terraces; for the Hazār Jarīb near Isfahan; and for the garden of Shāh 'Abbās at Ashraf in Mazanderan. As these three gardens were exceptional in their situation, they merit a detailed description.

The Bāgh-i Takht, to which Sir Thomas Herbert, who was there in 1628, gives the pleasing, if puzzling, name of Hony-shaw, appeared to him to challenge superiority over all the other gardens of Shiraz. Being fond of measurements, he paced it out, and found it to be 2,000 paces square. Unfortunately that is all he says about it, but we know from other accounts that it was built up into seven terraces, with a palace at the top and a pool at the bottom, and waterfalls tumbling between the two. By the time Edward Browne saw it, in 1887, it had fallen into neglect, but was still 'conspicuous for its white terraces and buildings . . . looking towards the city over avenues of Judas trees.'

The view over a Persian city from these elevations is indeed a thing to be remembered, and could be enjoyed equally from the Hazār Jarīb at Isfahan. This, likewise, was built in a series of terraces, held up by stone walls. The number of the terraces, as reported by different observers, leads us into some confusion: J. de Thévenot, in his *Travels into the Levant* (1687), first states that there are six, but when he starts climbing them and we add up the result, we find that it amounts to eleven. Sir Thomas Herbert states that there were 'nine easy ascents', but he may have been referring to steps, not terraces: his phrase is ambiguous. From all accounts, however, the Hazār Jarīb must have been very large and steep. Hazār Jarīb means 'a thousand arpents', and as the arpent was about half an acre of land the area of this celebrated garden must have been extensive, though still not to be compared with the 60,000

acres of the Chinese Emperor. Herbert again took the trouble to pace it out, and found that from north to south it was a thousand of his paces—which we may assume to have been a yard each—from east to west seven hundred, surrounded by a wall three miles in circumference. The description then continues on the normal lines—pools of white marble, summer-houses, fruit-trees—in fact, Herbert goes so far as to call it a 'fruit forest' rather than a garden, which again recalls the Paradise of Cyrus. Water was not lacking, for it was brought by aqueduct from 'the Coronian mountain', at the eastern end of the Elburz range, so formidable a distance that one wonders whether Herbert was mistaken. Anyway, the water was there, and spouted from lead pipes 'in a variety of conceits', to which Tavernier adds a charming detail. Shāh 'Abbās II (1642–67), he tells us, being then only ten years old, used to amuse himself by balancing an orange on a jet of water, as he sat entertaining his guests by the octagonal tank; but as the jet was not powerful enough to hold the orange against a puff of wind, it kept falling off into the pool and someone had to be at hand constantly to renew it. We are reminded—but with what a difference—of the ping-pong ball dancing on a little fountain at village fairs in France, and it remains for the imagination to supply the complete picture: the spoilt and already dissolute boy dressed in silks and brocades, attended by his eunuchs, watched from across the pool by the respectful company of French and Dutch merchants, a vast dish of fruit beside him, the golden oranges bobbing in the water where they had fallen; and, laid out in the plain below, the fair prospect of Isfahan with her turquoise domes.

At Ashraf, in Mazanderan, we move into scenery of a very different nature, for the province of Mazanderan, bordering the Caspian Sea, is damp and heavily forested, with all vegetation growing in extraordinary luxuriance. But even here, where the need for shade and water was not so urgent as in central Persia,

we find that the great garden of Shāh 'Abbās, laid out in 1612, was faithful to the usual plan. Sir William Ouseley, who was there in 1812, found 'a stream of admirable water flowing in successive falls along the half-ruined walks, shaded with lofty trees', and quotes from a contemporary (1612) manuscript, mentioning the 'baths and reservoirs of perfect beauty, filled with pleasant and salubrious water, ingeniously conveyed from the lofty mountain adjoining, into those cisterns which are like the celestial fountain. . . .'

From the description of these three gardens it may be seen that although they were built on hill-sides they retained the usual principle of geometrical straightness. The Persian landscape-architect seemed unable to get away from it. Whatever the lie of the land, there was always the main axis, the main or subsidiary avenues, the canals, the pools. Naturally, on the level this somewhat monotonous regularity was even more noticeable; and in the days when the sanded or gravelled walks were well kept and the trees well trimmed, the effect of rigidity must have been doubled. Today, the neglect which we may justifiably call a sweet disorder has done much to soften the contours, so that the severity of the plan is not immediately apparent. Edward Browne, that fine scholar, who spent a happy year in Persia in 1887-8 and had a warm appreciation of nearly everything Persian, allowed himself some slighting remarks:

The Persians take the greatest delight in their gardens and show more pride in exhibiting them to the stranger than in pointing out to him their finest buildings. Yet to one accustomed to the gardens of the West they appear, as a rule, nothing very wonderful. They generally consist of a square enclosure surrounded by a mud wall, planted with rows of poplar trees in long straight avenues, and intersected with little streams of water. The total absence of grass seems their greatest defect in the eyes of a European, but apart from this they do not, as a rule, contain a great variety of flowers, and, except in the spring, present a very bare appearance.

Browne's dismissal of the 'rows of poplar trees' is unfair. He has forgotten, in this somewhat ill-tempered passage, the 'great variety' of trees to be found in every Persian garden—the cypresses of Shiraz, and, above all, the ubiquitous *chenār*, or Asiatic plane, which is not only believed by the Persians to be a safeguard against the plague, but is a beautiful tree in itself, with its pale, leopard-like bark and shady spreading head. The Persian love of trees cannot be over-emphasized. We have already related how Xerxes hung golden armlets on the branches of a plane he particularly admired; and here we may recall the story, told by Plutarch, of Artaxerxes, who, halting with his army in midwinter, gave permission to his soldiers to cut down trees for fuel on one of his royal estates. The soldiers, overcome by admiration of the cedars and cypresses, refused to lay their axes to the trunks until Artaxerxes himself gave the example by cutting down the finest tree with his own hands.

A human touch is added by Herbert as to the familiar uses to which the Persians put their trees: 'I remember I saw ropes or cords stretched from trees in several gardens, bqys and girls and sometimes those of riper years swinging upon them . . . a pastime first practised by the Athenians.' The little Persians, the little Greeks, and the little English have evidently all had the same idea throughout the ages.

To the *chenār*, the poplar, and the cypress must be added the pine, the ash, the elm, the lime, the pistachio, the walnut, the chestnut, the myrtle; and among fruiting-trees the orange, the lemon, the almond, the plum, the cherry, peach, almond, apricot, fig, pomegranate, and many others. There was certainly no dearth of trees in a Persian garden. Nor would it be right to leave the reader with the impression that flowers were not carefully cultivated. It may be true that they were not planted according to the European idea, in formal beds and borders— why should they be?—but in a more natural way, under the

trees, dotted about, as may be observed in the foreground of many a Persian miniature. We are reminded also of the illustrations of medieval Books of Hours, or of some early Renaissance paintings and tapestries with the low, enamelled effect as though a flight of brilliant insects had fluttered down to anchor themselves upon the ground.

Naturally the dampest places would be chosen for such planting in a parched land, and those places would be found near to a pool, where a little turf might be induced to flourish. Various travellers have left us delectable lists of the flowers to be found: the carnation plays a big part (we have already seen it stoppering a bottle of wine), and existed in several kinds, single, double, and the Indian pink 'of a dazzling colour'; then there were lilies of the valley, violets 'in all colours'; primroses, tulips, narcissi, iris, evening primroses, hyacinths, jasmine; and, above all, the rose.

The rose is probably the flower most constantly associated by most people with Persia, and no note on Persian gardens could be complete without some historical reference, however incomplete, to the rose. We in England tend to regard the rose as our national flower, so it is salutary to be reminded that the Persian poets adopted her quite as early as we did. It is significant that there should be no specific word for 'rose' in the Persian language; they use merely the word *gul*, meaning flower, thereby implying that the rose is pre-eminent among all flowers. But the rose the Persians knew bore very little resemblance to the roses we now encourage in our gardens—the hybrid teas, the hybrid perpetuals, the Wichurianas, the polyantha, and whatnot. The Persian rose was a simpler and perhaps in some ways a more lovely thing. It is not easy to determine what the rose of the Persian poets really was. *Rosa hemispherica*, a double yellow, is a Persian, much esteemed for its musky scent and its value in the making of rose-water. So is the Persian Yellow, which some writers call *R. lutea* and others *R. foetida persiana*, undoubtedly

a native, said to have been brought in the seventh century to Spain, where it was cultivated by the Moors. Mr. G. S. Thomas, who has made a special study of old and specie roses, states that it was 'brought from Persia in 1837'. I presume that he means 'brought to England or France', where M. Pernet-Ducher experimented with it as a pollen parent, and eventually, after many disappointments, raised the entire race we know as the Pernet or Pernetiana roses. I presume also that Mr. Thomas is referring to the fact that this double form of *R. lutea* was brought from Persia by Sir Henry Willock in 1838. The only form of *R. lutea* I ever saw growing wild in Persia was a single form, of a brilliant buttercup-yellow: I never saw a double, either wild or cultivated, but that may have been just my bad luck. But with all deference to Mr. Thomas's superior knowledge, since he is an expert and I am not, I had always believed that the Yellow Persian had been introduced to England and to the Netherlands by Clusius in 1583, from Austria where he had found it; and that it had previously been described by Gesner in 1572 and by Lobel in 1581. Dalechamps, in 1587, called it *lutea*, the yellow rose, and gave a very accurate description of it. All this evidence would give it a far older ancestry in European countries than Mr. Thomas allows; and surely would explain the name of 'Austrian Briar' by which it is commonly and inaccurately known. Of course it is not Austrian at all, but Persian, or at any rate Asiatic, for its distribution extends from the Crimea through Asia Minor to Persia, Turkistan, India, Afghanistan, and Tibet. How it got to Austria we do not know. Clusius must be held responsible for the name.

This rose is known to us in two colours, the plain yellow, and the bicolor, yellow on the outside of the petals and a brilliant red on the inside. A bush of this so-called 'Austrian Copper' in full blaze under the Persian sun in May is an amazing sight. In France it is justifiably called *Capucine* (nasturtium), for no other rose so nearly approaches the flaming orange-red of the

nasturtium. I have in my possession a Persian miniature of this rose, drawn and coloured in the utmost detail; I have also, I rejoice to say, a living bush of it in my garden from a root acquired in Teheran.

It would seem that the bicolor 'Austrian Copper' is no more than a sport of the Yellow, and that sometimes both colorations may be found flowering on the same bush. I have never yet seen this, but I live in hope. It would be most exciting.

Chardin has some notes on Persian roses which must be of the deepest interest to rosarians anxious to establish what the flower beloved of Persians and Persian poets really was. Besides the rose 'in her natural colour'—and one wonders what he meant by this, and what he regarded as the natural colour of the rose —he reports five different colours, white, yellow, red, and 'a stronger red, which we call *ponceau*', i.e. a poppy-red, and 'of two colours, red on one side and white or yellow on the other. The Persians call these *dou rouyéh*, or two-faced . . .', and he adds that he has seen rose-trees bearing flowers of three different colours on one branch—yellow, yellow-and-white, and yellow-and-red.

There were many ways in which the Persians made use of their roses. They could be worn behind the ear, or carried in the hand, or given as a compliment to a superior, to a friend, or to a chance acquaintance; they were used for rose-water, to be sprinkled from an ewer or presented in a bowl for the guest to dip his fingers; they could be scattered on the water when a feast took place beside one of the many pools in which the gardens abounded. Sir William Ouseley noted this felicitous custom:

Though there was a profusion of meat and fruit [he writes], it might have been styled the feast of roses, for the floor of the great hall or open-fronted *tālār*, was spread in the middle and in the recess, with roses forming the figures of cypress trees; roses decorated the candle-sticks which were very numerous; the surface of the *hawz* or reservoir

was completely covered with rose-leaves, which also were thickly scattered on the principal walks leading to the mansion. . . . The reservoir, on the surface of which so many rose-leaves floated that the water was visible only when the wind occasioned them to move, now blazed with hundreds of candles . . . and, whilst at dinner, I three or four times observed servants throwing fresh rose-leaves and rose-buds, with lavish hands, both on the water and pavement. . . .

Roses were sold, hundreds for a mere trifle, in the bazaars, and also 'many balls formed entirely of rose-buds, very ingeniously tied together so that neither the stalks nor the thread which fastened them were in any part visible; some of these balls comprised sixty, eighty, and even a hundred buds'. It reminds us of the cowslip balls we used to make when we were young.

It seems curious that Tavernier, who made no less than nine journeys to Persia in the middle years of the seventeenth century, when travelling to Persia was something of an adventure, should have commented that

the flowers of Persia cannot compare with those cultivated in Europe, either for diversity or for brilliance. Once one has crossed the Tigris on the way to Persia, one finds nothing but roses and lilies and some little native flowers.

Yet he is at pains to emphasize the Persian love of flowers, which indeed we could illustrate by many quotations. Tavernier himself records that any nobleman desirous of currying favour with his sovereign, presents him with a bunch of fine flowers in a vase of crystal 'even as we in France put our flowers into a little glass full of water, to keep them fresh'. He records also that he never took his departure from the Persian court without being implored to bring back some flowers from France on his return; a request which came not only from the said noblemen, but mostly from four or five of the chief eunuchs, 'who each have their little garden in front of their room'.

Over and over again, even to this day, we find this gift of flowers as a gracious gesture; and we have further proof of the esteem for flowers. It is recorded, for instance, that 'the loveliest flowers' were grown in narrow beds on top of the encircling walls, a delightful idea which we in Europe might well emulate if only we had the encircling walls. Nor were the Persians averse to the use of artificial flowers for the decoration of their houses during the winter months when living flowers were not available. The Chinese, who had had the same idea, made their plants out of semi-precious stones, amethyst, coral, quartz, amber, and jade; but in Persia the humbler materials of wax, paper, and paint must serve the ends of the common man. The craftsman who formed and moulded these pretty fancies was known as the *nakhl-band*, or date-palm setter, and it was a definite profession, commanding a considerable demand for his merchandise. This expression, 'date-palm setter', requires some explanation, even if it takes us away for a moment from the garden proper; it is not so irrelevant as it might seem, for, in fact, it takes us back to the four quarters of the universe referred to on the fourth page of this essay, to the four rivers of Genesis, to the garden carpets, and to the cosmological symbolism of the ancient world. The date-palm setter was originally the maker of an 'artificially-constructed date-palm' which formed part of the cult equipment among the Hittites, the Cretans, and the Assyrians, and may be found also on Luristan bronzes and Sassanian seals. These artificial trees were sometimes of great size: the Emperor Tīmūr (the Tamburlaine of Marlowe's play) at Samarkand had a golden tree which 'simulated an oak, and its trunk as thick as might be a man's leg'; and the Mongol Mangū Khān (*c.* A.D. 1250; A.H. 648) had at the entrance to one of his palaces at Qaraqorum a 'great tree all of silver, in which were entwined four gilt serpents so arranged that from their mouths flowed four different kinds of liquor . . . while from the mouths of four silver lions seated at the base flowed white mare's milk'. Whether

the mouths belonged to the gilt serpents or to the silver lions, and whether they flowed with liquor or with mare's milk, the four mouths can obviously be related to the four rivers and the four quarters of the world. From these large trees derived the miniature version in little gardens to set on a table, popular with the Persian monarch and his humblest subject alike.

Another custom rather touchingly illustrates the Persian desire for something merely green. They sow cress mixed with fine soil all over the sides of a pot, keeping it in place with a wrapping of damp canvas till the cress germinates and the pot turns green 'like the mossy bark of a tree'. I confess that I fail to see why the soil accompanied by the cress does not all slide off once the wrapping is removed; but I suppose we must take Chardin's word for it, since he is reporting something he saw with his own eyes. It is at all events a pretty conceit, characteristic of a poetical and, in some respects, childish nation; using the word childish in a complimentary, not a derogatory sense.

The word 'poetical' suggests the Persian poets; and here we must make allusion not only to the part which flowers play in their verses, but also to the honour their compatriots pay to them in their graves. Ḥāfiẓ lies buried near Shiraz, in a garden planted with cypresses and orange-trees, or so says Edward Browne, writing in 1887. A photograph I took there in 1927 shows no oranges; and my memory will not serve me to say whether there were still oranges there, forty years after Browne's visit, or not. My photograph shows a paved courtyard with a rectangular pool and an arcaded pavilion whose central loggia of slender columns frames a view over Shiraz. My memory tells me that I looked down on to the tops of judas-trees beyond the columns, and that they were in flower, and that the whole composition was worthy of a great poet.

Saʿdī also lies buried near Shiraz. He lies a little farther away from the town than Ḥāfiẓ. His tomb is not so well kept. The

paving is not made of laid stone, but of ordinary rough ground. I have no space here, and indeed it would be irrelevant in an essay on Persian gardens, to go into the reasons why the tomb of Saʿdī should be less popular than that of Ḥāfiẓ. With these reasons we are not here concerned. We are here concerned only with the shrines of two poets. The tomb of Saʿdī has a sentinel cypress beside a group of stone pines, which is perhaps as much as any poet should ask for his last resting-place.

The works of both poets are kept at their shrines by guardians, the works of Ḥāfiẓ 'for purposes of divination and augury', surely more than can be said for burial-places of poets in this island-home of such poets who may compare, to put it modestly, with Ḥāfiẓ and Saʿdī.

'Umar Khaiyām asked to be buried in a garden. 'My grave', he said, 'will be in a spot where every spring-tide the north wind will scatter blossoms on me.' Another version says, 'My grave will be in a spot where the trees will shed their blossoms on me twice a year.' How this freak of nature was to be achieved is not explained, but Niẓāmī al-ʿArūḍī, who visited the shrine at Nishapur in A.D. 1135, found that 'his tomb lay at the foot of a garden wall over which pear-trees and peach-trees thrust their heads, and on his grave had fallen so many flower-leaves that his dust was hidden beneath the flowers', and such is the continuity of Persia that Sir Percy Sykes, some eight hundred years later, found fruit-trees still casting their blossoms on the grave, 'in a formal Persian garden, divided into four plots by cobbled paths'; and an even more recent traveller, W. V. Emanuel, in 1938, found peach-trees, cypresses, and weeping willows.

Firdausī, whose name means garden, elected to be buried in his own garden at Tabaran.

So much for the poets, but a word of gratitude should surely be registered in honour of the humble, anonymous multitude that tended the gardens of Persia, raked the gravel paths, tied

up a fallen jasmine, lopped a dangerous bough from a *chenār*, saw to it that the pools were always kept full to the brim, cleared the leaves from the blue-tiled canals, and irrigated the beds before the great heat of the day. The Persian gardener was, and is, in many cases a *gabr*, or *guebre*, belonging to a separate sect, the representative of the ancient Zoroastrian religion. His introduction to this world would seem to befit him especially for the profession he is destined to follow; for, by a kind of baptism, he is plunged shortly after his birth into water sweetened by flowers that have previously been boiled therein. Then he grows up, and should he happen to live in *Yazd* or Kirman, he would be obliged to wear a distinctive dress of dull yellow and a loose yellow turban; doubtless he looked none the worse for that as he moved about, a small saffron-coloured figure, among his flowers and trees. It was unfortunate for him as a gardener that his hereditary prejudices against certain animals should include a loathing of snakes, adders, lizards, toads, and frogs, all of which he would be likely to encounter in the pursuit of his calling. On the other hand, it was fortunate that his religion should allow him the use of wine, for this encouraged him to cultivate the vine with greater interest than the Muhammadans to whom wine was forbidden. The centre of his vine-growing was at Negefabad, a wholly Zoroastrian colony not far from Isfahan.

The fruits of Isfahan are justly renowned, especially its melons. Ibn Baṭūṭa, travelling there so long ago as the first half of the fourteenth century, mentions melons in company with 'apricots of unequalled quality with sweet almonds in their kernels, and quinces whose sweetness and size cannot be paralleled'. The voyager approaching Isfahan from the direction of Teheran, after traversing several hundred miles of desert, is instantly struck by the sudden luxuriance of the melon-gardens and acres of opium-poppies among the brown walls, with the

blue domes of the mosques in the background. It must look very much the same today as it did when Chardin, like Ibn Baṭūṭa, noted the apricots of the kind he calls *tukhmchems*, or sperm of the sun; and elsewhere, more politely, eggs of the sun. I can imagine no name for that oval, sun-freckled fruit which better combines the picturesque and the realistic than Eggs of the Sun: it might be commended to any nurseryman who raises a new variety of apricot to hang against an English kitchen-garden wall. But I doubt whether a pallid English sun would ever ripen that kind of apricot whose stone splits open at the same time as you open the fruit, 'with a sweet almond kernel of excellent taste', any more than our English sun will ever bleach the trunk of the poplar, as in Persia, to the whiteness of our northern silver birch.

Apricots and melons grow in luxuriance in Isfahan. The melons lie fat and flat on the ground, like vegetable marrows in an English allotment. Chardin says that they counted no less than twenty different kinds, and that the poorer classes of the population lived on practically nothing else during the four months of the year when they were available. They could eat as much as thirty-five pounds at one meal, without inconvenience, and could supplement this diet with cucumbers which they ate unpeeled. Their digestions must have been enviable. There was one kind of melon, however, which was not edible: it was no larger than an orange, and was striped in yellow, red, and green, like a coloquinte or ornamental gourd; but the great point was its delicious smell, which caused people to carry it about in the hand, as you might carry a bunch of flowers, or as Cardinal Wolsey carried his orange stuck with cloves.

Chardin was delighted with all the fruits of Persia, and no wonder, for in their variety and flavour they are without compare. It is interesting, however, to note that his criticism anticipated by nearly three hundred years the criticism made by Sir Percy Sykes in our own day on the lack of scientific cultivation.

'If only they [the Persians] understood the art of gardening as we understand it', says Chardin, 'their fruit would be even finer and more delicious . . . but they are ignorant of the arts of grafting or budding, and of espaliers and dwarf trees. All their trees are tall and old, and over-loaded with wood.' Such ingenuous neglect of a God-given opportunity must have been horrifying to Chardin, accustomed as he was to the extreme skill and neatness with which fruit-trees were trained, grown, and pruned in France, and which must surely have appeared in such contrast with the orderliness and symmetry of a Persian garden.

At this point I stopped in my scribbling to read over what I had written and to wonder what impression I had given, or what impression I had myself derived. I had been writing quickly and rashly, and not at all in a scholarly way, letting a bucket down into the well of my memories and picking a quotation here and there from other travellers, making a kind of jigsaw puzzle that should eventually compose itself into some sort of picture. I see now, with regret, standing back from my canvas, that I have produced no picture at all. It is a muddle with a fluff of pale fruit-blossom in one corner, a dab of yellow rose in another, a pavilion in the centre, a pool in the foreground, some straight lines of paths and avenues drawn with a ruler, the whole of it framed in equally straight brown walls, and surrounded by an indeterminate expanse of brown desert. Yet is this, after all, so misleading an impression? It does, perhaps, convey something of the picture given by a Persian miniature; and it does, perhaps, convey something of the desire for seclusion, shade, and coolness natural to the dweller in so vast and unmanageable a land. I suggest that the desire of the Persian for a tidy and elegant oasis in the midst of his immense country was a psychological desire: he wanted to rule some straight lines for himself, a mathematical exactitude of his own creation, a kind of triumph over the alarming waste without.

But even so, I have as yet made little mention of specific gardens. The difficulty of obtaining up-to-date information is considerable, short of making a journey to Persia and investigating the remains of some celebrated gardens for oneself; and the difficulty of obtaining historical information is as great. I had the good fortune to meet Mr. M. Minovi, who is an expert on the subject, but he tells me that most references to the gardens of the past would have to be disinterred from obscure Arabic manuscripts—a life's task, indeed, for somebody qualified to undertake it. A most valuable article by Arthur Upham Pope and Dr. Phyllis Ackermann appears in the second volume of the monumental *Survey of Persian Art* published by the Oxford University Press; but I was reluctant merely to reiterate the information therein contained; and, coming late upon this article, I did, in fact, discover that I had already extracted much of it from books in my possession. It seemed therefore as though I could contribute nothing original to the subject, and must decide either to repeat what others had written or to give a personal impression of my own. Still, I must not rest content with so easy a way out, but must come down to the brass tacks of describing some famous gardens as they once were, although they may no longer be.

The gardens of Shiraz are perhaps the most numerous, and the phrase is alone sufficient to call up all kinds of romantic associations. A garden in Shiraz! Let Edward Browne speak, with that lyricism to which he sometimes gave way, of the beauty of Shiraz as the traveller first beholds it:

At our very feet, in a grassy, fertile plain girt with purple hills, on the loftier summits of which the snow still lingered, and half concealed amidst gardens of dark stately cypresses, wherein the rose and the judas-tree in luxuriant abundance struggled with a host of other flowers for the mastery of colour, sweet and beautiful in its garb of spring verdure which clothed the very roofs of the bazaars, studded

with many a slender minaret and many a turquoise-hued dome, lay the home of Persian culture, the mother of Persian genius, the sanctuary of poetry and philosophy, Shiraz. Riveted on this . . . my eyes scarcely marked the remoter beauties of the scene—the glittering azure of Lake Māhatū to the east, the interminable gardens of Masjid-Bardi to the west. Words cannot describe the rapture which overcame me as, after many a weary march, I gazed at last on the reality of that whereof I had so long dreamed, and found the reality not merely equal to, but far surpassing, the ideal which I had conceived. It is seldom enough in one's life that this occurs. When it does, one's innermost being is stirred with an emotion which baffles description, and which the most eloquent words can but dimly shadow forth.

Browne was approaching Shiraz from the direction of Persepolis and it is small wonder that so astonishing a view should have moved him to so ecstatic an exclamation. During the following days he had occasion to visit many of the gardens he had first perceived from a distance, and he leaves us a useful list. To the east he found the Bāgh-i Dilgushā, the Bāgh-i Jānnumā, and the gardens Chahil-tan and Haft-tan; to the northwest the Bāgh-i Takht; to the west the Bāgh-i Shaikh and the Rashk-i Bihisht. These were just a few. 'The whole plain', he adds, 'is dotted with gardens, but on the slopes of the hills which bound it towards the west, overlooked by the dazzling summit of the Kū-i-Barf, the Snow Mountain, there is a compact mass of them. This is the Masjid-Bardi.'

What a wealth of gardens this list suggests, what a picture of luxuriance! and indeed it is not exaggerated, even today, when this prospect of Shiraz first breaks upon the traveller descending upon the city in its fertile plain, after the aridity of the desert. Lord Curzon, on a close inspection, did not think much of the gardens of Shiraz:

From the outside, [he rather peevishly writes] a square or oblong enclosure is visible, enclosed by a high mud wall, over the top of which appears a dense bouquet of trees. The interior is thickly planted with

these. . . . They are planted down the sides of long alleys, admitting of no view but a vista, the surrounding plots being a jungle of bushes and shrubs. Water courses along in channels or is conducted into tanks. Sometimes these gardens rise in terraces to a pavilion at the summit, whose reflection in the pool below is regarded as a triumph of landscape gardening. There are no neat walks, or shaped flower-beds, or stretches of sward. All is tangled and untrimmed. Such beauty as arises from shade and the purling of water is all that the Persian requires.

This was grudging of Lord Curzon, whose mind had perhaps been too nicely trained to English landscape gardening and to the shaped flower-beds and stretches of sward. He could not expect to find that in Persia. So, turning away from Lord Curzon, let us recall what other travellers have noted. Tavernier admired the cypresses, and was shown one supposed to have been planted by Shāh 'Abbās in 1607, or so the gardener assured him. He visited the garden called Bāgh-i Firdous, to the north of Shiraz, and found this full of fruit-trees and rose-bushes, with a pool in front of a pretty building—*un joli bâtiment*; he visited also the Bāgh-i Shāh, where he found another *joli bâtiment* in disrepair, more cypresses, more fruit-trees, more rose-bushes, some jasmine, and yet another pool with a stone surround. He decided that these gardens could not compare at all favourably with 'the delicious country houses in the environs of Paris'. Had he been writing today, instead of in the seventeenth century, he would have called them *maisons coquettes*; and that is doubtless what he had in mind.

The gardens of Shiraz did not correspond in the least either to Lord Curzon's conception of the English Victorian garden or to Tavernier's conception of the French garden whether in the environs of Paris or as laid out by Le Nôtre. Edward Browne found the garden of Dilgushā 'very beautiful, with its tanks of clear water, avenues of orange-trees, and variety of flowers'. Here the gardener, according to the pretty prevailing custom, brought him a bunch of wallflowers as a present, and related

how the late owner, the Ṣāhib-Dīvān, fallen from favour and dismissed from his office in disgrace, had regretted nothing so sharply as the thought of leaving his garden to strangers who might neglect it or injure its beauty. Browne visited also the gardens of Haft-tan (Seven Bodies) and Chahil-tan (Forty Bodies), 'pleasant shady groves' where those who were wearied of worldly cares might adopt the calm life of the dervish, but unfortunately he leaves no detailed description. At the Rashk-i Bihisht (meaning Envy of Paradise), some two miles out of Shiraz, where he was taken for a picnic by some Persian friends, it was raining, and Browne the Englishman expressed regret that the weather should be so bad, as they sat in a pavilion watching the dripping trees.

'Bad?' exclaimed his host. 'Why, it is beautiful weather! Just the day one would wish: a real spring day.'

There is nothing, he adds, which a Persian enjoys more than to sit sipping his wine from the shelter of a summer-house while he gazes on the falling rain-drops and sniffs up the moist, soft air laden with the grateful scent of the reviving flowers. This little anecdote gives us the whole meaning of his garden to a Persian. It is not a place where he wants to stroll; it is a place where he wants to sit and entertain his friends with conversation, music, philosophical discourse, and poetry; and if he can watch the spring rain pouring down, so much the better, for he knows it will not come again for months and months and months.

The Hazār Jarīb at Isfahan has already been mentioned, but probably the best-known gardens in the ancient capital are the gardens of the royal palace, which was entered by the Ala Kapi, or Lofty Gate, on the eastern side of the great central square, the Maidān-i Shāh. (It is not, in fact, a square, but a parallelogram, measuring 560 yards by 174 yards, but as the word *piazza* is lacking in the English language, what else can one call it?) This is no place to describe the magnificence of that royal

polo-ground, dominated at one end by the blue-domed Masjid-i Shāh or Royal Mosque, and terminating mysteriously at the other end in the vast, dark archway of the bazaars. Our business is with the gardens behind the Ala Kapi, where you may find a Persian pavilion at the peak of its loveliest expression. This is the Chihil Sutūn, or Hall of Forty Columns. Although it may not compare in splendour and intricacy with, let us say, the Tāj Maḥal, it is invested with a delicacy and a lyrical quality of its own which, to my mind, makes it one of the most poetical buildings in the world. 'Building' is too heavy a word, suggesting bricks and mortar, bricklayers and masons, plumbers and carpenters. The Chihil Sutūn seems to have arisen with no help from mortal hands; complete as a sonnet, perfect as a fairy-tale; and with a touch of wit in its name, for there are not forty columns but only twenty. The other twenty are the ones reflected in the mirroring water of the pool.

The gardens of the royal palace are not the only ones deserving mention in the heart of Isfahan. The Chahār Bāgh, or Four Gardens (originally Four Vineyards), were entered by a gateway at the end of a noble avenue of *chenār* (plane) trees, 50 yards wide. 'Water ran down the centre in stone channels and collected in basins at the cross-roads, and on each side tiled gateways led to the gardens of the great nobles of the Court.' These accounts of running water and central basins become repetitive and monotonous, which is always the difficulty for any writer endeavouring to deal with Persian gardens, but here in connexion with the Chahār Bāgh we fortunately have a description by Dr. J. Fryer, who was there in 1677 during the reign of Sulaimān, the son of that Shāh 'Abbās II whom we saw amusing himself with an orange bobbing on a jet of water in the Hazār Jarīb. It gives a vivid idea of the splendid scenes witnessed in Isfahan under the decadent descendants of the Safavid dynasty:

All the pride of Spahaun (Isfahan) was met in the Chahar Bagh,

[says Dr. Fryer] and the grandees were airing themselves, prancing about with their numerous trains, striving to outvie each other in pomp and generosity. . . . In the garden itself, variety of green trees flourishing, sweet odours smelling, clear fountains and rivers flowing, charm all the senses; nor is there less surprisal at the ravishing sight of the delicate summerhouses by each pond's side, built with all the advantages for recreation and delight.

Near Isfahan, some ten kilometres outside the city, lies the garden of Farahābād, or Sojourn of Happiness. This comes, chronologically, a little later than the Chahār Bāgh, since it was not laid out until 1700 as a summer retreat for the Shāh Sulṭān Ḥusain. Here, again, comes the same monotony of regularity, which I hesitate to repeat but must repeat, if I am to give any idea of what Persian gardens were like. The plan of this garden, drawn out by E. E. Beaudouin in 1931, shows a chess-board regularity in the planning of paths, avenues, pools, pavilions, all set in a geometrical precision. Everything was set at right angles to everything else, and it was all done on a lavish scale. The main avenue, and the secondary avenue, and the courts or *maidāns*, and the square gardens, and the pools in the centre of those square gardens, and the pavilions and octagonal kiosks, followed the old tradition. There is very little else to be said for the Persian garden, except to say the same thing over and over again.

The gardens near Teheran are of less historical interest than the gardens of Shiraz or Isfahan, Teheran being a less ancient city; nevertheless the sites on the lower slopes of the Elburz mountains can be very beautiful, with the view over the plain in which lies Teheran with its roofs among the poplars and the blue smoke, and the old caravan roads starting at three points of the compass towards Isfahan, Qazvin, and Meshed. The fourth point is blocked by the snowy range that terminates in the great cone of Mount Demavend, and it is in this direction

that the gardens lie. There are many. Some belong, or belonged, to the royal family, and some to the various legations or embassies accredited to the Shah when Teheran replaced Isfahan as the capital. The garden surrounding the summer quarters of the British Embassy at Gul-a-Hek is a cool, delightful place, all water and swimming-pools of ice-cold water coming down from the mountains on a hot day, with cool white-barked poplars and plane-trees: the very essence of what a garden in that climate and that situation ought to be. The villages of Shimran and Tajrish, on these slopes of the Elburz, are rich in gardens, all rather derelict now, as I remember them. There was a garden called the Valiabad, which shows the usual pavilion or summer-house reflected in water, with spindly trees also reflected in the water, curiously northern in suggestion, bleached-looking trees that seemed to belong to Finland or northern Russia, rather than to Persia and central Asia.

Prominent on a hill rising suddenly out of the plain round Teheran is the little pavilion or hunting-box called Doshan Tepé (Hill of the Hare). Browne describes it as being 'of a dazzling whiteness', which it certainly is not now, for the plaster has flaked off, exposing the mud-brown bricks beneath. Doshan Tepé, for all its charm and its superb position, cannot be called a garden; but at the foot of the hill lies a garden which once contained the menagerie of wild animals belonging to the Shah. Nāṣir al-Dīn Shāh had been greatly impressed by the zoological garden on his visit to Berlin; his diary gives a most detailed account, written with a naïve astonishment that could have been achieved only by a schoolboy or an Oriental potentate. 'Here were wild beasts that cannot be imagined, maned lions of Africa, huge in bulk, terrible in appearance . . . with glaring eyes fearful to look on. . . . I was extremely tempted to stay and observe this lion a long while; but through the thronging of the crowds of spectators, this was impossible.' One suspects that the crowds of spectators were attracted by the presence of

the moustachioed ruler of a fabulous Asiatic country rather than by the spectacle of the African maned lion to which the inhabitants of Berlin were well accustomed.

Not content with establishing one menagerie at Doshan Tepé, the Shah ordained another one in the heart of Teheran itself. An English traveller there in 1876 was about to ask for permission to visit it, when a passer-by, who also happened to be an Englishman, advised him to remain outside. The caging of the few beasts, he said, was quite uncertain. The lion was sometimes to be observed taking an airing, roaming where he pleased within the walls, and the bear had been seen from outside, climbing a plane-tree. The Shah, we are told in the same passage, had an English gardener, from whom 'his Majesty lately received, with great effusion, a bunch of radishes as a present'.

Here, then, we must bring these notes on Persian gardens to an end. The complete picture can perhaps only be gained from an exhaustive reading of the old travel-books, with their repeated accounts of the way in which Persians used their gardens, as places of retreat, either for prolonged discussions on philosophy, poetry, and metaphysics, or for feasting endlessly by the water's edge, to the sound of music and of the nightingale. In those great days the Persian garden must indeed have been what it was intended to be—a Paradise on earth.

V. SACKVILLE-WEST

# CHAPTER 11
# PERSIAN SCIENCE
## § i. *Introduction*

It is a difficult but happy task to attempt to restore to Persia some of the honour which has been lost to that country through the loose terminology of early writers, which has led to a confusion between Arab and Persian achievements. The racial and fundamental differences between them have always been recognized. But the driving force of Islam and the ready acceptance by the Persians of the language of the conquering Arabs seem to have blinded most historians to the fact that many of the intellectual achievements which they attribute to the conquerors should in fact be attributed to the conquered. Something of the same state of affairs is found in the Graeco-Roman relationship, but for obvious reasons to a far less degree.

It is very necessary at the outset to realize that Persia was great before Muhammad was born, that the terms Islamic and Persian have never been interchangeable. To the Arab great credit must be given for supplying the prestige, the language, and the resources for the scientific work that was begun under the caliphs of Baghdad and ultimately employed so many great brains of the Middle East. But to call all this 'Arabian Science' is to assign credit beyond the merits of the Arabs and considerably below those of the Persians. 'Take from what is generally called Arabian Science', writes Professor Browne, 'the work contributed by Persians, and the best part is gone.' Paul de Lagarde goes even further when he writes: 'Of the Muhammadans who have achieved anything in Science, not one was a Semite'. Nevertheless, Arabian Medicine, to take only one example, it is always called and, I suppose, always will be.

The fact of the enormous share of the Persians in Arabian Science has, of course, always been recognized by expert writers

on the subject. Thus, the author of the section on Astronomy and Mathematics in *The Legacy of Islam* (p. 377) is careful to point out that the terms 'Arab' and 'Muslim' must be taken in a very wide sense and embrace peoples from Spain to Turkistan, and include many non-Muslims. To one approaching the subject for the first time the question may well arise: Why, then, call it Arabian?

The answer to this is largely a matter of history. The Oriental renaissance happened to occur just at the time when the forces of Islam were overcoming the world. The soldiers were Arabs. Once countries and tribes had submitted, they received peace and a remarkable prosperity. Just as Florence became the leading city of the Renaissance in Europe, in part at least, because she possessed by good chance a family of rich merchants with good taste, so Baghdad became the centre of Muslim culture through the good fortune of having three or four caliphs in succession with cultured tastes. And just as the Medicis attracted men of art to their court because they could promise the resources for the employment of artistic talent, so al-Ma'mūn and Hārūn al-Rashīd could supply the needs and the required background for men of science. And these rulers were Arabs.

Who were these men of science? For the most part Persians, and that not because the Persian deliberately sought an opportunity to outshine the Arab, but because the Arab himself almost compelled him to come and work in certain branches of culture which he himself despised. The Arabs, consciously or unconsciously (I think the latter), adopted an almost Pythagorean division of the sciences and rigorously excluded the outsider from certain branches of learning and themselves from the remainder. Thus, the Arab considered himself alone worthy to study jurisprudence, scholastic theology, grammar, writing, poetry, prosody, and history. The remainder of the arts—philosophy, logic, medicine, arithmetic, mathematics, astronomy, astrology, music, mechanics, and alchemy—he designated

'the exotic arts' and assigned to the foreigner. Hence, although the division is by no means watertight, the Persians found themselves welcomed when they applied to the authorities in Baghdad for help in the study of any of the subjects which are today called 'science'.

The language they used was Arabic, partly no doubt because it was the language of their patrons and partly because it was both fashionable and readily understood throughout the Muslim world. Nor was this a disadvantage, for Arabic is a very flexible tongue and well suited to scientific works. Professor Browne gives an excellent example in the word *istisqā* which is formed by ordinary rules of grammar from the word *saqā*. This latter word means 'to give drink to', which makes the former word have a meaning of 'craving for drink' and hence 'dropsy'. An even better example is the word *mustashfā* which means 'a hospital' or 'a place whereto he comes who wishes to be healed', being derived from the root word *shafā*, 'he healed'. An interesting sidelight is that this word is perfectly good classical Arabic, yet so strong was Persian influence in medical affairs that the Persian word *bīmāristān* or 'place of sick people' completely ousted the native word, even as far away as Cairo. And today the Persian word is still retained in Egypt and Syria, but only in the limited sense of 'a hospital for the insane'.

What, then, is to be understood by the word 'Persian' as opposed both to 'Muslim' and to 'Arab'? Under Darius, the Persian Empire (with that of Media) extended over virtually the whole known world. That is obviously too wide a definition to use here. In later centuries, owing to Afghan and Russian encroachments, independent Persia had shrunk to less than its present size. Between these two an arbitrary line must be drawn.

I feel that no one will deny that if a man writes in Persian, Persia has the right to claim the renown of that man as a national glory even though he were residing in Bukhara, Herat, Khiva, or even Delhi. Persian never became an international

scientific language as did Arabic and Latin. If a man wrote in Persian, he wrote in that language because it was his native language. A possible exception is during a very short period under the Mughal emperors in Delhi. But I feel that so little original scientific work was done there that the reputation of Persia does not gain or lose much whether this claim is admitted or rejected.

I have already pointed out that the Arabs invited the Persians to come down from the hills and take over medicine, astrology, and mathematics in Baghdad. Many of them accepted and became domiciled in Iraq. Such men Persia may justly claim as hers. I shall therefore include in this survey men who migrated westwards from Persia to Iraq even though they wrote all their works in Arabic and lived and died in Baghdad, Basra, or Mosul.

Finally, of course, all those who were born and worked within the frontiers of modern Persia, whatever their family origin or whatever language they used, all these, if they contributed any-thing to science, contributed also to the glory of Persia and bequeathed a legacy to us.

On these principles certain well-known names will have to be excluded. Thus all the Sabaeans, of whom the most famous were the Qurra family and Hunayn's family, even though they worked hand in hand with Persian colleagues, must not be described here. For the legacy that they bequeathed to the world cannot be called a Legacy of Persia. Nor can I include al-Battānī, 'one of the most illustrious scholars of the East', because he came from Harran, or Qusṭā b. Lūqā of Baalbek. Nor can I add to Persian honour the reputation of al-Kindī, 'one of the few pure Arabs who were really distinguished in the domain of thought and letters'. Any reader interested in their contributions (which synchronized both in time and place with others about whom I write) will find them dealt with in full in *The Legacy of Islam* and similar works.

Even with these exceptions there is more than enough

material to justify the claim that I made at the outset, that Persia contributed the greater part of Arabian Science.

## § ii. *Mathematics*

So thorough was the destruction that Alexander the Great inflicted on Persia that there are not sufficient remains to allow one to estimate the mathematical knowledge of the early Medes and Persians. Herodotus records one engineering feat of those days. A certain Artachaees (d. 481 B.C.), a Persian, directed the construction of a canal across the Athos peninsula for the passage of Xerxes' fleet. Nor in later Sassanian times is there any evidence upon which any estimate can be based. For practical purposes the history of Persian mathematics begins in the court of al-Ma'mūn, whose mother and wife, be it noted, were both Persians.

The caliph al-Ma'mūn (A.D. 786–833) demanded a high standard in both theoretical and practical mathematics. An example of the latter is his command for two geodetic surveys to be made in order to determine the length of a degree of the meridian. His reign, too, is associated with the perfecting of the abacus. On the theoretical side he encouraged the translation of Greek and Indian mathematical texts into Arabic. Notable among the translators of these texts are Ya'qūb ibn Ṭāriq, who, besides translating from Indian authors, himself wrote on the calendar and other astronomico-mathematical subjects, Abū Yaḥyā al-Baṭrīq, who translated much of Ptolemy's work, and Muḥammad Ibrāhīm al-Fazārī, about whom I shall have more to say in the section on astronomy.

These, and others, whose names can be found in biographical notices, such as those of al-Qifṭi and Ibn Abī Uṣaibi'a, laid the foundations upon which later generations of mathematicians built. From the beginning it is to be remarked that the Persians approached mathematics from a different angle from that of the Greeks. The Greeks admired abstract philosophy and highly theoretical mathematics. They aimed at an intellectual training

through speculation and imagination. The caliphs on the contrary always demanded practical results. The Persians in the court of al-Ma'mūn were asked to apply the result of their studies to astronomy, surveying, architecture, and the art of navigation. Even attention to smaller details was expected of them, such as perfection of the calendar, determination of the direction in which Mecca lay, and an ability to measure time in order that the hour of prayer might not pass unnoted. So it will be seen that running through the whole of Persian mathematical research is the craving not for precise knowledge but for precision in the application of knowledge. In medicine there is a similar cleavage between the Persian and the Greek attitude of mind. The modern approach is that of the Greek rather than of the Persian. To the medieval Persian the problem to be solved in medicine was one of teleology, that is: Why? rather than: How? Above all is this true of anatomy?

The foundations of mathematical work were established, of course, long before this time. What we today call 'arabic numerals' were not invented by the Arabs, far less by the Persians. The Greeks used the letters of their alphabet in place of figures, giving to each a numerical value. Similarly the Romans gave a numerical value to some letters of their alphabet. Figures as we know them probably originated in India. The Persians took over both the Indian and the Greek systems, but only gradually adopted figures. Abu 'l-Wafā' (A.D. 940–97) did not use them, nor did al-Bīrūnī (A.D. 973–1048).

The Greek system has survived in Persian literature until today in the acrostics which writers love to introduce into their poems and epigrams. The value that they give to their letters, be it noted, depends upon the order of the letters in the Greek alphabet, not in the Persian. An example of such figure-play is the well-known epigram on the tomb of the poet Ḥāfiẓ:

> Since he made his home in the earth of Muṣallā,
> Seek for his date from the Earth of Muṣallā.

This epigram Bicknell has rendered in such a manner that the original play upon figures can be reproduced in English. He translates it:

> Thrice take thou from Muṣallā's Earth its richest grain.

The only figure-letters, according to our system, in the words 'Muṣallā's Earth' are M, L, and L, that is 1,000, 50, and 50, which give a total of 1,100. The phrase 'its richest grain' contains three I's, that is three 1's, or 3, and one C, that is 100. Now 103 taken three times over gives a total of 309. And 1,100 less 309 gives 791 which is the date of Ḥāfiz's death according to the Muslim system of reckoning. The calculation is no doubt somewhat involved, but this type of mathematical acrostic has always been extremely popular among the Persians.

The greatest of all the mathematicians who lived at the court of al-Ma'mūn was Muḥammad b. Mūsā al-Khwārizmī. His birthplace was Khiva and he may therefore be considered a Persian. His contribution to mathematics is set out at some length in *The Legacy of Islam* (pp. 381–5) and it is unnecessary to recapitulate here what is so well said there. It is possible that it was he who gave our language the word 'algebra' from the title of his book *al-Jabr wa'l-muqābala*, that is, 'The Sciences of Reduction and Cancellation'.

His importance in the history of mathematics does not lie in this interesting detail, but in the fact that he was the first to present a systematic treatment of his subject. He syncretized Greek and Hindu knowledge. He influenced mathematical thought more than any other medieval writer. His principal advance was in the application of the Hindu number names to the numerical solution of equations. And in the second place his contribution 'to the solution of linear equations was the definite recognition of the application of axioms to the transposition of terms and the reduction of implicit fractions to explicit ones'. His solutions of the quadratic equation $x^2 + px = q$ are both

based upon Greek methods. He also described the Check of Nines which Avicenna later popularized. On the other hand, he neglected the negative root, as did later Persian writers. It was not, in fact, recognized until the seventeenth century. Nor was he interested in cubic equations, although the term 'cube' must have been familiar to him.

Muḥammad b. Mūsā al-Khwārizmī died in A.D. 850. He must not be confused with his compatriot, Abū 'Abd Allāh Muḥammad al-Khwārizmī, who about A.D. 976 composed a book called *The Keys of the Sciences*. With typical Persian love of tabulation he here divides the sciences into the Indigenous and the Exotic. This second class he subdivides into the Natural Sciences and the Mathematical Sciences. In this last category he discusses geometry, arithmetic including the elements of algebra, and mechanics with a section on hydrostatics.

Contemporary with this book is the work of the secret society known to us as the Brethren of Purity. This society produced some fifty scientific works which deal with mathematical, astrological, and chemical subjects. They also discuss natural phenomena such as tides, earthquakes, eclipses, and propound questions such as: How is it that simultaneous sounds do not mix in the air? Many of the authors must have been Persians.

It is necessary to pass over a host of names connected with the court in Baghdad and to omit here Avicenna, whose scientific reputation rests rather on his medicine (with which I shall deal later) than on his mathematics. Yet he was no mean mathematician.

Al-Bīrūnī (A.D. 973–1048) can scarcely be refused mention. His original observations are spread over many subjects. He accurately determined latitudes and longitudes. He discussed the question whether the Earth revolves round its axis or not. He correctly measured the specific gravity of eighteen precious stones and metals and explained the working of natural springs

and artesian wells. He even wrote on the prehistoric formation of the Indus valley and on human monsters.

With the birth of 'Umar Khaiyām in A.D. 1044 we come to the end of the Golden Age of Persian science. His name is so well known to English readers in another field that I think it proper to adjust the balance by quoting the opinion of one or two of his fellow countrymen. Al-Zaizānī, for instance, calls him 'the greatest scientist of his time, an astronomer without peer'. Ḥājjī Khalīfa quotes the opening section of his *Algebra* as his finest work. His outlook on mathematics, however, was not different from that of two hundred years before. He followed his objective only so far as mathematics were useful for astronomy, survey, commercial transactions, and the law of inheritance.

His mathematical studies he carried very definitely beyond where al-Khwārizmī had left them. His principal achievement was in the realm of cubic equations. He applied the principle of intersecting conic sections in solving algebraic problems. He gave a complete classification of the forms of cubic equations and constructed a geometrical solution for each type.

He gave a complete classification of equations through the third degree with respect to the number of terms and then after setting the task of verifying its algebraic solutions by geometrical constructs and vice versa, he followed this problem systematically through his work. In fact here was an effort to unify geometry and algebra. . . . Furthermore it reveals a spirit of order and the systematic nature which characterizes his work. But his principal contribution is in the field of cubic equations, an achievement that ranks 'Umar as the most original and greatest mathematician of his time. He constructed geometrically each of his proposed third degree types of equations and presented a discussion of the necessary modifications for each particular case—a distinct contribution worthy of notice and admiration.

Others before 'Umar had, of course, taken up these problems. Thus, al-Māhānī (*c.* A.D. 860) had attempted to cut the sphere

into two segments, the ratio of which is equal to a given ratio (Archimedes' Problem). This he expressed, as $x^3 + a^2 b = cx^2$ and was called al-Māhānī's Equation. He found no solution. It was solved by Abū Ja'far al-Khāzinī, that is Abū Ja'far the Treasurer, or possibly the Librarian. He came from Khurasan about A.D. 960 and solved the problem by means of the intersection of conic sections. A little later Muḥammad ibn al-Laith (c. A.D. 1000) interested himself in cubic equations, the construction of regular polygons of seven and nine sides, and equations of the fourth degree, which incidentally he solved.

In trigonometry the earliest advances were made by the Sabaeans. The first Persian name that can find a place in such a brief summary as this is that of Abu 'l-Wafā' (A.D. 940–97). He was an astronomer and one of the greatest of the Muslim mathematicians. His astronomy was not superior to that of Ptolemy. He did not discover the variation in the third inequality of the moon, as is often stated. On the other hand, he was probably the first to show the generality of the sine theorem relative to spherical triangles. He introduced a new method of constructing sine tables, the value of sine 30° being correct to the eighth decimal place. He knew relations equivalent to ours for $\sin(a \pm b)$. He made a special study of the tangents, calculated a table of tangents, introduced the secant and cosecant, and knew those simple relations between the six trigonometric lines which are now often used to define them.

Naṣīr al-Dīn al-Ṭūsī (to whom I shall refer again) did much original work, but he lived a century too late to acquire international fame. The Renaissance of Europe was dawning. His work hardly had time to become known before it was overtaken and left behind by the rapid strides that were being made in the West.

The last name to reach Europe is that of Bahā' al-Dīn, who was born at Amul in A.D. 1547 and died in Shiraz in 1622. His work was published in Calcutta in 1812 and was subsequently

translated into German and French. But it is of no great merit and contains nothing original. I include him to complete the story, not because he bequeathed anything of value.

## § iii. *Astronomy and Astrology*

A study of the stars formed part of the normal curriculum of the educated Persian in medieval times. Just as mathematics served astronomy, so astronomy (or rather astrology) served medicine, and these subjects were so linked that it was held indispensable to study them all. Thus Avicenna, having memorized the Qur'ān, attended the classes of Maḥmūd the Geometrician from whom he learnt mathematics. From there he moved to the house of Abu 'l-Ḥasan Kushyār where he studied astronomy. And having worked at theology and logic in the meantime, he finally began medicine, all this by the time that he was sixteen years old.

In the *Arabian Nights* there are two good examples of this scientific education which show how general it was. There is the talkative barber of Night 160 who was 'the best barber in Baghdad, an experienced physician, a very profound chemist, an infallible astrologer, a finished grammarian, a complete orator, a subtle logician, a mathematician properly versed in geometry, arithmetic, astronomy, and all the refinements of algebra'. And the detailed examination of the slave-girl, Tawaddud, in these subjects occupies no less than five Nights (Nights 449–54) and is a very good summary of the state of general knowledge of medicine and astrology in medieval Baghdad.

Niẓāmī al-ʿArūḍī of Samarkand considered that an astronomer was one of the four essential men that a king should keep at his side—the others being a physician, a poet, and a secretary. But that this was not the opinion of all men is clear from a remark of Abū Ṭāhir al-Khusrawānī, the Samanid poet, who speaks of 'four sorts of men from whom not one atom of good has accrued' to him—physicians, devotees, astrologers, and charm-mongers.

Of astronomy and astrology in pre-Islamic Persia I am not aware that anything is known. The surviving Zoroastrian books are singularly free from the superstitions which astronomy fostered. Nor do the moon and stars play a part comparable to that of the sun.

With the Abbasid caliphate established in Baghdad the story is very different. Al-Ma'mūn threw himself into the study of the heavens with as much zeal as he displayed for mathematics and medicine. The reason, of course, is that these three subjects were so intimately linked in their fundamentals. Astronomy was perhaps the chief of the sciences and its study demanded a considerable amount of mathematical knowledge. Once again it is the practical side that interested men of those days. One such practical application was the survey ordered by al-Ma'mūn which I have already mentioned.

A far more ambitious scheme and one calling for considerable technical knowledge was the building of a new capital for the seat of the caliphate. Al-Manṣūr selected the site where Baghdad now stands and entrusted the work to a Persian astrologer named Naubakht. The building was begun in A.D. 762 and involved the construction of a walled city with appropriate gates, mosques, public buildings (including a hospital), and an intricate system of canals and bridges. Of all this early work unfortunately nothing has survived.

Just as the mathematicians borrowed largely from India, so did the astronomers. It was a Persian whom al-Manṣūr first employed to make Indian works available in translation. This was Ibrāhīm al-Fazārī (d. A.D. 777). He had a son who also translated into Arabic the Indian works on this subject which formed the basis of al-Khwārizmī's astronomical tables. Al-Fazārī is said to have been the first to construct an astrolabe from which later was developed our sextant. To encourage this work al-Ma'mūn had an observatory constructed in Baghdad and another near Palmyra.

The enthusiasm of the early caliphs for astronomy was matched by that of the Buwayhid Sultans, who coming from Persia entered Baghdad as conquerors in A.D. 975. The greatest of the line 'Aḍud al-Daula had as a teacher Abu 'l-Ḥusain al-Ṣūfī of Ray (A.D. 903–86). One of the greatest of Muslim astronomers, he wrote a work entitled *Book of the Fixed Stars* which was illustrated with figures. This book and the works of Ibn Yūnus and Ulugh Beg constitute the three masterpieces of Muslim observational astronomy.

Sharaf al-Dīn, a son of the first Sultan, built a new observatory in Baghdad and put in charge of it a Persian named Abū Sahl al-Qūhī, who was also distinguished for his writings on equations of a degree higher than the second. The instruments for the observatory were made by another Persian named Abū Ḥāmid al-Ṣāghānī, astronomer, inventor, mathematician, and maker of instruments.

There lived about this time Ḥabash al-Ḥāsib of Merv who was the first to determine time by an altitude (in his case, of the sun) and the first to compose a table of shadows, the equivalent of our tangent. About now, too, was born in Farghana, Transoxiana, the astronomer known to the West as Alfraganus. His books exerted a great influence on European thought. He measured the diameter of the Earth, determined the distances between and the diameters of the planets, and wrote a work on sundials. Abu Maʻshar the Jew (latinized to Albumasar) also flourished in this century. He wrote an astrological theory of the tides which was very popular in the Middle Ages.

Under the caliph al-Muʻtaḍid lived al-Faḍl al-Nairīzī (Latin, Anaritius), who came from a town near Shiraz. He was very versatile, composing astronomical tables, a treatise on the spherical astrolabe (the best work in Arabic on this subject), and a book on atmospheric phenomena. He also wrote commentaries on Ptolemy and Euclid.

The immediate result of the introduction of Indian science

into Baghdad was the construction of calendars. In pre-Islamic times the Persian year had been divided into twelve months of thirty days each, to which were added five extra days to complete the required number. In other words, the year was a solar year. The conquering Arabs replaced this as far as they could by their lunar year. The arrival of Indian astronomy at the court brought yet another method of calculation into favour, which was officially adopted as the result of the writing of al-Khwārizmī. He reckoned his longitudes from the meridian of Arin, a corruption of the name Ujjain, a town in central India. His tables were largely built upon the work of Naubakht's son. He reintroduced the old Persian New Year's Day. This meant a solar year once more and a return to pre-Islamic times. As such it met with the opposition of the orthodox.

In the time of Hārūn al-Rashīd [says al-Bīrūnī] the landholders assembled again and called on Yaḥyā the son of Khālid the son of Barmak, asking him to postpone the New Year by about two months. Yaḥyā intended to do so, but then his enemies began to speak of the subject and said, 'He is partial to Zoroastrianism'. So he dropped the subject, and the matter remained as it was before.

The New Year's Day, however, which in al-Khwārizmī's system coincided with the vernal equinox and the entry of the sun into the sign of Aries, was adopted and has remained a permanent feature of the Persian calendar. The New Year still begins on 21 March.

So matters remained until Malik Shāh in A.D. 1074 built a new observatory in which he employed 'Umar Khaiyām among others to compute a new Era. 'Umar's work resulted in the adoption of a new Era which began on 15 March 1079 and was known as the Jalālī Era. So accurate was his work that there is an error of only one day in 5,000 years. As such it is an improvement upon the Gregorian Calendar which has an error of one day in 3,330 years.

This calendar stood undisputed until the compilation of the

*Zīj* or Tables of Naṣīr al-Dīn al-Ṭūsī. Of this astronomer something more must be said. He was born at Tus in A.D. 1200 and much against his will was associated with that influential band of murderers known as the Assassins. After their destruction he passed into the service of Hūlāgū, the Mongol. He fought on the side of the Mongols in the siege of Baghdad, and, by plundering the city when it fell, enriched his own library to the extent of nearly half a million books. He retained enormous influence over his Mongol master who consulted him for an auspicious moment before beginning any undertaking. His more creditable work was accomplished in the new observatory at Maragha which was built for him in A.D. 1259. He wrote both in Arabic and in Persian. In the latter language are his famous 'Treatise on Ethics', his 'Twenty Chapters on the Science of the Astrolabe', his 'Treatise in Thirty Chapters on Astronomy and the Calendar', and some works on mineralogy, mathematics, and geomancy. His reputation among his own countrymen was enormous, but one at least criticizes him on the grounds that 'his scientific reputation was less due to his actual attainments than to his violent temper and impatience of contradiction which, taken in conjunction with the high favour he enjoyed at the Court of Hūlāgū, made it imprudent to criticize or disparage him.' His importance in the field of mathematics and the extent of the debt that Europe owes to him are well summarized in *The Legacy of Islam* (pp. 395–7).

The town of Tus produced about the same time another astronomer to win fame. This was al-Muẓaffar, who invented the linear astrolabe. The plane astrolabe is essentially the projection of a sphere upon a plane. The linear astrolabe represents the projection of that plane upon a straight line. It is sometimes known as Ṭūsī's Staff.

A pupil of the other al-Ṭūsī was Quṭb al-Dīn Shīrāzī (A.D. 1236–1311), who in one of his books discussed geometrical optics, the nature of vision, and the rainbow. His explanation

is essentially the same as that of Descartes. It was through a pupil of his that the *Optics* of Ibn al-Haitham (Latin: Alhazen) was transmitted to Europe, a work which so profoundly influenced Roger Bacon, Leonardo da Vinci, and Johann Kepler.

Contemporary with these men was Fakhr al-Dīn al-Rāzī, best known as a theologian. He was also a physician of repute. He also wrote in Persian a manual of astrology and an encyclopaedia of science. One of his works has been partially translated into English by the late Professor Nicholson.

Astronomy continued to flourish along the lines laid down by al-Ṭūsī. Under the Timurid prince Ulugh Beg (who was murdered by his own son in 1449) a new impetus was given to this science. His contribution can best be summed up in the words of an almost contemporary Persian writer:

Now as to the late Sultan of blessed memory Ulugh Beg Kurkān, he was learned, just, masterful, and energetic, and attained a high degree in the science of astronomy, while in rhetoric he could split hairs. In his reign the status of men of learning reached its highest zenith, and in his period the rank of scholars was at its greatest. In the science of geometry he was an exponent of subtleties, and on questions of cosmography an elucidator of the Almagest. Scholars and philosophers are agreed that in Islamic times, nay, from the days of Alexander, the Two Horned, until now no monarch like unto Mirzā Ulugh Beg Kurkān in philosophy and science has ever sat on a royal throne. He had the most complete knowledge of the mathematical sciences, so that he recorded observations of the stars with the co-operation of the greatest scientists of the age, such as Qāḍī-zāda-yi Rūmī and Maulānā Ghiyāth al-Dīn Jamshīd. These two great scholars, however, died before completing their work, and the Sultan devoting all his energies to this task, completed the observations and produced the *Zīj-i Sulṭānī* [or Royal Almanack], to which he himself prefixed an exordium. These tables are to-day in use and are highly esteemed by philosophers, some of whom prefer them to the *Zīj-i Ilkhānī* of Naṣīr al-Dīn of Tus.

After the death of Ulugh Beg great names in astronomy become rare. There was Ghiyāth al-Dīn who was brought from

Kashan to Samarkand to practise astronomy and mathematics
in the new college that had been built there. There flourished
also al-Kāshī, who was also a physician to Ulugh Beg. His
original work was an improvement on that of al-Karkhī (d. A.D.
1029). The latter had already given the sum of the third powers
of the successive series $1^3+2^3+3^3+4^3+...+n^3$. Al-Kāshī im-
proved on this and gave the summation to the fourth power.

It is hardly necessary for me to say anything about Persian
astrology, as belief in the justice of its claims is now confined to
readers of the Sunday and cheaper press. But as one reads Per-
sian histories and, above all, Persian anecdote writers, one
cannot help being struck by the number of correct predictions
which the astrologers of those days made. Apart from the
naming of the correct times for setting out on a journey, for
taking medicine, for being bled, and so forth, the astrologers'
main duty seems to have been prediction. If their claims were
totally false and they themselves knew it, they were a brave set
of men; for kings do not for long suffer fools or rogues. I some-
times wonder whether one day the world will not be surprised
by the discovery of a Persian manuscript which will reveal
astrology as a science as exact as was astronomy in those days.
Perhaps the genuine foundations of astrology were overlooked
when its fictitious claims were thrown overboard.

Among these oddly correct predictions many might be
selected. One refers to that very wise statesman Niẓām al-Mulk,
Prime Minister to Malik Shāh. He had great belief in an
astrologer named Ḥakīm-i Mauṣilī. This man prophesied that
the minister would die within six months of his own death. The
astrologer died in the spring of A.D. 1092 and at once Niẓām
al-Mulk made preparations for his own death. He was, in fact,
murdered in the autumn of that year. Similarly Ibn 'Aṭṭāsh,
the Assassin, was captured and paraded through the streets of
Isfahan for the mockery of the people. Finally he was crucified,
and while he was hanging on the cross a bystander asked why he,

an astrologer, had not foreseen this fate. He replied: 'I did indeed perceive from my horoscope that I should traverse the streets of Isfahan with pomp and parade more than royal, but I did not know that it would be in such a fashion.'

On the other hand, Anwarī, the poet, who declared himself proficient 'in every science, pure or applied, known to any of his contemporaries', failed badly when he predicted a gale of such severity that buildings and trees would be overthrown. Many who trusted him were so alarmed that they took refuge in cellars and caves outside the city. Yet on the night in question there was so little wind that a naked light burned without a flicker on the top of a minaret.

Yet it is precisely because of the honesty of the historians in reporting unfulfilled prophecies as well as correct ones that one cannot but feel that perhaps there is something which raises fortune-telling by the stars out of the realm of sheer quackery and deception. Nevertheless I cannot claim that Europe has received as yet any legacy from the Persian astrologer.

With the fall of the Timurid Empire the general decline of Persia set in and astronomy became only a matter of calculating eclipses and new moons. Astrology became a handmaid to magic. Their combined record is unimportant and scarcely interesting. It is better to pass on to medicine, in which Persia has played an outstanding part and bequeathed a vast legacy to the modern world.

### § iv. *Medicine, Botany, and Chemistry*

When we turn to medicine there is historical evidence for the first time of activities in the days before the Arab invasion. Non-Muslim Persians have a part to play. So vast is the subject-matter that I think it better to abandon the chronological method that I have adopted so far and will try and describe the legacy under the different branches of medical practice.

First take the *doctor* himself. The present honourable status

of a medical practitioner may be largely ascribed to the Persians. With a few exceptions the doctor in Greece and Rome held an ignoble position. In the earliest of Persian records he is found as the counsellor of kings. Greek doctors captured in the wars against Athens and later against Byzantium were received with honour and treated not as prisoners but as unwilling guests. Often it was a physician who was chosen as chief adviser and right-hand man of the king. Thus Perzoes (or Buzurmihr in Persian form) was Prime Minister to Anūsharvān the Just (or Chosroes) who reigned from A.D. 531 to 578. His autobiography has survived and has been translated into German by Noeldeke. His description of why he took up medicine as a profession shows the high ethical standards that the faith of Zoroaster had succeeded in introducing.

In the days of the caliphs of Baghdad these high standards for practitioners and the high esteem in which they were held continued. Exalted offices of state were often filled by physicians. Thus the famous Bukht-Yishū' family served as royal physicians and confidential advisers for six generations. Avicenna is hardly less famous as a statesman than as a physician.

In medieval Persia the *ḥakīm-bāshī* or Physician-in-Chief was a court official with powers which often equalled those of the Prime Minister. Even in later times the British Government recognized the unique position which the physician held in Persian eyes when Sir John McNeill, a graduate of Edinburgh, was promoted from his post as physician to the British Embassy to the dignity of Ambassador.

It is perhaps in their conception of *hospitals* that the Persians have conferred the greatest and most lasting legacy to Europe. The modern hospital is a direct growth from Persian foundations.

The first of which we have detailed knowledge is that of Jundi-Shapur, a town near the modern Ahwaz in south Persia. The town is an ancient one. The hospital, medical school, and

university date back to Shāpūr I (d. A.D. 271). The teaching
here at first was probably in Sanskrit, and Indian medical
methods prevailed. With the closing of the School of Edessa in
A.D. 439 there was a large influx of Greek teachers and, no
doubt, Greek principles became popular. From this mixture the
school developed a system of its own, so that al-Qiftī writing
later could say:

They made rapid progress in Science, developing new methods in
the treatment of disease along pharmacological lines so that their
therapy was judged superior to that of the Greeks and the Hindus.
Furthermore their physicians adopted the scientific methods of other
peoples and modified them by their own discoveries. They elaborated
medical laws and recorded their work that they had done.

Here is found the ideal of modern medicine—study of current
methods, modification through experience, and publication for
the use of others.

The school died a natural death through supplying teachers
for the new School of Medicine and the hospitals in Baghdad.
The best known of the Baghdad hospitals is that founded by
'Aḍud al-Daula, complete with equipment, numerous trust
funds, and a pharmacy stocked with drugs brought from the
ends of the earth. Here the in- and out-patient system, as we
know it today, was in operation. Here definite specialization
among members of the medical staff was encouraged. And here
is found the complete organization of interns and externs, lay
governors, and an almoner's office. There appears even to have
been a primitive nursing system.

Benjamin of Tudela, when he visited Baghdad in A.D. 1160,
found sixty-one well-organized institutions. At the same time
in Shiraz was a hospital which formed part of a university in
which were taught philosophy, astrology, medicine, chemistry,
and mathematics. In Arbela there were hospitals for the blind,
for chronic cases, and for foundlings. For the latter, wet-nurses
were in constant attendance. A hospital and school of medicine

still existed in Nairiz near Shiraz, now only a village, when Herbert passed through in A.D. 1628.

It is clear that the hospitals carried out all the duties of modern hospitals and that many of them also served as schools of medicine. Many such schools must have been very small and were of the nature of master and apprentices, rather than schools in the modern sense. For many years there was no restriction on such medical practice. Each teacher would launch his own pupils as soon as he thought fit. A clinical disaster aroused public interest in the matter and a form of central examination was introduced in the year A.D. 931. The caliph al-Muqtadir was then on the throne. With the break-up of the caliphate the examination system seems to have disappeared and only a permit to practise was required. In the days of the Safavids (roughly sixteenth century) this supervision over medical practice was exercised by the court official known as the *ḥakīm-bāshī*. A general supervision over all practitioners of every rank as well as over all those connected with the practice of medicine, such as druggists, needle-makers, and so forth, was exercised by a layman, called the *muḥtasib* or Inspector-General.

The high standard set up by the medical schools led to a recognized ethical code which was incumbent on all practitioners. Ultimately this code became very elaborate. Points of etiquette and medical ethics are dealt with in manuals such as the *al-Madkhal* of Ibn al-Ḥājj and the *Maʿālim al-Qurba* of Ibn al-Ukhuwwa. Laws relating to fees had been laid down in the Zoroastrian holy books and these with modifications were carried on in the days of Islam. There are several stories of physicians being defrauded of their fees and of their claiming them in the open court. Bar Hebraeus tells the story of a very original plea put forward by a doctor who was called in to treat a patient with a tertian fever. He was unsuccessful. When the patient refused to pay on account of the failure, the doctor

demanded half fees on the grounds that he had at least converted a tertian ague into a semi-tertian one.

In the subject of *ophthalmology* the Arabian School made great advances on Greek practice and bequeathed to posterity a considerable legacy. In their day the word 'oculist' lost the sneer which is so often found in Galen and the earlier writers. But neither in optics nor in ophthalmology were the Persians pioneers, with the exception of Rhazes who wrote a book on the Nature of Vision. He was the first to give an account of the operation for the extraction of cataract and was the first to describe the pupil reflex to light. Perhaps, too, Avicenna should receive some credit for introducing the treatment of lachrymal fistula by probing when he suggested the introduction of a medicated probe into the passage. I might also mention Jibrā'īl b. 'Ubaid Allāh, one of the great Bukht-Yishū' family, who was oculist to 'Adud al-Daula and wrote a treatise on the eye. This work is in Arabic. The first to write in Persian on this subject is Muḥammad b. Manṣūr of Jurjan. His book consists of ten treatises of which the seventh is particularly interesting, being on operative technique. But, taking the subject as a whole, there is no doubt that the outstanding names are those of Arabs, not Persians.

In *surgery* it is difficult to say whether the Persians made any advances or not. Works on surgery, whether in Arabic or Persian, are very rare. Such books do indeed refer to a wide range of operative technique and describe operations in all parts of the body from trephining of the skull to excision of varicose veins. But I am not persuaded that they added to our knowledge of the pathology of surgical diseases or of their treatment. Probably they were most expert in operating for stone, sometimes even removing a stone from the kidney itself. Possibly credit should be given to Bahā' al-Daula (early sixteenth century) for anticipating Fowler and Potin when he wrote that after abdominal operations patients should be nursed in the sitting-up

position, and proposed the making of an instrument to avoid opening the abdomen in a case of peritonitis. He suggested that a special drainage tube be used with a very fine point at one end and an airtight bag at the other. By making a small hole in the centre of the tube pus might be evacuated by suction.

In the treatment of fractures plaster of Paris was used by Persian orthopaedic surgeons long before it was known to Europe.

Whether the early Persians practised Caesarian section I am doubtful. Firdausī reports a case, but he is a poet. I reproduced in my book on Persian Medicine (Clio Medica Series) a miniature showing this operation in progress. But this must be the painter's imagination. I have never found in my reading of Persian medical text-books a description of how or when this operation should be performed.

In the realm of *clinical medicine* most historians give to the Persians more credit than I think is their due. Everyone knows that Rhazes was the first to distinguish measles from smallpox. His description of the two diseases can be read by anyone interested, as it was published in an English translation many years ago by the Sydenham Society. Yet I am not convinced that he did indeed recognize them as separate diseases except in the sense that anyone can see that the pustules of smallpox are very different from the macules of measles. Again, some think that he distinguished measles from scarlet fever when he wrote that measles of vivid coloration was more dangerous than that which is but moderately red. I think that more is read into the writings of Rhazes than he meant. Certainly he failed to point out that smallpox is contagious. As a prophylactic measure the Persians practised arm-to-arm inoculation. But this may have been introduced from China.

Avicenna, too, has been credited with certain original observations. He seems to have noticed the difference between obstructive and haemolytic jaundice. His description of meningitis has caused some historians to regard him as a neurologist in advance

of his times. But a study of his Canon shows that he followed in all respects the incorrect views of the men of his time. His championing of the unorthodox views of Alhazen on the cause of vision—views we now know to be correct—should be set to his credit. So should his description of Mollities or the Pathic Disease which in later times Krafft-Ebbing designated 'Effemination among sexual Psychopaths'.

Al-Jurjānī (eleventh century) seems to have made an original observation when he states that some cases of enlargement of the thyroid gland are accompanied by rapid beating of the heart, a condition we now call thyrotoxicosis. He also noted the curious fact that some diseases are antagonistic to others and that one disease may supervene and cure another. This principle is used today when we relieve general paralysis of the insane by inducing an attack of malaria.

Somewhat later that very keen observer Bahā' al-Daula (*fl.* A.D. 1500) gave the earliest known description of whooping-cough, a very complete account of the disease, and also described hay fever. In this latter I think he was anticipated by Rhazes, who wrote a book, now lost, which he called *A Dissertation on the Cause of the Coryza which occurs in the Spring when Roses give forth their Scent*. In almost the same year 'Imād al-Dīn of Shiraz wrote a monograph on syphilis which contains some very shrewd original observations. It is the earliest known work on the subject in Persian, probably in any language in the East. The disease had, of course, already been described in Europe.

In *treatment* the Persians made more advances than they did in diagnosis. Their pharmacopoeia was based upon Greek herbals. But to their Greek heritage they added such well-known remedies as rhubarb, senna, camphor, nutmegs, cloves, sandalwood, cassia, tamarind, and most important of all, the sugarcane. Botany and medicine marched hand in hand. To the Persians must be given the credit of going outside botany for their remedies and of adding to the pharmacopoeia a considerable

number of chemical drugs of which the sulphonamides of to-day are the heirs. Rhazes introduced mercury as a purge after experimenting with it on monkeys. 'Imād al-Dīn extended its use to syphilis. Rhazes also introduced white lead granules for application to the eyes. These were in consequence known in European pharmacopoeias as Trochisci Rhasis or Arab Soap (incorrectly, for Rhazes was a Persian, being a citizen of Ray, a village near the modern Teheran).

To Rhazes Europe owes more than the introduction of these few drugs. Not only did he write a System of medicine (known in its translation as the *Continens*) which became a text-book in most of the universities, but he also wrote a book on alchemy which paved the way to our modern conception of chemical bodies. Up to his time substances were divided into bodies, souls, and spirits. Rhazes introduced into modern speech the classification of animal, vegetable, and mineral. He further subdivided minerals into spirits, bodies, stones, vitriols, boraxes, and salts, and distinguished between volatile 'bodies' and non-volatile 'spirits'.

Many of Rhazes' chemical views were borrowed from 'Jābir', the father of Arabian alchemy. Whether 'Jābir' can be claimed as a Persian is a matter of doubt. The works ascribed to him probably come from the Brethren of Purity, that secret society to which I have already alluded. Their influence can be traced throughout the whole historic course of European chemistry. I would like, in virtue of the strong Persian element in these works, to hold that the legacy which 'Jābir' through Rhazes bequeathed can be entirely ascribed to the Persians.

Following Rhazes came Abū Manṣūr Muwaffaq, who was the first to write a medical treatise in Persian. Not only has this book considerable medical importance, but it is also interesting because it is the oldest extant prose work in modern Persian. Of the 585 remedies mentioned in the book seventy-five are of mineral origin. Abū Manṣūr here distinguishes between sodium carbonate and potassium carbonate. He shows some knowledge

of arsenious oxide, cupric oxide, and antimony. He also knows the toxic effect of copper and lead compounds and the depilatory virtue of quicklime.

The complete supremacy of Persia in the realm of pharmacy can best be seen by a study of the old pharmacopoeias of non-Persian writers. So many of the very terms display their origin. Julep, a favourite form of draught, is in reality *gul-āb* or a drug dissolved in rose-water. Collyrium, any fluid used for washing the eyes, comes from the word *kuhl* or powdered antimony, which was used by the Persians to strengthen sight. What is an elixir but *al-Iksīr* or the Philosophers' Stone?

In A.D. 869 a Persian, Sābūr b. Sahl, composed a pharmacopoeia. This was based on Greek sources with Nabataean, Syriac, and local Persian remedies added. It enjoyed unrivalled popularity until replaced by the *Antidotary* of Ibn al-Tilmīdh in the first half of the twelfth century. It is permissible to hold that these two works formed the basis of all other pharmacopoeias and catalogues of simples which were subsequently written.

I have omitted much that might be said about the legacy of Persia upon which we still are drawing. I have omitted all this partly because it has already been so well expressed elsewhere, partly because such credit should be shared by others. Thus, I have passed over all reference to the work of the early translators who kept alive Greek science and made possible the later renaissance. I have omitted any discussion on the use that the Persians may have made of anaesthetics. It is a subject upon which historians and chemists are not yet agreed. I have said very little about public health and preventive medicine because their practice did not agree with their theory. Enough, nevertheless, has been said, I think, to show that Persia was not only a torch-bearer (as Garrison described her) but that she handed back the torch to Europe with the flame undimmed and burning brighter than ever. C. Elgood

# CHAPTER 12
# PERSIA AS SEEN BY THE WEST

FOR some 2,500 years Western eyes have looked upon Persia; sometimes their gaze has been friendly and admiring, at others it has been the reverse. While Persia has, during this long period, undergone great transformations, these changes appear relatively insignificant when we consider how tremendously the West has itself altered. Limited at first to ancient Greece and her colonies, the West greatly increased in extent when the Roman Empire was established; in the Dark Ages, when the Roman power was disintegrating and nothing stable had yet arisen to replace it, there was a contraction, but the West took on a new shape and a new meaning when, in medieval times, the nations of central and western Europe emerged from the chaos as separate entities and became civilized states. And the discovery of the New World brought great expansion. These radical changes in the West have necessarily brought about great differences in the way in which it has viewed Persia and her people.

## § i. *The Achaemenian Empire*

It is improbable that the Greeks of the mainland or even of the colonies in Asia Minor knew anything of Persia before the successful revolt of Cyrus I against Media and his establishment of the Achaemenian dynasty in the middle of the sixth century B.C. The first intimation that a new power had arisen in the East was doubtless Cyrus' defeat and capture of Croesus, King of Lydia, in 546 B.C. Although Cyrus thereupon turned his attention elsewhere, his general, Harpagus, attacked and subjugated the cities of the Ionian Confederacy in Asia Minor in the following year, thus for the first time bringing Greeks and Persians into direct contact. Cyrus himself the Greeks regarded

with awe and admiration, not unmixed with fear. In the great empire that he and his immediate successors built up, they saw something very different from their own system of city-states, individually so puny and so often at variance; what they saw was, in fact, the Achaemenian universal state, with one single ruler, the King of kings. The fact that they translated his title by the one word *Basileus*, without the definite article, at the very time when they were striving to prevent him from extending his authority over their own city-states, gives some notion of his impact on their imagination.

The failure of the Ionian revolt against Persia, which culminated with the fall of Miletus in 494 B.C., must have served to confirm the almost mystical belief of the Greeks in the military might of Persia and the pomp and power of the Great King. The enormous extent of the empire and the innumerable hosts that it could put into the field made it seem unconquerable and even unassailable. Its capital cities—Susa, Ecbatana, Persepolis, and Pasargadae—appeared so remote as to be impossible to attack. And, indeed, it was the great distance of Susa from the Mediterranean coast that made Cleomenes of Sparta refuse to listen to Aristagoras of Miletus when he appealed for help before the abortive Ionian revolt. Aristagoras in vain described the enormous wealth in the royal treasury at Susa. 'Take that city,' he said, 'and then you need not fear to challenge Zeus for riches.'[1]

Remote though the capitals were, however, and of such fabulous repute, opportunities were not lacking for the Greeks to obtain authentic information regarding Persia. Many Greeks—Herodotus himself was one—were born and lived as Persian subjects; and numbers of them found reason, or were given it, to go to the court of the Great King. Some, like Histiaeus of Miletus, were taken there as captives or hostages, others went as envoys; others again made the long journey as suppliants for

[1] Herodotus, v. 49.

favours (which the Great King not infrequently deigned to grant). Of the captive craftsmen whom Darius I gathered together from many parts of his vast empire to embellish his great palace at Susa, some were Greek, and of these doubtless the more tenacious came back eventually, like modern Greeks from America, with full accounts of what they had seen. How complete these accounts were—no doubt they were full, if not accurate—it is now impossible to ascertain: for the literary works that may have rested on them have so often been lost in whole or in part.

It was probably the drama that first made the people of the Greek mainland fully conscious of the might of Persia. Too conscious, sometimes, as can be seen from what happened to Phrynichus. His play, a tragedy on the fall of Miletus, produced very shortly after that event, moved the Athenian public to tears; so harrowed, indeed, were they at the sufferings of a kindred folk that they fined the poet 1,000 drachmae. Aeschylus, who had played an active part in the great Greek naval victory at Salamis in 480 B.C., was more circumspect. He waited for six or seven years after the battle before producing his play *The Persians*, by which time the memories of relatives and friends of those lost in that action were no longer so fresh and poignant. And he chose a Persian instead of a Greek disaster as his theme. His play, the earliest historical drama that has come down to us, opens in the royal palace at Susa, where Atossa, the Queen mother, and the courtiers, long without tidings of Xerxes and his host, are filled with forebodings. The courtiers, who form the chorus, are attired more gorgeously than usual, in order to convey an idea of the pomp and magnificence of the Persian court. When the messenger reaches them with the news of the destruction of the Persian fleet and the terrible losses in the Great King's forces, their anxiety gives place to paroxysms of grief. In this scene Aeschylus in no wise exaggerated the propensity of the Persians to immoderate emotion. But he was fair-

minded enough, later in the play, when describing the battle of Salamis, to refer to the Persians as 'valiant-minded men'. For him, soldier before chauvinist, the contest had been one between the Persian bow and the Greek spear.

Not till considerably later in the fifth century did the Greeks get what is perhaps the fullest and, on the whole, the most accurate description of ancient Persia ever written.

Herodotus, who wrote his great history of the Persian War with the same admirable detachment as did Homer his account of the contest between Hector and Achilles, faithfully made mention of the many good qualities of the Persians, while by no means glossing over their defects. From him we get a picture of a race of hardy shepherds, inhabiting a rugged and inhospitable land and led by a king (Cyrus the Great) of great military ability, invading and overrunning country after country in the East. They trained their boys, he said, 'to ride, to shoot with the bow and to tell the truth' from the age of five until the age of twenty. This love of truth was exemplified by the good faith of the Persians in regard to treaties and of their kings in carrying out promises. Their horsemanship and accuracy with the arrow were as little doubtful, but being less surprising required less comment.

Next to falsehood, the thing that the Persians abhorred most was debt, because a debtor had perforce to utter untruths. Because trade also involved falsehood, it was distasteful to the Persians, who therefore had no market-places in their country. Cyrus the Great once informed a Spartan envoy that he had no fear of people like the Lacedaemonians 'who have a place set apart in the midst of their city where they perjure and deceive each other'.

But the Greeks were struck by other characteristics of the Persians, quite as paradoxical as the love of truth, as is clear from Herodotus. They regarded themselves, for example, as 'in all regards by far the best of all men'; yet they were 'of all men

those who most welcomed foreign customs', wearing the Median dress in preference to their own, and borrowing from the Egyptians their cuirass in time of war. Their luxurious practices were 'of all kinds and all borrowed'—a phrase which nicely mixes compliment and blame.

Although the Persians were defeated in the great battles of Marathon, Salamis, and Plataea, they were, as Herodotus admits and Aeschylus implies, 'no whit inferior to the Greeks in valour'. Their failure was due not to lack of courage, but to inferior weapons, no armour, and inadequate training.

Herodotus does not deal with the subject of the Persian religion in any detail. The Persians had no temples or statues or altars, he tells us, but offered up sacrifices on the highest peaks of the mountains. He says nothing, and perhaps knew nothing, of the dualism in their belief; neither does Xenophon, possibly for the same reason. It was left to Aristotle to be the first to probe deeply into the matter.

Herodotus' description is very full and detailed and, even when we allow for the love of antithesis that he shared with other Greeks in such matters, it brings out clearly the fact that, while at the outset they were a simple and hardy folk, led by able and truth-loving kings, they later became corrupted by contact with softer-living and self-indulgent subject races, such as the Babylonians. Their kings had absolute power and commanded unquestioned loyalty. So long as these rulers were men of the stamp of Cyrus and Darius all went well, but when kings became tyrants, the Persians themselves degenerated along with them and lost much of their vitality and spirit. It was the paradoxical development of the conqueror which the Romans, too, deplored when in their turn they saw themselves overtaken by it.

Plato, in his *Laws*, confirms this view. Persia, he says, fell from her high place among the nations because of the despotic power of her kings and the want of goodwill between them and

their people. While the great Cyrus and Darius, son of Hystaspes, were both trained as warriors and fought their way to the throne, Cambyses and Xerxes, born in the purple, proved weak and degenerate princes and their ruin was the result of their evil upbringing.

The unspoiled character of the early Persians, then, did not long survive contact with the peoples that they conquered. And the Greeks, the people that they failed to conquer, destroyed at Marathon, Salamis, and Plataea their record of invincibility. A little longer, and yet another notion about Persia current among the Greeks proved vulnerable: after Xenophon's successful extrication of the Ten Thousand it was no longer possible for a Greek to believe the Persian Empire impenetrable to invading armies. And some seventy years later Alexander the Great demonstrated to the wonder of the known world that it was possible not merely to defeat Persians but to conquer Persia itself.

Although Xenophon never set foot in Persia proper, he was in the closest touch with Cyrus the Younger, for whom he had a high regard, and many other Persians. The *Anabasis* and *Cyropaedia* contain much information regarding Persia and Persian customs, though the *Cyropaedia* must be read with the greatest caution: for Xenophon (like Montesquieu) in many matters used Persia and her customs as a cover for his own ideas, and, taken literally, the book contains a number of manifest absurdities—the peaceful end of Cyrus the Great, for example, and the Persian practice of sacrificing to their gods in the Greek manner.

But the Greeks did not draw on the Persians for moral instances only, for massive warnings about the universal state, or, in later times, for examples of Eastern luxury and corruption. If we may take a hint from Aristophanes' *Acharnians*, the Persians catered for their humour as well. The quaint titles, for example, of the officials known as the Eyes and Ears of the

Great King, whose duties were to keep the monarch informed of all matters of importance, made a strong appeal to their sense of the ridiculous. Aristophanes has as one of his characters the Great King's Eye, who appears in the guise of an enormous eye and behaves in an appropriately ludicrous manner.

When Alexander the Great, by putting an end to the Achaemenian Empire, freed the Greek world of an established menace and deprived Persia of its reputed immunity, he also enabled the Western world to get for the first time first-hand and authentic information about the heart of the country; and his admiral Nearchus, who successfully brought his fleet from the mouth of the Indus to the head of the Persian Gulf, obtained much valuable data concerning the coasts of Gedrosia (Makran), Carmania (Kirman), Persis (Fars), and Susiana (Khuzistan). He was the first to mention the pearl fishing for which the Persian Gulf was afterwards so famous. He likewise noted for the first time that Persia was divided into three zones or belts: the hot and sandy coastal region; an inland zone with a temperate climate where fruit of all kinds grew in abundance and where there were extensive forests; and beyond this again a cold and snowy region of rugged and mountainous character. These details were repeated by Strabo for the instruction of later generations.

Of greater significance than these discoveries, valuable though they were, was Alexander's own realization of the good qualities of the Persians when he had had occasion to see how they bore themselves after such a crushing defeat. It was this recognition of the Persian's worth that led him, against Macedonian disapproval, to try and place them on an equality with his Greek subjects, thus breaking rudely away from the narrow Hellenic conception by which the peoples of the world fell into two sharply defined categories, Hellenes and Barbarians.

Had Alexander lived long enough to establish a world system, the subsequent relations between Persia and the West might

have been vastly different; but, as is the way with epigones, his successors were men of lesser stamp. Because of their quarrels among themselves, the idea of a world empire ceased to prevail.

The historian Polybius (*c.* 204–122 B.C.) devoted some space to a description of Ecbatana (Hamadan), the former royal city of the Medes. He prefaced his account of the palace there with the following words:[1]

> To those authors whose aim is to produce astonishment, and who are accustomed to deal in exaggeration and picturesque writing, this city offers the best possible subject; but to those who, like myself, are cautious when approaching descriptions which go beyond ordinary notions, it presents much difficulty and embarrassment.

The palace, he went on to say, covered an area about three-quarters of a mile in circumference, and by the costliness of its structure it testified to the wealth of the original builders. All the woodwork was of cedar and cypress, and all the columns, as well as the beams and fretwork on the ceilings, were covered over with plates of silver or gold. Polybius was also the first Western writer to draw attention to the peculiarly Persian method of irrigation by means of the subterranean water-conduit that exists to this day and is known as the *qanāt*.[2]

Looking back on the Achaemenians, Strabo said that, of all the barbarians, they were the best known to the Greeks, since none of the other barbarians who governed Asia had also held sway over Greece. They were, in fact, the first people to bring Greeks under foreign rule. He quoted Eratosthenes as having said that the Persians ranked with the Greeks in their capacity for adopting an urban civilization.[3]

Another channel through which some knowledge of Persia in the Achaemenian period reached the Greeks and ultimately the Christian world was the Old Testament, in certain books of which there are numerous passages referring to Cyrus the Great

---

[1] *History*, x. 27.  [2] Ibid. x. 28.
[3] *Geographica*, xv. 23.

and others of the Achaemenian rulers. This source of information became available to the Greek-speaking world when the Septuagint translation of the Old Testament was made in the early years of the third century B.C. (It is possible that some portions of the Old Testament may have been translated into Greek at considerably earlier dates.) The account which the Jewish Prophets give of the Persians of those times is, in general, a very favourable one; but we have to be on our guard not to accept as fact all that we read in their books respecting Persia and her people.

The tolerance and kindliness displayed by Cyrus the Great and certain of his successors towards the Jews make it the less surprising that they should have spoken well of the Persians and have remained faithful to them for so long. Cyrus, on conquering Babylonia in 539 B.C., found the Jews in captivity there. As the Zoroastrian religion of those times was still monotheistic, with Ahura Mazda, the Lord of Good, not as yet associated with lesser deities such as Anahita (a later importation from Babylonia), the Achaemenian king felt a natural sympathy for a people whose sole God, Jehovah, he identified with his own—feeling, no doubt, that he was fulfilling the prophecy of Isaiah (chapter xliv):

I am the Lord . . . that saith of Cyrus, he is my shepherd, and shall perform all my pleasure: even saying to Jerusalem, Thou shalt be built; and to the Temple, Thy foundation shall be laid.

It is noteworthy that this chapter is contained in that part of the Book of Isaiah (chapters xi to lvi) which is now believed to be the work of the Unknown Prophet, who lived in the Exilic period and was therefore a contemporary, or nearly so, of Cyrus the Great.

Cyrus issued a decree ordering the rebuilding of the Temple at Jerusalem, restored to the Jews the sacred vessels that Nebuchadnezzar had carried off, and allowed those of them, who

wished, to return to their own country, as we are told by 2 Chronicles, chapter xxxvi, and Ezra, chapter i. Darius, according to Ezra, chapter vi, issued a decree confirming that of his predecessor, and the rebuilding of the Temple was completed in the sixth year of his reign.

Though much of the Book of Esther is imaginary, there seems to be a substratum of truth in her account of how Ahasuerus (who was probably Artaxerxes I), under her influence, prevented Haman from persecuting the Jews and then had him hanged upon the lofty gallows that he had set up for Mordecai. There may also be some truth in what she says of the splendours of 'Shushan the Palace' and of how the women of the royal household were segregated in a separate building. From Daniel, who is, in general, no more reliable a source than Esther, we get our Biblical authority for the immutability of the law of the Medes and Persians ('the law of the Medes and Persians which altereth not').

For the Jews, then, with their more varied experience of subjection, the Persians appeared not so much enemies of freedom as benevolent monotheists whose domination was more acceptable than many that the Jews had had to endure. And as this point of view filtered through to the West it must have modified the original conception of the Persians entertained by the Greeks. But it is that original conception which provides us with the truer idea of the Persians as they appeared to the West in the Achaemenian period. For in this period the Greeks were not merely the brains of the West, but also its eyes and tongue. And by far the most important element in the Greek view of the Persian Empire was its symbolization of the abjectness of the individual under autocracy; for when a Greek wished to take stock of the values inherent in his own civilization he could always assess them by their opposites as revealed in the lot of the subject peoples in the Persian Empire. In much the same way in our times, to become conscious of the privileges he

enjoys in a free democracy, a man has only to contrast his civil condition with that which would be his in a totalitarian régime.

## § ii. *The Parthian Period* (249 B.C.–A.D. 226)

Once Parthia emerged as the predominant power in the East, it was inevitable that the Western world should sooner or later consider her as the successor of the Achaemenian Empire and that, as such, she should come into conflict with the leading power in the West. That power was Rome, which had replaced Greece as the protector of Western civilization against the Eastern 'barbarians'. Rome, it is true, never had her very existence imperilled by Parthia in the same way that Athens and the rest of Greece had been threatened by Achaemenian Persia. Nevertheless the Romans, advancing towards world dominion, found Parthia a formidable lion in the path. For some three centuries the two great powers of the West and East strove for the mastery, but neither was strong enough to obtain it, and the martial Romans had to concede to their Parthian adversaries a prowess as considerable as their own.

As the two empires were either at war or on unfriendly terms for much of the time that the Parthian state endured, it is not surprising that Roman comment on Parthia and the Parthians was, on the whole, unappreciative, and that much of it concerned military matters. The Romans, not unjustifiably, tended to think the Parthians rude and unlettered, and notably inferior in respect of culture to the Achaemenian Persians; but as time went on the Parthians, as Strabo pointed out, became merged with the Medes and Persians into one Persian people who were 'almost of the same speech' (ὁμόγλωττοι παρὰ μικρόν),[1] and the Romans were made to realize, not always in an agreeable fashion, that the Parthian kings and nobles had acquired a surprising amount of culture, including a good knowledge and keen appreciation of the Greek language, literature, and drama.

[1] *Geographica*, xv. 724.

These lessons were no doubt the more effectively learnt for coming in the wake of humiliating military disasters. The terrible Roman defeat at Carrhae (Harran) in 53 B.C., in which the imprudent proconsul Crassus lost his life and his army, must have been very damaging to any tendency of the Romans to credit themselves with effortless superiority; and seventeen years later, Mark Antony's costly and futile attempt to capture the formidable Parthian mountain stronghold of Phraata (now Takht-i Sulaimān), in Media Atropatene, rudely reinforced the lesson. Its echoes, indeed, may be heard still in Roman letters in a phrase like Virgil's 'fidentemque fuga Parthum versisque sagittis';[1] and our own 'Parthian shot' is an inherited tribute to the same tactic that impressed Virgil and the rest of the Roman world: the manœuvre by which the mounted bowmen of Parthia, apparently in flight, would suddenly turn in their saddles and rain disconcertingly accurate arrows on their pursuers.

The lesson in tactics taught so impressively by Crassus' defeat was followed fittingly by the grim and instructive incident of Crassus' head, which showed the West that Parthians as well as Romans had been to school with the Greeks. The rash, intruding proconsul killed, his head was cut off and sent as a trophy to Hyrodes, the Parthian king. It arrived while Hyrodes was present at a performance of Euripides' *Bacchae*. When the gory head was brought in, one of the actors, to the delight of the audience, seized it and quoted:[2]

> We bring from the mountains
> A young one freshly killed,
> A fortunate prey.

A present-day critic might well contrast the keen appreciation felt for the Greek drama by the Parthian king and his nobles with their insensibility in countenancing (and, no doubt, encouraging) the barbarous practice of cutting off the heads of

---

[1] *Georgics*, iii. 31.　　　　[2] Plutarch, *Life of Crassus*, xxxiii.

their principal adversaries and subjecting them to such ignominious treatment; but to a Roman, perhaps, the incongruity would be apparent only because of the special circumstance that a Roman was the victim.

But Carrhae brought other consequences beside military humiliation and a dramatic lesson in comparative civilization. One of its remoter results was that the West, somewhat later, gained first-hand information not only about Parthia itself but also about the oasis of Margiana (Merv). After the battle the victorious Parthians sent the Roman soldiers captured there through Parthia to Margiana. Those who eventually managed to return to their homeland brought back with them the information which enabled Pliny the Elder to compile his accurate account of that little-known region; no doubt it was also from these men that he derived the data for his brief but correct description of Parthia itself. By rightly terming the eighteen Parthian provinces 'kingdoms' instead of 'satrapies', Pliny showed that he appreciated the fact that the Parthian state was somewhat loosely knit, a point in which it differed essentially from both the Achaemenian and Sassanian empires.[1]

Of the Persians themselves the West heard but little during the five centuries of Seleucid and Parthian supremacy; for them it was a period of eclipse. Nevertheless, during this time writers like Strabo, Pliny, and Ptolemy assiduously collected much information from earlier sources respecting Persia. Thus Western knowledge of the country gradually increased, although certain data were inaccurate and many gaps remained.

Although Pliny was accurate when describing Margiana and Parthia, he was on less sure ground when he attempted to deal with Persia and Media (e.g. his statement that Ecbatana was founded by Seleucus); but much of what he wrote was nevertheless of value. He devoted some space in his *Historia Naturalis* to the flora of the country, stating, *inter alia*, that the peach

[1] *Historia Naturalis*, vi. 25.

was indigenous to Persia, as its Latin name *persicum* (*malum*) indicates.

The Romans did not regard the Parthians as a strongly religious people; and, in fact, the monarchs of the Arsacid line were on the whole better Philhellenes than they were Zoroastrians. Nevertheless, it was during the Parthian period that Rome received, indirectly, a legacy from Persia. Many of the Roman legionaries who had been sent to Cilicia and other outlying provinces to guard them against the traditional foe proved more vulnerable to their enemy's religion than to his arms, and became converts to Mithraism. Its militant element had a strong appeal for the Roman soldiers, and it was through them that the religion spread to all parts of the Roman world. It is improbable, however, that many of the Western converts to this faith realized its Persian provenance.

No doubt where the frontiers of two great powers march together there is always likely to be friction and one need not seek an economic basis. But it is interesting to notice that the Romans found the Parthians not merely rivals in power but rivals in commerce also. Chinese silk was one of the commodities that could reach Rome only through Parthia, and it is hardly surprising that the latter took advantage of this fact; not only did she satisfy her own requirements fully before allowing any silk supplies to pass on to the West, but she also charged a high price for all such supplies. As silk was in great demand in the Roman world, this monopoly proved most irksome; but the Romans, unlike Justinian in a later age, were unable to devise any means of breaking it.

## § iii. *The Sassanian Period* (A.D. 226–641)

The Sassanian Empire, which lasted from A.D. 226 to the middle of the seventh century, was, from the contemporary Western point of view, the successor of Parthia as the great rival and enemy of Rome. Throughout this long period the two

powers were engaged in a series of wars that were really a continuation of the struggles of the Parthian era and of the earlier contests between Achaemenian Persia and Greece.

The West was fortunate in having two notable writers, Ammianus Marcellinus and Procopius, who, being soldiers as well as historians, were able to give detailed and accurate relations of the campaigns against the Sassanians in which they were active participants. This is not the place to give an account either of these campaigns or of the Sassanian armies and their methods of warfare. It is sufficient to state that through these two soldier-historians and through other sources the West came to know that the Sassanian Persians were a people of both courage and resource. A notable instance of the latter was their invention and use of what was then an entirely new weapon—fire; and it may well be that it was this discovery of theirs that led Callinicus, several centuries later, to hit upon its effective variant, Greek fire.

The Romans came to realize, only a few years after Ardashīr's triumph over the Parthians in A.D. 226, that a new and most formidable military power had arisen in the East. The severe defeat which Ardashīr inflicted upon the Emperor Alexander Severus caused dismay in Rome; and the contemporary historian Herodian went so far as to describe it as the greatest disaster ever inflicted on the Romans. Blow though it was, however, the defeat was not so great a catastrophe as Carrhae. More humiliating to Roman pride and more damaging to her prestige than either of the earlier reverses was the battle fought at Edessa in A.D. 260, for in this battle Ardashīr's son and successor, Shāpūr I, did more than defeat the Emperor Valerian: he captured him as well. This disaster made a great impression in the West. Later historians—among them Lactantius—tended to exaggerate the harshness and cruelty in Shāpūr's treatment of his imperial prisoner. But it was the fact of the capture, rather than the treatment that followed it, which did the damage to Roman

prestige. And when the Emperor Julian's attempt to capture Ctesiphon, the Sassanian capital, ended in failure and his own death from wounds, the Romans had ground enough to recognize the mettle of their Sassanian foes.

Rome certainly had her victories as well as her reverses in these wars, but, as had been the case in the Parthian period, the outcome of the long struggle was inconclusive. In striving after victory both powers exhausted themselves; so that when Islam, a *tertius gaudens*, launched her hosts upon the world, the Sassanian Empire went down beneath them, and if the Eastern Empire kept half her provinces, this was due at least in part to her more favourable position.

Inevitably in so long a time of war it is war that preoccupies the historians; and to the same cause, no doubt, is due the inevitable hostile bias that crept into the works of contemporary Western writers. But there were times when they could, by way of contrast, view Sassanian Persia in a better light. A case in point is the friendship between the Emperor Arcadius and his contemporary Yazdajird I. So highly did Arcadius esteem his fellow sovereign that he entrusted to him the guardianship of his young son Theodosius, a charge which Yazdajird willingly undertook and most faithfully carried out.

In spite of these smiling interludes, the face turned towards the West by the Persian lands was still, as in the days of the Achaemenians, predominantly threatening. But new developments had supervened since then, and religion, which in the time of Themistocles had remained ambiguous in Delphi or mysterious in Susa, had now a larger role to play, sometimes as the handmaid of politics, sometimes as its mistress. Christianity was growing stronger among the Romans, and even in Persia, where a revived Zoroastrianism was now the national religion, it had put down roots so firm as to threaten to supplant its rival. So long as the Roman Empire remained predominantly pagan, this Christian penetration had but little effect upon the

relations between Persia and the West. A very different situation arose, however, when the Emperor Constantine became converted to Christianity. After that event, Constantine's contemporary and adversary, Shāpūr II (A.D. 309–79), said of the Christians in his realm: 'They live in our midst and share the sentiments of Caesar.' Shāpūr thereupon began a series of persecutions of his Christian subjects, a practice which several of his successors also followed. As so often, the action caused by suspicion made the ground of the suspicion actual. And it was natural that, when the persecuted Persian Christians turned for help to the Christian Roman Empire, it should regard itself as their protector. Stories of the sufferings of these Persian Christians and the painful martyrdom of many of them made a profound impression in the West. (Pope Hormisdas, although an Italian by birth, took the name of a Persian martyr when he became Pope in 514.)

It thus seemed as though religion, in crossing the frontier, had given one more reason for that frontier to be a sharp dividing-line between foes already inveterate. Yet a similar cause— a Byzantine bigotry which fitly matched the Persian intolerance —was soon to bring one curious result: the reversal of the Western point of view regarding Persia. This happened when the Byzantine rulers began their fierce persecution of the Nestorians. At the synod of Bait-Lapat (Jundi-Shapur) in A.D. 484 the majority of Persian Christians embraced Nestorianism. When the Sassanian monarchs realized that their Christian subjects were, by reason of the schism, no longer protected by, or loyal to, their Byzantine enemies, they greatly moderated their treatment of them and even welcomed fugitive Nestorians from the Byzantine Empire. In consequence the West came to look upon Persia not as a persecutor of Christians but as a harbourer of heretics.

Besides regarding Persia in this light, the West could not fail to observe that her soil was fertile in religions and heresies

different and more dangerous, namely, Manichaeism and Maz-
dakism. Manichaeism, it is true, had only an initial success, after
which it was so savagely suppressed there that it never recovered.
On the other hand, the teaching of its founder Mani reached
Rome in A.D. 277, only four years after Bahrām I had brutally
executed him and put to death thousands of his followers.
From Rome the new creed penetrated to North Africa, where
it speedily gained many adherents, amongst them one who
was later to become more orthodox and to be canonized as
St. Augustine. The rapid eradication of Manichaeism from Persia
and its subsequent widespread growth far beyond the borders
of that country tended in time to obscure its Persian origin; a
tendency strengthened, perhaps, by the curious spectacle of
Paul the Persian, the Bishop of Nisibis, espousing the cause of
Christianity in a public dispute at Constantinople against Photi-
nus, a Byzantine champion of Manichaeism.

So far as Persia was concerned, the fate of Mazdakism was
very similar to that of Manichaeism. After being initially
accepted, it was later suppressed with the utmost severity, with
the result that it was completely stamped out and never revived.
But, unlike Manichaeism, although its Communistic doctrine
made some appeal for a time in Syria and Greece, it never took
root outside Persia.

We now come to the Western conception of Persian philo-
sophy in the Sassanian era. Unfortunately we have no precise
information about either the extent of philosophical learning
in Persia under the earlier Sassanian kings, or the value which
the West attached to it. But it is obvious that Western thinkers
did in fact regard Persian philosophy as of some importance,
for Plotinus wished to go to Persia to study it.[1] It was for this
purpose that he accompanied the Emperor Gordian on his
expedition against Persia in A.D. 242. Since, however, this
campaign ended in inglorious failure, Plotinus never set foot on

[1] Plotinus also wished to go to India for the same purpose.

Persian soil and could have had few, if any, opportunities of making direct contact with Persian sages. As Dean Inge has pointed out,[1] there is no noticeable trace of Oriental influence on Plotinus' thought.

We are on more certain ground when we come to the time of Khusrū Anūsharvān, nearly three centuries later. That sovereign, who began the study of philosophy as a young man, became acquainted with the teachings of Plato and Aristotle and caused most of their works to be translated into Pahlavi. It is probable that he undertook these studies when under the influence of such scholars as Paul the Persian, the Bishop of Nisibis. This Persian ecclesiastic, whom we have already met debating against Photinus, was a Neoplatonist of repute, spent a number of years at the Sassanian court, and wrote in Syriac a summary of Aristotle's *Logic* for the edification of the king.

Reports of Khusrū's philosophical attainments reached the West in an exaggerated form, with the result that it came to be believed in certain quarters that a philosopher-king had at last arisen in the East and that he had, in his own realm, brought about the realization on earth of Plato's Republic. Amongst those holding this belief were the seven pagan philosophers, the last of the famous Golden Chain, who, by reason of Justinian's closing of the famous schools at Athens, found themselves not only deprived of their means of livelihood but also threatened with persecution. The seven philosophers, buoyed up with the hope of finding their ideal in Persia, set out to seek sanctuary there, 'the Wise Men of the West going towards the East with no star for guide'.[2] The Western sages found, alas! that the reality did not come up to their expectations. Khusrū, it is true, received them very graciously and hospitably, and was able to discuss with them the works of Plato and Aristotle, as well as such questions as the origin of all

[1] *Mysticism in Religion*, p. 109.
[2] Rufus M. Jones, *Mystical Religion*, p. 78.

things; but they found, nevertheless, that he could not enter profoundly into esoteric matters. Even more disappointing, they discovered that he failed to come up to the Platonic standard as a ruler, being in fact more of a despot than a philosopher. As for the Persian nobles and courtiers, they fell even farther short of Platonic standards.

Disappointed and disillusioned, the seven philosophers came to Khusrū and begged leave to return to their own country. He pressed them to stay, but, as they persisted, he at length acceded to their request. And, much to his credit, in the treaty of peace that he was then negotiating with Rome he inserted a special clause to ensure that the philosophers should be unmolested and be free to profess their beliefs in their own country. Amongst these sages was Damascius, who incorporated in his book *De Principiis* particulars of some little-known Oriental beliefs, using, no doubt, a knowledge that he had acquired while at the Persian court.

The disillusionment of the seven sages produced its ripples in the West: Agathias, for example, a writer of some Byzantine bias, unduly belittled Khusrū's philosophical attainments. Agathias was followed in this respect, many centuries later, by Edward Gibbon, who described Khusrū's studies as 'ostentatious and superficial',[1] a judgement that seems somewhat harsh and unfair when we consider the age and environment in which Khusrū lived. Although he was not a profound scholar, he had a genuine love of learning; and there can be no doubt that by his welcome to Greek and Syrian learned men, such as Uranius, as well as to the seven pagan philosophers, and by his foundation of the famous school or university at Jundi-Shapur, he greatly encouraged the advancement of learning in Persia and in some measure facilitated the development in later times of Ṣufism and mysticism in that country.

In the lulls during the long-drawn-out struggle between

[1] *Decline and Fall of the Roman Empire*, v. 249.

Sassanian Persia and Rome, the latter was able to gain some knowledge of Persian industry and craftsmanship. The magnificent products of the Persian looms made a great impression in the West; in the fifth century A.D. Sassanian textiles were much admired even as far west as Gaul, as we know from the works of Caius Apollinaris Sidonius, the Bishop of Clermont. The Persian weaving industry had, it is true, benefited very considerably from the practice by which the Sassanian kings settled Greek and Roman prisoners with a good knowledge of weaving in such cities as Susa, Jundi-Shapur, and Shushtar and transferred other skilled workers there from Antioch; but the native craftsmanship was itself excellent and became justly celebrated in the West.

While Persia's beautiful textiles aroused the enthusiasm of the artistic in the West, her stranglehold over the silk trade excited very different feelings, as it had done in Parthian times. The Sassanians, like the Parthians before them, kept a rigid control over the silk routes from China, taking for their own subjects all that they required at a relatively low price and levying exorbitant dues on what they allowed to pass on to the West. This long-held monopoly was at last broken during the reign of Justinian, through the instrumentality, curiously enough, of two Persian monks from China.

In sum, the Western view of Sassanian Persia was one of deep respect for her military prowess; a curiosity about her religious beliefs mixed with a fear of their contagious qualities; contempt (to some extent undeserved) for her philosophical attainments; and, lastly, admiration for her textiles.

§ iv. *The Islamic Period up to the End of the Reign of Nādir Shāh* (A.D. 650–1747)

For the purposes of this survey, the period from the Islamic conquest of Persia to the end of the reign of Nādir Shāh in 1747 can be divided into two very nearly equal parts, between

which there is a striking contrast. In the first—from the middle of the seventh century until the coming of the Mongols some 600 years later—the Muslim conquest veiled the face of Persia and the other parts of the East so completely that even had the peoples of the West been free of the many troubles that distracted them they would not have been able for most of this time to penetrate the veil and follow what was going on behind it. The Mongol conquest of Persia and the adjacent countries, however, broke down the barriers and began the second half of our period; one in which the West, by then emerging from its chaos, could once more enter into relations with the lands the Mongols had conquered.

The ease with which the Muslim Arabs overthrew the Sassanian Empire must have surprised many Western observers; but those with knowledge and a turn for analysis would have seen that the sudden collapse had two main causes. In the first place, Sassanian Persia had long been bleeding to a slow death in the interminable struggle with Rome and Byzantium and so was in no state to batter back the tremendous and not only physical onslaught of Islam. And, secondly, the Arabs, usually so divided, were now unified as they had never been before by extreme religious fervour. These acute observers of ours, however, especially if they inhabited the outlying provinces of the Eastern Empire, would have had little time for ruminating on the fall of the Sassanians; for the victorious Arabs soon turned against the West.

The veil that now intervened between East and West leaves us little to say for almost the whole of the first part of the Islamic period. Western Europe had throughout no means of contact with Persia, and itself turns a dark enough face to scrutiny. True, as time went on, the darkness so far lifted as to reveal the new feudal Europe. But between this Europe and Persia commercial relations would have been difficult, not to say impossible, even if the barrier of the caliphate had been removed.

On the other hand, though much of the West was thus shut off from the East, there was a steady stream of Hellenic culture flowing into the Muslim world in the spacious days of the Abbasid caliphate. As other chapters in this volume have made plain, it was fortunate for the West, and indeed for the world in general, that this flow took place when it did, because it was the means of preserving a vast amount of learning that would otherwise have been irretrievably lost.

The Mongol menace to the Islamic world was the means whereby the curtain shrouding Persia from the West was drawn partly aside some years before the Mongols themselves tore it away altogether. In A.D. 1238 the Grand Master of the Assassins sent from his headquarters at Alamut, in the heart of the Elburz mountains, emissaries to the kings of England and France to ask for aid against the Mongols. The envoy to the English court said that the West would assuredly be devastated as well as the East unless the latter received help. Matthew Paris has graphically described the chilling reception which this envoy received. Evidently, the first Persian ever to visit England (unless we accept as authentic the story of St. Ive, the sixth-century Persian missionary) aroused no sympathy and little or no curiosity. The envoy to the French court fared no better.

Although the Mongols triumphed in the East, their attempt to dominate the West failed. Shortly afterwards a rumour reached the West that the Mongols had embraced Christianity. On the strength of this Pope Innocent IV decided, in 1245, to inaugurate a great religious movement in their domains. With this end in view he sent the Franciscan Jean Plano de Carpini on a mission to the court of the Great Khan at Qaraqorum in the following year. Although the friar travelled through Persia, he unfortunately recorded nothing of interest regarding the country and its people. Seven years later another missionary, the Minorite friar William de Rubruquis, followed in Carpini's footsteps. His account of Persia is disappointingly meagre, con-

taining little more than a brief reference to the Assassins and their mountain fastnesses. Thus, although the way was now open, scarcely anything was done to give Europe an idea of what Persia was like in those days. It must, however, be borne in mind that these friars did not undertake their long and hazardous journeys with that as their primary object.

It was reserved for the great Venetian, Marco Polo, to throw the first real light on Persia for many centuries. Through him Europe at last learnt something of that country, its cities, and its people. Tabriz he found a thriving place, with very industrious inhabitants. At Kashan the local velvets and silks attracted his attention; he was particularly impressed with the beautiful embroideries made at Kirman. It is not too much to say that, so far as the West was concerned, Marco Polo changed Persia from a mere name into a reality. It was he who gave to the West the first really detailed description of the formidable Order of the Assassins and their sinister chief 'the Old Man of the Mountain' (the crusaders had, it is true, already come into contact with the Syrian Assassins, but these were an offshoot from the main body in Persia). Marco Polo showed, *inter alia*, that the sturdy Persian peasant could, under certain conditions, rise to great heights of heroism; unfortunately, in the case of those under the influence of the Assassins, their deeds were of a most reprehensible nature.

Such, in greatly summarized form, is what the West was able to learn of Persia through Marco Polo. The canvas, blank for so long, was at last showing not only outlines but also some colour and detail.

For rather more than a century after Marco Polo's time there was a singular lack of fresh information. This silence was broken by the Franciscan friar Odericus who travelled through Persia on his way back to Europe from the Far East. He spoke of the great sea of sand one day's journey from Yazd, which was 'a most wonderful and dangerous thing'. Kashan, which was among

the other towns that he visited, was, he said, the place whence the three Magi had set out on their memorable journey. Far more interesting and entertaining than Friar Odericus' meagre and rather jejune narrative was that of his contemporary, the ubiquitous Moorish traveller Ibn Baṭūṭa, but his works only became available in any European language much later.

Seventy years after the journeys of Odericus and Ibn Baṭūṭa, new ground was broken by Clavijo, the Spanish Ambassador to Tīmūr Lang (Tamburlaine). In 1404 he and his suite, while on their way to the conqueror's court at Samarkand, travelled through Khurasan. At Meshed they were allowed to visit the shrine and even to enter the tomb-chamber of the Imām Riḍā, the eighth of the Shī'a Imāms. The West could form some idea of the great sanctity of the Imām's last resting-place, in Shī'a eyes the most hallowed spot in Persia, from Clavijo's statement that 'when travelling later through other parts of Persia, it came to be noised abroad that we had been at Meshed and visited this holy place, the people would come and kiss the hem of our robes, deeming that we were of those who had acquired merit for having made the pilgrimage to the shrine of the great saint of Khurasan'.[1] It is, nevertheless, open to question whether the true import of the great schism in Islam was then apparent to even an intelligent European observer. Many years had still to elapse before the Safavids established their Shī'a theocracy in Persia and embarked on their long duel with Sunnī Turkey. It was only then that Christendom, also gravely menaced by the Turks, took note of the potentialities of Shī'a Persia as an ally against the common foe.

During the remainder of the fifteenth century Europe derived most of such information as she received on the subject of Persia through the Venetians. Being merchants, their prime concern was, naturally enough, industry and trade. Giasofo Barbaro, who was at 'Jex' (Yazd) in 1474, described it as 'a

[1] *Embassy to Tamerlane*, p 185.

towne of artificers, makers of fustians, chamletts and the like. This towne is walled, of v myles in circuite, with very great suburbes, and yet in maner they are all wevers and makers of divers kinds of sylkes.'[1]

The sixteenth century saw great changes not only in Persia herself but also in the nature of her relations with the West. In the first place, Shāh Ismāʿīl (1500–24) founded the Safavid dynasty at the very beginning of the century, setting up a theocratic state with himself as the supreme head and with Shīʿism as the state religion. His aims went far beyond the bounds of his own country, as it was his ambition to make Shīʿism a universal religion. Although he failed in this object, he and his successors nevertheless made Persia a great power. As Shīʿa Persia's western neighbour was the strong military power of Turkey, the champion of Sunnī orthodoxy, it was inevitable that war would ensue between them. This struggle, which began early in the reign of Shāh Ismāʿīl, continued, with some intermissions and with varying fortunes, until 1639.

In the second place, there was a remarkable change in Persia's contact with the West. With the discovery, late in the previous century, of the sea route to the East via the Cape of Good Hope, the fortunes of Venice began to decline, and she slowly but steadily lost ground to the Western maritime powers not only in Persia but elsewhere as well.

In 1507 a European fleet, the first since Nearchus' squadron over 1,800 years before, appeared in the Persian Gulf. It was a Portuguese fleet under the command of the great Albuquerque. The Portuguese admiral, noting the strategic importance and commercial potentialities of the small island of Hormuz, seized it together with Qishm Island and part of the adjoining mainland. He thus secured for his country control over the entrance

---

[1] *Travels to Tana and Persia*, p. 73 (William Thomas's English translation of Barbaro's *Viaggio*; Thomas was hanged at Tyburn in 1554, after having taken part in the Wyatt rising against Mary).

to the Gulf and also an excellent trading centre. For over a century no other Western power ventured seriously to challenge the Portuguese in these regions. As for the Persians themselves, they were too taken up with their life-and-death struggle with Turkey to attempt to oust the intruders; moreover, they had no navy.

Except as regards the Persian Gulf, the West was not able to add to its knowledge of Persia through Portuguese channels. The Safavid monarchs, not unnaturally, regarded the Portuguese as intruders and infidels, and would have prevented by force any attempt by them to penetrate deeply into the country. The West was, however, destined to learn far more through the commercial contact made by the English, Dutch, and French in the not very distant future.

The English were the first of these three nations to open up trading relations with Persia. The Muscovy Company, having decided to attempt to trade with Persia via Russia, sent a mission under Anthony Jenkinson to the former country early in the reign of Queen Elizabeth. When Jenkinson reached Qazvīn (then the Persian capital) in 1562, he was received graciously enough by Shāh Ṭahmāsp, Shāh Ismāʿīl's son and successor. However, as soon as the fanatical Shah discovered that Jenkinson was a Christian, he abruptly bade him depart. Notwithstanding this inauspicious start, the Muscovy Company sent further expeditions to Persia by the same route. It was in this way that Thomas Banister, Geofrey Ducket, and other Englishmen journeyed to Persia, visiting Kashan and other towns. Their impressions and experiences found a public wider than the directors of the Muscovy Company for whom they were compiled. Richard Hakluyt published them in London in his *Principal Navigations, Voiages, Trafficques, and Discoveries*.

Hakluyt also included in this same compilation translations of the travels of Jean Plano de Carpini, William de Rubruquis, and Friar Odericus. He printed, besides, the much more recent

journals of Ralph Fitch and John Eldred who, in company with some other merchants, were the first Englishmen to travel to the Persian Gulf and beyond by the overland route via Tripoli, Aleppo, and the Euphrates Valley.

How widely were these records studied and to what extent did they enable the Elizabethan 'man in the street' to form some conception of Persia and her people? One way to glimpse an answer is to examine the works of Shakespeare and see what they contain on the subject. The result is disappointingly meagre, but it may nevertheless be of interest to quote certain of the relevant passages and to try to discover how Shakespeare had obtained his scanty data.

In *A Comedy of Errors* (Act iv, scene i) the Second Merchant says to Angelo: 'I am bound for Persia, and want guilders for my voyage'; he then demands payment of some money due. There can be little doubt that Shakespeare had Ralph Fitch or one of his companions in mind when he wrote these lines. The First Witch in *Macbeth* (Act ii, scene i) says: '. . . her husband's to Aleppo gone, master o' th' Tiger.' And as we know from Fitch's journal that he sailed in the *Tiger* for Tripoli, this suggests a strong likelihood that Shakespeare read the journal in Hakluyt's *Principal Navigations*.

Again, *King Lear* (Act iii, scene vi), Lear says to Edgar: 'You, sir, I entertain for one of my kindred; only I do not like the fashion of your garments; you will say they are Persian attire, but let them be changed.' The ground here is far from sure. It may have been Jenkinson's account of his visit to Shāh Ṭahmāsp's court which led Shakespeare to speak of 'Persian attire'. The fact that he added the words 'but let them be changed' does not necessarily mean that he looked upon Persian garments as mean or ugly; he may merely have considered them unsuitable for that particular occasion. In the following century, with far more data to go upon, English opinion of Persian dress was on the whole very favourable. For instance, Samuel Pepys was

much struck by the 'comely' attire and appearance of the Persian Ambassador when he saw him at Whitehall waiting to be received by King Charles.[1]

In *The Merchant of Venice* (Act II, scene i) Shakespeare puts the following words into the mouth of the Prince of Morocco when he is addressing Portia:

>                        I pray
> Thee, lead me to the caskets
> To try my fortune. By this scimitar
> That slew the Sophy and a Persian prince
> That won three fields of Sultan Solyman
> I would òutstare the sternest eyes that look.

It would appear that Shakespeare was working on something gleaned from Jenkinson. No 'Sophy' (i.e. Shah) or prince was actually slain in the wars between Persia and Turkey in the first half of the sixteenth century, although Shāh Ismā'īl was badly wounded and narrowly escaped capture in the battle of Chaldiran in 1514. Milton, nearly sixty years later, made better use of the same source of information in *Paradise Lost* (Book X, lines 431–6):

> As when the Tartar from his Russian foe
> By Astracan over the snowy plains
> Retires, or Bactrian Sophy from the horns
> Of Turkish crescent leaves all waste beyond
> The realm of Aladule in his retreat
> To Tauris or Casbeen. . . .

One wonders why Milton used the epithet 'Bactrian'; apart from that the meaning is perfectly clear. 'Aladule', the 'Alidoli' of Venetian travellers, was 'Alā' al-Daula Dhu'l-Qadar of Erzincan, a great adversary of Shāh Ismā'īl.

But instances can be taken for little more, as evidence, than their negative worth: Sophy and Aladule are romantic and uncertain echoes fetched from the far unknown.

---

[1] See the entry in his *Diary* dated 10 January 1668.

The accession of Shāh 'Abbās I to the throne of Persia in 1587 brought fundamental changes not only in that country but also in her relations with the West. Faced with the necessity of waging war against the formidable Turks, he decided to form a regular army; for he saw the danger of depending on tribal levies under chiefs who, like feudal barons in Europe, were often of doubtful loyalty and might on occasion prove more of a menace than a help. But he saw also how inferior his troops were to the Turks in artillery, an arm which the Persians had hitherto disdained; and so, correctly concluding that to achieve his aims he must have European aid, he deliberately abandoned the bigotry and narrowness of his predecessors and welcomed Christians to his court.

Reports of the new Shah's character and change of policy reached Europe in due course; but, as often happens, the facts had suffered some distortion on the way. Pope Clement, believing that Shāh 'Abbās was willing to embrace the Catholic faith, sent priests to minister to his needs. He fondly cherished the hope that, if the Shah became converted, Christianity might be reintroduced into Persia, where it had flourished for so long in former times. Moreover, the Pope, in company with the Emperor and other temporal rulers in the West, saw in Persia a potential ally against the Turks,[1] then at the zenith of their military power and a real menace to Christendom. Envoys were therefore sent to Shāh 'Abbās urging him to attack Turkey.

One of the consequences of Shāh 'Abbās's change of policy was that not only missionaries and priests, but a strange medley of European merchants, diplomats, craftsmen, and soldiers of

---

[1] The idea of an alliance between Persia and the West against Turkey had occurred over a century before to Uzun Ḥasan, the Turkoman ruler over the greater part of Persia in the troubled period between the Timurids and the Safavids. When he asked the Venetians for military aid, they sent Caterino Zeno as an envoy to him. Although Zeno returned with pressing requests for assistance they fell on deaf ears in Venice.

fortune thronged to his court. The reports that these oddly assorted visitors sent or brought back to their respective lands would fill many volumes. In fact, from the time of Shāh 'Abbās onwards, such sources of information become so copious that the difficulty is no longer to find material but to decide what to retain and what to discard. As it would be manifestly impossible to quote from all these sources, or even briefly to refer to them, a few excerpts have been taken and in some cases abridgements made from the works of men of different nationality, outlook, religion, and profession. In this way some idea can be formed of what the inhabitants of western European countries could glean from their nationals travelling through Persia or resident there in the seventeenth and eighteenth centuries. With the wider dissemination of knowledge in the West brought about by the growth of literacy and the more extended use of the printing press, and with the closer contact that was established between West and East, it is safe to say that, as time went on, the term 'Persia' came to mean more to the ordinary man in Europe than it had done in Shakespeare's day.

Abel Pinçon, a Frenchman who accompanied that romantic figure Sir Anthony Sherley on his mission from the Pope and the Emperor to the Persian court at the close of the sixteenth century, said of Shāh 'Abbās that he was:[1]

> . . . about 30 years of age, small in stature, but handsome and well-proportioned; his beard and hair are black. His complexion is rather dark like that of the Spaniards usually is; he has a strong and active mind and an extremely agile body. . . . He is gracious to strangers, especially to Christians.

Pinçon then drew attention to the strange contrasts in the Shah's character. While he generously provided for the needs of an aged French clock-maker, who was too old to work, he

[1] Quoted by Sir Denison Ross in his *Sir Anthony Sherley and his Persian Adventure* (London, 1933), p. 158.

could be most capricious and cruel to his own subjects, 'cutting off their heads for the slightest offence'.[1]

In 1608 Father Paul Simon, an Italian Carmelite, who was the first Superior of that Order in Isfahan, sent to Rome a very much more detailed description of the Shah. He stressed his vivacity and alertness of mind, as well as his great physical strength and his dexterity as a swordsman. The Shah, he went on to say, was wont to walk through the streets of his capital, mixing freely with the people. And he quoted the Shah as saying that this was: 'how to be a king and . . . the King of Spain and other Christians do not get any pleasure out of ruling, because they are obliged to compass themselves with so much pomp and majesty.'[2] Notwithstanding this attitude, the Shah insisted on his subjects treating him with proper respect, and punished severely anyone who failed to do so.

Sir Thomas Herbert, who accompanied the English Ambassador Sir Dodmore Cotton and Sir Robert Sherley to Persia late in Shāh 'Abbās's reign, wrote as follows on the subject of the Shah's attitude towards foreigners:[3]

The King . . . esteemed it an addition of lustre, to his Court to behold exotics in their own country habit, so that the greater the variety appeared, he would say the more his Court and country were honoured at home and in estimation abroad.

Persia was, Herbert said, a formidable military power, and the Shah was able to muster 300,000 horse and 70,000 musketeers; though, he added, not more than 50,000 were usually levied, this number being 'enough to find forage and provand in such barren countries.'[4] Of the Persians themselves, Herbert stated that they were[5]

. . . generally well-limbed and straight, the zone they live in makes them tawny, the wine cheerful, the opium salacious. The women paint,

[1] Ibid.
[2] *A Chronicle of the Carmelites in Persia*, i. 158.
[3] *Travels*, p. 232.     [4] Ibid., p. 242.     [5] Ibid., p. 230.

the men love arms; all affect poetry; what the grape inflames, the law allays and example bridles.

Father Paul Simon described the Persians as being[1]

. . . white, of fair stature, courteous, friendly towards foreigners and tractable; they set great store on nobility of birth, which the Turks do not. They are very ceremonious and use many forms of politeness after their own fashion. The Persians were formerly very superstitious and abhorred Christians, as if the latter were a foul race. . . . Nowadays, because the Shah shows great regard for the Christians, passes his time with them and sets them at his table, they have abandoned all this and act towards them as they do to their own people.

It would be out of place to give here any detailed description of the manner in which the English East India Company began, in Shāh ʿAbbās's reign, its long connexion with Persia or of how an alliance between the two in 1622 resulted in the expulsion of the Portuguese from Hormuz and the small strip of the mainland seized over a century before. For well over a hundred years the company's officials and merchants travelled extensively in the country, and many resided for long periods at Gombrun (Bandar Abbas), Isfahan, Shiraz, and elsewhere. Through the letters and reports sent to England by these officials and merchants, much information of importance about not only trade, but also other matters was received there. Hot on the heels of the English came the Dutch, who likewise maintained for many years a close commercial connexion with Persia.

In the religious field, Shāh ʿAbbās's tolerance and his friendliness towards Christians made it possible for missionaries of various orders and denominations to go to Persia, build churches there, and freely practise their religion. Though they made few converts, they came to know the country and the people extremely well. Shāh ʿAbbās, well named 'the Great', died in 1629, but his tolerant policy did not die with him; and so

[1] *A Chronicle of the Carmelites in Persia*, i. 156.

missionaries, as well as merchants and others, continued to come and go freely.

Amongst the missionaries, the most remarkable was Père Raphaël du Mans, a French Capuchin, who arrived in Isfahan in 1644 and remained there until his death in 1696. During his long stay he became a good Persian scholar, and did a great deal not only to further French interests, lay as well as ecclesiastical, but also to make Persia and her people better known in Europe. His work, entitled *L'Estat de la Perse en 1660*, was of great value to Louis XIV's capable minister Colbert when he was seeking information on Persia before establishing the French Compagnie des Indes in 1664. There can be no doubt that the well-known French travellers Tavernier and de Thévenot, as well as Chardin (of whom more will be said below), were indebted to Père Raphaël for much of the data regarding Persia that are contained in their works. Moreover, when the French Orientalist Jean-François Pétis de La Croix (whom Colbert had sent to the East in 1670 to study Oriental languages and to collect manuscripts) reached Isfahan in 1674, Père Raphaël tended him during a serious illness and later helped him with his Persian studies. Pétis de La Croix's translations of various Oriental works, some of them Persian, aroused great interest in Europe in the early years of the eighteenth century, and led the West to realize that Persia had a culture and a literature of her own.

The greatest single contributor to Western knowledge of Persia in the seventeenth century was undoubtedly Sir John Chardin, a French Huguenot, who spent in the aggregate ten years in that country. He was a jeweller by profession and so had access to all the notables in the land, from the monarch downwards. Thanks partly to Père Raphaël, but more to his own acute observational powers, Chardin was able to amass a great store of information on practically all aspects of Persian life. Of particular interest is his description of Isfahan as it was in his time, when it was in its hey-day and one of the largest cities of

the world. The publication of Chardin's *Voyages* in several European languages did a great deal to spread knowledge of Persia in the West. Seen through his observant eyes, both the country and the people took on a far more concrete shape.

It is of interest to compare Chardin's opinion of the Persians with those of the earlier writers already quoted:[1]

Pour esprit, les Persans l'ont aussi beau et aussi excellent que le corps. Leur imagination est vive, prompte et facile. Leur mémoire est aisée et féconde. Ils ont beaucoup de dispositions aux sciences, aux arts libéraux et aux arts mécaniques. Ils en ont aussi beaucoup pour les armes. Ils aiment la gloire ou la vanité, qui en est la fausse image. Leur naturel est pliant et simple, leur esprit facile et intrigant. Leur pente est grande et naturelle à la volupté, au luxe, à la dépense, à la prodigalité, et c'est ce qui fait qu'ils n'entendent ni l'économie ni le commerce; en un mot, ils apportent au monde des talens naturels aussi bons qu'aucun autre peuple; mais il n'y en a guère qui pervertissent ces talens autant qu'ils le font.

Ils sont fort philosophes sur les biens et les maux de la vie, sur l'espérance et sur la crainte de l'avenir, peu entachés par l'avarice, ne désirant d'acquérir que pour dépenser. Ils aiment à jouir du présent, et ils ne se refusent rien qu'ils puissent se donner, n'ayant nulle inquiétude de l'avenir dont ils se reposent sur la Providence et sur leur destinée. Ils croient fortement qu'elle est certaine et inaltérable, et ils se conduisent là-dessus de bonne foi. Aussi, quand il leur arrive quelque disgrâce, ils n'en sont point accablés, comme la plupart des autres hommes. . . . Ils disent tranquillement: *mektoub est*: il étoit ordonné que cela arrivât.[2]

Chardin's contemporary, Dr. John Fryer, showed that the Persians had a very convivial side:[3]

It is incredible to see what Quantities (of wine) they drink at a Merry-meeting, and how unconcerned the next day they appear . . . they will quaff you thus a whole Week together. They are conversable Good Fellows, sparing no one the Bowl in their turn.

[1] *Voyages du Chevalier Chardin en Perse* (Paris, 1811), iii. 404–6.
[2] Intended for *maktūb ast*, '[it] is written'.
[3] *A New Account of the East Indies and Persia* (London, 1698), pp. 245, 246.

Fryer was at Gombrun in 1676, and described how the English sailors from the East India Company's vessels disported themselves ashore. The men had, however, a poor opinion of the climate there, as they 'stigmatised this Place for the excessive Heat, with the Sarcastical Saying, that there was but an Inch-Deal betwixt Gombroon and Hell'.[1]

Europe had no lack of competent observers of the course of events that, beginning with the accession of the pious but effete Shāh Sulṭān Ḥusain in 1694, culminated with the Afghan invasion and the fall of the Safavid monarchy in 1722. In Isfahan were the heads of the religious missions with their staffs, the representatives of the English and Dutch East India Companies, and, from time to time, the diplomatic envoys of various powers. In many of the principal towns were resident missionaries and, in certain of them, merchants and agents of the two East India Companies. In addition, there were a number of travellers, such as the Dutch writer and artist Cornelius le Bruin (in whose book are some excellent engravings of Isfahan and other cities that he visited), the Frenchmen de Tournefort and Lucas, and the Scotsman John Bell of Antermony. Through the medium of these eyewitnesses, people in the West could see how, with the reins of government in the hands of the incompetent but well-meaning Shah, the Safavid edifice of state progressively decayed and finally collapsed.

The missionaries wrote of the cancellation of the royal decrees on which their privileges depended; they also reported the renewal of religious persecution, the result of the growing influence of the fanatical element amongst the *mullas* and the machinations of the orthodox priesthood. The merchants, like the missionaries, complained of the withdrawal of privileges and the demanding of huge bribes by the corrupt court officials for their renewal; they also reported the adverse effect upon trade of the growing lack of security in the country.

[1] Ibid., p. 224.

The French view of Persia at this time was a broader one than that held by the English and Dutch, whose interests there were purely commercial. Louis XIV, who had for long assumed the role of protector of Christians in the East, was, in company with the Pope, seriously perturbed when reports reached Europe of the persecution of missionaries and the forcible closing of churches and missions. To put an end to these persecutions and at the same time to further French commercial and political interests, Louis XIV and his ministers decided to open negotiations with the government for a treaty that would contain the necessary provisions. In spite of an inauspicious start and formidable obstacles, this treaty, the first ever to be concluded between France and Persia, was signed at Isfahan in 1708. However, for reasons into which it is unnecessary to enter here, this treaty brought about only a temporary alleviation in the lot of the missionaries and did not result in any progress in the political or commercial sphere.

In 1714 Shāh Sulṭān Ḥusain sent an envoy named Muḥammad Riḍā Beg to France for the purpose of concluding an agreement with that power for joint action against the Muscat Arabs whose piracies in the Persian Gulf were having a disastrous effect on trade. The French Government astutely took advantage of the envoy's arrival to start negotiations for a further treaty with Persia on lines distinctly more advantageous than those of the instrument of 1708. The French ministers concerned had as their advisers the Abbé Gaudereau, a French Orientalist of some note, and a merchant of Marseilles named de Cansevilles. Both Gaudereau and de Cansevilles had spent some time in Persia and had come to know it well.

Although Muḥammad Riḍā Beg was not empowered to conclude such a treaty and was at first disinclined to begin the negotiations, he was at length induced to do so, and affixed his signature to the treaty in August 1715. No mention was made in it of the Muscat project, but it was verbally arranged that

a French naval officer was to be sent to Persia to see what steps could be taken. This new treaty, besides giving France all the commercial privileges that she wanted and safeguarding the religious missions, provided that the French ambassador who was to be sent to the Persian court should have precedence over the diplomatic representatives of all other nations. Moreover, there was to be French consular representation at Isfahan and elsewhere. The great pains taken by Louis XIV and his ministers to conclude these two treaties and the ceremonious reception which they accorded to Muḥammad Riḍā Beg in France showed that they attached very great importance to Persia.

Muḥammad Riḍā Beg, however, had exceeded his powers, and there was consequently much difficulty in securing the treaty's ratification. It was not, in fact, ratified until May 1722, by which time Isfahan was already being besieged by the Ghal-zai Afghans. In the following October the capital fell, the Shah abdicated, and the once glorious Safavid régime came to an ignoble end. The treaty of 1715 thus brought no lasting advantage to France.

Although ministers such as Pontchartrain could, by recourse to experts like Gaudereau and de Cansevilles, form a fairly just appreciation of Persia as it was then, the average Frenchman tended to look upon it to an exaggerated extent as a land of glamour and romance. It is not without interest to examine the reasons for this tendency. In the first place, the translations of Pétis de La Croix were in great vogue, and they invested Persia and other parts of the East with the atmosphere of the *Arabian Nights*. Secondly, the extraordinary adventures of Marie Petit in Persia had recently become widely known in France. She had accompanied a Frenchman named Fabre to Persia when he was sent there on a diplomatic mission in 1704. On Fabre's sudden death from fever at Erivan while *en route* to the Persian court, she assumed charge of the mission, and was subsequently displaced only with extreme difficulty by a new

envoy. She had nevertheless succeeded in being received by the Shah. On her return to France she was thrown into prison, where she languished for a long time. When her dossier was at length referred to Pontchartrain, he was so impressed with the diary she had kept in Persia that he not only ordered her release but also asked Le Sage, the author of *Gil Blas*, to put her diary into literary form. It is unfortunate that Le Sage did not see his way to comply.

The third reason for the holding of erroneous and exaggerated ideas regarding Persia was the visit of Muḥammad Riḍā Beg. His journey through France from Marseilles and his entry into Paris attracted a great deal of attention. The Parisian crowds were greatly interested in his exotic appearance, his strange mode of life, and his extraordinary behaviour on a number of occasions. His doings achieved wide publicity. Engravings of him were made and found a ready sale, and a picture was painted showing him being received in audience by Louis XIV (the last public audience that the aged monarch gave before his death). Muḥammad Riḍā Beg brought his mission to a romantic close by eloping with a French lady of some position.

The overthrow of the Safavid power by the Afghans and the simultaneous invasion and occupation of western and north-western Persia by Turkey and Russia respectively aroused a sensation in Europe. It appeared there that Persia had sunk so far that she would never be able to regain her position as a nation of importance. This view, however, proved mistaken. Persia, against expectation, recovered as she had done several times before; and only seven years later. Thanks to the genius and military skill of a hitherto unknown leader named Nādir Qulī Beg, the Afghans were routed and expelled; Ṭahmāsp, a son of the late Shāh Sulṭān Ḥusain (murdered by the Afghans), was placed on the throne; the Turks, after being heavily defeated, were forced to withdraw to their side of the frontier;

and Russia deemed it prudent to relinquish without fighting the territory she had occupied.

Nādir Qulī Beg's seizure of the throne in 1736 (when he took the title of Nādir Shāh) and his subsequent spectacular invasion of India greatly enhanced his fame in the West and led to him being called 'the second Alexander'. We have the testimony of a number of well-qualified European observers regarding Nādir's remarkable gifts as well as his defects. William Cockell, the Resident of the English East India Company at Isfahan, speaking from close personal knowledge, said that it was

. . . scarce credible how quick he is in discerning the Odds on either Side, and how active in succouring his Troops. If any of his General Officers give Ground without being greatly over-powered, he rides up and kills him with a Battle-ax (which he always carries in his Hand) and then gives the Command to the next in Rank.[1]

The Jesuit Père Bazin, who was Nādir's physician for some years, said of his qualities as a ruler:[2]

Malgré la bassesse de son extraction, il sembloit né pour le trône. La nature lui avoit donné toutes les grandes qualités qui font les héros, et une partie même de celles qui font les grands Rois. On aura peine à trouver dans l'Histoire un Prince d'un génie plus vaste, d'un esprit plus pénétrant, d'un courage plus intrépide. Ses projets étoient grands, les moyens bien choisis, et l'exécution préparée avant même que l'entreprise éclatât.

That was one side of the picture. Other observers, however, could not fail to note how Nādir, with his zest for war, eventually brought his country to ruin by his terrible drain on its resources.

A curious feature of this period was the belief by some Europeans that certain prominent figures in the Persian scene were of Western origin. There were many who believed that Nādir

[1] Quoted from James Fraser's *Nadir Shah*, pp. 233–4.
[2] *Lettres édifiantes et curieuses* (Paris, 1780), iv. 316.

was a native of Brabant and that he had gone to Persia at an early age. In consequence of the fact that Nādir was known for a time by the title of Ṭahmāsp Qulī Khān, corrupted by European merchants and others into Thamas Kouli, others imagined that he was really an Irishman named Thomas O'Kelly. In one case, at any rate, this false attribution of European origin was quite deliberate. The Abbé Talment, in his spurious memoirs of Ṭahmāsp II (a book which he saw fit to publish anonymously), purported to show that the Shah was really the son of a Frenchman named Jolyot who had taken service under Shāh Sulṭān Ḥusain.

We may conclude this survey by noting how Persia, after being no more than a mere name in the West, became in the second half of the Islamic period progressively better known as contact became closer and more frequent. As has already been seen, the conceptions of Persia formed by Europeans differed widely, some regarding her merely as a country to trade with, others as a land to evangelize, while others again looked upon her as an ally against the Turks. As time went on, it came to be realized in Europe that Persia meant something more than all this, that she had a real culture and literature of her own, her people having a fine taste for poetry and a keen zest for mysticism and for philosophical speculation.

<div style="text-align: right">L. LOCKHART</div>

# CHAPTER 13

## 'THE ROYAME OF PERSE'

In the year 1835 two small volumes entitled *Persia* were added to 'Uncle Oliver's Travels' in the Library for the Young series published by Messrs. Charles Knight of Ludgate Street. They contained instructive dialogues by means of which a conscientious guardian told the orphaned Henry, Frank, and Jane what he thought they should know about a country that had a curiously obstinate habit of remaining in fairyland. His information was ruthlessly selective. Among the birds of Persia, he told his young listeners, peacocks were great favourites. Indeed, on either side of the famous throne of the King of Persia were square pillars on which peacocks were carved—peacocks studded with precious stones and each holding a large ruby in its beak. Thrones, however, and their ornaments, were so many glittering obstacles in the path of instruction; and Uncle Oliver moved on to the next species of bird: 'Hawks also——.' He was interrupted. 'Do,' cried his youngest listener, 'do, dear Uncle, tell us something more about the king and his throne.' 'Not now,' was the firm reply. 'Remember we are now talking about birds,' and the child sighed, wriggled, and resigned herself. But how persistent these children were. A few days later it was Henry's turn to be snubbed. 'Pliny,' said Uncle Oliver, speaking of the pearl fisheries of Ormuz, 'Pliny and other old Roman writers [fancied] that the pearls were formed of dew, which the [oyster] comes up to the surface every morning and opens its shell to imbibe.' 'What a pretty idea!' said Henry. 'Yes,' admitted Uncle Oliver, 'but what we want and most admire in natural history is not pretty poetical fancies, but facts.'

Yet even a sternly repressive uncle had some knowledge to impart which must stir fancy, for he was describing a country in which fact and fancy had long been interwoven. In this

country legend had said, and experience had confirmed, that the king, clothed in garments blazing with pearls and precious stones, did indeed sit on a resplendent peacock throne delecting in the compliments of poets and orators. At times he found the compliments so ravishing that he rose and—a mark of highest favour—stuffed the poet's mouth with sweetmeats. His palace contained little furniture besides his throne, for in Persia kings and their meaner subjects alike were wont to sit cross-legged on the ground on carpets, carpets of a design and texture which held the eye entranced, carpets which—and in crept the fable— at times held magical properties and could rise into the sky, soaring over desert, mountain, and chasm, bearing sorcerers to work evil or restoring princesses to their lovers.

An enchanted Orient moved gradually into the Englishman's vision about the thirteenth century, when tales filtered back to Europe of a marvellous realm of Cathay to which the wandering Franciscan and Dominican friars were bringing Christianity. By the mid-fourteenth century Higden, drawing on Greek and Latin historians, had given Persia and the Persian Wars a place in his *Polychronicon*. At the same time 'Sir John Mandeville' (Southey's 'undaunted liar') was compiling a book of travels which became known first in French and Latin versions and which, at the end of the century, was printed in English by Wynkyn de Worde and Pynson. In it he pictured for the delectation of all escapists an Orient which was at one moment Cathay, at another Persia, a Persia which stretched beyond Arabia, beyond Abyssinia, and even to the 'londe of Inde'. Geography was inexact, and the early cosmographers put seas where no seas existed, set the Ark upon Ararat, and left the mandrake holding his tortured peace over the Nile Delta. The boundaries of Persia were to be nebulous for centuries to come, nebulous first because they were marked only by fable; later, perhaps, because the ordinary man found it difficult to grapple with the history of their changes.

The Persia inherited from Mandeville was an earthly para-
dise, the cradle of Biblical story, bounded by one of the four
rivers that came out of the Garden of Eden. It was a country
of luxury, light, and colour, of gardens sunlit and scented, mur-
murous with bird song and the sound of running water. Wise
men and soothsayers, astrologers and magnificent barons peopled
its goodly cities, together with old men of fantastic and often
murderous proclivities. Its rulers lived in gold-domed palaces
of which the chambers were lighted with carbuncles and scented
with balm. They were clad in cloth of gold sewn with 'grete
perles oryent' and diamonds 'norysscht with the dew of heuene'
Caxton's *Mirrour of the World* added a pleasing shudder. In the
'Royame of Perse . . . a science called Nygromancie was first
founden, whiche science constrayneth the enemye, the fende,
to be taken and holde prisonner'. It added, too, a scrap of
information which heralded the day when magic itself would
fade and shrink before political fact. 'In this contree', wrote
Caxton, 'groweth a pese[1] whiche is so hoot that it skaldeth the
handes of them that holde it.' But the pipelines carrying the
scalding substance across the Iranian plateaux were hidden in a
future which not even the necromancers could read.

Trade, all the time, was adding firmer detail to the vision
conjured up by religion and chronicle. The 'Royame of Perse'
contained cities with names like music—Sultania, Trapezunda,
Bokhara, Samarkand—to which spices and drugs ('notemeg' and
'much rhubarbe'), silk, velvets, carpets, shawls, gold and cloth
of gold, silver, and precious stones were brought from India,
Africa, and Cathay. By river, inland sea, and overland routes
the merchandise was taken from these centres to Aleppo and
there received by the Venetian galliasses which had brought
pilgrims to the Holy Land. Back the galliasses came to Europe,
and with them tales of the countries they had left. Perhaps

[1] i.e. pitch. Caxton, translating the *Mirrour of the World* from the French,
mistook 'la poiz' (pitch) for 'le pois' (pea).

they told of a thirteenth-century Venetian who had travelled in the Eastern parts of the world and had seen remarkable things and places. He had encountered sheep with tails heavy beyond all proportion, which had to be borne on trucks; had seen the trees of the Sun and the Moon on which the Phoenix rested, and small birds whose multi-coloured plumage streaked the air with brilliance. In the country through which he journeyed plains of unbounded fertility contrasted with cold, high, mountain passes or with deserts baking in the sun, waterless, and like a land accurst. In its harbours lay ships laden with spicery, gems, and other treasures. Its monarchs, fabulously rich, wielded sceptres carved from emeralds and bore the title 'Khan', which signified the Great Lord of Lords. And one of them, whose gorgeous summer palace the Venetian traveller had seen, was called Kubla Khan.

Ser Marco Polo's narration of his travels was edited at the end of the fifteenth century. In the year 1556 it was printed in French and in 1579 it was translated into English. By the mid-sixteenth century, too, scholars to whom the fall of Byzantium and the invention of printing were bringing Greek and Latin texts were reading Strabo, the geographer, or Plutarch's *Lives*, or the ancient history of Diodorus Siculus, with its liberal mixture of fact, hearsay, and conjecture. Or they may have studied the Persian Wars in the works of a Greek historian and traveller who, unlike Sir John Mandeville, had visited some at least of the countries he described. Did the scholars talk of Herodotus with the cosmographers and the merchant adventurers who were at that time planning voyages of discovery? What meat they could extract from their reading, and for how many mouths! Here, for the geographers, was a Persian Empire less nebulous than the 'Royame of Perse'. Here, for the merchant burning to fill his coffers, was talk and ever more talk of gold, silver, and gems, of gaily coloured tapestries, of monarchs who poured their molten revenues of gold-dust into earthenware

vessels, and when money was needed broke away the earthen-
ware and cut off what would serve their purpose. Here, too, for
the gentleman adventurer were tales upon tales to feed his
thirst for discovery. In this country were trees so beautiful that
a monarch had once ordered them to be adorned with gold. In
its gardens rose-bushes grew of themselves, bearing flowers of
surpassing fragrance. Its people were like their landscape in
character, full of contrasts. They were chivalrous, but roused
when angry to unexampled ferocity. They held lying to be the
foulest of sins. They loved sweetmeats and luxurious practices.
They were given to wine, and would deliberate when drunk
and decide when sober. When their kings rode to battle in
jewelled chariots, accompanied by their concubines, warriors,
chosen out of all Persians, preceded them on white horses; and
behind came the 'Immortals', whose spears were topped with
golden pomegranates. Imagination and the English trading
instinct were stirred to their depths. If it pleased God and the
Government the inhabitants of this land of glamour would
soon be clothed in good English broadcloth.

And so, in 1553, the newly formed Company of Merchant
Adventurers planned 'new and strange navigation', and three
ships set sail for search and discovery of the Northern Parts of
Asia. Two came to grief: the third discovered the north coast
of Russia; and the way to Moscow and thence to the Caspian
Sea was opened. A few years later Sir Anthony Jenkinson had
penetrated as far into Asia Minor as Bukhara and was back in
England, his mind teeming with projects for an overland trade
route through Russia to Persia. One after another, the Eliza-
bethan voyagers expanded trade and won prosperity and renown
for the Virgin Queen ('For which of the Kings of this land
before her Majesty . . . hath ever dealt with the Emperor of
Persia?'). One after another they enriched the language with
new, intoxicating, evocative words which rang with a golden
sound in the Renaissance ear; and they left narratives of their

voyages which were to beget, and sometimes were in themselves, the very magic of poetry.

By the close of the sixteenth century the Englishman had developed a sense of geography. The world was steadily being mapped, and the Orient as a concrete reality was detaching itself from the enfabled background of even a hundred years earlier. Yet where Persia was concerned circumstances for long combined to preserve enchantment. With India and, later, China, traffic was carried on by sea and became easier and more frequent. Acquaintance with the marvellous bred explanation, or acceptance, if never contempt. From India, too, the tales of correspondents and returning officials made for a sense of familiarity with life at the East India Company's trading stations, where an English atmosphere had somehow been created amidst un-English surroundings. But Persia, still a country of names, remained off the track, accessible only by caravans which wound slowly along a golden road.

Nor were even the most concrete descriptions such as would restrain fancy. In the narrations collected by Hakluyt and Purchas the reader could feed on facts which might be sobering but were never sober. Conjecture, he found, had paled beside truth, and the adventurers had encountered experiences as extravagant as the tales that made them adventure-thirsty. 'Who reads Sir John de Mandeuil', said the poet William Warner after reading Hakluyt,

> That wonders not? and wonder may
> If all be true he wrights.
> Yeat rather it beleave (for most,
> Now modernly approv'd).

The road to Samarkand was to remain obstinately golden. Men might freeze to death on the way, but the eye of imagination saw the bales of silken shawls and carpets that were lowered from the camels at the journey's end, not the stark corpse of

one who had been placed between them in a hopeless endeavour to preserve warmth.

It was from Persia that merchants returned to tell of audiences with kings who held court in rich pavilions 'wrought with silk and gold', set pleasantly upon hill-sides where the air was balmy and cooled with the water of fountains. Within, the ground before and beneath the king—Emperor, Shaugh, Sophy, he had many titles—was covered with carpets many-hued and glowing with the silver, gold, and precious stones from which they were woven. And could fancy, even Elizabethan fancy, unaided have imagined anything so costly as the king's garments, gem-encrusted and rutilant like the sun itself in splendour? His tolipant, or turban, tulip-shaped like the flowers springing from the hill-side, had 'a sharpe end, standing upward halfe a yard long, of rich cloth of golde, wrapped about with a piece of India silk at 20 yards long, wrought with golde, and on the left side a plume of fethers set in a trunke of golde richly inameled and set with precious stones'. The reader, dazzled, rose from his Hakluyt and went to the theatre, where ear and imagination were again intoxicated by the tale of Tamburlaine, the Scythian shepherd who had conquered the 'Royame of Perse'.

It does indeed seem that from the Middle Ages until well into the nineteenth century the word Persia fed the love of the luxurious, the extravagant, the romantic, which makes the Englishman in his secret heart an escapist. Samuel Purchas had this characteristic in mind in 1613 when he introduced his Pilgrimes: 'Far fetched and deare bought are the lettice sutable to our lips.' But escapism was not all. The Englishman who obeys an irresistible urge and goes far afield to seek for marvels has also a disconcerting tendency to greet what is un-English with anything from gentle satire to open ridicule. Samuel Pepys was to be struck by this in 1661 when watching a procession of Russian Ambassadors on their way to the King's Court in Whitehall: 'But Lord! to see the absurd nature of Englishmen

that cannot forbear laughing and jeering at every thing that looks strange.'

There was much that looked strange in Persia and the Persians, and the Englishman's conception of the country began to contain a comic element. He learned, for instance, that the Great Shah of Shahs, that dignified potentate, was wont to occupy himself 'two dayes in the weeke in his Bathstoue; and when he is disposed to goe thither, he taketh with him 5 or 6 of his concubines, *more or less*, and 1 day they consume in washing rubbing and bathing him and the other day in paring his nailes, and other matters'. At court, he noted, the Persians sat cross-legged upon their rich carpets, 'like so many inanimate statues, joyning their bums to the ground, their backs to the wall, and their eyes to a constant object'. But they were not always inanimate. At Shiraz 'the Duke himself (like a statue) at the end of the room sat cross-legged, not moving one jot till the Ambassador was almost at him, and then (as one affrighted) skipt up, imbraced and bad him welcome'. In India Sir Thomas Roe, a shabbily dressed figure amid the splendours of the Great Mogul's court, stood gravely at the King's Durbar and observed the behaviour of the Persian Ambassador. 'He appeared rather a Jester or Jugler, then a person of any gravity, running up & downe & acting all his words like a Mimicke Player . . ., ever calling his Majesty King and Commander of the World (forgetting his owne Master had a share in it). . . . When all was delivered . . . hee prostrated himself on the ground, & knocked with his head, as if hee would enter in.'

Then in London there was the great clash between Sir Robert Sherley and his Persian rival, which may have caused some on-lookers to revise their notions of the dignity of Khans and Begler Begs. Sir Robert Sherley, an English adventurer, one of three famous brothers, fell so much under the spell of Persia when once he reached it that he remained in the service of the Great Shah, married a Persian wife, dressed continually in Per-

sian garb, and eventually acted as Envoy for his Oriental Master on missions to the King's Court in London. For trade leads to politics: English merchants had found a Persia at war with Turkey; and would an alliance not be of benefit, to Persia in her fight against her old enemy, to England in opening up wider markets? Sir Robert Sherley, bringing his Persian wife and wearing his turban, journeyed from Persia to Moscow and from Moscow to London to treat of this matter. A strange thing happened. He was long on the way, and on arrival in London he found his title as the Shah's envoy disputed by another Persian nobleman who had suddenly appeared on the scene. When the Englishman presented his letters to his Persian rival the new-comer, who had been 'sitting in a chair on his legs double under him after the Persian Posture, and affording no motion of respect to [anyone] . . ., suddenly rising out of his chaire, stept to Sir Robert Sherley, snatcht his Letters from him, toare them, and gave him a blow on the face with his Fist'. Small wonder, after such a pantomime, that both ambassadors were shippéd back to Persia (in separate vessels) at the earliest opportunity.

Sir Robert Sherley made the return voyage in an East Indiaman, the *Rose*, which set sail for the Persian Gulf on Good Friday of 1626. Among her other passengers were Sir Dodmore Cotton, Ambassador from the King of England, Charles I, to the Great Shah, and, in the ambassadorial suite, a young man of twenty, Sir Thomas Herbert, one of the most lively writers who ever put Persia on an English bookshelf.

Arrived at Gombrun in the Persian Gulf the party disembarked and began their 'Land Trauuaile into Persia, furnisht with Twenty nine Cammels and tweluve Horse'. With the Ambassador and his suite young Herbert found himself, among other adventures, entertained in splendour at Shiraz, a city 'defended by Nature, enriched by Trade, and by Art made lovely'. He feasted his eyes upon the walls of the Sulṭán Shock

Ally-Beg's house, embossed with gold and wrought into imagery, and from the lofty surrounding hills looked down upon mosques and hummums with cerulean tiles and gilded vanes where storks nested. He saw a college where Philosophy, Astrology, Physics, Chemistry, 'and the Mathematicks' were studied. He learned that the Persians were above all lulled by Poetry, 'that Genius seeming properly to delight itself among them'. He had some experiences that caused him to note that the Persians were in truth liberal wine-bibbers and lovers of magic, and to fear that under the hot sun Pleasure was thought to be a delightful conqueror of Virtue. Then Shiraz was left behind and the party reached the black acres of broken pillars, the storied fragments of wall, the blocks of marble, that were still a glory and had once been Persepolis. From one corner of the gleaming ruins to another our traveller went, pacing every side of the presence-chambers to measure them, peering into the engravings, copying inscriptions which 'without the help of a Daniel could hardly be interpreted', commenting that the four carven monsters at the stairhead were 'such Beasts . . . as issue from the Poet's or Fictor's brains'. He studied the varieties of regal ornaments worn by former kings, and remarked that in ancient times the nobler sort of Persians had worn their hair very long, whereas the present custom was that the head was shaven save for one long lock on top by which the Believer would be hoisted up to Paradise. (And Meredith, two hundred years later, wove a fantasy around this 'Identical'.)

Persepolis stirred Sir Thomas to an impassioned plea for the preservation and investigation of so much ruined magnificence. The twenty-year-old traveller was transformed into a historian, antiquary, and archaeologist. His plea was to have momentous consequences, but did Sir Dodmore Cotton at the time have to remind the enthusiast that he was in Persia in the interests of English trade? The party, with Dick the interpreter and Dr. Goch the chaplain, proceeded 'over the most craggie steepe

and dogged Hils in Persia' towards Isfahan, and were welcomed
outside the city with a volley of acclamations and with Kettle-
drums, Fifes, Tabrets, Timbrels, dancing-Wenches, Hocus-
pocuses, and other antics. Persepolis was forgotten while for
three weeks Sir Thomas visited gardens, palaces, and hummums,
made a sketch of the Maidan and studied ancient burial customs.
Then came a stretch of four hundred miles, often across salt
desert, and with gnats, snakes, and the loathsome chirping of
frogs for company.

Finally, on a Sunday in May, at Ashraf, on the Caspian Sea,
Sir Thomas Herbert and his Master, with Sir Robert Sherley
and seven or eight other English gentlemen, were received in
audience at the Emperor's court. Sir Dodmore Cotton outlined
his mission to secure a trade agreement: Sir Thomas Herbert
used his eyes. He observed the luxury and magnificence of his
surroundings, the floors overlaid with carpets, large and rich
as befitted the Monarch of Persia, the 'Ganymed Boys in Vests
of cloth of gold, rich bespangled Turbants and embroidered
Sandals', with 'curled hair dangling about their shoulders' and
'rolling eyes and vermillion cheeks'. He noted, too, that in his
person the Monarch of Persia united the qualities of exquisite
courtesy and exquisite ferocity. The same individual who had
blinded his son out of jealousy was now toasting his English
guests and lifting up his turban 'the more to oblige' when the
English Ambassador acknowledged the honour by standing up
and uncovering his head.

And now the Caspian Sea was left behind. The party climbed
laboriously up Mount Taurus and still more laboriously down
to Qazvin. Progress for Sir Thomas, in the grip of dysentery,
was agonizing, but youth and a Yorkshire constitution were in
his favour. It was he, at Qazvin, who buried Sir Robert Sherley,
a weary old man, heartsick and fallen from a despot's graces. It
was he, a fortnight later, who buried 'that religious gentleman'
Sir Dodmore Cotton himself. The Ambassador, thought Sir

Thomas, had died of eating too much fruit. Self-restraint might indeed have been difficult when temptation took the form of pomegranates, peaches, 'apricocks', plums, apples, pears, cherries, and chestnuts.

'He may well call himself a miserable Man, whose welfare depends upon the smiles of Persia.' The skies of Paradise were clouded with gloom. Foreboding and dejection ruled while the deceased Ambassador's train, a lonely 'body without a head', waited till the High and Mighty Star, Great Abbas Emperour, or Potshaw of Persia, was pleased to let them leave his dominions. Eventually the Phirman for their safe travel was delivered, enveloped in cloth of gold and secured with a silken string, written in gold ('in their letters backward') upon red paper. The homeward journey began and the gloom lightened as Qum, Kashan, and Baghdad were reached. The last scarcely equalled Bristol either for bulk or beauty. It had passed from Persian, to Arabian, to Turkish rule in a bewildering series of vicissitudes which led Sir Thomas off on an excursion into ancient history and the impious splendours of Babylon. Ancient and Biblical history were again in his mind as he contemplated the ruins of Susa, but he turned from them to speculation on the actual whereabouts of Paradise.

Sickness put an end to speculation, and he travelled three hundred miles in misery, hanging upon the side of a camel in a cage resembling a cradle. This, too, he survived, though the treatment of a physician, one of those 'moral men, humane in language and garb, but swayed by avarice and magick studies', made it hard to judge whether his spirits or his gold declined faster. At long last he reached home, and his task now was to annotate the evidence of his eyes with information culled from ancient historians and geographers. In 1634, a not unimportant point in time, his *Relation of Some Yeares Travaile*, a handsome volume devoted largely to 'a Discription of the Persian monarchy', with numerous plates and diagrams, found a welcome in

the English gentleman's library. By the end of the century it had been re-edited, augmented, and translated into French and Dutch.

Once more, with Herbert, fancy, fact, and fable were woven together. The stories of Mandeville and a more credulous age were rebuked, yet not altogether discredited. (Were not the snakes of the desert, which wreathed and festooned the legs of the Ambassador's horse, themselves descended from a mythical dragon?) Tales justifying the magnificent curiosity of the adventurers were offered to a more solid age of colonial and mercantile expansion. And before an age of enlightenment could either demand or provide too much in the way of rationalization Persia was, it seems to us, more than half consecrated as the escapist's paradise.

It is for scholars, historians, and economists to trace the dawning and rapid development of Oriental scholarship after the mid-seventeenth century, the expansion of trade, the increasingly informed pursuit of geographical studies, or the movement of political clouds upon our enchanted horizon. Ours is no more than the gentle, far from erudite interest of remarking the persistency with which the escapist clung to the paradise he had appropriated, welcoming only what suited his fancy from all that exploration and scholarship had to offer him, and discarding the harder facts and the sharper outlines. He was not disturbed, but rather amused, by incongruity. 'The Sophy of Persia', remarked Howell, in 1655,

... calls himself The Star high and mighty, whose Head is cover'd with the Sun, whose motion is comparable to the ethereal Firmament, Lord of the Mountains Caucasus and Taurus, of the four Rivers Euphrates, Tygris, Araxis, and Indus; Bud of Honour, the Mirror of Virtue, Rose of Delight, and Nutmeg of Comfort. It is a huge descent, methinks, to begin with a Star and end in a Nutmeg.

For another couple of centuries the Persia of the Englishman's conception, no matter how he elaborated it, remained

fundamentally a secret place to which he could escape from the
drab and the familiar. It was a place of glowing suns and fires
and the worshippers thereof, of treasure lambent and sparkling,
to be had for the asking or the conjuring, of epic terrors,
ferocity and despotism, of flowers and fountains, of palaces and
gardens where kings disported themselves and beauty led a
veiled but not always unrevealed existence. Elaborations there
were, and from various quarters. There were, for instance, the
*Voyages en Turquie en Perse et aux Indes* (1676)[1] of Tavernier,
the French map-seller's son—the ancestry is appropriate—who
set out in 1632 to companion two young French gentlemen on
a visit to Asia Minor, abandoned them at Constantinople to
their own devices, and proceeded on his own account to Persia,
where he became a merchant in jewels. Still more, there were
the *Travels . . . into Persia and the East Indies* (1686),[1] of Jean
Chardin, a Huguenot jeweller—again the calling is appropriate
—who went to Persia and became a court merchant. In 1681
he came to London and figured at the court of Charles II, who
made him a knight and a minister.

With Chardin, Sophys and their subjects emerged again as
individuals from their gorgeous trappings. They were grave,
gentle, majestic beings, philosophers who lived for the day and
accepted fate when things went wrong. They were aesthetes,
indolent (a softer, more voluptuous word than *lazy*), and
pleasure-loving, who played caressingly at intervals with the
jewels carried in little sacks about their necks. They were polite,
their talk easy and full of compliments couched in the most
flowery language. (At times, it is true, these gentle, affable
beings took to bandying insults which were a mixture of scurri-
lity and praise of God.) And what luxury, extravagance, and
profligacy governed their habits, above all, what incredible sums

---

[1] Tavernier's *Voyages* were translated into English in 1678. The 1686
edition, 1 vol., was only the first part of Chardin's *Voyages*. The first complete
account was the Amsterdam edition of 1711, 4 vols.

they spent on their harems! Sir John Chardin had much to say about these palaces of mystery, so strictly secluded from the outside world, so carefully guarded by beardless and dismembered slaves, so ripe for furious dramas of passion and jealousy leading to bloody murder. But our escapist was no psychologist. He enjoyed the wittily licentious background of drama with which M. de Montesquieu enlivened the satire of his *Lettres Persanes*. He probably read some of the more licentious but less witty imitations to which the *Lettres Persanes* gave rise. But on the whole he versified:

> Oft, as I sigh amidst the beauteous throng
> For All by turn, but not for any long,

or said

A seraglio, a seraglio . . . wipes off every inconvenience in the world,

and left it at that.

Most of all, however, for nearly two hundred years after Sir Thomas Herbert's *Persian Monarchy* the common reader was able to embroider his conception of Persia from what the scholars offered him. We say 'embroider' purposely, for we must emphasize that he did no more than add charming or curious details to the essential fabric woven between the twelfth and the sixteenth centuries. The scholars, fired by the travellers' tales, had themselves become explorers, among manuscripts, inscriptions, and monuments. They returned from their explorations with universal encyclopedias of Oriental knowledge and peoples, and with histories of ancient dynasties and beliefs. Oriental scholarship was founded, and in Cambridge and Oxford, in Paris, and before long in Calcutta, windows were opening on civilizations which had preceded the Greeks and Romans by centuries. The need was for more scholars, to translate texts and decipher inscriptions; and translations, grammars, and collections of Persian and Arabian tales for the improvement of young students were published as quickly as they could be compiled.

What happened? Scholarship, certainly, profited; but a minor outcome was that the works so issued were a treasure-trove for authors in search of subject-matter, and through them for the general reader, who now had scholarly justification if the Orient of his conception became more romantic, more extravagant than ever.

The translations were miscellaneous. There were rules for procedure at the courts of the Great Shahs, as jewelled and colourful in their writing as the pomp and magnificence of the ceremonies they regulated. Or there were examples of letters and petitions, with superscriptions written in an elaborately descending scale of floweriness. There were accounts of the philosophers, with specimens of their sayings. But for the most part it was the fables, allegories, and pleasingly instructive narrations, and the translations of the epic and lyric poets whose names were now becoming familiar, which fed the fancy. All combined to set the eighteenth century revelling in a land 'awfully magnificent', where sacred flames curled round towers built with the heads of decapitated rebels, where ravishing Circassian slaves stirred some monarchs to passionate frenzy while other monarchs, less susceptible, were content with days passed in rose-scented gardens. There, on gem-studded thrones or sofas, they reclined, tasting idly from time to time of the exotically coloured pilaffs and sweetmeats which surrounded them and calling for more music, more Shiraz wine, and more, still more, tales.

Tales, in this land, were the recreation of kings, barbers, and cooks, the manner by which favourites restored themselves to grace or philosopher-poets undertook the education of young princes, walking in the evening on aromatic hill-sides. Often the prose of the tales gave way to poetry; and always the language was of a warm and animated nature such as contrasted with the coldness and indifference in European languages and was well suited to convey thoughts with ardour and intensity. Or so thought Addison and many other writers; and Oriental imagery

abounded, and tales in the Oriental manner in which all was often, as an Eastern tale by English standards should be, 'sonorous, lofty musical and unmeaning'. Ferocity and barbarity again, but also dignity and epic chivalry, and above all wine, passion, love, and lovers came into the picture with the poets whom the scholars translated or the writers adapted. For a time, indeed, the common reader tended to grow drunk with Shiraz wine, and the gardens of his paradise knew only roses and nightingales and were strewn with the corpses of chaste and impassioned lovers. Or they would have been if they had not already been peopled with beings from other sources.

The first of these was that vast and fascinating compendium, the *Bibliothèque Orientale* (1697) of the French scholar d'Herbelot. It had only to be opened for a host of supernatural beings to spring from its pages. Some, the peris, gentle and benevolent, came wafted on air scented with the perfume on which they fed. Others, the genii, workers of magic and destruction, appeared and disappeared at the twist of a ring. Others, the dives, as hideous as they were malignant, were creatures of, but not confined to, hell and roamed the world 'scattering discord and wretchedness among the sons of Adam'. They were connected, the historians said, with the mythological origin of the Persian dynasties. That was as might be; and the dynasties were a complicated succession of resounding names. Under d'Herbélot's guidance these Miltonic beings could be followed to their visionary land of Ginnistan, a land poised on an emerald and rotating with a slow motion that shook the air with earthquakes and volcanoes.

D'Herbelot's *Bibliothèque Orientale* was a reference book, if anything so romantic can be given such a prosaic name. From the early years of the eighteenth century the escapist found his paradise almost ready-made in the second source of which we have spoken, those tales by which Scheherazade kept her husband's curiosity aroused and her own head firmly upon her

shoulders. Here the peris, genii, and magicians of d'Herbélot were seen at work with rings, lamps, carpets, and enchanted horses to conjure glittering palaces out of waste land, send honest wood-cutters home with their pack-saddles laden with gold, and make distance a thing of naught for love-sick Princes of Persia. The tales were called 'Arabian'. They ranged from Baghdad to Balsora, from Abyssinia to the confines of China. But from the very beginning their locus was fixed in a Persian empire which 'spread over the continents and islands of India . . . and almost to China', and which was of so vast an extent that its monarchs had it in their power to bestow the Kingdom of Great Tartary as their fancy pleased.

The *Arabian Nights' Entertainments* became household reading during the eighteenth century, at a time when reading and the possession of books were ceasing to be a gentleman's privilege. In 1810 we even find Southey recognizing them as a source of information. Everyone, he considered, who had read the *Arabian Nights' Entertainments* possessed all the knowledge of the Muhammadan religion necessary for readily understanding and entering into the intent and spirit of his long 'Indian' poem, *The Curse of Kehama.*

Arabian Nights, Persian Tales, Eastern Tales—in a century which made little distinction between Arabians and Persians, Turks and Tartars, the names varied. But the world in which the tales were situated still hovered, luminous and enchanted, behind clouds that were gilded with 'Persia's utmost pomp'. So much so that in the *British Critic* of 1797 a reviewer doubted whether, amidst 'such a mass of absurdity', 'fictions so romantic and characters so monstrous', the 'vestiges of genuine historic truth' could ever be successfully explored.

The trouble was that so far as the Persia of history, art, and archaeology was concerned the reading public was being asked to assimilate too much and too quickly. The purely visual imagination could play happily with the occasional vestiges of

historic truth dressed up by the poets. It could wander in the legendary country of the early chroniclers (and these in the eighteenth century were being re-edited), or through the rose gardens and coruscating palaces of the Oriental tales. It could see and people the landscapes described in the rapidly multiplying accounts of exploration and travel, which appeared especially in the second half of the eighteenth century. Translations, chronicles, *bibliothèques orientales*, and explorers' narratives could stir the creative imagination too, when the gods so willed, and send it beyond sleep and dreams, beyond memory and associative memory, into the 'shoreless chaos of the fancy'. It seems to us, though, that what our reviewer of 1797 was in fact deploring was the lack of *re*-creative imagination in the reading public. But did he expect the great mass of a newly literate public to seize the implications of 'vestiges of historic truth', to reconstruct for themselves, from the bare bones of descriptions or scale drawings of tombs, the amazing history of an empire which had its birth in the shadowy margins of time? Even the scholars had not yet solved the riddle of the cuneiform inscriptions; and education in becoming more universal was also becoming less classical.

Towards the end of the eighteenth century, however, we can notice a change in the popular conception of Persia. It is barely perceptible, and still more difficult to define. Something of the early, naïvely Biblical quality with which medieval piety had imbued the 'Royame of Perse' had disappeared. A more sensuous picture had taken its place, and at the same time the hints of the comic which had at all times so disconcertingly insinuated themselves into scenes of pomp and splendour were magnified into recognizably burlesque elements. In the Persia of the escapist's fancy, as time passed, the jewels sometimes shone with a tinsel glory, the music that could turn men from their chosen paths sometimes fell brassily on the ear, and magic carpets were to bring Princes of Persia to earth in the transformation scene of a pantomime.

What influences were at work to bring about such a change?
One, of course, was the Eastern tales so much deplored by the
*British Critic*. Another was the emergence of Persia as that
unpleasant twentieth-century product, a political entity.

The tales were many; and besides translations and adaptations
there were times when creative genius poured chronicles, Orien-
tal lore, original texts themselves into a crucible, and with an
alembic known only to itself distilled fresh enchantment. Such,
for instance, was Coleridge's *Kubla Khan*—a vision captured
for one immortal moment before it sank again into the deep
romantic chasm from which it had sprung. Or such, in 1786,
was Beckford's tale of *Vathek*. His proud Caliph's Palace of the
Five Senses was an Arabian Nights edifice. The Mountain of
the Four Fountains to which, when fever wasted him, Vathek
was brought to breathe a purer air, was surely the Paradise
Mountain of medieval chronicle, the place of ineffable beauty,
'delectable in balminess and brightness of atmosphere'. But
Beckford, fresh from the study of Persian and Arabic manu-
scripts, brought to his descriptive writing the sensuousness of
the Oriental poets. His studies, again, gave him his despots and
slaves, his dives and sorcerers, his lovers and musicians. But the
tale they people rises straight from his own conception, mingling
fable and fantasy and asking no aid from fact. Now it floats
along, gay and iridescent, like a soap-bubble—and because Beck-
ford wrote first in the language of Voltaire he all but destroys
his soap-bubble from time to time with the most delicate and
impudent of pricks. But as the tale advances, from the moment
the expedition sets out for the Palace of Subterranean Fire,
there is a hint of more sombre happenings. The clarions and
trumpets which prelude departure are intermingled with the
'sullen hum of those nocturnal insects which presage evil'. The
glittering palanquins, climbing painfully towards the moon,
form a strange vegetation on half-calcined rocks and are over-
taken by darkness and disastrous tempest. The tension increases

when Vathek and the daughter of Fakreddin, whose future is now allied with his, leave behind them the pleasures of Rocnabad. For one moment only they waver, stirred to remorse by the pathetic melodies pouring from a shepherd's flute, but ambition still drives them on. At last with beating hearts they descend from their litter at the staircase which leads to the pillar-strewn platform of Persepolis. Overhead, the birds of night fly away croaking: the blood is chilled, for all the deathlike stillness that reigns, with a wind that seems to whistle over dry bones.

And if the opening passages of the tale have recalled the *Arabian Nights*, the closing scenes assume a Miltonic grandeur. The doomed pair, having descended to the Subterranean Palace, find themselves in the presence of Eblis himself, the majestic ruler of the apostate angels, whose mild voice renders only more terrible the impression of melancholy, pride, and despair by which he is, and must be, eternally, racked. Their fatal curiosity gratified, they wander on, abject and apathetic, and ultimately join the company of those whose hearts are consumed with unrelenting fire and who have lost the most precious gift of heaven—Hope.

We have travelled with Vathek too far from the Palace of the Five Senses. Our escapist's paradise at the end of the eighteenth century was sensuous, scented, and melodious. If any other element knocked at the gate for admittance it might be the 'awfully magnificent' or even, as we have said, the burlesque. It was never the sublime.

In 1801 there was little of the sensuous or the awfully magnificent in Southey's *Thalaba the Destroyer* and, for all that the tale was in verse, absolutely nothing of the melodious. The subject was promising: the seminary for evil magicians, called Domdaniel and situated under the roots of the sea, which is mentioned in the continuation of the *Arabian Nights' Entertainments*. But what Southey made of this was a tale with a moral

purpose. It was, too, so diligently enframed in notes and quotations designed to explain the Oriental setting that it demanded an acrobatic eye from the reader; who even then could never be certain whether he had before him a narrative or an encyclopedia.

Perhaps the truth of Southey's failure is that having chosen to write an Oriental tale he brought disapproval to the task. On the 'azure tabletures' of his stately palace he comments:

Ornament and labour characterise all the works of the Orientalists. I have seen illuminated Persian manuscripts that must each have been the toil of many years, every page painted, not with representations of life and manners, but usually like the curves and lines of a turkey carpet, conveying no idea whatever, as absurd to the eye as nonsense-verses to the ear. The little of their literature that has reached us is equally worthless.

And again, when the maiden who is to save Thalaba's life at the cost of her own says of her father

He read the stars,
And saw a danger in my destiny,

a footnote puts such folly in its place:

It is well known how much the Orientalists are addicted to this pretended science.

Alas for Kubla Khan's splendid feasts, when wise men, soothsayers, and astrologers sat at table, and all with astrolabes before them. Alas for Tamburlaine, who 'seldom marched till the astrologers fixed the lucky hour'.

If Southey would have little truck with glamour the case was altered in 1817, when Moore's *Lalla Rookh* appeared. Moore, just as conscientiously as his predecessor, and spurred by a publisher's offer of £3,000, equipped himself for his task by ransacking the libraries of Oriental lore, but this time all was 'in motion; rings and plumes and pearls' were 'shining everywhere'. If the public wanted an Oriental tale they should have

it. Veils of silver tissue hid the dazzling countenances or the ravaged hideousness of impostor-prophets, not to speak of the warm blushes of youthful maidens. Eyes of full and fawn-like ray sparkled bewitchingly through the gossamer network of the harem, or with their long, dark languish ravished the hearts of young poets. Houris danced in the moonlight, their white forms weaving a flashing way through the entwining roses, while genii and peris went about their deadly or beneficent tasks. Gheber chieftains scaled inaccessible towers for love of Muslim maids, but doom was ever upon their heels and they perished at last in the sublime element of their worship. And always the nightingales sang and the fountains played. Always the air was heavy with the odours of jasmine and musk and roses, the pomegranates were melting with sweetness; and the whole was so melodious, so clingingly scented, so dripping with glamour that the enraptured public fastened on it delightedly and having fastened—could take no more. The escapist was cloyed with the sweetness of his paradise: and so we come back to the burlesque.

The burlesque element which, in the eighteenth century, becomes perceptible in the popular conception of the Orient had its origin in France as, indeed, had the vogue for things Oriental. In England it developed largely through harlequinades and pantomimes, with plots taken time and again from the *Arabian Nights*. Now it is impossible to read the *Arabian Nights* without being struck by the homely realism with which their glamour and magic are at all times interspersed. Sindbad the Sailor was careful to have the porter's barrow brought into safety from the street before he embarked on the tale of his surprising voyages. Pastrycooks left off making cheesecakes to sleep with Queens of Beauty. The frugal background of Aladdin's early life with his mother, that anxious, toiling widow, rises as vividly from the pages as the resplendent palace to which he took the Sultan of China's daughter. Ali Baba would have fallen a victim to the avenging robbers if he had not ordered

broth to take with him on a journey, and if the lamp had not gone out while the cook was making the broth. Here was a harvest for an inspired clown. It was reaped, by Grimaldi first, in the early years of the nineteenth century. In 1813, by which time the pantomime had become one of the regular amusements of the populace, *Aladdin; or the wonderful lamp*, at Covent Garden, presented a new kind of Orient in which necromancers and clowns held the stage by turns, while palaces floated cumbrously overhead and from time to time jewelled fruits became detached from the Paradise trees and clattered tinnily to the ground.

Nor must we forget that during the latter half of the eighteenth century Europe in general and Britain in particular had begun to turn a noticing eye towards happenings in Persia. These were not so very different at first from the happenings in the Oriental tales. For when Sophies warred with Turkish Sultans, or turned in the intervals of a dubious tranquillity to punish their own subjects, the Oriental despot stalked in all his familiar ferocity across the Foreign Intelligence columns of monthly reviews. In English country homes, over the log fire and the tapestry frame, the ladies indulged an appetite for horrors, while the head of the family mastered his own disgust and the atrocious print of the *Gentleman's Magazine* sufficiently to read aloud. He read to them of the rebellious governor of Shiraz, whose wives were dishonoured, whose sons and fifty of his party were beheaded, before his very eyes; after which he himself was blinded in one eye and taken to the Shah at Kars, a piece of his flesh being cut out at every town he passed. A singular country, where despots ruled with uncontrolled savagery over a people who—as might also be read in the *Gentleman's Magazine*—

from highest to lowest all esteem and chuse to wear woollen cloaths, and that so much that they wear stockings of no sort but what are made of woollen cloth.

Once again, in the mid-eighteenth century, imagination and trading instinct were going hand in hand. Merchants were agog to capture the monopoly of the silk trade with northern Persia and to clothe the Persians in English broadcloth sent to them across Russia and the Caspian Sea. Unfortunately the Russians viewed the idea less favourably. Became, indeed, openly hostile. The project was abandoned and British merchants had to be content with such trade as could be carried on through the Persian Gulf in competition with other Powers. Still, trade did increase; and so did Persia's potential importance as a pawn in the great game of politics. One after another Russia, France, and Britain looked towards her with eyes lit alternately by ambition and apprehension; and one after another helped her obligingly to reorganize her army. By the year 1809 more than one treaty had been negotiated, a British Legation had been established at Teheran, and a Military Mission was soon to be in Persia training artillerymen to handle their guns and persuading them to abolish their beards.

More interesting from our point of view, as we gaze after a receding paradise, is the fact that the early nineteenth century also found a Persian Ambassador in England, the first, if we are not mistaken, since Sir Robert Sherley and his rival had visited the court of Charles I. In November 1809 Mirza Abuhassan, the 'Father of Beauty', arrived in London to negotiate a treaty with George III and the East India Company. He was lodged in one of the grey, dignified houses in Mansfield Street, where he and his retinue, on their comings and goings, must have introduced an unwonted note of colour. With him, for the Queen, he brought drugs, shawls, and carpets, 'whatsoever was most curious and costly in his own country', and to the Prince of Wales, who entertained him superbly, he presented 'half a pound of most unique and exquisite tobacco'. He enjoyed himself, and was allowed on all hands to be a most accomplished gentleman. He was taken the round of the sights, went into

society, talked loud and incessantly, and replied gallantly to the
ladies' many questions. His recreations created some stir. For
instance, when riding in the Park he delighted in sending one
of his attendants to ride a little way ahead while he himself
curvetted in the rear, from time to time throwing a *Gereedo*,
a sort of javelin, which if all went well would dislodge the
attendant's cap, but might pierce his head, and did on one
occasion lay the 'lazy awkward dog's' cheek completely open.
But such amusements were tolerated with every sympathy until
the day when one of his suite offended him and was ordered to
lose his head. That, he was told, could not be allowed. He does
not seem to have taken the restraint amiss, if we are to accept
as authentic his impression of the English people published in
the *Morning Post* before his departure the following summer.
His letter, written in English (which he had learnt during his
stay), shows deep appreciation, and a charming disregard of
prepositions, conjunctions, and verbs:

> English King best man in world. He love his people very good much.
> This very good country. English ladies very handsome, very beautiful.

He returned to his own country with several packing-cases full
of looking-glasses, bought in the Strand; and with at least one
unsolved problem. Why should English gentlemen, English
lords, who drove their own coaches for pleasure, persist in
sitting outside on the box and driving even when it rained?
'I say why he not go inside?'

What with Persian ambassadors in the audience at the Opera
and clowns popping out of Oriental necromantick boxes at the
pantomime the escapist was having to travel an ever-increasing
distance to reach his paradise. He found it again, as we have
seen, with all its luscious, sensuous accompaniments, in *Lalla
Rookh*. But even as he walked in its perfumed groves he had,
frolicking beside him, a serpent whose cheerful whisperings
were to strip his Orient of glamour and leave him with a

country where rascally barbers' sons lied and cheated their way through life, skipping frivolously from one calling to another, dervish today, executioner tomorrow, quack physician the day after, often cowardly, always nimble with trick and argument to profit by the ups and downs of fortune, and always irresistibly entertaining. The serpent was Morier's *Hajjî Baba*,[1] the book which, well into the nineteenth century, took the place of Mandeville, d'Herbélot, and the *Arabian Nights' Entertainments* in moulding the popular conception of Persia.

Perhaps it was inevitable that Morier's hero should pursue his inglorious career across a background which reduced marvels and legends to explicable social customs and characteristics. An age of assimilation was beginning, and the delights of fable were yielding to a passion for facts. Even children were being steered carefully past the reefs of pretty poetical fancy as the Victorians turned to the pleasures of instruction. Where Persia was concerned these were many, and exciting, for Oriental studies were making a dramatic progress. The rock-tombs of Persepolis were soon to give up their secrets. 'Darius, the King, son of Hystaspes' and 'Xerxes, the King, son of Darius' were to be seen taking their places in the pattern of history together with the Feridoun of Firdusi and the monarchs dallying amidst the roses in the manuscripts scorned by Southey. Already, too, tiles, pottery, and fragments of sculpture were arriving in quantities from the sites where excavations were being conducted. They were on view in museums, or reproduced in journals; and they served, with the enlightened comment which accompanied them, to familiarize the public with an art and a civilization brought daily closer in a shrinking world. The nebulous country was at last coming out of the clouds, and between the living manners of the East, as Morier had noted, and the descriptions in sacred

---

[1] *The Adventures of Hajjî Baba of Ispahan.* By James Morier. 1824 and many subsequent editions. Morier was at one time Secretary to the British Legation at Teheran.

and profane writers, could be found a coincidence which tended
to elucidate ancient history and the Scriptures themselves.

So we find soldiers, diplomats, politicians, archaeologists,
missionaries visiting Persia and returning to write carefully
documented accounts of flora and fauna, of religious practices
and the daily operations of domestic life; of the systems of
taxation and education, or the method of tying horses by the
leg in the stable. At times they played with fiction and we get
by-products of a type which can all be classed under the title
*Tales of the Caravanserai*,[1] narratives which were or might have
been based on actual happenings and which offered an edifying
but prosaic mixture of information and adventure.

There were occasional exceptions. In 1855 a Meredith, with
little but the 'sweetmeat childish oriental world' of his (like
FitzGerald's) boyhood reading to inspire him, produced an
Arabian Tale, a *jeu d'esprit* compounded of all the familiar
ingredients plus a lyrical freshness and delicacy of its own. But
life, in 1855, was real, and earnest. Caliphs, genii, lovers, and
the whole paraphernalia of romantic orientalism were at a low
ebb, and if the truth is to be told the continual involutions of
the plot by now had a sameness which palled. *The Shaving of
Shagpat* was remaindered. A few years later the same fate over-
took FitzGerald's English rendering of the *Rubáiyát of Omar
Khayyám*. In this case, with the passage of time, fortune's
wheel was dramatically reversed. A day came when the Orient
conjured up by Mandeville, d'Herbélot, the *Arabian Nights*
and *Hajjî Baba* faded, the glories of Persepolis and Susa were
temporarily eclipsed. Even Persia as the political problem which
held the attention of the later nineteenth century was neglected
as edition after edition of the Quatrains brought the slightly
bibulous musings of the Persian astronomer-poet to the pink,
azure, and violet pages of autograph albums. This vogue, too,
passed; though it left behind it, unfairly, a bogus Orient in

[1] The book with this title, by James Baillie Fraser, was published in 1833.

which for several years the nightingales worked overtime and pale hands vanished with spring and the roses into the recesses of Edwardian drawing-rooms.

Nowadays the country about which so many fancies were woven has gone very far away—or has it come too near? Much of the glamour bestowed on it by fable has vanished, or become worn in the handling. Its golden domes are besmirched at times with a viscous film, a 'hoot pese'. Yet there are moments when the twentieth century stands still, perhaps in Oxford, where Oriental studies flourished early, on a soil fertilized by marvels and legends. Overhead, among the dark, glistening buds of the chestnut, the blackbird's song falls with a suddenly more liquid note upon the evening sky. At our feet the paving-stones leap into colour as the gayest, most magical of carpets is unrolled. We sit down, quite naturally, with our legs crossed, after the Persian Posture; return the gravely courteous salutes of the beplumed and turbaned prince on our right, the rather paunchy poet on our left; note that our astrologer is of the company to ensure that fortune and the stars go with us; are in no wise perturbed by the presence of a lean and hungry magician. Then the journey begins. Into the air we rise, over Bodley's library, and on we soar. Over London, where strange new navigation was planned; over the lagoons and islands of Venice, where no more galliasses come; farther eastward, towards the confines of the Oxus; on and up, till we find the Royame of Perse, 'sphear'd in a radiant cloud'.

And the Drum of Prosperity and the Kettledrum of Mirth, the dancing-Wenches and the Hocus-pocuses, have all come to meet us.

J. E. HESELTINE

# SELECT BIBLIOGRAPHY

Most of the books listed below contain more or less extensive special bibliographies, to which the reader is referred for further information.

ARBERRY, A. J. *Sufism*. London, 1950.

BINYON, L. (with B. GRAY and J. V. S. WILKINSON). *Persian Miniature Painting*. Oxford, 1933.

BROWN, P. *Indian Architecture (The Islamic Period)*. Bombay, 1943.

BROWNE, E. G. *A Literary History of Persia*. 4 vols. 2nd ed. Cambridge, 1928.

—— *Arabian Medicine*. Cambridge, 1921.

CHRISTENSEN, A. *L'Iran sous les Sassanides*. 2nd ed. Copenhagen, 1944.

CORBIN, H. (and others). *Les Arts de l'Iran*. Paris, 1938.

ELGOOD, C. *History of Persian Medicine*. New York, 1935.

FRANKFORT, H. (and others). *Intellectual Adventure of Ancient Man*. Chicago, 1946.

GIBB, H. A. R. *Mohammedanism*. Oxford, 1949.

GLOVER, T. R. *From Pericles to Philip*. London, 1919.

HAAS, W. S. *Iran*. New York, 1946.

HERZFELD, E. *Archaeological History of Iran*. London, 1935.

—— *Iran in the Ancient East*. London, 1941.

HUART, C. *La Perse antique*. Paris, 1925.

JACKSON, A. V. W. *Zoroastrian Studies*. New York, 1928.

KUEHNEL, E. *Die Islamische Baukunst*. Leipzig, 1928.

LAURENT, J. *Byzance et les Seljoucides*. Nancy, 1913.

*The Legacy of Islam* (ed. SIR T. W. ARNOLD and A. GUILLAUME). Oxford, 1931.

OLMSTEAD, A. E. *History of the Persian Empire*. Chicago, 1948.

POPE, A. U. (ed.). *A Survey of Persian Art*. 6 vols. Oxford, 1939.

ROSTOVTZEFF, M. *Iranians and Greeks in South Russia*. Oxford, 1922.

SARTON, G. *Introduction to the History of Science*. Baltimore, 1927.

STEIN, SIR A. *Innermost Asia*. 2 vols. Oxford, 1932.

STOREY, C. A. *Persian Literature*. In progress. London, 1927–.

SYKES, SIR P. M. *History of Persia*. 2 vols. 3rd ed. London, 1930.

TARN, W. W. *Alexander the Great*. Cambridge, 1948.

TRITTON, A. S. *Muslim Theology*. London, 1947.

VASILIEV, A. A. *Byzance et les Arabes*. Brussels, 1935.

WILSON, SIR A. T. *A Bibliography of Persia*. Oxford, 1930.

# TABLE OF DATES

## MEDIAN EMPIRE

B.C.

708 Deioces founds Median Empire.

655 Accession of Phraortes.

633 Accession of Çyaxares. Scythian Invasion.

625 Death of Assurbanipal.

606 Fall of Nineveh.

584 Death of Cyaxares.

558 Accession of Cyrus to throne of Anshan.

550 Cyrus defeats Astyages and captures Ecbatana.

## ACHAEMENID DYNASTY

546 Cyrus I proclaims himself King of Persia. Defeat of Croesus and capture of Sardis.

539 Capture of Babylon.

538 Cyrus I enthroned as King of Babylon.

536 Restoration of the Temple at Jerusalem.

529 Death of Cyrus I. Accession of Cambyses.

528 Conquest of Egypt.

521 Revolt of Gaumata. Death of Cambyses. Accession of Darius I.

499–4 Ionian Revolt.

490 Battle of Marathon.

486 Death of Darius I. Accession of Xerxes I.

480 Battle of Salamis.

466 Accession of Artaxerxes I.

462 Revolt of Hystaspes.

455 Revolt of Egypt.

424 Accession of Xerxes II. Accession of Darius II.

405 Revolt of Egypt.

404 Accession of Artaxerxes II.

401 Battle of Cunaxa. Retreat of the Ten Thousand.

387 Peace of Antalcidas.

358 Accession of Artaxerxes III.

336 Accession of Darius III. Assassination of Philip of Macedon.

334 Alexander the Great invades Asia.

333 Battle of Issus.

331 Battle of Arbela.

33 Revolt of Tiradates. **Phraates IV flees.**
30 Phraates IV returns. **Tiradates flees to Octavian.**
20 Restoration of Roman Standards. **Tigranes nominated King of Armenia.**
 2 Murder of Phraates IV.

A.D.

 1 Treaty of Phraataces with Rome. Parthia withdraws from Armenia.
18 Germanicus proclaims Artaxias King of Armenia.
34 Artabanus of Parthia appoints Arsaces to Armenian throne.
35 Arsaces assassinated.
37 Artabanus yields Armenia and makes peace with Tiberius.
40 Death of Artabanus.
51 Volagases invades Armenia.
66 Nero invests Tiradates as King of Armenia.
77 Death of Volagases. Accession of Pacorus.
105 Accession of Osroes.
114 Trajan's Eastern conquests begin.
115 Trajan occupies Mesopotamia.
117 Death of Trajan. Hadrian withdraws from Armenia and Mesopotamia.
122 Peace between Parthia and Rome.
133 Raid of the Alani.
148 Accession of Volagases III.
163 Avidius Cassius defeats the Parthians.
191 Death of Volagases III.
199 Severus sacks Ctesiphon.
217 Death of Caracalla. Peace between Parthia and Rome.
220 Revolt of Artaxerxes (Ardashir).
226 Rout and death of Artabanus. End of Parthian period.

## SASSANIAN DYNASTY

226 Ardashir I proclaims himself Emperor of Persia.
232 Ardashir concludes peace with Rome. Annexation of Armenia.
241 Accession of Shapur I. Invasion of Syria.
260 Capture of Emperor Valerian.
263 Odenathus defeats Shapur.
272 Accession of Hormuzd I.
273 Accession of Bahram I. Execution of Mani.
276 Accession of Bahram II.
283 Carus captures Ctesiphon, and dies suddenly.
286 Tiradates seizes Armenia.
293 Accession of Bahram III. Accession of Narses.

614 Parviz captures Damascus and Jerusalem. Rape of the True Cross.
617 Parviz captures Chalcedon.
622 Heraclius defeats the Persians. The Hegira.
627 Heraclius raids Dastajird.
628 Deposition and death of Parviz. Accession of Kavadh II. Beginning of anarchy in Persia.
632 Accession of Yazdajird III. Death of Muhammad.
635 Arabs capture Damascus.
636 Persians defeated at Qadisiya.
637 Arabs capture Ctesiphon.
642 Persian rout at Nahavand. Persia annexed to Arab Empire.
651 Death of Yazdajird III.

## ARAB DOMINATION

747 Abbasid rising in Khurasan under Abu Muslim.
750 End of Omayyads. Establishment of Abbasid caliphate.
765 Khalid the Barmecide appointed governor of Tabaristan.
786 Harun al-Rashid becomes caliph.
803 Fall of the Barmecides.
813 al-Ma'mun becomes caliph.

## MINOR PERSIAN DYNASTIES

820 Tahir appointed governor of Khurasan, founds the Tahirid dynasty.
872 Tahirids overthrown by Ya'qub b. Laith, founder of the Saffarid dynasty.
878 Accession of 'Amr b. Laith.
903 Isma'il b. Ahmad captures Khurasan from the Saffarids. Rise of Samanid dynasty.
913 Accession of Nasr II b. Ahmad.
928 Establishment of Ziyarid dynasty of Jurjan.
945 Caliph al-Mustakfi recognizes the Buwayhid rulers.
976 Accession of Qabus the Ziyarid.
999 Mahmud of Ghazna extinguishes the Samanids and establishes the Ghaznavid dynasty.
1001 Mahmud begins his campaigns in India.
1007 Establishment of Kakuyid dynasty of Hamadan and Isfahan.
1030 Death of Mahmud.
1037 Rise of Seljuks under Tughril.
1042 Ziyarids overthrown by Ghaznavids.

## ILKHANID AND TIMURID PERIOD

## AFSHARIDS

1736 Nadir Quli proclaims himself Shah of Persia.
1738 Nadir Shah invades India and sacks Delhi.
1740 Nadir Shah conquers Bukhara and Khiva.
1747 Assassination of Nadir Shah. Accession of 'Adil.
1748 Accession of Shah Rukh the Afsharid.

## ZENDS

1750 Karim Khan occupies Southern Persia.
1763 Foundation of English Factory at Bushire.
1779 Accession of 'Ali Murad.
1785 Accession of Ja'far.
1789 Accession of Lutf 'Ali.
1794 Aqa Muhammad Qajar overthrows and kills Lutf 'Ali. End of the Zend
      dynasty.

## QAJARS

1795 Aqa Muhammad invades Georgia. Capture of Tiflis and Erivan.
1796 Coronation of Aqa Muhammad.
1797 Assassination of Aqa Muhammad. Accession of Fath 'Ali.
1800 Malcolm's first mission to Persia.
1808 Mission of Sir Harford Jones.
1812 Treaty of Gulistan. Persia cedes extensive territories to Russia.
1827 Russia seizes Tabriz.
1828 Treaty of Turkmanchai.
1834 Accession of Muhammad Shah.
1848 Accession of Nasir al-Din.
1850 Execution of the Bab.
1865 Russians capture Tashkent.
1868 Russians occupy Samarkand.
1873 Russians conquer Khiva.
1876 Russians annex Khokand.
1881 Russians crush Turkomans.
1896 Assassination of Nasir al-Din. Accession of Muzaffar al-Din.
1906 Promulgation of the Persian Constitution. Death of Muzaffar al-Din.
1907 Accession of Muhammad 'Ali Shah. Overthrow of Constitution. Anglo-
      Russian Agreement.
1908 Nationalist uprising.
1909 Abdication of Muhammad 'Ali Shah. Accession of Sultan Ahmad Shah.

1919 Anglo-Persian Agreement.
1923 Riza Khan becomes Prime Minister. Sultan Ahmad Shah leaves for
     Europe.
1924 Republic established in Persia, with Riza Khan as President. End of the
     Qajars.

## PAHLAVIS

1925 Riza Khan proclaimed Shah Riza Pahlavi.
1941 Abdication of Riza Shah. Accession of Muhammad Riza Shah.

# INDEX

D d

**HIJAB**
IN ISLAM

Maulana Wahiduddin Khan

Size: 22×14.5cm,
Pages: 16

*Islam*
AND MODERN CHALLENGES

Maulana Wahiduddin Khan

Size: 22×14.5cm,
Pages: 272

**MUHAMMAD**
A PROPHET FOR ALL HUMANITY

MAULANA WAHIDUDDIN KHAN

Size: 23.5×16cm,
Pages: 248

The Beautiful
Commands of
**ALLAH**

Size: 12.5×19 cm,
Pages: 192

THE LIFE OF THE PROPHET
**MUHAMMAD**

MUHAMMAD MARMADUKE PICKTHALL

Size: 11.5×15 cm,
Pages: 64

The
Beautiful
Promises of
*Allah*

Size: 12.5×19cm,
Pages: 200

The Wonderful
Universe of
**ALLAH**

SANIYASNAIN KHAN

Size: 14×14cm,
Pages: 150

THE SOUL OF
THE QUR'AN

Size: 12.5×19cm,
Pages: 160

A-Z
Steps to Leadership
from the Qur'an and Words of
the Prophet Muhammad

Size: 12.5×19cm,
Pages: 64

Size: 22×14.5cm,
Pages: 128

Size: 22×14.5cm
Pages: 192

Size: 22×14.5cm,
Pages: 159

Size: 22×14.5cm,
Pages: 392

Size: 22×14.5cm,
Pages: 68

Size: 22×14.5cm,
Pages: 96

Size: 22×14.5cm,
Pages: 64

Size: 22.5×14cm,
Pages: 292

Size: 22×14.5cm,
Pages: 114

Size: 11.5×15cm,
Pages: 112

Size: 11.5×15cm,
Pages: 92

Size: 22×14.5cm,
Pages: 255

Size: 12.5×19cm,
Pages: 168

Size: 22×14.5cm,
Pages: 24

Size: 22×14.5cm,
Pages: 56

Size: 22×14.5cm,
Pages: 43

Size: 22×14.5cm,
Pages: 48

Size: 22×14.5cm,
Pages: 48

## ∾ ISLAMIC BOOKS ∾

*Goodword*
B·O·O·K·S

1, Nizamuddin West Market, New Delhi 110 013
Tel. 462 5454, 461 1128, Fax 469 7333, 464 7980
e-mail: skhan@vsnl.com / goodword@mailcity.com